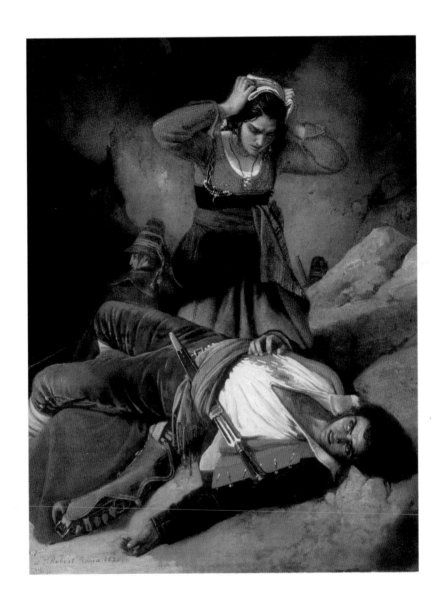

PUBLISHED BY CHAUCER PRESS
20 BLOOMSBURY STREET, LONDON WC1B 3JH

ISBN 1-904449-59-X

A COPY OF THE CIP DATA IS AVAILABLE FROM THE
BRITISH LIBRARY UPON REQUEST

DESIGNED BY POINTING DESIGN CONSULTANCY

ADDITIONAL PICTURE RESEARCH BY EMMANUELLE PERI

REPROGRAPHICS BY GA GRAPHICS

THE
FRENCH ROMANTICS
Literature and the Visual Arts 1800 – 1840

DAVID WAKEFIELD

CHAUCER PRESS
LONDON

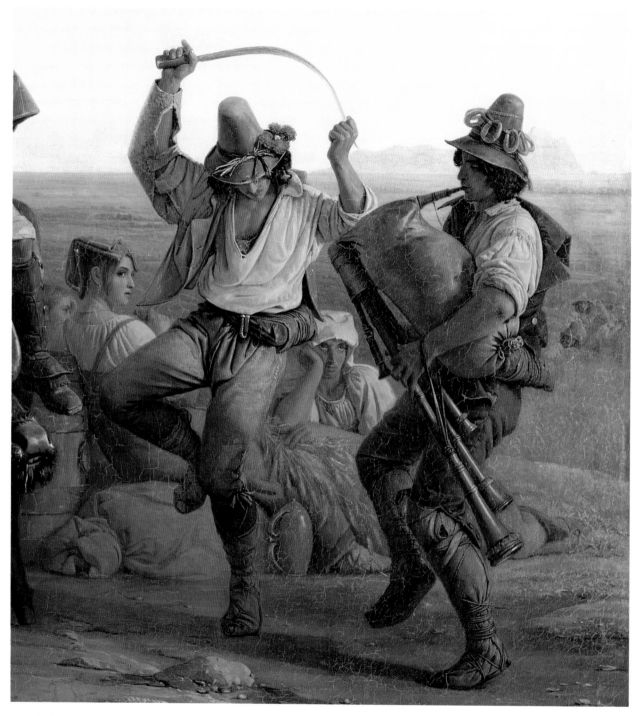

Detail of **The Harvesters in the Pontine Marshes**, Léopold Robert (Paris, Louvre)

CONTENTS

ACKNOWLEDGMENTS

SO MANY PEOPLE HAVE helped me during my research on this subject, in Oxford, London and Paris, that it would be impossible to thank them all individually. My greatest debt of gratitude is to the late Jean Seznec, formerly Marshal Foch Professor of French at Oxford, whose teaching and scholarship in the relations between literature and the fine arts was an example and constant source of inspiration. The late Professor Francis Haskell was always generous in his enthusiastic support and in making available to me the indispensable facilities of the departmental library of Art History at Oxford. Jon and Linda Whiteley have helped me in more ways than I can mention. I owe Dr Anita Brookner, formerly of the Courtauld Institute, a special debt for allowing me to try out my ideas on many of her students in the form of lectures and seminars. Some of them may well recognise suggestions and ideas of their own, which I have consciously or unconsciously borrowed. Simone Balayé of the Bibliothèque Nationale in Paris showed me extreme generosity in putting at my disposal her material on Madame de Staël. Paul Joannides kindly allowed me to read and make considerable use of his PhD thesis on the influence of English literature on French art of the nineteenth century (Cambridge, 1974). I would also like to thank the staff of the Witt Library and of the Taylorian Institution. Generous grants from the Leverhulme Foundation and the British Academy sustained me during my research on this project. I would like specially to thank Keith Pointing and my editor Christopher Wright for enthusiastically taking up my idea for this book, when other publishers might have baulked at the subject.

Finally, my thanks to Emmanuelle Peri for checking the translation and helping to raise the full quota of illustrations.

Preface

A BOOK OF THIS NATURE, which attempts to reduce a complex subject to manageable proportions, demands a few words of introduction to the reader and an explanation of the author's critical approach to the problems raised in the course of this inquiry. The parallel study of literature and the visual arts is already well established in the curriculum of universities; the value of such comparative studies, though still resisted in some quarters, is now generally accepted. A number of seminars and colloquia (for example, *French Nineteenth-Century Painting and Literature, Manchester*, 1972) and at least one book of essays (*The Artist and the Writer in France. Essays in honour of Jean Seznec*, Oxford, 1974) have been devoted to the theme. There is still, inevitably, a wide divergence of approach to what should be recognised as an important cultural phenomenon, namely the close interdependence of all the arts (including music) which reached its climax in France during the Romantic period. Some mutual suspicion may linger on both sides; literary specialists tend to regard painting as a secondary art fit only for illustration, while art historians treat literature as 'background' material and a useful source of documentary evidence, but not as a form of art in its own right. The differences between them are reflected still more acutely in their respective methods. Art history is still partly dominated by a nineteenth-century determinist philosophy, of cause and effect, of influence and logical, inevitable progression; its modern variant, the social history of art, leans even more heavily on historical context and circumstances.

Literary studies, on the other hand, have largely outgrown or rejected the historical method inaugurated by Hippolyte Taine, systematised by Gustave Lanson and carried to extremes by his pupils like Daniel Mornet, with his formidable array of sources, dates and biographical facts. In place of this old-fashioned '*histoire littéraire*' criticism has virtually monopolised the study of literature, basing itself exclusively on the internal evidence of the book or poem, on its rhythm, style, imagery, conscious or unconscious themes or forms of repetition. As a result – until recently at any rate – external factors such as biography, historical circumstances, the intellectual climate, and so on have been largely ignored. In the hands of its most radical structuralist critics like Roland Barthes and the most recent phenomenon 'deconstruction', literature has been virtually reduced to an object studied in a void. Consequently the studies of art and of literature rest on fundamentally different assumptions. There seems little likelihood of the two disciplines moving towards a closer mutual understanding until these assumptions are seriously challenged: until, in fact, all sides of the cultural divide come to recognise that art, literature, music or indeed any other creative activity, are merely different facets of the human imagination. This truth,

intuitively perceived by the great writers and artists of the Romantic generation, was clearly stated by Marcel Proust who wrote in *Le Temps Retrouvé*: 'Style, for the writer as well as the painter, is a matter of vision rather than technique.' Paul Valéry vigorously protested against the habit of creating artificial cultural divisions and stressed the unity of all creative effort: 'If academic tradition and routine did not prevent us from seeing things as they are, and did not insist on classifying the types of mind according to their means of expression instead of grouping them according to what they have to express, a single history of the mind would replace the various histories of art, of literature . . .' (*Variété*).

The 'single history of the mind' advocated by Valéry has yet to be written, if it ever could be. Cultural history on the lines of Burckhardt's *Civilization of the Renaissance* or Huizinga's *Waning of the Middle Ages* certainly went a long way to meet this demand, based on a clear perception of the relative contribution of history, literature and art to the overall pattern of civilisation. A book of this kind would undoubtedly be of great benefit to an understanding of the Romantic period; but it would also require vast knowledge and a measure of historical detachment which few possess. Meanwhile, a variety of approaches has been adopted to the question of art and literature, few of them entirely satisfactory. One well-worn approach, typified in H. Hatzfeld's *Literature through Art* (New York, 1952), tries to establish some common historical affinity between, for example, a Corneille tragedy and a painting by Poussin, and – by stretching the meaning of words – claims to find a link between Pascal's '*Infini*' and the infinite vistas of the park of Versailles. Though comparisons between contemporary works are sometimes helpful and illuminating, more often they are merely fanciful. Loose parallels of this kind also abound in Hautecoeur's *Littérature et Peinture en France du XVIIe au XIXe siècle* and in S. Rocheblave's *Le Goût en France. Les Arts et les Lettres de 1600 à 1900* (Paris, 1914) and in L. Hourticq's *L'art et la littérature* (Paris, 1946); all three, though useful in passages, are old fashioned in approach and leave many questions unanswered.

More recently Jean Seznec, a pioneer scholar in the field of literature and the visual arts, suggested that research might be more usefully concentrated on specific points of contact between the arts using biographical, historical, textual and visual evidence wherever relevant. Sound documentation is often more helpful than bold generalisation. The sort of questions the student should ask, he suggests, are: what kind of pictures did a writer know? What collections and galleries did he visit? And, in the case of artists, what kind of books did they read? We should also pay close attention to individual paintings which hold a particular fascination for writers, for example Correggio's frescoes for Stendhal, Léopold Robert's *Moissonneurs* for Lamartine, Dürer's *Melancolia* for Hugo, Nerval, Michelet and many others. Paintings like these become archetypal images in the writer's mind, often

transformed and distorted out of recognition. In Proust's words, they are a kind of 'spiritual equivalent' to the writer's state of mind or an entire creative process.

These are the questions I have borne in mind in this book. I have not, therefore, tried to write a synthesis, or a general history of Romanticism, nor have I embarked on semantic discussions on the origins and meaning of the term. Rather I attempt to approach the relationship between the two arts from a variety of different angles, both from the literary and pictorial points of view, illustrating the influence of painting on literature and vice versa. The many gaps in these studies will, I am afraid, be obvious to specialists on individual authors and artists. I hope, though, they will be willing to concede the benefit of a cross-disciplinary approach, so that by juxtaposition of text and image, by cross-reference and comparison, some general notion of the Romantic movement as a whole will emerge. The chronological limits on the period are not wholly arbitrary, as it seemed that the relationship between literature and painting was at its closest and most fruitful between the years 1800-40. This is, admittedly, to exclude the poetry of Baudelaire and Balzac's novels, both rich in pictorial allusions and imagery, but they were the inheritors rather than the creators of a pattern of interdependence which had already been firmly established by the earlier generation.

Introduction

The period of literary and artistic activity to which this book is devoted is generally known as Romanticism. Like all such generic terms used to describe a phase of civilisation, the word has lost much of its original meaning through use and abuse. Indeed, some modern historians have even doubted whether the term has any meaning at all when so many conflicting definitions of the movement have been proposed and so many of its manifestations seem in mutual contradiction. For this reason – and because my purpose is to study certain specific aspects of the Romantic movement, not to attempt a synthesis – it seemed wiser to confine this inquiry within the perhaps arbitrary limits of the period from 1800 to 1840. By adopting this historical definition of Romanticism, I have tried to avoid the kind of long and often fruitless semantic discussion as to whether, for example, Lamartine can be considered a Romantic, or whether he was both Classic and Romantic simultaneously. This is not, however, to deny that, despite far-reaching differences of temperament, the writers and artists all shared certain common assumptions which can be seen, retrospectively, as the common ideological property of the Romantic movement. All of them, in varying degrees, believed in the supremacy of the individual, in the value of self-expression and personal feeling and, above all, the primacy of the imagination; their ultimate aim was to re-create the world according to their own subjective vision. Images, visual memory, ideas, vision: these were the dominant preoccupations of the Romantic artist, whether writer or painter, and help to explain why the two arts were in such unusually close contact during this period.

In all this the Romantics mark a significant departure from the mainstream of eighteenth-century literature. The leading figures of the French Enlightenment, Montesquieu, Voltaire, Diderot and d'Alembert, all believed that the secret of human wisdom and happiness lay in a spirit of justice, tolerance and the systematic codification of empirical knowledge. The basis of this knowledge rested on fact and sensation which, in its turn, generated ideas; but 'imagination', in the Romantic sense, hardly came within their spectrum, in fact was regarded with some suspicion as one of those irrational faculties like religious belief which did more harm than good.

The first writer to depart radically from these assumptions was Jean-Jacques Rousseau (1712-78), the Genevan philosopher who revolutionised eighteenth-century thought and, almost by accident, shook the very foundations of society. The crux of his belief was the uniqueness of the individual, stated in forthright terms on the first page of *The Confessions*: '*Je sens mon coeur et je connais les hommes. Je ne suis fait comme aucun de ceux que j'ai vus; j'ose croire n'être fait comme aucun de ceux qui existent.*' ('I am conscious of my heart and I know

men. I am like no other that I have seen; I dare believe that I am like no other that exists.')
This emphasis on the authenticity, the sanctity, of personal emotion was the basis of
Rousseau's philosophy, and provided him with the vital yardstick which enabled him to
justify even the worst aspects of his own conduct. The same belief can be seen
retrospectively at the root of the Romantic movement. Rousseau has also been castigated
by critics like Irving Babbitt as the evil genius behind much of the anti-rationalist
impetus and iconoclastic nihilism in nineteenth-century thought. For the Romantics – and
all the writers who come within the scope of this book – whether they were conscious of
their debt to Rousseau or not, all shared his passionate individualism and belief in the
priority of personal emotion over social values. Traces of this individualist ethos and its
attitude of rebellious defiance towards the established order can be found in all the heroes
and heroines of Romanticism, in Chateaubriand's René, in Madame de Staël's *Corinne*, in
Byron's *Don Juan*, in Stendhal's *Julien Sorel*, and in the dandyism of Musset and Delacroix.
Its influence reaches as far as the late nineteenth century, in the narcissistic egotism ('le
Culte du Moi') of the writer Maurice Barrès.

The French Revolution and its aftermath inevitably left an indelible mark on the
writers and artists of the Romantic generation. Most of them were born either just before
or during this period; some, like Stendhal, welcomed the end of the Ancien Régime,
others like Madame de Staël tried to come to terms with the Revolution, others again like
the aristocrats Chateaubriand (who lost several members of his family during the Terror)
and Alfred de Vigny recoiled from it in horror; all were profoundly changed by the event.
Life could never be the same again. In the first place, polite society, in the form the
literary salon which had regulated intellectual life in the eighteenth century, virtually
disappeared overnight. There were no more hostesses like Madame du Deffand and
Madame Geoffrin to launch authors such as Montesquieu and Voltaire and to applaud their
brilliant theories. Henceforward writers, whether their basic instincts were democratic or
not, had to reach out over the heads of the intellectual élite to the minds of a mass
audience, now that the Napoleonic system of education had ensured a far higher degree of
literacy among the French. Most of these writers were not nurtured in drawing-rooms but
in action and in the thick of battle, like Stendhal who trudged the length and breadth of
Europe in the wake of the Imperial army; or Chateaubriand who began his literary career
in exile, half-starving in a London garret, and found the subjects of his stories *Atala* and
René in the virgin forest of North America. Written from direct personal experience, books
like *Corinne*, *Atala* and Lamartine's *Méditations* struck an immediate response in the
contemporary public. The Romantics can count some of the first truly popular heroes in
literature.

And yet the paradoxical fact remains that the Romantic artist and writer felt no degree of sympathy with the public who devoured his works, indeed he often regarded it with contempt and loathing. More often than not he found himself at odds with society, not part of it. Hence the chronic boredom and misery, the 'mal du siècle', expressed in so much Romantic literature, by authors for whom any kind of compromise was unthinkable. This state of dispossession can partly be attributed to the fact that since the end of the eighteenth century, 'society' had changed; artists and writers were no longer content to take part in it on the inferior social level of artisan and resident entertainer. In the wake of the social disintegration resulting from the Revolution, the writer began to regard himself as unique, superior to all around him in intelligence and vision, and therefore outside society altogether. This form of self-imposed isolation is a constant theme of Romantic writing, typified in Vigny's theory of the 'pariahs' of the modern world (soldiers, writers and philosophers), and in Stendhal's dedication to 'happy few'; the portrayal of sexual guilt in Byron and incest in Chateaubriand's *René* further emphasises the isolation of the Romantic hero from the rest of society. The artist, in fact, had achieved aristocratic status; not only was he, like Delacroix, a man of fastidious taste and impeccable dress, but he also feared that the new democratic institutions which the liberal intelligentsia of around 1770 had encouraged were a threat to civilisation itself. In reaction, therefore, against the forces which they themselves had helped to unleash, some writers turned away and, like Vigny, retreated into their ivory towers, or else concentrated on the search for a new spiritual élite.

The ambiguity of the nineteenth-century writer's position is exemplified by some remarks made by Stendhal in the *Vie de Henry Brulard*. Though a radical and republican by conviction, Stendhal retained some of the aristocratic attitudes of the previous century when he wrote that he both passionately desired the happiness of the masses but at the same time loathed to have any contact with them. Lamartine too, after many years in politics devoted to the 'proletarian question' and strenuous attempts to improve the working conditions of its members, confessed his sense of disillusionment with in them in the line:

J'ai vécu pour la foule, et je veux dormir seul.

Au Comte d'Orsay

('I have lived for the masses, and I wish to sleep alone.')

The position in the visual arts was somewhat different. Long before the Ancien Régime drew to its close the so-called Rococo style associated with Boucher, Fragonard and Van Loo (dubbed 'insipid' and 'vaporous' by critics of the Romantic generation such as Stendhal) had fallen from favour. Its decline was hastened by the repeated attacks of Denis Diderot, whose *Salons* published between 1759 and 1781 constantly called for the rejection of Rococo eroticism and the return to *'un goût sévère et antique'* (in other words

Neo-Classicism, as it was soon to appear in the work of Joseph Marie Vien and Jacques-Louis David). The political implications of Diderot's criticisms were fully apparent, for by accusing Boucher of immorality in his love of naked female bodies he was also, by extension, attacking the painter's clientèle, the wealthy connoisseurs and small privileged clique centred on the court who sought only pleasure in art and showed no concern for its possible ennobling influence. The argument was, in effect, about two rival systems of patronage, private versus public. Diderot and several leading intellectuals in the late eighteenth century believed that since private patronage had failed to infuse any kind of idealism or sense of purpose into art, it was up to the State to perform that task. David's picture, *The Oath of the Horatii* (Salon of 1785, Paris, Louvre), was a landmark in this new direction; though without explicit political allusion, this painting forged a permanent link in the public mind between artistic and political revolution. A well-established system, based on the Academy, the Salon and the *Prix de Rome* prize, bound French artists to a position of dependence on the State. The political institutionalisation of art was a permanent feature of French life which carried on through the Revolution, the Empire, the Restoration, the July Monarchy and survived down to the late nineteenth century. The Napoleonic régime strengthened its hold over artistic patronage still further, by offering artists like David the opportunity to paint occasions full of pomp and splendour (like the Imperial coronation in 1804) and in the endless sequence of battles, Austerlitz, Arcole, the Pyramids (to name a few), immortalised in the canvases of David, Gérard and Gros. The strict regimentation of artists under the Revolution and the Empire meant that, unlike writers, they were too busily occupied with State commissions to have much time for the expression of personal feeling. Only with Girodet, the strangest but most original artist to emerge from David's studio, does the strain of conscious individualism begin to appear. Although many of his major works, like the huge Ossianic picture of Napoleon's generals (*Apotheosis of the French heroes who died for their country*, Château de Malmaison), were official commissions, Girodet injected into them his own bizarre poetic fantasies which drew him instinctively to the writings of Chateaubriand. His paintings display that deliberate confusion between the boundaries of art and literature so characteristic of Romanticism. For the archetypal Romantic artist – exemplified perhaps by Victor Hugo – was a man who refused to recognise limitations of any kind, whether of medium or of subject-matter, in his insatiable urge to comprehend the whole of human experience.

With the collapse of the Empire in 1815 and the restoration of the Bourbon monarchy artists were suddenly deprived of their sense of political direction and were thrown back on their own resources. By around 1820 large-scale history painting, which had provided the standard form for official commissions, was seriously in decline and threatened with extinction by the new popularity of easel painting, landscapes, portraits and genre scenes.

Though the Bourbons made a serious attempt at reviving official patronage in the form of commissions by the Ministry of the Interior, by far the greatest number of pictures painted during this period were for private individuals. As Stendhal observed, few people lived in houses large enough to accommodate the enormous canvases required by history painting. During these years (especially between 1820-30) the regular exhibition or Salon became an event of national importance, drawing huge crowds and attracting endless comment from journalists and professional art critics. The part played by the press in the evolution of French painting cannot be overestimated. The democratisation of art was not a new phenomenon, but part of a gradual process which began around the middle of the eighteenth century and continued throughout the nineteenth. The typical member of the public to whom the nineteenth-century critic addresses his remarks is no longer the cultivated amateur (the '*honnête homme*'), Diderot's ideal reader, but the bourgeois apostrophised by Baudelaire, the grocer or tradesman of Balzac's novels, ignorant and philistine perhaps, but with a genuine thirst for the culture which was now his birthright.

The outstanding exceptions to this general trend towards small-scale art were the two great artists of the early nineteenth century, Ingres and Delacroix. Though totally opposed in style, temperament and nearly everything else, both painters were consciously working against the tide in their obstinate adherence to the grand style and to the prestige of historical and mythological subject-matter, long after these had been pronounced dead and buried by the critics. Elitist by nature, both held staunchly conservative views and were contemptuous of popular opinion. Ingres' *Apotheosis of Homer* (1827) [Fig. 56] is the ultimate statement of his belief in the traditional hierarchy of art; throughout his life he consistently defended the classical principle of form and the primacy of drawing over colour. Delacroix, for his part, though widely hailed as a revolutionary early in his career on the strength of the *Massacre at Chio*s (1824) [Fig. 33], was always at pains to deny any revolutionary intentions in his art and invariably snubbed critics who put such an interpretation on his love of strong colour and violent themes. Delacroix, in fact, embodies many of the ambiguities of the nineteenth-century artist: a Romantic in the extraordinary daring and originality of his technique, a Classicist in his love of order and harmony, the painter of subjects from Byron, Scott and Shakespeare who preferred the works of Boileau as his bedside reading, the creator of the celebrated painting of the popular insurrection, *July Revolution* (1830, Paris, Louvre), who inwardly disdained the masses and never dropped his mask of aristocratic reserve. All these tensions in Delacroix's artistic personality suggest that one of the most fundamental characteristics of the early nineteenth century was the perpetual and unresolved conflict between opposing forces – between order and chaos, Classicism and Romanticism, belief and unbelief, aristocracy and democracy. The following study of the relations between French art and literature during the Romantic period is merely one aspect of this phenomenon.

CHAPTER I

Madame de Staël

Madame de Staël[1] may not at first seem the obvious figure to begin a study of the French Romantic movement. Born in Paris in 1766, the daughter of Jacques Necker, the Genevan banker who rose to become Finance Minister to Louis XVI, Germaine de Staël's origins were firmly rooted in the European Enlightenment. In the best eighteenth-century tradition she was brought up by her parents to believe in moderation, progress and the power of reason. These virtues, she believed, were personified in the figure of her father, whom she idolised and regarded as the source of all wisdom; her mother, Suzanne Curchod, a Genevan Protestant, had been the object of Edward Gibbon's courtship in her youth. Something of a blue-stocking, she kept a *salon* in Paris and had been on friendly terms with many of the leading intellectuals and philosophers of the late eighteenth century, including Diderot, d'Holbach and the abbé Galiani. This was the background in which the young Germaine Necker was nurtured. A precocious child – as we can see from Carmontelle's portrait of her at thirteen, with her strong brow and alert eyes – she was already writing poetry at a tender age. Her early contact with the most brilliant men of the time, with their bold paradoxes and radical ideas for social reform, further sharpened her already considerable intellectual powers. They provided her with the basic equipment which she needed to become one of the most original thinkers of the early nineteenth century, and the leading proponent of Romantic theory in art and literature.

Germaine, however, became dissatisfied at an early age with the typically eighteenth-century virtues represented by her parents and their circle of friends. Their dry brand of irony and wit appealed to her intellect but not her emotions. Her rebellious spirit already protested in the name of idealism, enthusiasm, and all the potential in human beings which the eighteenth century had largely ignored. It was true that her mother had paid due homage to the fashionable cult of sensibility but she had never allowed it to escape the control of her will and a rigid sense of moral duty. It was, significantly, to Rousseau's example that Madame de Staël turned in her first important piece of literary criticism, the *Lettres sur Jean-Jacques Rousseau*, published in 1788. This early tribute to the greatest rebel of the age, the advocate of personal freedom and equality, the enemy of social conventions, set the tone for the rest of Madame de Staël's life and work. Freedom – in the political sense of opposition to tyranny and in the emotional sense of obedience to the dictates of the heart – was to be the keystone of her intellectual edifice and the one basic instinct which guided her in all she did and wrote.

Moreover, never afraid to practise what she preached, she showed considerable personal courage in her opposition to attempts by the Napoleonic régime to suppress freedom of thought and speech.

The vagaries of Madame de Staël's private life, her outlandish dress and disregard for social conventions, have perhaps received more than their due attention from biographers. Her extraordinary personality was, however, an integral part of her literary genius and cannot entirely be divorced from her writings. All who met and knew her – even a witness as unimpressionable as Goethe – were struck by her remarkable magnetic power, something which had nothing to do with looks or charm in the ordinary sense. A combination of high intelligence and dedication to the noblest causes, all expressed in a torrent of eloquence, attracted people to her in droves and made the gatherings at her château of Coppet on Lake Geneva the focal point for the intellectual élite of Europe. From the start she sensed that she was destined to play a great role in the political life of France. Married in 1786 to Baron de Staël-Holstein, the Swedish ambassador to Paris, she entered the political arena with zest and used her new position to promote the cause of liberalism. Although she welcomed the outbreak of revolution in 1789, the excesses of the Terror and, above all, its ungrateful treatment of her father who was finally dismissed from office in 1790, convinced her that the only course of salvation lay in a constitutional monarchy. She was a lifelong liberal; though opposed to feudalism and absolutism, she believed in property as the proper basis of democracy. In pursuance of her views, and after the failure of her marriage, Madame de Staël exerted her considerable powers of persuasion on a series of lovers, among them Benjamin Constant, whom she met in 1794, a writer of brilliance equal at least to her own, who portrayed their relationship in his novel *Adolphe* (1816), a masterpiece of lucid psychological analysis.

In 1797, after a period of exile in Switzerland, Madame de Staël returned to Paris where Napoleon Bonaparte was the rising star on the political horizon. Instantly recognising his genius, she offered him nothing less than total adulation, pursuing him with her attentions in the hope no doubt of exercising some feminine influence on his thirst for power and glory. Napoleon, however, did not take kindly to women in politics, least of all those who never ceased to denounce tyranny. From the outset he regarded her as a dangerous meddler; in 1803, when Benjamin Constant joined the opposition and spoke out against Bonaparte in the Tribunal, he took the opportunity to banish her to a safe distance from Paris. This measure was increased to total exile when Napoleon learnt the contents of *De L'Allemagne* in 1813 and had the proofs destroyed. Thus began that nomadic existence which was to become the basic pattern of Madame de Staël's life; the theme of exile recurs like a plaintive leitmotiv throughout her writings. Her mostly

involuntary travels to Germany, Italy, Austria and Sweden, however, provided her with the indispensable source of raw material needed for her comparative studies of society, literature and the arts. In the process she became the first truly cosmopolitan writer of the nineteenth century. The only settled and relatively happy periods in her life were the summers spent at Coppet, which became the rendezvous of all the most distinguished minds of the day, including August-Wilhelm Schlegel, Simonde de Sismondi and Benjamin Constant. There, in that fine setting overlooking Lake Geneva, politics, religion and literature were debated with passionate intensity. Their hostess always occupied the centre of the stage, dominating all around her with her prodigious physical and intellectual energy. After the restoration of the monarchy in 1815 Madame de Staël was finally allowed to return to Paris. But by then her health was seriously damaged by the strain imposed by her peripatetic life and intense labours. After a brief period of happiness leading to her second marriage in 1816 to the officer John Rocca, she died in 1817 from sheer physical exhaustion.

De La Littérature, published in 1800, embodies the first and most ambitious attempt by Madame de Staël to deal with the problems of literature, the arts, politics and society. The work is set out on fairly orthodox eighteenth-century lines, marked by a strong preference for rational classification, with chapters and subdivisions reminiscent of Montesquieu's *L'Esprit des Lois*. In it literature is studied in relation to the changing pattern of civilisation as it evolved from the early Greeks, through the Renaissance and the seventeenth century in France, to Madame de Staël's own times. Literature – and to a lesser extent the fine arts – is seen as an expression of the social values, particularly of those most esteemed by the author, freedom, happiness, fame and virtue. Hence Madame de Staël's confident assertion: literary criticism is often a moral treatise.[2] Literature and the arts were, in her view, inseparable from morality, both reflecting and helping to create the predominant mental outlook of a given period; Homer was typical of the values prized by the early Greeks just as Racine personified the qualities of the *Grand Siècle*.[3]

The single most important idea which recurs throughout *De La Littérature* is that of human progress. An optimistic belief in the perfectibility of mankind was Madame de Staël's chief legacy from the French Enlightenment, and one she never renounced. Following Voltaire and the Encyclopaedists, she was firmly convinced that mankind was not only capable of moral improvement but had made great progress towards humanitarian ideas and respect for human rights. Christianity had made the greatest contribution to this process, for by substituting courtly love with its attendant virtues of devotion and self-sacrifice in place of the purely carnal notion of the Greeks, it had inspired the troubadour poets in the Middle Ages and the great chivalrous epics of Tasso and Ariosto in Renaissance Italy, as well as the finest painters of the modern age. Thus the arts and literature were

directly involved in this process of historical evolution. Indeed they made a positive contribution to civilisation and were an active force for good. Giving voice to his contemporaries' preoccupations, the writer bore a heavy social responsibility; he was not to lecture them, but had to be closely in tune with their feelings and aspirations. Madame de Staël rejects the notion of the isolated genius – a notion which was to gain wide currency among the later Romantic generation of 1830 – since every great artist is deeply rooted in the historical context of his times. According to this view every major masterpiece is in some way a microcosm of its period: hence *Werther* was not Goethe's unique personal creation but a type only he managed to portray.[3] This tendency to emphasise general cultural developments at the expense of the individual is the natural consequence of the author's intellectual approach, rooted in the twin ideas of progress and historical relativity.

The vital critical distinction made in *De La Littérature* (Vol 1, Ch XI) – and one which later proved easily transferable from literature to the visual arts – is that between the literature of the North and the literature of the South. The essence of Mediterranean poetry, in Madame de Staël's view typified by Homer, is a succession of concrete, plastic images evoking pleasure and agreeable sensation, but not conducive to profound thought. The poetry of the North, on the other hand, is deeply marked by melancholy and introspection. Ossian, whom she regarded as the representative Northern poet, is full of gloom and pessimism. There is no doubt that, of the two, her preference was for Ossian and the North because she believed that this brand of Northern melancholy was more in tune with the philosophic mood of her own times. Tormented souls like her own found a more sympathetic echo in the grey, evanescent effects of the Ossianic landscape, or the spectral imagery of Young's *Night Thoughts* than in the extrovert adventures of the *Iliad* and Homer's classical offspring. As Stendhal later put it in his *Histoire de la Peinture en Italie*, psychology had replaced physique in the nineteenth century's order of values.[4] Madame de Staël rightly defined this soulfulness, this deep inner passion combined with a restless striving for immortality and infinity, as the prime motive force of the new age and one which, in retrospect, marked out the products of Romanticism like Goethe's *Faust* from all others: 'The imagination of the men of the North breaks out beyond the land whose borders confine them; it darts forth through the clouds which border their horizon and which seem to symbolise life's obscure passage to eternity.'[5]

De L'Allemagne **and the formulation of Romantic theory**[6]

It was, however, with the publication of *De L'Allemagne* in 1813 that Madame de Staël made her vital contribution to the theory and practice of Romanticism, both in literature and the visual arts. The book is a seminal work for the entire nineteenth century. It was the first sustained attempt to interpret a foreign civilisation to the French, and to breach

the cultural barriers which they had so successfully erected round their own country in the seventeenth century. It should be remembered that in 1800, when Madame de Staël was writing the book, the German language and literature were either totally unknown to the average French reader, or else the object of contempt. The long French cultural hegemony created by Louis XIV persisted throughout the eighteenth century and had produced an inbred classical civilisation, convinced of its own superiority and hostile to any innovation or outside influence. It was largely to change this state of affairs and to persuade the French to look beyond their frontiers to Germany, where a profound literary and philosophical revolution was in the making, that Madame de Staël wrote *De L'Allemagne*.

The book is closely based on her own travels and experience. Exiled from Paris on 15 October 1803 by Bonaparte, she set out for Germany ten days later in the company of Benjamin Constant. As with all her travels, this journey was not undertaken for pleasure, but forced on her by political circumstances. The opening chapters of *De L'Allemagne* convey all the bitterness of exile, the feeling of desolation experienced by the travellers in an inhospitable foreign country. The snow-capped pine forests of northern Germany in the depths of winter, the sleepy provincialism of its small towns and villages and its lethargic population – all produced an instinctive revulsion in Madame de Staël. Germany seemed the antithesis of the kind of civilised society she enjoyed in France. Gradually, however, the differences between the two countries began to arouse her interest and eventually to absorb her mind. She soon perceived that the apparent defects in the German national character – provincialism, inwardness, unworldliness – were the necessary conditions of its spiritual strength and immense capacity for concentration on philosophy and metaphysics.

After an inauspicious beginning, her journey reached its climax late in 1803 in Weimar, the intellectual capital of Germany. There she was received like an ambassadress by the Duke of Weimar, and the foremost German writers, Goethe and Schiller. Although at first somewhat chilled by Goethe's detached Olympian manner, Madame de Staël eventually came to recognise him as a great European writer with a universal mind capable of transcending limited national horizons. The next most important stage on her journey was Berlin, where she arrived in April 1804. Here she met August-Wilhelm Schlegel, the most influential critic and theorist of early Romanticism. His recently delivered series of lectures on *Dramatic Art and Literature* made such a profound impression on Madame de Staël that she instantly engaged him as tutor to her children and returned with him to Switzerland in May 1804.

While *De L'Allemagne* was being written German Romanticism was still in its infancy, and it is for this reason that Madame de Staël's account of the movement is incomplete. But she clearly perceived the great sense of spiritual and intellectual

rejuvenation, which swept through German life and radically transformed the attitudes of an entire generation. Previously, for most of the eighteenth century, German literature had largely followed the dictates of French classical culture. It was only when Lessing led a revolt against this French hegemony and turned instead to Shakespeare and the English poets, that German writers began to develop their own distinctive idiom. This process of liberation reached a climax in the so-called *Sturm und Drang* movement, typified by such early dramas as Goethe's *Götz von Berlichingen* and Schiller's *Die Räuber*, both glorifying the rebellion of the individual against an authority which they refuse to recognise. By the time Madame de Staël appeared on the scene both writers had long outgrown this early phase and had reached a mature philhellene stage known as Weimar Classicism. German Romanticism was still too recent a phenomenon to have revealed its true character, namely a persistent nostalgia for the Middle Ages, a flight from the present into a mythical Christian past and a preference for the irrational and supernatural. This obscurantist, reactionary strain in German Romanticism – particularly in its later phase – was retrospectively portrayed with devastating irony in Heine's *Die Romantische Schule* in which he defined the movement as 'the revival of the poetry of the Middle Ages, a passion flower sprung from the blood of Christ'.

Nevertheless, by 1800, the new movement was already clear in its main outlines. The intellectual revolution in history, philosophy and criticism, largely identified with Hegel, Kant and the Schlegels, was complete and provided a new vantage point from which Madame de Staël could survey French civilisation. Furthermore, her Swiss cosmopolitan background enabled her to look dispassionately at both French and German civilisations, and to weigh their respective strengths and weaknesses in the balance. Viewed through her eyes, the contrast between the two countries is total. On the one hand Germany, the home of mediaeval chivalry and Nordic myths, feudal, reactionary, mystical, religious; a land of popular legend and folk poetry (recently revived in *Des Knaben Wunderhorn* by the Romantic writers, Arnim and Brentano) inhabited by a gauche, unworldly, sentimental and devout population, contemptuous of social values and yet rigidly divided by social class, intellectually bold but submissive to authority. The French nation, on the other hand, is seen as the embodiment of the social virtues, charm, taste, elegance, concision in the form and expression of ideas and, above all, brilliance in conversation.[7] All these qualities ideally equip the French writer to deal with man in relation to society. On the debit side the French are criticised for superficiality and a narrow-minded reluctance to admit new, especially foreign, ideas.

This implicit criticism of France, coupled with praise of a foreign country, brought *De L'Allemagne* into serious trouble with the Napoleonic régime. Alarmed by rumours that

Madame de Staël was about to publish a subversive work, Napoleon ordered his chief of police to have the publication stopped immediately. Fortunately, she managed to save her manuscript and took it to London, where the book appeared in 1813. In revenge, Napoleon had the author exiled permanently from France, on the grounds that the book was 'un-French'. [8] The Emperor had good reason to fear Madame de Staël's book, for had he read it – which he had not – he would have found, as well as a broad international outlook, advocacy of free speech and powerful arguments in favour of personal morality taking precedence over national expediency. None of these are virtues favoured by a totalitarian state.

The originality of *De L'Allemagne* is in no way diminished by the reminder that many of its ideas were closely inspired by its author's study of recent German philosophy and criticism. The single most important influence was that of August-Wilhelm Schlegel, who with his brother Friedrich founded the review *Athenäum* in 1798, the earliest significant organ of Romantic poetry and aesthetic theory. Between 1801 and 1804 Schlegel delivered a series of lectures in Berlin on *Literature and the Fine Arts*; in 1807 he wrote a controversial treatise comparing Racine's *Phèdre* with Europides' original, and in 1807-8 delivered a further series of lectures in Vienna on *Dramatic Art and Literature*. He also produced distinguished translations of Spanish theatre and one of Shakespeare which is still considered a classic to this day. Schlegel then worked together with Madame de Staël at Coppet, accompanied her on her travels, and quietly but relentlessly played the part of her *éminence grise*, from whom she learnt a great deal; she also made immense efforts to understand his entire way of thinking and modes of perception. These were all the more valuable to her since, although an omnivorous reader, she lacked the patience for systematic study and was all too happy to benefit from his vast erudition. Moreover, Schlegel had a considerable knowledge and understanding of the visual arts, which at this stage Madame de Staël lacked. Many of his ideas on the meaning and symbolism of art found their way into *Corinne* and *De L'Allemagne*.

The crux of Romantic theory, quickly adopted by Madame de Staël, was clearly formulated by Schlegel in the *Athenäum*: 'Romantic poetry is a progressive, universal poetry.' 'All Art must become Science and all Science become Art; Poetry and Philosophy must be united.' 'Life must become poetic, and poetry reconciled with life.' Such pronouncements give the measure of the ambition of the German theorists of Romanticism. They wanted nothing less than a fusion of all areas of human knowledge and experience, which eighteenth-century rationalism had segregated. At a stroke the artist's sphere of influence was vastly increased; from being a mere craftsman or technician, he was immediately promoted to the role of philosopher, scientist, priest and social legislator, all in one. Moreover, Schlegel's

theory of art and poetry allows for indefinite growth: 'The Romantic style of poetry is still in a process of evolution; indeed that is its essential character, that it can eternally only become, never be completed. Art is infinitely perfectible.' Precisely because the formal perfection of classical art leaves him dissatisfied, the Romantic artist, and the Romantic hero like Goethe's *Faust*, is condemned to strive after some eternally shifting and elusive goal; hence the unfinished quality of so many nineteenth-century works of art.

These definitions lead to the fundamental division, invented by the Schlegel brothers, into Classical and Romantic, Mediterranean and Northern art, the twin poles which underlie the whole of European civilisation. For Friedrich Schlegel Romanticism, that is the modern era, began in the Middle Ages, when courtly love replaced the purely physical notions of classical antiquity; reading history backwards, he claimed to discover Romantic characteristics in many writers of the post-classical age, in the age of chivalry, in Shakespeare, Cervantes, Tasso and Ariosto. This is the source of Madame de Staël's definition of Romanticism, decisively formulated in Chapter XI of *De L'Allemagne*: 'The word 'Romantic' was recently introduced in Germany to designate the poetry which had its origins in troubadour songs and came into being in the age of chivalry and Christianity. If one does not admit that the empire of literature is shared equally between paganism and Christianity, the north and south, antiquity and the middle ages, chivalry and the Greek and Roman institutions, it will be impossible to form a philosophical judgement of ancient and modern taste.'[9]

This simple and somewhat arbitrary division of Europe into two cultural and geographical entities forms the basis of Madame de Staël's literary and aesthetic theory. The twin poles are represented by the classical Mediterranean culture of Italy in *Corinne*, on the one hand, and the Northern Christian mediaeval one of Germany in *De L'Allemagne,* and England on the other. French civilisation occupies an intermediate position in this scheme, deriving both from its native troubadour tradition and from the classicism imported from Italy during the Renaissance. But, in Madame de Staël's view, imported cultures are artificial and never thrive, because they lack genuine roots in the native population.[10] Her main objective in *De L'Allemagne* is to persuade the French to discard their recently acquired façade of classicism and to reorientate them towards the Germanic North, on the grounds that the latter was closer to the hearts and minds of the people. There is undoubtedly a good deal of over-simplification in this theory, but intellectual subtleties are subservient to her main aim, which was to define the conditions most favourable to the rejuvenation of French culture. Modern Germany, on balance, seemed to offer the most fertile ground for the creative originality which the French so desperately needed.

The greatest obstacle to this creative renewal was the classical doctrine of imitation. Even in 1800 the belief was still widely held that classical antiquity had achieved

a peak of perfection in literature and the arts which could never be surpassed. The entire repertory of French seventeenth-century tragedy was deeply indebted to this classical hegemony. Following the arguments of Schlegel, Madame de Staël began to question seriously the wisdom of slavishly copying outmoded prototypes: 'The only point is to know whether by limiting ourselves as we do now to the imitation of these masterpieces, anything new will ever be created.'[11] She was, in fact, opposed to any kind of revivalism, either of classical or of Christian models. Christianity and the Middle Ages were to be used as a source of inspiration and not piously copied as some later Romantics were to do; building mock-Gothic churches in the nineteenth century was no less absurd than building Greek temples. The latent creative energies of the French needed to be liberated from their long repression by the classical tradition, the blight of eighteenth-century irony and scepticism, and the oppressive weight of political authority. For this reason Madame de Staël turned to Germany, the country of free abstract speculation and imaginations untrammelled by social and political prejudice.

Like its predecessor *De La Littérature*, *De L'Allemagne* is still cast in the eighteenth-century ideological mould, with short chapters written round a particular topic. Its aim was to present a brief aperçu of the main literary and philosophical currents in Germany, with the help of copious extracts from writers' works. As Madame de Staël put it to a friend before embarking on the book: 'What I intend to do is not metaphysics; but in order to give an idea of the character of the Germans and the spirit which distinguishes their literature, it is necessary to present a simple, general notion of their philosophical systems.'[12] *De L'Allemagne* opens as a travelogue as we follow Madame de Staël on her journey through north Germany, but as the author works herself into her subject, abstract speculation takes over and the book turns into a philosophical and moral treatise. The last section on German religion and mysticism reaches its climax in the chapter on Enthusiasm. Here is the most vital element in Madame de Staël's philosophy, the semi-divine capacity for idealism and self-sacrifice which distinguishes great men from the mediocre herd: 'It is the love of beauty, elevation of the soul, and the power of self-sacrifice combined in one single emotion which has greatness and tranquillity.'[13] Madame de Staël's own integrity and readiness to sacrifice her personal comfort in the defence of her ideals set a notable example of what she meant by Enthusiasm. Similarly in her fiction her heroines – Corinne especially – embody this quality to a marked degree. For her enthusiasm was more than the eighteenth-century notion of '*sensibilité*'; it was a kind of spiritual overflow, '*un superflu d'âme*', a willingness to reach out beyond the call of duty to a higher moral and imaginative plane. This is the point where the writer most explicitly prefigures the aspirations of early Romanticism.

Enthusiasm was the antithesis of what she believed to be the main vices of contemporary France, greed, corruption and egotism. She saw herself as the agent of a new

moral regeneration of the French race, depraved by a century of irony and libertinism, and recently cowed by a tyrant, all attributable to the prevalent philosophy of hedonistic materialism. The French, she believed, had to be changed in their entire mental outlook. Hence her espousal of the philosophy of German idealism which, with its emphasis on free will, held men directly responsible for their own actions and could make them active agents for the good and true. In *De L'Allemagne* her moral fervour is directed against the cynical time-servers of Napoleon's government. Rejecting the Emperor's manipulation of morality to suit his own ends, Madame de Staël demonstrates – using Kant as her authority – that morality is not variable according to circumstances but an absolute which demands unquestioning adherence. By placing moral responsibility with the individual conscience, she thereby refutes the argument of national expediency.

The relevance of *De L'Allemagne* to philosophy and literature is immediately clear, but its application to the evolution of Romanticism in the visual arts is less obvious. Nevertheless, while only very limited space is allotted to the discussion of individual works of art (mainly in Chapter XXXII), many important tenets of a new aesthetic theory lie embedded in the text. Like the German authors she admired, Madame de Staël was deeply convinced of the indissoluble link between the Good and the Beautiful. The starting point for her aesthetics, as well as her ethics, is the philosophy of Kant as expounded in his *Critique of Judgement* (1799). The Beautiful, as well as the Good, is shown to be an innate concept of the mind and therefore possessing an objective, universal validity. While it is not always possible to know or define Beauty in the abstract, it is easily recognisable; the fact that men disagree about what constitutes Beauty in particular instances does not disprove the existence of the concept – on the contrary, this argues more strongly in its favour.

The notion of Beauty as an Idea, or an innate human concept, is directly opposed to the eighteenth-century materialist philosophy which, starting from Locke's denial of innate ideas, reduced all human reasoning and experience to sensations. According to this sensualist philosophy – implicit in the thought of the Encyclopaedists and still stoutly defended by Stendhal – art is merely a form of hedonism, aesthetic responses are pleasurable reactions to external stimuli. The work of art is merely a distillation of agreeable, or disagreeable, impressions. Madame de Staël adopts the contrary position of German idealism which posits the ideal as an autonomous creation of the mind: 'From this application of the feeling of the infinite to the fine arts arises the ideal, meaning beauty, considered not as the combination and imitation of whatever is best in nature, but as the realisation of that image which is constantly present in the soul.'[14] This is a radically different notion from the traditional classical meaning of '*La belle nature*', which places Beauty outside man in the external world and assigns to the artist the role of copyist, or at

best rearranger. The sense of Beauty – no less than the sense of duty – is within us: 'It is an innate faculty, as is the feeling of duty and the necessary notions of understanding, and we recognise beauty when we see it because it is the outward image of the ideal, the model of which exists in our mind.'[15] An immediate consequence of this view is a far greater subjective licence for the artist, freed from his obligation to be 'true to Nature'. Henceforward, creativity can replace imitation. Imagination and fantasy are thereby accorded their full rights, and the artist's only duty is to be true to his own vision.

A further basic tenet of Kantian aesthetics adopted by Madame de Staël is the separation of beauty from utility. 'In separating beauty from utility, Kant clearly proves that it is not in the nature of the fine arts to give lessons.'[16] Given the autonomy of beauty, any definite aim, even a moral one, runs counter to the nature of art. While a fervent believer in the morality of art and its ennobling influence, Madame de Staël felt that any beneficial effect produced by a painting or book was a fortunate but accidental by-product. As soon as an artist consciously set out to moralise or preach a doctrine, the result was propaganda, however noble the cause: 'The arts should seek to elevate the soul not to indoctrinate it.' It might, incidentally, be objected that the writer was the first to infringe her own rule, for nearly all her books are tracts of one kind or another, political, social or literary. But she was careful to draw a distinction between the 'useful' arts (i.e. philosophy and prose) and the 'fine arts' (poetry, music and painting). The former may legitimately set themselves a practical aim, but the sole object of the fine arts should be free creative activity: 'It is an entirely creative theory, a philosophy of the fine arts which far from constraining them, seeks, like Prometheus, to steal fire from heaven to give it to poets.'[17]

Having discarded the doctrines of utility and the imitation of nature, Madame de Staël went on to make a highly influential equation between painting and music which was to have wide repercussions in nineteenth-century art. For music is the most exemplary form of non-mimetic art: 'Music, foremost of the arts, what does that imitate?' she asks rhetorically.[18] The effect of music depends not on its explicit meaning, or in the case of opera, on conformity to the action, but on some indefinable inner quality which stirs the soul and produces a sensation of dream-like pleasure ('*une rêverie délicieuse*'). In one of the most important passages of the book, which profoundly impressed Delacroix, Madame de Staël went on to elaborate this idea and to extend the parallel to painting. As an example of art relying too heavily on literary explanation she quotes Poussin's painting *Et in Arcadia Ego*. The artist, in her view, should be able to communicate with the spectator without such a written inscription: 'There is thought in this way of conceiving the arts … but the arts are superior to thought: their language is colour, forms, or sound.'[19] Here, in half-stated form, Madame de Staël seems to be groping towards the Romantic notion of

communication of a message, a kind of mysterious bond between artist and spectator. This, at any rate, was the interpretation put on the passage by Delacroix, who quoted much of it word for word[20] and in his *Journal* (26 January 1824) proclaimed himself in complete agreement with this theory: 'I recognise precisely in Madame de Staël the exact way I develop my ideas about painting. This art, as well as music, are superior to thought; hence their advantage over literature, through their vagueness.'[21] This vagueness, or indefinable quality, was regarded by Delacroix as positive proof of painting's superiority over literature, for it gave the painter immediate access to the innermost recesses of the human heart. The work of art is thus no longer a 'copy' of the external world, but a reflection and microcosm of the inner world of thought and feeling.

The implications of this theory are all the more remarkable since Madame de Staël had very little technical knowledge of art and her experience of actual works of art was limited. In the chapter *Les Beaux-Arts en Allemagne* her treatment of them is summary, mainly because German art at that time had produced little of note and had not evolved beyond a late form of Neo-Classicism. There are short, not especially revealing comments on a painting by Christian Ferdinand Hartmann (1774-1842) showing the *Visit of Mary Magdalen to Christ's tomb* (probably in Dresden) and Gottlieb Schick's *Sacrifice of Noah after the Deluge* (1805) Stuttgart. Gemäldegalerie) which Madame de Staël had seen in Rome [Fig. 1]. Religious and historical subjects were on the whole better suited to painting than literary ones since they needed no explanation and were immediately intelligible (Corinne, incidentally, expresses the same view in her discussion with Oswald). No painter could hope to rival the effectiveness of the written word in attempting to portray a literary subject. But in religious subjects, where he is not bound by a set text, the artist can allow free rein to his imagination and can recast the scene at will. Madame de Staël found confirmation of her views in two supreme religious paintings, Raphael's *Sistine*

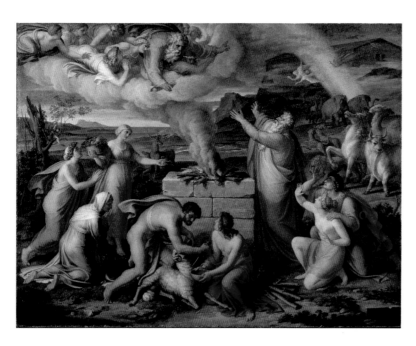

1 **The Sacrifice of Noah after the Deluge**
Gottlieb Schick (Stuttgart, Gemäldegalerie)

Madonna and Correggio's *La Notte*, which she had seen in the Dresden Gallery.[22] Here the artist achieved the highest expressive effect by the simple pictorial device of allowing the source of light to fall full on the Infant Christ while leaving the shepherds in the shadow, as if to symbolise human life before the Revelation.

De L'Allemagne finally became known as the bible of Romanticism.[23] It exerted such a far-reaching influence on the minds of a whole generation of writers, artists and thinkers that many of its author's ideas became common currency in the nineteenth century, so totally assimilated that their source was forgotten. However, they penetrated France only gradually and continued to meet resistance. In Northern Italy Madame de Staël's books and theories were first diffused through the translations of the Biblioteca Italiana and quickly adopted by the group of young Italian liberals who responded warmly to the writer's cosmopolitanism, political liberalism and advocacy of freedom in artistic expression. Stendhal was closely associated with this circle, and it was in Milan that he became familiar with these ideas, even though he later repudiated many of them and was always strongly critical of her style.

From there Madame de Staël's ideas soon spread to Paris, where the intellectual world of around 1820 was sharply divided between the conservative monarchist faction centred on *La Muse française* and the younger liberal party represented by men like Ludovic Vitet (author of a tract called *De L'Indépendance en matière de goût,* 1825), Ampère, Stapfer, Guizot and Thiers. Adolphe Thiers, a lawyer from Aix, contributed articles of art-criticism to *Le Globe* and *Le Constitutionnel*, and was a fervent champion of the freedom of artistic expression: 'Art must be free, and free in the most unrestricted way.' The newspaper *Le Globe* espoused Madame de Staël's literary doctrines with most enthusiasm and intelligence. It was under the direction of Guizot, whose friends, especially Ampère and Prosper de Barante, were keen devotees of foreign literature. Between them they did much to make Shakespeare, Byron, Goethe and Schiller known to a wider French public. Guizot himself, under the guidance of Albert Stapfer (a noted germanophile and translator of *Faust*) had made a profound study of German literature and he constantly expounded its virtues to the French. In all these efforts Madame de Staël's *De L'Allemagne* served both as intermediary and inspiration.

The influence of *De L'Allemagne* was, therefore, primarily a literary one, but many of the implications of its theories were readily extended to painting and the visual arts. Its immediate effect was to open up a wide new range of subject matter. The artist Ary Scheffer (1795-1858), of German-Dutch origin who had recently settled in Paris, was among the regular readers of *Le Globe*. There he would have found the original German plays, poems and ballads (like Goethe's *Der König von Thule* of which he later painted a

version) and extracts from Madame de Staël's commentaries on them.[24] It was, therefore, almost certainly from Madame de Staël, via *Le Globe*, that Scheffer's interest in his native German (especially the poems and ballads) was rekindled. Much of his time and energies were devoted to the somewhat laborious re-creation of scenes from Goethe's *Faust* like *Marguerite praying to the Virgin* (1829, Dordrechts, Museum) and *Faust in his Study* (1831, Dordrecht), and numerous other paintings redolent of Germanic mysticism which progressively degenerates during the 1830s into a sickly and fashionable piety.

Many other French artists, unable to read German in the original, found in *De L'Allemagne* an entire new repertory of literary themes and images. Foremost was Delacroix who declared himself in complete agreement with Madame de Staël's theory of artistic creation and it was no doubt partly through her that the painter came to see the creative possibilities offered by Goethe's *Faust*. In illustrating a scene from the play,[25] Delacroix brought a freshness and spontaneity which the writer himself, not usually given to extravagant praise, claimed to have almost surpassed his own original.[26] Madame de Staël introduced several other works of lesser stature into the French repertory, including a somewhat chilling ballad by Gottfried Bürger (1747-94) translated as *Les Morts vont vite* - the story of a girl Leonora whose blasphemy is rewarded by finding that her lover, galloping furiously with her into the night, is only a skeleton concealed by his armour. 'Bürger is the one German who has best understood this vein of superstition which plumbs he depth of the soul.'[27] The macabre typically Romantic trappings of this ballad naturally appealed to Horace Vernet in his version *Les Morts vont vite* (1839, Nantes) [Fig. 2].

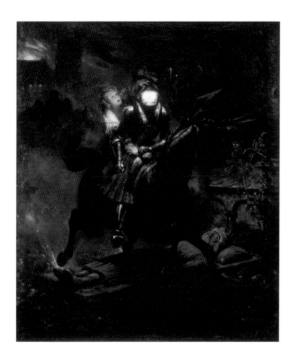

2 **Les Morts vont vite**
Horace Vernet (Nantes, Musée des Beaux-Arts)

In addition to providing new sources of material for artists, *De L'Allemagne* breached old barriers and opened up new horizons in a more general sense which was of permanent benefit to French art and literature. In more than embryonic form, *De L'Allemagne* contains the crux of a new theory of Romanticism. Freed from the strict classical doctrine of imitation, artists and writers were no longer bound by pre-set categories. They were free to make their own rules, to invent, imagine and create with a duty to nothing except the truth of their own vision. Moreover, by implication, art and literature were at liberty to borrow from one another if they wished, without having to fear the pedantic strictures of critics

with a rigid eighteenth-century mindset. Criticism itself becomes a creative activity, instead of the dispensation of rules and taste. Henceforth, self-expression was the watchword of Romantic theory and practice, and remains so to this day. The results of this new sense of liberation were, admittedly, sometimes disastrous and responsible for some of the worst excesses of nineteenth-century art. But, equally, without it the triumphs of Romantic art and writing would be inconceivable, and the fruitful exchange between painting and literature to which this study is devoted would hardly have been possible.

Corinne

The twin poles of attraction in European civilisation, North and South, provided the background for Madame de Staël's celebrated novel, *Corinne*. The book was rapturously received when it first appeared in 1807, translated into many foreign languages and devoured by readers all over Europe; its vast popularity is further attested by many paintings, engravings and illustrations inspired by the novel's most famous episodes. *Corinne* profoundly affected the outlook of an entire generation and its attitudes to relations between the sexes, especially the problem of a creative woman who is manifestly superior to all around her, not least the man she loves.[28] With the crucial difference of her sex, *Corinne* is in the noble lineage of early Romantic heroes, from Werther to René and Childe Harold. Unlike Chateaubriand's and Byron's heroes, however, who are suffering from little more than a sublime aristocratic *ennui*, the problem with Madame de Staël's heroine is not lethargy resulting from inactivity, but an excess of creative energy for her feminine role in life. *Corinne* is the prophetess of Romanticism and in her hands art, poetry and music is a kind of spontaneous outpouring of emotion, a semi-divine form of inspiration.[29] More than any other single work perhaps, *Corinne* crystallises this new Romantic conception of the artist. Like Madame de Staël herself, who became closely associated with her heroine, she is a self-proclaimed genius, brilliant improviser, poetess and musician, a kind of latter-day Sappho who wins the admiration of all her contemporaries by her charm and outstanding gifts. Corinne also resembles her creator in the independence conferred by her financial position, and in her capacity for great love and suffering. Genius, in fact, in the author's eyes, is inseparable from suffering and is the direct cause of Corinne's tragedy, as her lover, the morose Scottish peer Lord Oswald, cannot accept her on her own terms and finally abandons her for another woman.

Madame de Staël had been vaguely drawn to Italy before she finally set foot in that country in December 1804. In her father's circle of friends, at the château of Coppet and in Paris, she had met distinguished Italian patriots exiled in 1799 by the Napoleonic régime. Like all her educated contemporaries, Madame de Staël was well versed in the classics and the writings of Montesquieu had revealed to her the grandeur of the Roman

past. But at this stage she showed very little interest in Italian art. The sections devoted to Italian literature in *De La Littérature* were thin and criticized for their inadequate treatment of the subject.[30] Gradually, however, through friends like Simonde de Sismondi, Charles Bonstetten and Wilhelm von Humboldt, Madame de Staël showed an increasing interest in Italy and even considered living there to escape the turmoil of France. In the summer of 1802 she urged her friend Camille Jordan to accompany her on a journey to Italy, but when he refused she abandoned the idea.[31] Then in 1803, following the publication of her first novel *Delphine* the previous year, like a thunderbolt from the sky, came Napoleon's order forbidding her to set foot within forty leagues of Paris. Henceforth travel and exile were to be the constant feature of her life.[32] Much though she hated staying at home and the intellectual stagnation which ensued, travel – though it brought her no real pleasure ('*Voyager est un des plus tristes plaisirs de la vie*', she wrote in *Corinne*) – provided the inspiration and subject matter for her greatest works.

It was not to Italy, however, but to Germany that she first turned in the autumn of 1803, returning to Switzerland in May 1804 on the news of Necker's death. The death of the father she had so idolised left an immense void at the centre of her life which nobody else ever filled; as she said to Chateaubriand from her deathbed: 'I loved God, my father and freedom.'[33] The all-powerful presence of the loved but remote father-figure, and the sacrifice by an unworthy lover of a divinely gifted woman in favour of a lesser mortal, these two fundamental leitmotivs in *Corinne* were already firmly rooted in Madame de Staël's mind before she left for Italy in the company of August-Wilhelm Schlegel in December 1804.[34] It was, therefore, not as an idle tourist that she travelled in Italy in June 1805, but in quest of the social, literary and artistic documentation needed for the novel which she had already decided to write.

Corinne is, as a result, composed of two distinct layers, one descriptive, the other narrative. The dual nature of the book was clearly perceived by Madame de Staël's cousin and earliest biographer, Madame Necker de Saussure: 'It is a composition of genius in which two different works, a novel and a portrait of Italy, have been blended together.'[35] For the purely autobiographical strand in *Corinne* Madame de Staël drew largely on her own experience, especially her unhappy love affairs with Prosper de Barante and Benjamin Constant. In the process she heightened the dramatic content by emphasis on the cultural and temperamental differences between Corinne and Oswald. Both are, to some extent, conceived as symbolic representatives of their native countries, Corinne the artistic, spontaneous and passionate Italian (though with an English father), Oswald the frigid, melancholy northerner straight from the land of Ossian. Corinne gives absolute priority to personal emotion; Oswald, on the other hand, to social considerations and duty

to family and country. In Stendhal's words, Oswald is 'the sad victim of prejudice which he has neither the strength to overcome nor the courage to surrender to'.[36] In fact, they disagree about almost everything, about politics, society, art and literature. The result is a highly significant cultural debate, but it does not make for a harmonious relationship.

From the start, despite protestations of eternal love, Oswald senses that Corinne is not his idea of a 'suitable' wife; such a match would never find favour in the eyes of his father, an ultra-Tory Scottish peer, whose unseen but all-powerful presence determines his son's behaviour. Called back to England by military duty, Oswald finally decides to marry Lucile Edgermond, a demure domesticated virgin who belongs more to the world of Jane Austen than that of Madame de Staël. But the marriage is not a success. Plagued by the memory of Corinne, Oswald finally returns to Rome where, as he had predicted, the heroine dies in his arms. Given the impossibility of Corinne's position, torn between the demands of her art and a consuming human passion – and unable to stifle one for the sake of the other – this melodramatic ending was the only possible one in the context of the novel. In Corinne's tragedy Madame de Staël was consciously pleading to men to treat the feelings of women, especially those of genius like herself, with infinite respect.

The other layer of the novel, the descriptive travelogue, was partly the fruit of Madame de Staël's personal observations of Italy, but also of thorough preparatory reading. The ground had already been well trodden by such eighteenth-century travellers as the Président de Brosses and, especially, the Président Dupaty, author of *Voyage sur l'Italie* (1788) and a personal friend of Necker with similar philanthropic views; according to one critic,[37] Dupaty's views on art and architecture left a distinct mark on those of Madame de Staël in *Corinne*, but this similarity may be no more than coincidence. More directly useful to her were the works of her friends and contemporaries, men like Bonstetten and Simonde de Sismondi, who joined her in the summer months for those brilliant gatherings at Coppet where the European élite assembled. There, in 1804, Sismondi, the Genevan historian and economist, was already hard at work on his study of mediaeval Italy, the *Histoire des républiques italiennes au Moyen Age*, the first volume of which appeared in 1807. Madame de Staël was deeply impressed by Sismondi's patient, methodical scholarship, and traces of his particular interest in the independent republican spirit of pre-Renaissance Italy can be found in several passages of *Corinne*.[38] More of the gentleman amateur than the professional historian Sismondi, Bonstetten was an accomplished writer and author of a travel book on Italy entitled *Voyage sur la scène des six derniers livres de l'Enéide* (1805). This book contains a passage on the Roman Campagna in which the author deplores the poverty of the rural population and the neglect of agriculture in the region. Evidently struck by this passage – although she did not altogether share the author's conclusions – Madame de Staël wrote

to Bonstetten on 15 February 1805 to congratulate him on the accuracy of his description, adding, incidentally, that her interest went from the written word to direct observation of the objects and places described in his book.[39]

The subject of the Roman Campagna had already been treated by a far more distinguished writer, Chateaubriand, in his celebrated *Lettre à Fontanes*, which appeared in the *Mercure de France* in April 1804. When Bonstetten's book covering similar ground came out the following year, Chateaubriand took offence and much later, in the *Mémoires d'Outre-tombe*, felt the need to put the record straight over the question of priority. In fact, their respective viewpoints are entirely different; nor could anyone else have rivalled the majestic sweep of Chateaubriand's prose: '*Vous apercevez çà et là quelques bouts de voies romaines dans des lieux où il ne passe plus personne, quelques traces desséchées des torrents de l'hiver: ces traces, vues de loin, ont elles-mêmes l'air de grands chemins battus et fréquentés, et elles ne sont que le lit désert d'une onde orageuse qui s'est écoulée comme le peuple romain. A peine découvrez-vous quelques arbres, mais partout s'élèvent des ruines d'aqueducs et de tombeaux, ruines qui semblent être les forêts et les plantes indigènes d'une terre composée de la poussière des morts et des débris des empires.*'[40] ('Here and there you see Roman roads petering out in places which are no longer frequented, dried-out vestiges of winter torrents: seen from afar, these tracks look like important roads, well trodden and travelled, and yet they are only the bed abandoned by stormy waters which have ebbed away like the Roman people. Scarcely any trees can be seen, but ruined aqueducts and tombs rise up all round, ruins which seem to be the indigenous forests and plants in an earth composed of the ashes of the dead and the waste of empires.') What attracted Chateaubriand to the Campagna was its sublime and poetic sterility, unploughed, uncultivated and useless to man except as a place for meditation on human destiny. Whereas Bonstetten and Sismondi saw the Italian countryside in terms of productive agriculture, for Chateaubriand nature was merely the object of aesthetic contemplation. Opinion in Madame de Staël's circle of friends was, it seems, more favourable to the utilitarian than the aesthetic viewpoint. But Madame de Staël herself appears to hold the balance between the two opinions when writing in *Corinne* that such barren countryside held no attraction for farmers, administrators and speculators; only meditative souls ('*les âmes rêveuses*'), preoccupied with death as much as with life, found beauty in the Roman countryside.[41] The implicit reference to Chateaubriand shows, however, that Madame de Staël's emotional, if not intellectual, preference was for the '*âme rêveuse*', the poetic evocative view of nature, without thoughts of profit or material gain. This was to become one of the main themes of Stendhal's travel books, especially in *Rome, Naples et Florence* and the *Promenades dans Rome*. The epoch-making significance of the *Lettre à Fontanes*, which gave rise to an entire new school of

pictorial writing and landscape painting in the nineteenth century was decisively recorded by Sainte-Beuve: 'That fine letter has been the source of a French school of painters, a school which I shall call Roman. Madame de Staël was the first to be inspired by Chateaubriand's example: her imagination was stimulated by it and became fruitful; she was able to create *Corinne*, which she certainly would not have attempted before the advent of her young rival.'[42]

If Chateaubriand helped Madame de Staël to visualise *Corinne* against a Roman background, August-Wilhelm Schlegel, her travelling companion, played a direct part in her artistic education. Before leaving for Italy Madame de Staël had had something of the intellectual's distrust of the visual arts; to a person accustomed to dealing in ideas, colour and form held very little meaning until she could see their relation to more general human concerns. In *Delphine* she even went so far as to state: 'You know that of all the arts, painting is the one to which I am the least responsive.' On her arrival in Milan late in 1804 her friend the poet Vincenzo Monti did his best to cure Madame de Staël of her prejudice against the visual arts, chiding her in half-jocular fashion that it was not their fault if she was unmoved by them.[43] Gradually, however, the combined effects of the Italian climate and atmosphere, visits to the galleries of Milan, Parma and Bologna, and direct contact with the country's masterpieces overcame her natural resistance to the arts and opened her eyes to their beauty. Above all Schlegel's presence as *cicerone*, with his patient and exhaustive commentaries on the works of art they encountered, helped her to understand that painting and sculpture could express human values no less than literature and philosophy. Only by this transposition from the aesthetic to the moral sphere could she come to see the fine arts as worthy of study. Schlegel's method was to proceed by analogy and by ingenious comparisons between art and literature.[44] Thus Madame de Staël came to the visual arts not instinctively, but by a process of reasoning and reflection – an intellectual approach to art shared by her heroine, Corinne.

She completed her artistic initiation in Rome where she arrived in February 1805 with visits to the studios of several artists, including those of Angelica Kauffmann and the greatest sculptor of the day, Antonio Canova. Rome at this time was the artistic mecca of Europe, the centre of the international Neo-Classical style and the Nazarene school, then in its infancy. Guided by Schlegel, Madame de Staël found access to the main private collections in Rome, that of the Earl-Bishop of Bristol, for example, whose two Ossianic landscapes by George Augustus Wallis reappear in Corinne's fictional gallery, as well as important individual paintings like Gottlieb Schick's *Sacrifice of Noah* (1805, Stuttgart), discussed in *De L'Allemagne*. The furthest point in her tour was Naples. There she entertained friendly relations with the Archbishop of Taranto, Monsignore Giuseppe

Capecelatro (1744-1836), a witty and cultivated cleric who owned a notable collection of religious paintings by Giorgione, Caravaggio, Correggio, Salvator Rosa and, above all, one of *Christ bearing the Cross* probably by Murillo (believed by Madame de Staël to be by Titian) which reappears in a privileged place in Corinne's gallery at Tivoli: 'There, without doubt, is the most beautiful of my paintings, the one to which my eye constantly returns, without ever exhausting the emotions which it causes me.'[45] This collection, housed in the Palazzo Sessa, greatly impressed Madame de Staël and was clearly uppermost in her mind when she came to write about painting in *Corinne*.

No novel about Italy would have been complete without extensive mention of the visual arts.[46] They are inseparable from the cultural context of *Corinne* and play a number of roles in the novel, from one of simple characterisation to the psychological differentiation of the main protagonists. Unlike later writers, Madame de Staël never introduces works of art into fiction for purely decorative reasons, nor – unlike Chateaubriand – does she attempt pictorial effects in prose. But many of her characters and their settings are seen in pictorial terms, and her prose is often marked by the formal, symmetrical effects of Neo-Classical painting. From the moment Oswald first glimpses Corinne during her coronation on the Capitol, the heroine is seen as a demi-goddess in a white tunic, with a crown in one hand and a palm in the other, seated in a chariot led by a team of horses. Isolated from her surroundings like a single figure against a classical relief, Corinne is compared to Domenichino's *The Sibyl of Cumae*[47] [Fig. 3], with an Indian urban round her head and a blue drapery around her bosom. Corinne is, in fact, the embodiment of youth, beauty and poetic inspiration and her large eyes express the fixed clarity of far-sighted vision. The Sibyl, that traditional symbol of prophecy, reappears several times in the novel, always linked with Corinne's destiny. Corinne's villa at Tivoli is significantly placed above the cascade, opposite the temple of the Sibyl, a location ideally suited to a woman 'moved by divine inspiration'.[48] This divine inspiration manifests itself for the last time in the famous

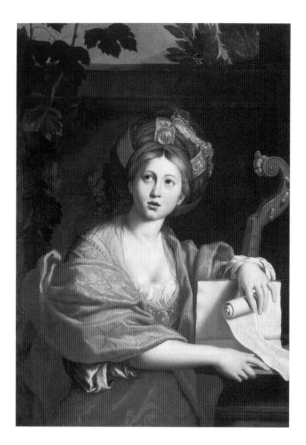

3 **The Sibyl of Cumae**
Domenichino (Rome, Borghese Gallery)

improvisation on Cape Miseno when Corinne clearly prophesies the tragedy and suffering which lie in store for anyone of her own genius: '*Je ne sais quelle force involontaire précipite le génie dans le malheur: il entend le bruit des sphères que les organes mortels ne sont pas faits pour saisir; il pénètre des mystères du sentiment inconnus aux autres hommes, et son âme recèle un Dieu qu'elle ne peut contenir*'.[49] ('I do not know what involuntary power plunges genius into unhappiness: it hears the sound of the spheres which mortals cannot grasp; it penetrates the mysteries of feelings which are unknown to other men, and its soul conceals a god which it cannot contain.')

Finally, after Oswald has abandoned Corinne to marry Lucile, they return to Italy to find that Domenichino's *Sibyl* in Bologna has nothing to say to them. Like the shattered heroine deserted by her lover, the Sibyl's power of prophecy has vanished with her

4 **Madonna della Scala**
Correggio (Parma, Pinacoteca)

genius and artistic gifts, leaving only an empty void. Thus a single painting, like a mirror, comes to reflect Corinne's successive states of mind, as she moves from optimistic confidence in her own beauty and talent to a mood of vacant despair which ends in suicide.

The other main characters too have their symbolic counterparts in art. As Stendhal did later in *La Chartreuse de Parme*, Madame de Staël consciously differentiated the two women, Corinne and Lucile, in pictorial opposites corresponding to their characters. This was neatly expressed by Madame Necker de Saussure: 'Lucile and Corinne are also universal ideas; they are England and Italy, domestic happiness and the pleasures of the imagination, shining genius and modest severe virtue.'[50] In place of the dazzling but somewhat remote image of Domenichino's *The Sibyl of Cumae* [Fig. 3], Corinne's half-sister Lucile is compared with the more immediately attractive fresco by Correggio in Parma, the *Madonna della Scala* [Fig. 4], a work in keeping with her gentle and maternal character; whereas the Sibyl seems to fix the brilliance of her gaze on the distant future, Correggio's *Virgin*, with modestly downcast eyes, turns towards her Child to embrace Him in an

attitude of tender affection. This is precisely how Lucile appeared to Oswald after their marriage, when they return to Italy and stop to admire the Correggios in Parma: 'Lucile's face bore such a resemblance to the ideal of modesty and grace painted by Correggio that Oswald moved his gaze alternately from the picture towards Lucile and from Lucile to the picture ... because Correggio is perhaps the only painter who knew how to give the eyes, when lowered, as penetrating an expression as when they are lifted towards heaven.'[51] By contrast, the *The Sibyl of Cumae* by Domenichino now seems to Oswald cold and sterile, and no longer speaks to his heart.

The third of the trio, Oswald, is also personified in a work of art. In view of his frigid character, the comparison is appropriately to a piece of sculpture, to Canova's *Genius of Grief* (part of a monumental tomb which the sculptor designed in 1799 for the Archduchess Christine, Duchess of Saxe-Teschen, and erected in 1805 in the Augustiner Kirche in Vienna). Madame de Staël had visited Canova's studio during her visit to Rome and her lover Don Pedro de Souza had commissioned a monument by the sculptor to the memory of his father in San Antonio dei Portoghesi in Rome. In the novel, Corinne and Oswald visit Canova's studio by night to view the statues by candlelight – an effect designed to soften the uniform white of marble and accentuate the *chiaroscuro* sense of moonlight. They are particularly struck by 'an admirable statue for a funeral monument representing the *Genius of Grief* resting on a lion, the symbol of strength.[52] This image of grief [Fig. 17] seems both to Corinne and to the sculptor to portray Oswald's gloomy character. It also contains a clear prefiguration of Oswald's mourning over Corinne's death at the end of the novel.

The importance attached by Madame de Staël to the visual arts is further attested by the inclusion of several contemporary paintings in Corinne's private gallery at Tivoli.[53] These are all of historical subjects by prominent artists of the Neo-Classical school, David's *Brutus* (a copy, presumably),

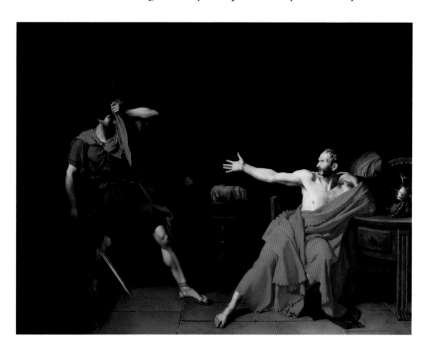

5 Marius at Minturnae
Jean-Germain Drouais (Paris, Louvre)

Drouais' *Marius at Minturnae* [Fig.5], Gérard's *Belisarius*, Guérin's *Phèdre*, Rehberg's *Dido and Aeneas*, an unidentified work of the *Death of Clorinda* from the 'galerie de Florence' (meaning either the Uffizi or Pitti Palace, or perhaps Wicar's large folio volume of engravings of that title), a version of Henry Fuseli's *Macbeth and the Witches* from Boydell's Shakespeare Gallery and, finally, two landscapes by George Augustus Wallis, one from Ossian showing *Comalla asleep on his Father's tomb* and the other of *Cincinnatus requested to lead the Roman Armies*.[54] The last two paintings were intended to symbolise the polarity between North and South. Corinne's choice of paintings is didactic and severe in the extreme; all illustrate some object lesson in stoicism and suffering, and are designed to promote thought and discussion on a high moral plane. There is no concession to 'bourgeois' taste, no portraits, no landscape, no genre and no still-life. David's *Brutus condemning his Sons to death* (exhibited at the Salon of 1789, in Paris, Louvre), taken from the annals of republican Rome, illustrates the idea of patriotism carried to its most fanatical extreme. Madame de Staël clearly chose the painting as it related to the central theme of Corinne, namely a son's sacrifice to his father's rigid conception of duty and patriotism. The point is still more forcibly emphasised by the discovery that in an earlier manuscript of the novel, Madame de Staël had originally considered an anonymous painting representing *Regulus saying farewell to his Family*; in front of him his children kneel devotedly but make no attempt to impede the hero's undertaking to return to Carthage.[55] The pendant to David's *Brutus* is another Neo-Classical example of stoical morality, Drouais' *Marius at Minturnae* (1786, Paris, Louvre) [Fig. 5], first exhibited in Rome at the Palazzo Mancini; with its theme taken from Plutarch, the painting shows the former Roman general who came into conflict with the Senate and is condemned to be executed by a former enemy. In an oblique reference to the public ingratitude shown to her father, Necker, after his dismissal from office, Madame de Staël comments that Drouais' painting shows what happened during the decline of the Roman Empire, when 'talents and fame attract only misfortune and insults'. The same moral of public ingratitude to great men is pointed with even more pathos by Gérard's *Blind Belisarius* of 1795[56] [Fig. 6], showing the distinguished Roman general condemned in

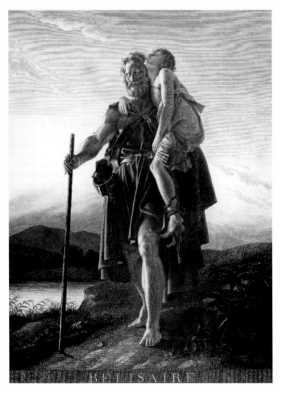

6 **Blind Belisarius**
Engraving by Auguste Desnoyers after
François Gérard

his old age to eke out a living by beggary: 'Belisarius' countenance is marvellous, and no-one else has executed one so beautifully since the painters of antiquity.'[57]

Paintings of Corinne and portraits of Madame de Staël

Throughout the nineteenth century the pictorial arts played a vital role in the diffusion of literature, through engravings, illustrations and paintings inspired by poetry and novels. *Corinne* was one of the earliest novels after Chateaubriand's *Atala* to enter the main current of Romantic imagery. Indeed it is hard to imagine Madame de Staël's heroine except in terms of Gérard's famous painting, draped in a toga, lyre in hand, with Vesuvius in the background. Paintings and illustrations fixed the image of *Corinne* in the public imagination more forcibly than words alone would have done.[58] First, there were nine paintings with subjects from *Corinne* exhibited at the Salon, beginning with the second version of Gérard's *Corinne at Cape Miseno* at the Salon of 1822, re-exhibited at the Salon of 1824; in 1822 Léopold Robert announced a *Corinne at Cape Miseno* but, unable to finish the picture, he changed it into the work now known as *The Neapolitan Fisherman improvising*, shown at the Salon of 1824. Also at the Salon of 1824 was a *Corinne* by Jean-Baptiste Lecoeur (1795-1838). Apart from the minor painters, Jean-Louis Ducis (1775-1847), a talented Troubador painter, exhibited a painting at the Salon of 1838 entitled *Corinne and Oswald at Naples*. The last recorded paintings at the Salon inspired by Corinne are two by Jean-Louis Victor Viger (1819-79), a pupil of Drolling and Delaroche, the first called simply *Corinne* (formerly at Argentan in Normandy) at the Salon of 1873, and the second *A Visit to St Peter's, Rome* (Cherbourg, Musée) at the Salon of 1874 [Fig. 7]. These two little-known works are a belated tribute to the long popularity of the novel, echoing down to the last decades of the nineteenth century.

By far the most familiar of these is Gérard's *Corinne at Cape Miseno* (1819) in the museum of Lyon [Fig. 8]. Though in some respects awkward, this is a most impressive and moving painting which does full justice to the impassioned quality of the novel. Staged like the last act of a classical tragedy, it illustrates the moment when Corinne bursts into a passionate

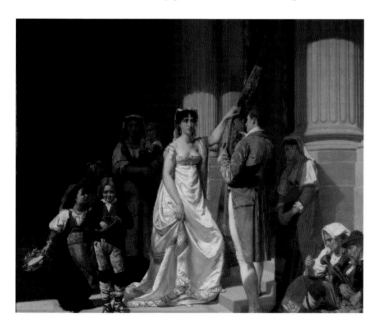

7 **A Visit to St Peter's, Rome**
Jean-Louis Victor Viger (Cherbourg, Musée Thomas Henry)

improvisation on the theme of poetic genius and suffer-
ing. The setting is Cape Miseno in the Bay of Naples, with
Vesuvius smouldering in the background and Capri and
Sorrento in the far right of the picture. Leaning against a
truncated column with her lyre in front of her, Corinne
looks upwards in search of inspiration, while two young
Englishwomen, some Greek fisherman and Lord Oswald
(the morose Byronic figure in the centre) listen in rapt
admiration. The passage chosen by Gérard is from Book
XIII of the novel: '*Cependant Corinne souhaitait qu'Oswald
l'entendît encore une fois, comme au jour du Capitole, avec tout
le talent qu'elle avait reçu du ciel: si ce talent devait être perdu
pour jamais, elle voulait que ses derniers rayons, avant de s'étein-
dre, brillassent pour celui qu'elle aimait. Ce désir lui fit trouver,
dans l'agitation même de son âme, l'inspiration dont elle avait*

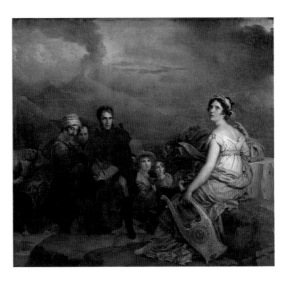

8 **Corinne at Cape Miseno**
Baron François Gérard (Lyon, Musée des Beaux-Arts)

*besoin. Tous ses amis étaient impatients de l'entendre; le peuple même, qui la connaissait de réputa-
tion, ce peuple, qui dans le Midi est, par l'imagination, bon juge de la poésie, entourait en silence
l'enceinte où les amis de Corinne étaient placés, et tous ces visages napolitains exprimaient par leur
vive physionomie l'attention la plus animée.*'[59] ('Corinne, however, wished Oswald to listen to
her once more as he had on the day at the Capitol, with all that talent with which she had
been endowed by heaven: if this genius had to vanish forever, she wanted its last rays to shine
upon the man she loved before its extinction. This wish helped her to find the inspiration she
so needed in the turmoil of her soul. All her friends were impatient to listen to her; even the
people who knew her by reputation, this southern people whose imagination makes them
good judges of poetry, silently surrounded the circle in which Corinne's friends were placed,
and all these Neapolitan faces expressed the keenest attention through their lively features.')

Though still cast in the Neo-Classical mould of single figures isolated against a
backcloth, Gérard's painting is fully Romantic in its tragic intensity and the sense of
foreboding which hangs over the entire scene. Aware of her weakening hold over Oswald's
emotions, Corinne makes one last desperate effort to win him through admiration of her
poetic gifts; a passing cloud on the horizon clearly prefigures her death. The improvisation
which follows, prompted by the memory of the great men and persecuted geniuses like
Tasso who found refuge in the region of Naples, is couched in Madame de Staël's most
high-flown language; and yet, despite the sincerity of its emotion, the words somehow fall
short of the lyrical heights at which she was aiming. Only poetry could have fully expressed
what the author tried to say in short sentences of symmetrical prose. The importance of

9 Madame Récamier at L'Abbaye aux Bois
Engraving after François-Louis Dejuinne

her message is nevertheless clear. Corinne spells out, in the most decisive terms, a truly Romantic theory of artistic creativity and inspiration, a spontaneous outpouring of sincere and tragic emotion.

The story behind the commission of Gérard's painting is familiar. On one of his visits to Coppet, Prince August of Prussia (a nephew of Frederick the Great) had fallen in love with Juliette Récamier, the celebrated virginal beauty who was then staying with Madame de Staël and contemplating divorce.[60] Though unsuccessful in his suit, the prince later decided to commemorate both his love for Madame Récamier and his admiration for Madame de Staël by commis-

sioning a painting illustrating a scene from *Corinne*. In a letter to Gérard dated 6 April 1819, he wrote: 'Wishing to preserve the memory of Madame de Staël in art, just as it will remain in literature through her works, I had thought that the best way would be to ask you to paint a picture for me of a subject taken from *Corinne*.'[61] The prince then suggested that either the scene of Corinne's triumph on the Capitol or her improvisation on Cape Miseno would be a suitable theme. From this letter it is clear that he himself chose the subject, for like his contemporaries, he saw Corinne as an idealised version of Madame de Staël. In a second letter of 20 February 1821 he repeated his wish to pay homage to the novel … 'one of Madame de Staël's most beautiful works', expressing the desire to offer the painting as a present to Madame Récamier, who duly received it. The first large version found its way to l'Abbaye-aux-Bois, where it hung in the apartment of the convent in which Madame Récamier spent her declining years in genteel poverty.[62] It can be seen, in reverse, on the drawing-room wall in the engraving after François-Louis Dejuinne's painting [Fig. 9]. There we can imagine Gérard's *Corinne*, a silent witness to the sonorous intonations of Chateaubriand as he read out the last volumes of his *Mémoires d'Outre-tombe* in Madame Récamier's salon. Finally in 1849, after the latter's death, the painting entered the museum of Lyon, an eloquent tribute to Madame de Staël and her heroine.

From the moment it appeared in 1822, Gérard's *Corinne* received a warm welcome from critics and the public. In Germany it became widely known through a eulogistic

article by A. W. Schlegel which appeared in the *Kunstblatt* of September 1821. Rapidly diffused through engravings (including one by Aubry Lecomte), the painting was repeated in a number of replicas and variants, few of which have yet to come to light. Talleyrand, for example, is reported to have owned one in which Corinne is alone without bystanders.[63] Another smaller replica was executed for Madame du Cayla in 1828. The most significant variant with an extra fisherman on the left, was that commissioned by Louis XVIII and exhibited at the Salon of 1822; since then it has completely disappeared and is known only through engravings [Fig. 10]. So successful was this second version that Stendhal, for one, considered that Gérard had surpassed his own original and he particularly admired the 'childlike, blissful happiness' of the *lazzarone* added by the painter to the left-hand corner of the

10 **Corinne at Cape Miseno**
From Charles-Paul Landon's 'Annales du Musée, Salon de 1822'. Engraving after second version by Baron Gérard

picture. Stendhal characteristically recognised in this painting a true portrait of nineteenth-century love, a 'modern' psychological conception of passion entirely different from the purely carnal notions of the ancients: 'I see in Corinne's eyes the reflection of tender passions such as those revealed to modern people; I feel something which belongs to Werther's sombre rapture. In a word, I catch a glimpse that this inspired woman walks to her death along a flower-strewn path.'[64]

Other prominent French critics also admired the painting, each from his own particular angle. Adolphe Thiers wrote to Gérard to congratulate him on his achievement, and spoke for most of his contemporaries when he wrote: 'All warm-hearted youth was standing in front of this beautiful and unhappy woman, and would have willingly applauded her.'[65] The same critic published an enthusiastic article in *Le Constitutionnel*. Like Stendhal, Thiers was by no means uncritical of Madame de Staël's novel, which he criticised for an inflated style and sentiments no longer in favour with progressive liberal critics of the 1820s, for whom the more melodramatic aspects of *Corinne* were too much of a hangover from the *mal du siècle*. But these defects, in Thiers' view, had been happily banished from Gérard's painting which, significantly, he preferred to Madame de Staël's novel: '… I recognise above all the profound melancholy which charms me in the novel and makes me reread it often despite its false sentiments.'[66]

Another significant painting of *Corinne at Cape Miseno* by the Swiss artist Léopold Robert (1794-1835) was announced in the catalogue of the Salon of 1822. But the work

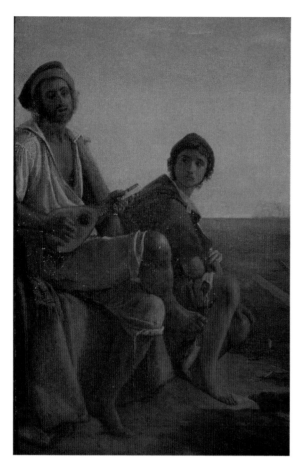

11 The Neapolitan Fisherman improvising
Léopold Robert (Neuchâtel, Musée d'Art et
d'Histoire)

never appeared in its projected form, and was then changed into the painting known as *The Neapolitan Fisherman improvising*, exhibited in 1824 [Fig. 11]. The story behind this artistic fiasco is of great interest and clearly illustrates the problems of literary painting in the nineteenth century. Robert, a native of Neuchâtel and later a pupil in David's studio in Paris, made a speciality of scenes of Italian life, especially the brigands and peasants of the Neapolitan region. In his own estimation – if not in ours today which tends to see him as a minor example of '*le romantisme pittoresque*' – Robert was not a Romantic but a Realist, offering a faithful portrayal of the Italy which he passionately loved. In 1821, living in Rome, he received what was his first major commission to paint *Corinne improvising at Cape Miseno* for the baron de Foucaucourt. He set about the work with his usual painstaking zeal, but from the start he was evidently ill at ease with Madame de Staël's novel. 'I have read Madame de Staël and Monsieur Dupaty with some pleasure', he wrote to his parents in 1821, 'even though they are both very verbose in their own special ways; nor is everything they have to say true.'[67]

The painter clearly considered Madame de Staël's portrayal of Italian life to be insufficiently based on direct personal observation, striking an awkward compromise between truth and fiction and mingling simple Italian peasants with people from the world of fashion. Robert's intention was to convey his own simple poetic impression of Neapolitan life; but this proved incompatible with the demands of his patron, who wanted a literal illustration of the highlight of the novel. By the end of 1821 it was clear that he was having considerable difficulty with the subject, especially with the central figure of Oswald. The artist first tried to show him in civil dress, then in military costume. In despair, he vainly asked his patron's permission to replace the two figures of Oswald and Corinne with non-fictional characters. In the end, after countless erasures and alterations, he dropped the original idea entirely and changed it into a simple *Neapolitan Fisherman*. That is how the painting

finally appeared at the Salon of 1824, a straightforward piece of genre stripped of its literary associations. The result, however, betrayed its fictional origins in its slightly posed figures, stiffly arrayed against the Bay of Naples. The completed composition can unfortunately only be judged from a late engraving made by the painter's brother, Aurèle Robert, for after it had been bought at the Salon by the duc d'Orléans and hung in the gallery at Neuilly, it was destroyed by fire in 1848. All that now remains of this painting which cost the artist so much toil and sweat is the central fragment, now in the museum of Neuchâtel [Fig. 11].

The second scene most frequently represented by artists was the death of Corinne, described in the very last pages of the novel. Unhappily married to Lucile, Oswald returns to Italy to find Corinne dying. The setting is Corinne's house in Rome: '*Elle se fit transporter sur un fauteuil, près de la fenêtre, pour voir encore le ciel. Lucile revint alors; et le malheureux Oswald, ne pouvant plus se contenir, la suivit, et tomba sur ses genoux en approchant de Corinne. Elle voulut lui parler, et n'en eut pas la force. Elle leva ses regards vers le ciel, et vit la lune qui se couvrait du même nuage qu'elle avait fait remarquer à Lord Nelvil, quand ils s'arrêtèrent sur le bord de la mer en allant à Naples. Alors elle le lui montra de sa main mourante, et son dernier soupir fit retomber cette main.*'[68] ('She had herself carried on an arm-chair to the window so that she could see the sky again. Lucile then returned; and the unhappy Oswald, no longer able to restrain himself, followed her and fell on his knees as he came up to Corinne. She tried to speak to him, but did not have the strength. She lifted her gaze to heaven, and saw the moon obscured by the same cloud which she had pointed out to Lord Nelvil when they had stopped on the coast on the way to Naples. She pointed it out to him with her dying hand, which fell back on her last breath.')

The earliest depiction of this final episode appears to be the water-colour of *The Death of Corinne* by Christophe Thomas Degeorge (1786-1854) [Fig. 12], possibly commissioned as early as 1807 by Prosper de Barante, a lover of Madame de Staël who later became known as author of the *Histoire des ducs de Bourgogne* (1824-8). Prompted perhaps by feelings of guilt towards Madame de Staël, Barante clearly identified himself with Oswald seeking forgiveness of the woman he had abandoned. This little-known water-colour has all the moving simplicity of the novel's last pages. Oswald, dressed in black, kneels in front of Corinne who points feebly to the moon passing in front of the cloud, the fateful presage of the end of their love. The Neo-Classical sobriety of the décor combined with a few significant accessories – Corinne's letter of farewell to Oswald on the table and her abandoned lyre on the floor – make this unpretentious little work one of the most sympathetic illustrations of *Corinne*.

The pen and ink sketch by Sergel of the same scene is in a far more feverishly Romantic vein [Fig. 13]. Johan Tobias Sergel (1740-1814) was a prominent Swedish sculptor who worked

in Rome between 1767 and 1778 and again in 1783-4, moving in the cosmopolitan circles of Houdon and Fuseli whose work clearly influenced his own. Madame de Staël had visited his studio in Stockholm in 1812 while on a political mission to persuade the King of Sweden to join the alliance against Napoleon. Her contact in Stockholm was Count Jacob de la Gardie, a diplomat, who arranged the visit to the sculptor's studio. The occasion was amusingly but perhaps not very accurately recorded in the novel *Illusions* by Sophie von Knorring, who relates how Madame de Staël arrived, accompanied by a Polish prince, and made herself at home before the sculptor had time to ask them to sit down.[69] If he resented Madame de Staël's *hauteur*, Sergel was nonetheless sufficiently impressed by her novel to sketch this last scene from *Corinne*, probably executed immediately after her visit in 1812. His treatment of the subject is radically different from the restrained pathos of Degeorge's version. In the highly dramatic manner of Fuseli, it shows Oswald and Corinne in the same positions but also includes the prince de Castel-Forte, the shadowy figure on the right. Rapidly sketched in sparse, cursive lines, Sergel's drawing is the most thoroughly Romantic example of all the works inspired by *Corinne*.

There are finally countless portraits of Madame de Staël herself.[70] Thanks to these, her features became known to a wide public throughout Europe who had never met her personally; in fact, like Lord Byron, her image became inseparable from her literary creation. Despite her lack of regular beauty, Madame de Staël exercised an extraordinary

12 The Death of Corinne
Christophe Thomas Degeorge, Watercolour
(Private collection)

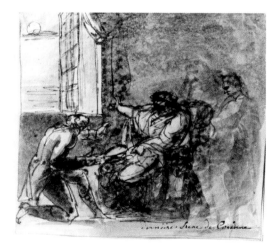

13 The Death of Corinne
Johan Tobias Sergel, Drawing in pen and ink
(Stockholm, Nationalmuseum)

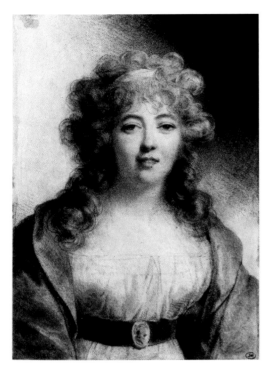

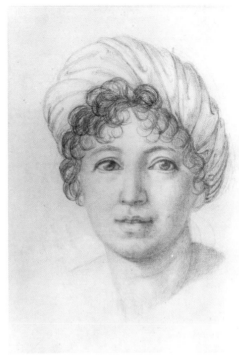

14 **Portrait of Madame de Staël**
Jean-Baptiste Isabey, Drawing (Paris, Louvre)

15 **Portrait of Madame de Staël**
Friedrich Tieck, Drawing (Paris, private collection)

fascination on men and women alike, partly through the brilliance of her conversation but also through the sheer intensity of her expression. Her eyes were the one feature which haunted Chateaubriand's memory of her on her deathbed.[71] Even Goethe, who was less easily impressed, found 'something delightful in her person as well as from the intellectual point of view'. This unusual power of mind combined with deep feeling speaks out clearly in all Madame de Staël's portraits, even in the earliest, a red chalk drawing of her as a girl of thirteen by Carmontelle (Château de Coppet), and in others by Firmin Massot, a drawing by Amélie Munier-Romilly of the authoress as *Corinne* (Geneva, Musée), a miniature by P-L. Bouvier painted in 1816 and others by Jean-Baptiste Isabey, Friedrich Tieck and Gérard, to name only a few. In the large finished portraits of Madame de Staël, including those of Elisabeth Vigée-Lebrun and Gérard, there is a strong element of stylisation which tends to obscure the sitter's true personality; in these she appears in the loosely antique garb, consciously or unconsciously copied from Domenichino's *The Sibyl of Cumae* [Fig. 3], of turban, cashmere shawl and low-cut dress, exactly as Corinne is described in the novel. But in the smaller, more intimate drawings by Jean-Baptiste Isabey (dated 1810)[72] [Fig. 14] and Friedrich Tieck[73] [Fig. 15] (a sketch for a bust, dated 1808) there is no

literary posturing, only spontaneity and natural expression. The maternal tenderness in her character is admirably brought out in the *Portrait of Madame de Staël with her Daughter* (Château de Coppet), attributed to Marguerite Gérard and painted around 1805.[74]

Madame de Staël had met the painter Elisabeth Vigée-Lebrun at some date before September 1807 when the latter came to stay at Coppet. A fruit of this visit was the ambitious but not altogether successful *Portrait of Corinne*.[75] Despite political differences between the liberal daughter of Louis XVI's ex-minister and the worldly portraitist of Marie-Antoinette, the two women no doubt had a good deal in common and mutual respect for the other's talents. On 18 September Madame de Staël wrote to a friend saying that she enjoyed Madame Vigée-Lebrun's company as much as her talent and anticipated her visit with pleasure.[76] During her week's stay at Coppet Madame Lebrun began the portrait, suggested to her by reading *Corinne*: 'I spent a week at Coppet with Madame de Staël; I had just read her last novel, *Corinne, ou l'Italie*; her countenance, so full of animation and genius, gave me the idea of painting her as Corinne, seated on a rock, her lyre in her hand; I painted her in antique costume.'[77]

In its general composition and Neo-Classical décor, Vigée-Lebrun's painting clearly anticipates Gérard's version of *Corinne*. An undated letter, from Vigée-Lebrun to Madame de Staël after her return to Paris, reveals that she had first intended to include the Bay of Naples in the background (as Gérard did), but was persuaded by Madame de Staël's friend to substitute the cascades of Tivoli and the temple of Vesta.[78] The painting appeared in this form in 1808, a brave but not quite convincing attempt by an artist trained in the *dix-huitième* style to come to terms with the new age. Madame Vigée-Lebrun and her Parisian friends were delighted with the result, but the recipient was less so, hardly recognising herself in it. She received the finished picture in July 1809, and soon afterwards ordered a smaller version (with noticeably different features) which she gave to the man who became her second husband, John Rocca. She left the original painting to her cousin, Madame Necker de Saussure, who then gave it to the museum of Geneva.

The last and perhaps least attractive of Madame de Staël's portraits is the one by Gérard [Fig 16], painted shortly after her death in 1817 at the request of her daughter, the duchesse de Broglie.[79] For once, Gérard's talent for evoking feminine charm (as in his portraits of the Empress Josephine and Madame Récamier) deserted him. Madame de Staël is shown with all her usual trappings – her turban, her shawl, the tiny antique cameo and the branch of olive or poplar which she was in the habit of constantly twisting in her hands. But the result is somehow official and lifeless, more like an oversized wax image preserved for posterity. Madame de Staël, of course, never saw Gérard's portrait, but if she had it is doubtful whether she would have appreciated it. She might, perhaps, have found a truer

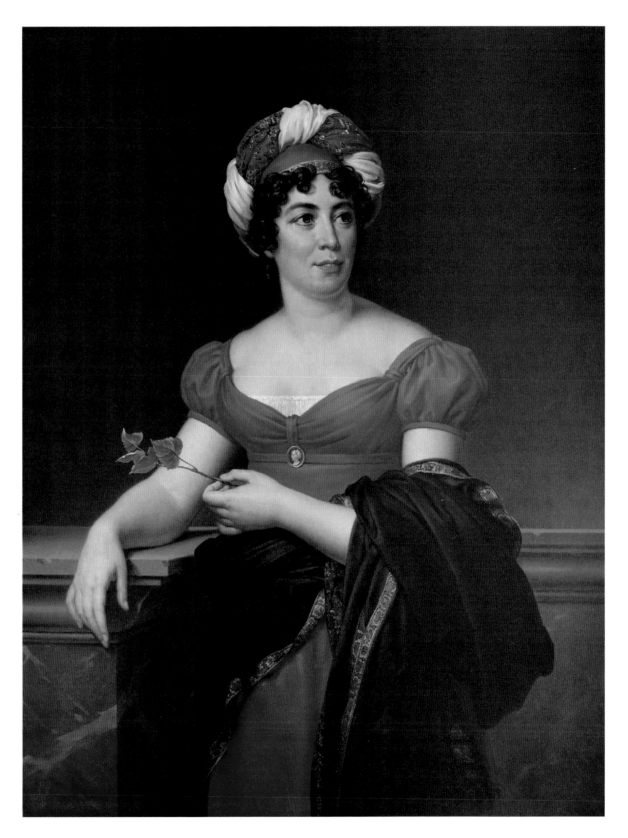

16 **Portrait of Madame de Staël**
François Gérard (Château de Coppet, Switzerland)

17 **The Genius of Grief from the Monument to Maria Christina Duchess of
Saxe-Teschen in the Augustiner Kirche**
Antonio Canova, Marble (Vienna, Augustiner Kirche)

reflection of *Corinne* in the numerous miniatures, engraved frontispieces, images on
calendars, in periodicals, on a fan,[80] and even on a tea service,[81] for the decorative arts too,
in a modest way, helped to perpetuate the features of this remarkable woman and to keep
her spirit alive.

CHAPTER II

CHATEAUBRIAND'S *ATALA* AS A SOURCE OF
INSPIRATION IN NINETEENTH-CENTURY ART[1]

THE APPEARANCE OF *Atala* by François-René de Chateaubriand in April 1801 created a major sensation on the French literary scene. This short story of the love between two devout savages, Chactas and Atala, against the exotic backcloth of the North American forests, offered the public a mixture of passion and highly-coloured descriptive prose which it found irresistible. Between 1801 and 1805 the novel was published in no less than eleven editions, some of them illustrated. Images of Atala even invaded French clocks, plates and pieces of Empire furniture;[2] a whole generation of European artists, of whom Girodet was the best known, succumbed to the spell of this novel. On a journey in Austria in 1833, Chateaubriand was surprised to find a picture of Atala on the walls of a country inn, but in such a travestied form that he hardly recognised her.[3] In fact, to judge by the author's own testimony, Atala became something of a popular cult image in his own lifetime.[4] Even the voices of the most *retardataire* critics like the Abbé Morellet[5] were drowned in the general acclaim. *Atala* was, in fact, only a preliminary extract from a far grander project, *Le Génie du Christianisme*, which Chateaubriand had written in London during his exile from the Revolution and which was published in complete form in 1802. He decided to publish *Atala* one year in advance of the main work 'as a little trial balloon to test the state of the atmosphere'; once this was found to be favourable he released the rest.

Le Génie du Christianisme was a full-scale apology for the Catholic religion, designed, in the author's words, to demonstrate the 'moral and poetic beauties' of Christianity and its inherent superiority over paganism as a source of moral and artistic inspiration. It was a deliberate rejection of eighteenth-century scepticism, Voltairean deism and revolutionary iconoclasm. Chateaubriand clearly expressed the main theme of the book in the preface: 'Of all the religions which have existed, Christianity is the most poetic, the most human, the most favourable to the arts and letters.'[6]

There was also a political motive behind the work which escaped few of the author's contemporaries. In 1801, after the open hostility of the revolutionary régime to religion, Napoleon signed the Concordat with Pope Pius VII in an attempt to bring about a reconciliation between Church and State. By the timely publication of his work, therefore, Chateaubriand quickly established himself as a leading Catholic apologist and, temporarily at least, enjoyed the Emperor's favour and was struck off the list of *émigrés*.

18 Marius on the Ruins of Carthage
Engraving from Charles-Paul Landon's 'Annales du
Musée, Salon de 1824' after Léon Cogniet

Atala was originally conceived as a '*roman à thèse*', its purpose to show the benefits of the Christian religion to savages. Chateaubriand inserted the story of *Atala*, first to show that Christianity and, in particular, the priesthood, was not in conflict with human nature as its eighteenth-century rationalist opponents maintained, but in sympathy with it; secondly to illustrate the divine origin of natural creation in a series of magnificently voluptuous images. It is clear from the start that he made no appeal to the rational intelligence, but to the senses.

Reduced to its barest outline, the book tells the unhappy love story of two Indians separated by religion. Chactas is a member of the Natchez tribe, and Atala is a half-caste, the illegitimate daughter of an Indian mother who became a convert to Christianity, and a Spanish father. The story is told in quasi-Homeric narrative by Chactas in his old age, who relates to the French exile René how he was captured by a hostile tribe and saved from death at the stake by the chieftain's step-daughter Atala, who unties the cords binding him to his captors. The couple escape, fall in love and for a while live happily amid the exotic splendour of the forests of Louisiana. Though Atala obviously reciprocates Chactas' passion she seems inhibited by a guilty secret. Just as she is about to overcome her scruples and succumb to her lover in the middle of a spectacular storm, the Christian missionary Père Aubry arrives on the scene in time to rescue the couple from sin. He takes them back to his cave, gives them modest hospitality and proudly shows Chactas the Christian missionary community he has founded nearby. On their return to the cave they find Atala gravely ill. She then reveals that her mother, in order to expiate her sense of guilt, made her daughter take a vow of virginity and promise never to marry; aware of her crime in loving Chactas, Atala has already taken a fatal poison.

Père Aubry then launches into a long homily on the Christian virtues of abstinence and renunciation. But his well-meaning intervention has come too late; the Christian message which the novel was designed to embody rings hollow in his mouth, for the author has already built up a highly charged emotional atmosphere which positively invites passion and seduction. In fact, as many critics pointed out, the story of *Atala* might well be read as a *conte* in the manner of Voltaire on the dangers of religious fanaticism. The only real obstacle to the happiness of Chactas and Atala is the girl's misconceived vow, and even Père Aubry admits that this was an act of folly, which if Atala had not already taken

poison, could easily be annulled. It is not surprising, therefore, that Chateaubriand has often been charged with 'tacking on' a Christian message to a frankly pagan novel. But these inconsistencies were overlooked by the vast majority of the author's contemporaries, who saw *Atala* as something new, exciting and exotic, a strange blend of primitive 'Homeric' simplicity and a brooding Romantic melancholy which set the fashion for literary heroes and their pictorial counterparts for the next half-century. Théophile Gautier spoke for a whole generation when he wrote: 'Chateaubriand may be looked upon as the forefather or, if you prefer it, as the Sachem [an Indian chief] of Romanticism in France.'[7]

The appeal of *Atala* for so many artists lay first of all in the highly-coloured descriptive prose which in his own day earned Chateaubriand the epithet of 'the magician'. Undoubtedly one of the greatest masters of the French language, with an unrivalled range and variety of expression, his determination to rival the painter on his own ground frequently leads to purple passages of the sort to which Stendhal, for one, strongly objected.[8] In his evocation of the forest of Louisiana in strong sunlight, for example, Chateaubriand includes a whole new range of colour: butterflies, brilliantly coloured insects, green parakeets, blue jays against a background of white moss, producing the effect of a tapestry worked by a European artist.[9] It was the exact antithesis of the bald, discursive style of eighteenth-century prose to which the public was accustomed. Chateaubriand is a supremely visual writer, one of the first who set out consciously to use language for pictorial ends. Realising the best way to win back his own incredulous generation to Christianity was to make religion attractive, he conjures up a train of seductive images. Thus the aisle of a Gothic cathedral is seen in terms of an avenue of trees, and their boughs the vaults in the roof;[10] forests become '*le berceau de la religion*' (the cradle of religion). By this technique of abridged simile Chateaubriand manages to establish a permanent though perhaps spurious link between the object and the effect he wishes to create, here between nature and religion. Everything in his writing depends on atmosphere and association; imagery is turned into the receptacle for a particular mood. It is no accident, therefore, that painters were strongly attracted to Chateaubriand's novel which falls so neatly into a series of '*tableaux vivants*'.

While Chateaubriand quite frequently draws on pictorial sources in his own creative writing, it is far more characteristic of him to offer suggestions and ideas for painters to represent. Thus in his early *Essay on Revolutions* (1799) he writes that painters ought to seek in history those subjects which combine moral dignity and natural splendour.[11] As an example, he sketches a picture of the ruins of Carthage half buried in the sand against the background of a stormy sea, with the defeated Marius leaning on the broken stump of a column meditating his misfortune. It may have been as a direct result of

reading this passage that Léon Cogniet painted his famous *Marius on the Ruins of Carthage*[12] [Fig. 18], one of the most prominent exhibits at the Salon of 1824. Although the Salon catalogue[13] makes no mention of Chateaubriand, the details of Cogniet's painting coincide closely with the text. This is by no means the only instance of Chateaubriand suggesting ideas for artists. *Le Génie du Christianisme* contains a chapter entitled 'The subject-matter of paintings',[14] designed to show that Christianity has been the most fertile source of imagery for painters. Again, in *Les Martyrs*, Chateaubriand specifically designed certain scenes, notably the martyrs' last meal before their execution (*Le Repas libre des Martyrs*), with a view to their pictorial representation: 'I sought to design my picture in such a way that it can be transferred easily onto the canvas.'[15]

Still more important, perhaps, is the fact that by his own eloquent advocacy on behalf of the French national and religious past in *Le Génie du Christianisme*, Chateaubriand opened up an unexplored area of subject-matter to artists. While his precise influence on the arts would be hard to determine, he may well be directly responsible for the proliferation of subjects like *Henri IV and his children*, *Joan of Arc* and the *Death of St Louis* which began to invade French art soon after 1800 and which maintained their popularity right up to the end of the Restoration. There is plenty of evidence throughout his writing to suggest that Chateaubriand consciously set out to create pictures in words for artists to translate into paint. When artists in their turn borrowed subjects from his novels they were merely following the author's own cue.

But before discussing specific paintings from *Atala* it is perhaps worthwhile considering briefly the relationship between Chateaubriand's literary theory and current French aesthetic doctrine around 1800. While it is often dangerous to draw general parallels between the literary and pictorial styles of a period, there is a strong affinity between Chateaubriand's prose and contemporary Neo-Classicism which goes beyond the merely accidental. Chateaubriand defined his own literary ideals in clear, consistent terms.[16] In the first place, he shared the dislike of David and his followers for crude realism in art: 'This precision in the representation of the inanimate object is the essence of the literature and arts of our times: it proclaims the decadence of high poetry and true drama …'[17] The high moral tone and gloomy prognostication of artistic decline following the abandonment of classical ideals coincide almost word for word with the views of critics like Delécluze and Landon. Like them, Chateaubriand was a classicist at heart, a lover of noble subjects and grand, formal design: 'Let us paint nature, but the finest in nature; it is not the business of art to imitate monsters.'[18] For Chateaubriand, intrinsically repulsive objects like skeletons had no claim to representation in art. He rigorously proscribed ugliness of any kind, and could

only tolerate the portrayal of suffering when ennobled by pathos and restraint: '*Les Muses sont des femmes célestes qui ne défigurent point leurs traits par des grimaces; quand elles pleurent, c'est avec un secret dessein de s'embellir.*'[19] ('The Muses are celestial women who never disfigure their features by grimaces; when they weep, it is secretly to enhance their beauty.')

Thus in the first preface to *Atala* Chateaubriand outlines his own literary aims in terms of the current '*beau idéal*' of expressive beauty. These similarities between Chateaubriand and the art of his time extend to his practice as well as his theory. It was Sainte-Beuve, one of Chateaubriand's most astute but least favourable critics, who noted that the rather stiff, theatrical poses of the author's characters were reminiscent of certain early nineteenth-century paintings by David and Girodet. He added the important reservation, 'that nature too forms such groups, but less self-consciously, with forms and attitudes in less pronounced relief'.[20] Allowance must of course be made for Sainte-Beuve's bias in favour of the more fluent style of his own Romantic contemporaries, but his remarks apply with great force to Chateaubriand's method of characterisation; for example, when Chactas first catches sight of Atala as she comes to untie his cords, he is struck by her beauty and a 'mixture of virtue and passion in her expression'.[21] From the start Atala is seen by the author as a Neo-Classical heroine, with a passionate and intense temperament and a pale, beautiful form often enhanced by moonlight and other artificial effects. This same love of slightly over-accentuated relief which Sainte-Beuve criticised is apparent too in Chateaubriand's presentation of figures in landscape. He shows a marked predilection for simple, clearly outlined characters projected against a distant horizon or contrasting background, like the solitary Indian warrior encountered by Chactas and Atala, resting on his bow and perched on a rock. The uncanny immobility of this figure gazing out into space is statuesque rather than pictorial in effect. Nearly all Chateaubriand's characters, in fact, are cast in this heavy, passive mould – especially the sight of Chactas plunged in grief at the foot of Atala's tomb, resting his head in his hands.

These few instances are enough to illustrate Chateaubriand's innate pictorial sense, his taste for clear, sharply delineated outlines, strong colour and carefully grouped characters. He arranges his scenario in the manner of a classically trained landscape painter, with statuesque figures silhouetted and highlighted often by *chiaroscuro* effects of torches or moonlight; the most dramatic instance of this technique is the description in *Les Martyrs* of *The Sleep of Eudore* which in itself is a piece of literary transposition from Girodet's *Sleep of Endymion*.[22] Chateaubriand's entire vision of landscape, in fact, with its urns, tombs, ruins and luxuriant vegetation is quintessentially picturesque – the literary equivalent of early nineteenth-century French landscape painting.

Given these affinities between Chateaubriand's writing and contemporary art, it was natural that painters turned to it as a source of inspiration. A brief statistical count of paintings exhibited at the Paris Salons between 1802 and 1848 shows that 51 took their subjects from Chateaubriand: of these 18 were taken from *Atala*, 23 from *Les Martyrs* and four from *René*.[23] This may not seem a large number in comparison with subjects from English literature (in the period from their publication until 1848 there were 75 from Byron and 146 from Scott), but among contemporary French writers Chateaubriand was by far the most popular literary source with painters. It might have been expected that this popularity would have declined simultaneously after 1820 with Ossian[24] (with whose fortune Chateaubriand was closely linked), but in fact this continued unimpaired right up to 1848.

Chateaubriand's impact on French art made itself felt immediately after the publication of *Atala* in 1801. At the Salon of 1802 two works inspired by *Atala* were exhibited: Henriette Lorimier's *Young girl by a window, weeping as Atala passes by*[25] and Pierre Gautherot's *Atala carried to her grave (Convoi d'Atala)* [Fig. 19].[26] The first, to judge by its title, is merely a touching little Troubadour scene in the style of François Fleury-Richard's *Valentina of Milan weeping for her Husband*. Gautherot's picture is a more serious attempt to come to terms with the text; it portrays the moment when Chactas, preceded by the hermit holding a spade, carries Atala's dead body down a winding path to the tomb: '*Cependant une barre d'or se forma dans l'Orient. Les éperviers criaient sur les rochers et les martres*

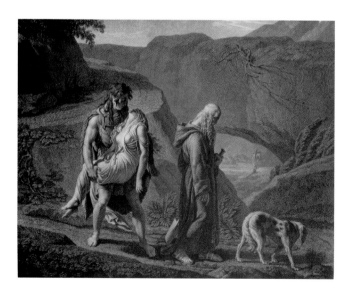

rentraient dans le creux des ormes: c'était le signal du convoi d'Atala. Je chargeai le corps sur mes épaules; l'ermite marchait devant moi, une bêche à la main.'[27] ('Meanwhile, a golden streak formed in the East. The hawks screeched on the rocks and the martens returned to the hollow of the elms: it was the signal for Atala to be carried to the grave. I lifted her body onto my shoulders; the hermit walked before me, a spade in his hand.')

It is difficult to form a fair idea of Gautherot's painting since it is only known to us from engravings, but it would seem that the painter has only partially succeeded in rendering the slow and solemn movement suggested by the text. This was not, however, the opinion of most of the

19 **Atala carried to her grave**
Engraving by F. Lignon after Gautherot

critics of the day, including Charles-Paul Landon. Alphonse Leroy, for example, in the *Décade Philosophique*, commended Gautherot expressly for his full understanding of the melancholy of his subject,[28] and he went on to praise the characters' expressions and the artist's skill in rendering the local colour and accessories; he was no doubt referring to objects like the minuscule palm tree stranded in the middle distance. The next artist to attempt a version of *Atala* was Louis Hersent who exhibited *Atala poisons herself in the arms of her lover Chactas* at the Salon of 1806.[29] Again there is no record of the original picture except contemporary engraving and criticism. This time, however, the same critic of the *Décade philosophique*[30] was less moved to pathos; mocking the artist's choice of subject, he wrote that it was rather late for Atala to remember her vow of chastity in her lover's arms. He concluded by praising the fine draughtsmanship and the beautiful expressions, but found the whole composition lifeless: 'But what coldness at such a moment: No passion and no ecstasy.'

Another touching but essentially undramatic attempt to treat the novel was Pierre Jérôme Lordon's *Atala's Last Communion* (Salon of 1808) [Fig. 20],[31] showing the moment when Père Aubry administers the last rites to the dying heroine: 'The priest opened the chalice, taking a host white as snow between his two fingers and approached Atala, uttering mysterious words.'[32] The painter has obviously tried to convey some of the mystical, ecstatic atmosphere of this last scene, and the attitude of Atala laid out on a couch with Chactas supporting her and the hermit's dog at her feet is reminiscent of late mediaeval and Renaissance tombs; but Lordon could not resist the genre painter's habit of introducing all kinds of accessories – the torch, the Bible, Chactas' bow and arrow – which encumber the composition and add nothing to its dramatic effect.

These works are all by very minor artists who, if not actually pupils of David, gravitated around his sphere of influence. It is notable, however, that David himself, and even painters of the rank of Guérin or Gros are conspicuously absent from the list of artists who illustrated Chateaubriand. Many other examples of nearly forgotten artists who borrowed themes from the writer could be quot- ed from the Salon catalogues where subjects from Atala appeared consistently until

20 **Atala's Last Communion**
Engraving by Charles Louis Lingée after Pierre Jérôme Lordon

21 **Le Repas libre des Martyrs (The Last Meal of the Christian Martyrs)**
François-Marius Granet (Aix en Provence, Musée Granet)

about 1830. In 1817 Frosté exhibited a *Vigil by Atala's Deathbed (Veillée funèbre près d'Atala)*[33] and at the famous Salon of 1827 there were four scenes from the novel: one by Pierre Jérôme Lordon, *Atala on the Raft*,[34] another by Jean-Michel Moreau, *The Deathbed of Atala*[35] *(Le Lit funèbre d'Atala)*, one by Louis Edouard Rioult, *Chactas at the tomb of Atala*,[36] and a fourth scene by Madame Rullier of *a young Indian woman of the Natchez tribe drying the dead body* of her child on a tree.[37]

Gradually, however, *Atala* was overtaken in popularity with painters by Chateaubriand's major but almost unreadable work, *Les Martyrs*, published in 1809, an epic novel about two early Christians, Cymodocée, a pagan virgin who falls in love with Eudore, is converted to Christianity and shares his martyrdom in the Roman amphitheatre. This is the final episode represented in Rioult's painting at the Salon of 1819.[38] François-Marius Granet, an artist of far more than average talent, illustrated the book in two watercolours, *Pope Marcellinus excommunicates Eudore*[39] (signed and dated 1842), and *The Last Meal of the Christian Martyrs*[40] [Fig. 21], and finally in a painting recorded at the Salon of 1847, *Eudore in the Roman catacombs*

[Fig. 22].[41] From the date of its publication until 1848, *Les Martyrs* proved a perennial favourite with artists, largely no doubt on account of its eminently pictorial, spectacular subject-matter with the same kind of pseudo-historical appeal which post-war epic films enjoyed.

22 **Eudore in the Roman catacombs**
François-Marius Granet (Aix en Provence, Musée Granet)

Girodet-Trioson (1767-1824) was the first artist of outstanding ability to tackle a subject from Chateaubriand[42] and was in many ways the writer's ideal interpreter. Brought up in the strict academic discipline of David's studio, he was profoundly unorthodox by nature and soon outgrew his master's classical doctrines. Temperamentally Girodet was moody and idiosyncratic, with a poetic strain in his nature which left him dissatisfied with David's uncomplicated moral and artistic beliefs.[43] It is significant that the latter's real criticism of his pupil's work was that it was 'too learned'; there was something artificial and fantastic about it which David found incomprehensible, although this never destroyed the mutual respect between master and pupil. Delécluze, David's staunch supporter and orthodox follower, was also baffled by this strange new element in Girodet's work.[44] What both of them failed to see was that Girodet's powerful imagination was not just the product of wilful eccentricity but the real basis of his originality. Girodet was one of the first painters to lay explicit claim to the right to exercise his imagination in the way that writers had long exercised theirs. Why, he argued, should the painter remain enslaved to classical antiquity and natural observation while the poet was free to explore the figments of his own creation? Girodet may be seen as an early type of the painter-poet, determined to extend the range of painting to include emotions and effects hitherto reserved for literature; he was also an omnivorous reader, and during his lifetime produced many illustrations for editions of Homer, Virgil, Anacreon, Racine and Bernardin de Saint-Pierre. He was, moreover, a firm adherent to the principle of '*ut pictura poesis*' and in his long didactic poem *Le Peintre* he defined his essentially literary conception of painting:

> *Soeur de la poésie, ô peinture éloquente,*
> *Dont le charme puissant, sur la toile vivante,*
> *A l'aide du mensonge et de la vérité*
> *Fixe le mouvement, la grâce et la beauté . . .* [45]

('Sister of poetry, O eloquent painting, whose powerful magic on the living canvas fixes movement, grace and beauty with the help of deception and truth . . . '). He

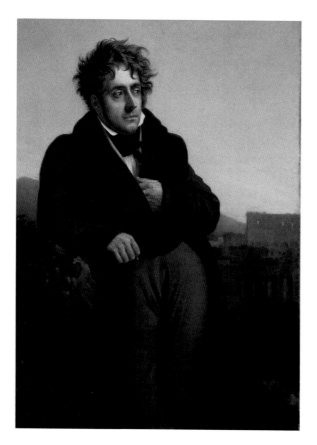

23 Portrait of Chateaubriand
Anne-Louis Girodet de Roucy-Trioson
(Saint-Malo, Musée)

therefore believed that exchanges between literature and painting were to the benefit of both arts, and he strongly urged poets to seek inspiration in great paintings: 'Which poet has not felt his spirits kindled by contemplating the masterpieces of great painters?'[46]

This strong literary bent drew Girodet instinctively to Chateaubriand's work. The close sympathy and mutual understanding between them may have been due partly to the fact that both stood in a similar relationship to the tradition on which they had been nurtured; both continued to cling to certain formal vestiges of their classical training, even though this conflicted with their emotional, Romantic leanings. This instinctive sympathy can immediately be gauged from Girodet's famous *Portrait of Chateaubriand* (Saint-Malo, Musée) [Fig. 23], painted in 1807–8, showing the author in self-consciously Napoleonic pose, with tousled locks, hand tucked under his lapel, reclining against the Roman background with the Colosseum on the left. It epitomises the role in which Chateaubriand cast himself: the solitary genius against the background of eternity. Everything about this picture, the grandiose posture, the decaying ruins overgrown with ivy and the Sabine hills in the distance, is in close harmony with the mood of his writing.

Girodet immediately responded to the charm of *Atala* on its publication. In 1801,[47] in the preface to *Le Peintre* he paid tribute to Chateaubriand's powers of description and took the hero of his poem on an imaginary journey through the North American deserts celebrated by the writer. In the main poem itself he returns to the theme of the virgin forest; the allusion to *Atala* is again unmistakable:

> *Vers un monde nouveau prenons un libre essor . . .*
> *Où sans art la nature étale avec fierté*
> *Et son luxe sauvage et sa vierge beauté,*
> *Où des forêts sans fond les noires profondeurs*
> *De la hache jamais n'ont ressenti l'outrage,*
> *Et, portant jusqu'au ciel leur dôme de feuillage,*

De l'Indien errant cachent l'amour heureux.

Des tableaux plus touchants viennent s'offrir au sage,

Mais laissons les tracer au chantre de Chactas.

Qui peindrait mieux que lui ses amours, ses combats,

La Vierge du désert et, du fils des cabanes

Les berceaux suspendus aux festons des lianes.[48]

('Let us soar freely towards a new world where nature artlessly and proudly spreads out her wild splendour and virgin beauty, or the black depths of endless forests which have never suffered mutilation by the axe and, carrying their leafy canopy to the sky, conceal the wandering Indian's happy love. More moving images present themselves to the sage, but let us leave them to Chactas' bard. Who better than he could describe the Indian's loves, his struggles, the Virgin of the desert and the son of log cabins, cradles hanging from festoons of creeper.')

Despite its rather stilted and sinuous paraphrase reminiscent of certain minor eighteenth-century poets, this passage is a genuine expression of Girodet's fascination with *Atala*. It is probable that he had reflected on the novel for some time before he finally produced his masterpiece, the *Burial of Atala* [Fig. 24] at the Salon of 1808.[49] At first he was evidently uncertain which episode of the novel to portray, and he executed several preliminary sketches. His original idea seems to have been to take the moment when Atala receives Holy Communion, as in Lordon's picture, also of 1808; this is the subject of a drawing at Besançon.[50] The essence of Chateaubriand's text is one of gloomy resignation and profound melancholy. Girodet finally settled on the grouping seen in the two sketches in the Louvre, adopting the traditional Christian iconographic pattern of an entombment, with Atala's dead body wrapped in a shroud suspended over her grave, her head and shoulders supported by the hermit and Chactas at her feet [Figs. 25, 26]. Girodet seems to have been in doubt as to how to represent Père Aubry. In the first, and otherwise supremely accomplished sketch, only his leg is indicated in the barest outline, while in the second he appears as an academic and rather too muscular nude. Only in the final painting is due prominence given to the hermit, whose role in the novel is after all crucial; he is seen as the traditional Christian missionary, with a cloak and flowing white beard, and yet has something in common with that semi-pagan, Ossianic type of figure who recurs more than once in French art of this period (for example, in Girodet's *Fingal gathers Malvina's last Breath*).[51]

As it now stands the *Burial of Atala* portrays the most solemn and moving moment of the novel. It must also rank as a masterpiece of pictorial transposition, if we compare the

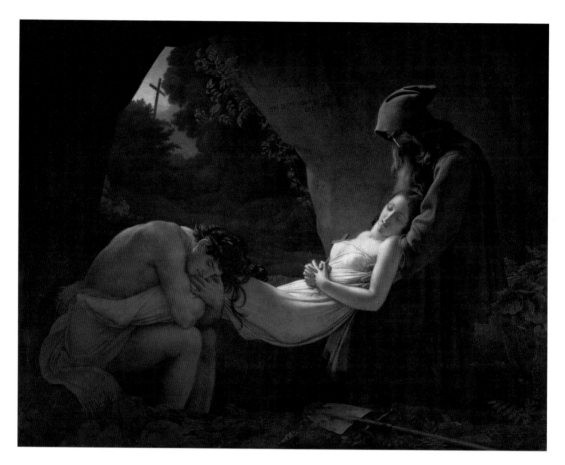

24 **Burial of Atala**
Anne-Louis Girodet de Roucy-Trioson (Paris, Louvre)

painting with the text which inspired it: '*Vers le soir, nous transportâmes ses précieux restes à une ouverture de la grotte, qui donnait vers le nord . . . Atala était couchée sur un gazon de sensitives de montagnes; ses pieds, sa tête, ses épaules et une partie de son sein étaient découverts. On voyait dans ses cheveux une fleur de magnolia fanée . . . celle-là même que j'avais déposée sur le lit de la vierge, pour la rendre féconde. Ses lèvres, comme un bouton de rose cueilli depuis deux matins, semblaient languir et sourire. Dans ses joues d'une blancheur éclatante, on distinguait quelques veines bleues. Ses beaux yeux étaient fermés, ses pieds étaient joints, et ses mains d'albâtre pressaient sur son coeur un crucifix d'ébène; le scapulaire de ses voeux était passé à son cou. Elle paraissait enchantée par l'Ange de la mélancolie et par le double sommeil de l'innocence et de la tombe. Je n'ai rien vu de plus céleste. Quiconque eût ignoré que cette jeune fille avait joui de la lumière, aurait pu la prendre pour la statue de la Virginité endormie*'.[52] (Towards evening, we carried her precious remains to an opening in the grotto, which faced north . . . Atala lay on a bed of tender

25 **Burial of Atala**
Anne-Louis Girodet de Roucy-Trioson,
Preliminary drawing (Paris, Louvre, Cabinet des
Dessins)

26 **Burial of Atala**
Anne-Louis Girodet de Roucy-Trioson, Preliminary
drawing (Paris, Louvre, Cabinet des Dessins)

plants from the mountains; her feet, head, shoulders and part of her bosom were exposed.
A faded magnolia blossom was in her hair . . . the very one that I had placed on the maiden's bed, to make her fruitful. Her lips, like a rose-bud plucked the day before, seemed to smile languorously. We could see blue veins in her dazzling white skin. Her beautiful eyes were closed, her feet were together and her alabaster hands pressed an ebony crucifix to her heart; the scapular of her vows hung around her neck. It seemed as if she had been enchanted by the Angel of Melancholy, and by the twofold drowsiness of innocence and the tomb. I have never seen anything more celestial. Anyone who did not know that his young girl had once enjoyed the light of day could have taken her for the statue of Sleeping Virginity.') Chateaubriand himself was delighted with Girodet's picture and in the *Mémoires d'Outre-Tombe* he reciprocated the artist's tribute: 'I was entirely right to pay this feeble homage to the author of the admirable painting of *Atala at the tomb*.'[53] With a characteristic touch of mock modesty he added that while Girodet embellished his pictures, he was afraid of spoiling the painter's. Girodet's painting, indeed, could hardly be more faithful to the spirit of the novel, with its peculiar blend of eroticism, death and religious piety. It is only by the carefully contrived atmosphere and setting that the heroine's unnecessary self-sacrifice is raised to the level of tragedy and her dead body becomes the object of morbid aesthetic contemplation. Chateaubriand presumably had something like this in mind when he proscribed hideous or grotesque objects from art, for he believed that death or the grave, his lifelong obsession, could be transformed by pathos and the Catholic ceremony into a beautiful and moving experience. Girodet effectively conveyed this meaning by outlining the cross over the Indian cemetery against the sky, framed by the mouth of the cave. While he strictly observed Chateaubriand's grouping of the three interlocking figures, he slightly simplified the details by eliminating the scapular and the faded

magnolia mentioned in the text; the only accessories are the hermit's spade, the small ebony crucifix and the inscription from the Book of Job inscribed on the rock: *J'ai passé comme la fleur. J'ai séché comme l'herbe des champs.* ('I died like the flower. I have become dried like the grass in the fields.')

When it appeared at the Salon of 1808 some critics considered that Girodet's picture was too sensual, but the same charge applies to the work of Chateaubriand himself. He cannot help making his supposedly Christian heroine into a kind of early nineteenth-century '*femme fatale*' with her beautiful white alabaster hands marked with blue veins. There could be no more striking illustration of Chateaubriand's pictorial, or sculptural, style than the description of Atala as '*la statue de la Virginité endormie*'. In fact, as Sainte-Beuve observed in another remarkable piece of criticism, the whole passage is a ready-made picture which Girodet merely had to copy and translate: 'Chateaubriand's group is like a marble by Canova, breathing a divine sweetness.'[54] ('*Une morbidezza divine y respire*'.)

The *Burial of Atala*, however, has subsequently proved less popular than when it first appeared in 1808. It fell an obvious victim to the vicissitudes of taste, rejected first by the Romantics who saw it as a typical old-fashioned product of the Davidian school, then by the late nineteenth century with its strong anti-classical prejudice. By a curious irony, Girodet's *Atala* became the symbol of academic orthodoxy and classical rigidity – even though the artist's intentions were quite the reverse of this. The attitude of an earlier generation of art historians is summed up in Bénézit's comment on Atala as '*ce chef d' oeuvre du mauvais goût*' ('this masterpiece of bad taste').[55] Baudelaire was one of the few critics to rise above these ephemeral judgements when he wrote that Girodet's *Atala* was a 'drama far superior to a whole lot of modern nonsense'.[56]

Of Girodet's contemporaries, Ingres also showed a keen interest in Chateaubriand, although he never completed a subject from the writer's work. Ingres had the greatest respect for Chateaubriand, and the writer's name became synonymous for him with religious emotion and piety.[57] For, like Chateaubriand, Ingres was a devout orthodox Catholic and a lover of ritual and ceremony, and he recorded how in Rome in 1807 he was deeply moved by the experience of mass in the Sistine Chapel.[58] He would, moreover, have found confirmation in Chateaubriand's writing for his staunchly conservative views on social and artistic matters. To Ingres, as to other pupils of David, Chateaubriand seemed a pioneer explorer of remote exotic civilisations, and a worthy modern representative of the neo-Primitive tradition beginning with the Bible, Homer and Ossian. In fact, Chateaubriand became so closely associated with the cult of Ossian that Girodet's sketch of the *Funeral of Malvina* was for a long time mistaken for a funeral of Atala.[59] Although Ingres never executed a theme from Chateaubriand, it is clear from a notebook that he had

27 **The Natchez**
Eugène Delacroix (New York, Metropolitan Museum of Art)

meditated on the subject of *Atala* and had planned one or more illustrations of it. The only remaining evidence is various jottings of scenes from the last stages of the novel: 'Chactas raised Atala's body onto his shoulders, the hermit with a spade in his hand going on ahead. They go down from rock to rock. Age and death halt their steps. The dog. They dig the grave. He throws some earth on the body. They leave and look at the place where she lies alone. He comes to pray at Atala's tomb and places a modest cross there. Chactas also came there to weep. At last he falls on the tomb. The hermit in the background.'[60] We can only speculate about what Ingres would have made of Chateaubriand's novel, but the laconic precision of these short verbal sketches suggests that he might have treated it in a more

sober and restrained manner than Girodet; his selection of material seems to indicate an episodic rather than an epic approach to the subject.

Eugène Delacroix, Ingres' great rival and opponent, only once painted a theme from Chateaubriand in *The Natchez* [Fig. 27], but the work is a minor masterpiece and wholly in sympathy with the mood of the book. The painting, which was begun in 1824 and shown at the Salon of 1835,[61] is taken from the epilogue of *Atala*: René's granddaughter and her husband have travelled up the Niagara, fleeing from the French who are threatening to destroy the Natchez, the Indian tribe to which they belong. During the journey the young wife has given birth to a stillborn child. In Delacroix's painting the parents are seen on the bank of the river, mourning their dead child; the heavy, slumped forms and the ashen tonality of the picture, broken only by the strong red of the mother's garb, are all in close accord with the Romantic melancholy of Chateaubriand's story. Delacroix has also caught its primitive, epic simplicity to a remarkable degree. This success in rendering the mood of *Atala* was not necessarily to be expected of Delacroix, for if we turn to his *Journal* we find that he was by no means always well disposed to Chateaubriand who he ranked among the idle Romantic dreamers: 'I am beginning to loathe the Schuberts, the dreamers, the Chateaubriands (I began a long time ago), the Lamartines, etc . . . This vagueness, this never-ending sorrow depicts no-one. It is the school of sick love.'[62]

It was perhaps only because Delacroix himself had been a victim of the '*mal du siècle*' in his youth that he reacted so strongly against it in later middle age. But he always retained the greatest respect for Chateaubriand as a literary figure, admitting that the writer had been 'the father of a school'. By 1860, towards the end of his career, Delacroix's attitude to Chateaubriand had undergone a remarkable change. In the *Journal* he copied out long extracts from the *Mémoires d'Outre-Tombe*, particularly the passages on the giants of literature, Homer, Shakespeare and Tasso.[63] All of these extracts, as the editor of the *Journal* points out,[64] were carefully chosen for their connection with Delacroix's own thoughts, preoccupations and life in general, and they revolved on the central problem of artistic creativity which obsessed the painter throughout his career. They suggest that Delacroix had come to recognise in Chateaubriand a champion of the great luminaries (or '*Phares*' in Baudelaire's language) whose works mark the high point of human achievement and who open up new horizons for future generations.

It would be misleading to conclude this short survey of paintings inspired by *Atala*, without a brief glance at a few notable versions by Italian artists.[65] For Chateaubriand's reputation soon spread to Italy where he was readily adopted along with Madame de Staël, Byron and Scott by the incipient Romantic movement centred on Milan; this, in its turn, was a late offshoot from French Romanticism, but with a particular emphasis on

28 **Atala receiving Extreme Unction from Père Aubry**
Natale Carta (Naples, Museo di Capodimonte)

29 Atala carried to the Tomb
Natale Carta (Naples, Museo di Capodimonte)

liberalism and national historical subject-matter. Italian painters seem to have been attracted to *Atala* for its strong element of '*morbidezza*' or sweetness which they push to the point of caricature. Thus two versions by Natale Carta, an artist about whom little is known except that he came from Messina, worked for a while in Naples and studied under Vincenzo Camuccini: *Atala receiving Extreme Unction from Perè Aubry* [Fig. 28], and *Atala carried to the Tomb*.[Fig. 29] Both date from 1833 and apparently found official recognition, since they were bought by King Francesco I of Naples for the picture gallery ofCapodimonte, where they still are. It should be admitted, however, that these paintings make some of their counterparts in the French Salons seem masterpieces in comparison; they are limp, lifeless and without any feeling for structure or composition. Among the last recorded paintings from *Atala* is the highly melodramatic work by Andrea Gastaldi[66] of 1862 in Turin [Fig. 30], showing the dead body of the heroine pinned down like a martyr over her grave, with Chactas burying his head in the lap of the hermit who prays to heaven. This painting might be considered the swan song of *Atala* and of this particular type of Romanticism. For most of the twentieth century the novel, as well as the paintings it inspired, suffered an almost total eclipse of favour. If *Atala* is read at all it is only as a period piece or as 'background' to the period, for Chateaubriand, like Byron, was a writer whose contemporary reputation was perhaps greater than his intrinsic merits. And yet *Atala* must still rank as one of the key works produced by the early Romantic imagination. A pioneer book in that it consists almost entirely of imagery hung on a loose narrative thread, it was undoubtedly the predominance of the visual element which drew artists to it in such largenumbers.Chateaubriand was the inventor of pictorial literature which Gautier, the Goncourt brothers and Marcel Proust carried to its logical conclusion; this, in its turn gave rise to literary painting, and both phenomena are fundamental to the nineteenth century.

30 **Atala**
Andrea Gastaldi (Turin, Museo Civico)

CHAPTER III

THREE ROMANTIC MANIFESTOS

HISTORIANS OF ROMANTICISM are still in profound disagreement as to the origins and nature of the movement. In view of the many conflicting definitions of Romanticism which have been propounded, both by nineteenth-century writers and by modern historians, some critics have reached the conclusion that there was no single unified movement at all and that definition is therefore impossible.[1] Others have decided, with more justification perhaps, that these apparent contradictions cannot disguise the fundamental point that 'Romanticism' in its widest sense marked a transformation of consciousness throughout Europe around 1790 and 1800, and that an entirely new set of intellectual, social and personal attitudes came into being at that time. The movement began in its purest and most abstract form in Germany, later spreading to France and the rest of Europe. These attitudes, which Jean-Jacques Rousseau was among the first to express in his books and educational tracts, are based on the uniqueness of the individual, freedom, the value of self-expression, the relativity of taste, morals and behaviour. They form the basic ideological norm, the common denominator, to which any writer or artist in the early nineteenth century loosely calling himself a Romantic would have subscribed. Indeed, such ideas became so totally assimilated in the nineteenth century that they were never again to be seriously questioned. Today we are still living off the intellectual capital of Romanticism. Who, for example, would seriously attempt to defend 'rules' of literary or artistic composition against the notion of self-expression?

The Romantic movement began, therefore, as a revolt. It was, first of all, a rejection of the assumptions underlying classical taste, the unities and the hierarchy of genres. Young writers and artists of the 1800 generation refused to accept that what had been considered standard practice from the Renaissance onwards was eternally valid. Their revolt was often not only aesthetic – rejection of the prevalent idea of 'good taste' – but also social and political, like the *Sturm und Drang* movement in Germany around 1770 whose adherents, including Goethe and Schiller as young men, refused to acknowledge any authority other than their own individual consciences; hence their glorification of the outlaw and the brigand.

In France, where people were less inclined to take up such extreme positions as their German counterparts, this revolt took a more limited and specific form. Indeed, for various reasons, chiefly national differences, Romanticism never took hold of the French imagination as exclusively as it did in Germany. Restrained by their native prudence and their predominantly pro-classical culture, the French showed an instinctive reserve towards

Romanticism and were never whole-hearted in their adoption of foreign literature. Lamartine, for example, who might qualify as the first quintessentially Romantic poet, was described as 'Lord Byron in the guise of a Frenchman'. Even Madame de Staël, whose sincerity in her espousal of foreign literature is beyond question, shows the same moderation in her balanced view of the respective merits of the German and French civilisations. No French writer would have been willing to plumb the metaphysical depths of Goethe's *Faust*, even if he had been able to. Nor was any French artist of the time capable of the kind of pure spiritual creation to be found in the paintings of Philip Otto Runge and Caspar David Friedrich. Work of this intensity was simply outside the range of the French temperament in the early nineteenth century.

Another paradox of the Romantic movement in France was a constant unremitting urge to justify its own literary and artistic efforts in a spate of tracts, manifestos and prefaces. With the outstanding exceptions of Stendhal, Victor Hugo and Alfred de Musset, few of them have any literary merit, but they do bear witness to an extraordinary polarisation of views on the current debate on Romanticism; nearly all were written by hack journalists and literary critics whose names have only been preserved by diligent historians of the movement.[2] They can be seen as the exact counterpart of the Salon critics (studied in the following chapter), and their reactions to contemporary works, their enthusiasms and their aversions all relate to one fundamental issue: that of tradition versus innovation. The Quarrel between the Ancients and the Moderns, in the seventeenth century, and the Classics and the Romantics in the nineteenth, were only different formulations of the same age-old problem of whether free creativity was compatible with respect for the achievements of past civilisation.

The issue, as before, remained unresolved. French writers and artists, even the most vociferous champions of freedom who claimed the absolute right to use words and colours exactly as they pleased, rarely went to the extreme of denying their classical birthright altogether. This is to say that they were considerably bolder in theory than in practice. In the last analysis the French Romantic movement must be judged not so much on the strength of its manifestos – which often provide only a retrospective justification of a *fait accompli* – as on its original creations, *Corinne*, *Atala*, Lamartine's *Méditations*, and Delacroix's paintings. It was these, rather than the criticism which followed in their wake, which collectively served to define the nature of French Romanticism. Nevertheless, criticism and theory played an important and constructive role in preparing the French public for the reception of new and often difficult works. They also helped to give the movement some sort of ideological unity when it might otherwise have disintegrated under the combined attacks of its opponents.

The evolution of Romanticism in the historical sense takes up from the gradual assimilation of Madame de Staël's theories in Italy, and shortly afterwards in France. Through the translations of the Biblioteca Italiana, the basic tenets of *De L'Allemagne* gained a wide following among a group of Milanese liberals, including Manzoni, Visconti and Silvio Pellico (editor of the radical paper *Il Conciliatore* and author of *Le mie prigioni*, a chilling account of his time in the Austrian prison-fortress, *Der Spielberg*). These radicals, with a strong sense of their national identity and passionately opposed to the Austrian domination of Italy imposed by Metternich, combined a faith in democratic liberal politics with modern Romantic theory and practice.

An exiled, ex-Bonapartist Frenchman, Henri Beyle, alias Stendhal, who had been living on and off in Milan since 1811, was one of their strongest supporters. Kept in Milan partly by his lifelong love of Italy, partly by his unrequited passion for Métilde Dembowski – herself a close friend of the poet Ugo Foscolo and a woman in strong sympathy with the radical *carbonari* – Stendhal accepted without question the Milanese equation of Romanticism with liberal politics. Directly influenced by the ideas of his Italian friends, he published in 1819 his first venture into literary polemics, a short treatise entitled *Del romanticismo nelle arti* which in retrospect can be seen as a first preliminary draft of the ideas he was soon to expound more fully in *Racine et Shakespeare*. It was also during his stay in Milan that Stendhal became a devotee of the *Edinburgh Review*. This well-known periodical played a vital role in the diffusion of Romantic literature and theory, and Stendhal professed total allegiance to its doctrines: 'I am a wild Romantic, that is, I am for Shakespeare against Racine, and for Lord Byron against Boileau,' he wrote in 1818.[3]

For Stendhal Romanticism was a revolt, if not an outright revolution. It meant casting off the shackles of outdated literary rules, rejection of the classical unities and, above all, the adaptation of the arts to the changed circumstances of post-Revolutionary society. These and other related ideas, notably on the relativity of taste and the social context of literature and the arts, Stendhal found clearly formulated in the writings of Madame de Staël; but, always determined to assert his independence, he never acknowledged the slightest debt to her and repeatedly criticised her style for its inflated rhetoric. Armed with a ready-made ideology and an acute intuition of literary and social currents, he arrived at a clear perception of the dominant nineteenth-century mood. In the final chapters of the *Histoire de la Peinture en Italie*, published in 1817 and described as the 'first Romantic manifesto', Stendhal rightly predicted that the outstanding characteristic of the new century would be 'an ever-increasing thirst for strong emotions' and that this thirst would lead his contemporaries back to the works of Michelangelo.[4] Basing his argument on the twin opposed concepts of '*le beau idéal antique*' (classical beauty) and '*le beau idéal moderne*' (modern beauty), he sought to define the psychological temper of the new age, so

different from all its predecessors: 'It is therefore by the precise and passionate depiction of the human heart that the nineteenth century will distinguish itself from all previous epochs . . .'[5] Stendhal set himself this ideal in his own novels, *Le Rouge et le Noir* and *La Chartreuse de Parme*, whose heroes are distinguished not by physical strength but by their nimbleness, mental agility and charm of manner.

On his return to Paris in 1821 Stendhal found, to his chagrin, that the term 'Romanticism', imported into France via *De L'Allemagne*, had been adopted by young pro-monarchist conservative writers like Victor Hugo, Vigny and Lamartine, and invested by them with a religious, traditional sense quite alien to his own temperament. The brand of Romanticism which flourished in Restoration Paris was once defined by Sainte-Beuve as Royalism in politics, Catholicism in religion and Platonism in love. It was, needless to say, abhorrent to Stendhal, whose own views were diametrically opposed on all three counts. He protested strongly against the unquestioning acceptance of Madame de Staël's definition of Romanticism, rooted in German mysticism and the idealist philosophy for which he had no use, complaining bitterly in a letter to Louis Crozet that the Germans 'have laid their hands on the idea of Romanticism, christened the movement and ruined it'.[6] He therefore resolved to wrest the movement from them, and to substitute his own definition of Romanticism – modern, democratic, realistic and designed to meet the needs of contemporary society.

This formed the background to Stendhal's second but more important foray into literary polemics with the publication of *Racine et Shakespeare* (1823-5). The immediate cause of this militant pamphlet was the performance of *Othello* in 1822 at a Paris theatre by a company of English actors who were greeted with boos and jeers from a violently hostile French public. Outraged by this display of blatant French chauvinism, Stendhal set out in the first instance to cure his compatriots of their prejudice against Shakespeare and to downgrade Racine and the tradition of classical tragedy which still dominated the French theatre. In place of the outworn conventions of classical drama, the Aristotelian unities of time, place and action, Stendhal demanded a new specifically Romantic drama, written in prose and not verse, and inspired by national, historical themes. Shakespeare, he believed, offered a more appropriate model for this new type of drama.

The theoretical basis for his challenge is immediately stated under the heading: 'What is Romanticism? Romanticism is the art of presenting to the nations those works of literature which, in the present state of their habits and beliefs, are likely to give them the greatest pleasure.'[7] Classicism, on the other hand, is the art which gave most pleasure to their great-grandfathers. Even Racine, according to the logic of Stendhal's argument, was a Romantic in his own day because he delighted and moved seventeenth-century audiences; but to imitate him in the 1820s was an absurd anachronism (i.e. classicism). This

assertion follows naturally from the premise stated in the *Histoire de la Peinture en Italie*, that each age produces, or must be helped to produce, forms of art appropriate to its way of life and outlook. Racine offered a type of tragedy suitable to the courtly, hierarchical society of Louis XIV, but which no longer satisfied the egalitarian temper of 'the sons of the Revolution'. Arguing that modern Frenchmen have more in common with strife-ridden Elizabethan England than with the *Grand Siècle*, Stendhal proposes Shakespeare as a better model than Racine for the rejuvenation of French national drama. Shakespeare, moreover, was not afraid of crude realism and his plays express a far greater range of human emotion than Racine's carefully modulated tirades permit. Dramatic intensity, psychological depth and realistic detail were the specifically Shakespearean qualities Stendhal admired, and with which he hoped to infuse new life into the French theatre.

Romanticism for Stendhal, however, was not a set of precepts or formulae but an attitude of mind, a certain recklessness of spirit: 'You need courage to be Romantic for you must take risks.'[8] *Racine et Shakespeare*, as well as Stendhal's art-criticism and journalism, is characterised by an aggressive militant tone and a casual disregard for the ordinary canons of style and taste. He frequently wrote in the offhand manner of an aristocrat for whom letters and the arts were merely an amusement: 'I write as one smokes a cigar: to pass the time.'[9] With its ill-disguised contempt for official and academic opinion, *Racine et Shakespeare* was an open invitation to the ordinary spectator to state his preferences and to enjoy the type of art which appealed to him, without respect for convention. It was also, by implication, an attack on authority of whatever kind, political, social and artistic. This readiness to defy accepted taste, combined with a passionate belief in the value of the self, was in Stendhal's view the *sine qua non* of the creative temperament. Once released from the tedious doctrines of classicism, the artist's only real obligation is to be true to himself: 'For how long will our true character in the arts lie buried under imitation?' he wrote rhetorically in the *Histoire de la Peinture en Italie*.[10]

Stendhal's entire view of the history of the arts, in fact, is focussed on the struggles of the individual artist to free himself from ready-made prototypes, the eternal battle between creativity and mindless routine. He shows how all the great innovators of the past, from Masaccio, through the Bolognese artists up to David, were Romantics in the sense that they had the courage to break with the past and impose their own vision on the public. The outstanding example of modern times was David, hailed by Stendhal on the opening page of *Racine et Shakespeare* as 'that bold genius' who rejected the effete Rococo tradition in favour of a Stoical ideal in keeping with the aspirations of the new era. The same principles of integrity, modernity and psychological realism, which Stendhal sought in the theatre, also apply to his art-criticism (fully expounded in his only full-length review, the *Salon of 1824*)[11] whose implications are studied in the following chapter.

On account largely of its flippant manner and lack of sustained argument, its provocative *boutades*, its quips and swipes at authority, *Racine et Shakespeare* failed to attract the attention it deserved. Attacked by Stendhal's enemies, the pamphlet was not even taken seriously by his friends, who saw in it only the intention to shock and amuse. All failed to see the originality of the author's linking of Romanticism with modernity of feeling and outlook. In France of the 1820s the notion of Romanticism was still too deeply entrenched in the past, in the Middle Ages, Catholicism and traditional social values, to be so easily overturned into its exact opposite, identity with the present moment. It was only when Baudelaire, a writer of a later generation with no more than distant youthful memories of the heady days of Romanticism, began to publish art-criticism in 1845 that Stendhal's theories began to take effect.[12] There is a distant echo of Stendhal's ideas in Baudelaire's assertion in the *Salon of 1846*: 'For me Romanticism is the most recent, the latest expression of the beautiful. There are as many kinds of beauty as there are habitual ways of seeking happiness.'[13] The same notion underlies the whole of Baudelaire's essay on '*The painter of modern life*', the artist who extracts beauty from the contemporary scene and ephemeral fashions – subjects, in fact, which Delacroix and most of his generation would have considered too prosaic to qualify as suitable material for art.

In the short term, however, Stendhal's theories were largely ignored. He quickly lost interest in the debate, especially after 1827 when Victor Hugo published the much noisier and more grandiloquent *Préface de Cromwell* which led the Romantic movement in an entirely different direction. The contrast between Stendhal's position and that of Hugo could not be more striking. Whereas Stendhal was still a moderate rationalist, nurtured on eighteenth-century empirical philosophy and preferring prose to poetry, Hugo was the first writer to give free rein to the imagination. He was the champion of absolute and unrestrained artistic licence. Moreover, possessed of unbounded intellectual ambition, he showed a strong preference for those comprehensive metaphysical interpretations of history, for myth and all creation so typical of the nineteenth century.

The *Préface de Cromwell* begins with a simple and arbitrary division of the past into three ages of Humanity. The first, the primitive era, found expression primarily in naïve, lyrical forms, typified by the *Book of Genesis*, the 'ode' of early times. The second, the antique or classical era, was represented by Homer and epic poetry. The third – corresponding to Madame de Staël's derivation of Romanticism in *De L'Allemagne* – is the modern Christian age, whose supreme expression is drama, in which the physical and spiritual elements in mankind are reconciled. Echoing Chateaubriand, Hugo underlines the intimate association between religion and poetry: 'for the departure point of religion is always the same as that of poetry'.[14] The aesthetic form corresponding to the first two stages of civilisation was the

classical '*beau idéal*' which, in its monotonous perfection, was no longer suited to express the richness and variety of the modern imagination. He therefore advocates, like Stendhal, abolition of the classical rules, the convention of the unities, and makes a plea for the fusion of different genres (i.e. tragedy and comedy) and different levels of style (i.e. noble and colloquial) in a single work. Hugo also wished to see a vast extension of the vocabulary of the French language, which had largely been confined to abstract and unspecific terms ('*le langage noble*') ever since its relentless purification in the seventeenth century. Finally, unlike Stendhal, he believed in the superiority of poetry over prose and argued in favour of the alexandrine verse in drama.

An entirely new and highly influential concept, Hugo's substitute for classical beauty, is his theory of the 'grotesque'. Originating in the Middle Ages, in the porches and under the gables of Gothic cathedrals, the grotesque is a generic term for all the anti-classical shapes, forms and episodes which proliferated in European art and literature from the thirteenth century onwards: the gargoyles and crockets, devils, demons, and dwarfs, everything amorphous, distorted, comic, vulgar and ugly to be found in Dante, Shakespeare, Molière, Rabelais, in Callot, Michelangelo, Rubens and Veronese. The supreme embodiment of the 'grotesque' was, of course, Shakespeare, rated by Hugo as the greatest artist of all time. This new predilection for everything discordant, inharmonious and asymmetrical, contrasting with the elegant façades of classical architecture and the smooth, even flow of its diction, was to be Hugo's lasting contribution to the Romantic movement. The 'grotesque' in its various manifestations, in its strong contrasts of light and shade, its taste for bizarre shapes and strident colours, was to dominate French art and literature for the next two decades – most spectacularly in *Notre Dame de Paris*; it is even reflected in Hugo's personal style of interior decoration in his houses on the Place des Vosges and at Hauteville House on Guernsey, in which pieces of assorted clutter of the Gothic, Italian and Spanish styles jostle side by side, creating a powerful but restless effect.

The second fundamental idea in the *Préface de Cromwell* is that of art as an organic whole. Life, movement and evolution were essential to Hugo's conception of the arts; here and elsewhere he appears to echo Schlegel's familiar definition of Romantic poetry as progressive and universal. According to this view, language – the work of art itself – is not a finite entity, as the classics thought, but something alive and growing: '*Une langue ne se fixe pas*'.[15] Given the basic unity of the work of art, form and content are seen by Hugo as identical, in a critic's words, 'as indivisible as flesh and blood'.[16] 'An idea has always one form which suits it, which is its essential form . . . With the great poets nothing is more inseparable, nothing more consubstantial than the idea and the expression of the idea. Kill the form, and you almost always kill the idea.' One last, and fundamental, corollary of Hugo's

synthetic notion of art is the acceptance of any kind of subject-matter; comic or tragic, beautiful or ugly, all subjects are grist to his mill: 'Besides, everything is subject-matter, everything comes within the sphere of art; everything has citizen's rights in poetry.'[17]

With such far-reaching, but in certain respects backward-looking, ideas, trumpeted with all the verbal power at his command, Hugo finally won the day. In place of Stendhal's modest and perhaps more enlightened proposals, he succeeded in the short term at least, in imposing his own quasi-Germanic conception of Romanticism based on nostalgia for the Middle Ages, and a semi-mystical notion of the poet as a kind of latter-day Moses, bearing down odes and ballads instead of tablets of stone. His views were further vindicated by events in the French theatre, with the performance in 1829 of Alexandre Dumas' historical tragedy *Henri III et sa cour* and Vigny's *Le More de Venise* (a Shakespearean adaptation). Finally, in February 1830, Hugo achieved his ultimate triumph with the famous *Battle of Hernani*, a noisy melodrama which owed its success more to the rowdy demonstrations of his youthful followers (including Théophile Gautier in his notorious red waistcoat) than to any intrinsic merit.

Stendhal was forced to concede that he had lost the battle of Romanticism. This was confirmed in a letter from a friend, Madame Jules Gaulthier, who wrote that his own charming rational type of Romanticism had been supplanted by a 'roaring monster' and urged him to turn to something else.[18] This is precisely what Stendhal did, in common with many other like-minded people of liberal and moderate views who regarded the triumph of the 'roaring monster', with all its attributes of the irrational and the supernatural, with profound distaste. Nothing could be further removed from the picturesque Gothicism of *Notre Dame de Paris* than the down-to-earth realism of *Le Rouge et le Noir* (subtitled *Chronique du XIXe Siècle*), published in 1830; as Stendhal himself predicted, his novel only came to be fully appreciated a century later. The most popular writers of the 1830s were Victor Hugo and George Sand, whose lyrical and highly melodramatic novel *Indiana* appeared in 1832. The same note of violent protest against society was sounded by Musset's *Rolla* (1833) and, with revolutionary fervour allied to religion, by the apocalyptic utterances of Lamennais' *Paroles d'un croyant* in 1834. At this point Romanticism, initially conservative and royalist in sympathy, became democratic, egalitarian and often openly revolutionary.

In literary theory, though, as in art-criticism, the polemical aspect of Romanticism ceased to be a burning issue after about 1830. Writers, like artists, went their separate ways and no longer felt the need to adhere to a collective theory. The public, for its part, was baffled by the many conflicting definitions of Romanticism which had been propounded in the past two or three decades. The inevitable reaction against the movement set in. In 1833, Théophile Gautier, himself a fellow-traveller and typical product of early

Romanticism, mocked at its absurdities and excesses in the stories *Les jeunes-France*. Then in 1835 Sainte-Beuve, initially one of Hugo's most ardent champions, turned against his former idol and declared himself in favour of reason and analytical intelligence.[19]

The last word, however, fell to Alfred de Musset, whose Romanticism, though passionate, had never been more than skin-deep; he was too much of an individualist and the child of eighteenth-century wit and gallantry ever to give the movement his complete allegiance. He also had too lively a sense of humour to accept the more radical implications of a thorough going Romantic 'attitude'. This is the spirit of Musset's parting shot on the subject of Romanticism, the *Lettres de Dupuis et Cotonet*, published in the *Revue des Deux Mondes* in 1836. Cast in the form of letters from two naïve provincials in La Ferté-sous-Jouarre (i.e. nowhere in particular, or a typical French *sous-préfecture*), the whole piece is a delightful parody on the absurdities of the movement. In their literal-minded simplicity – which is perhaps less absurd than the fashionable crazes of the Parisian public – the two provincials are determined to get an answer to their question: what is Romanticism? 'I was telling you that we did not know what the word Romanticism means . . . It was therefore towards 1824, or a little later, I forget exactly; they were arguing in the *Journal des Débats*. It was a question of the picturesque, of the grotesque, of landscape introduced into poetry, of dramatised history, of blazoned drama, pure art, broken rhythm, tragedy mixed with comedy, and the revival of the Middle Ages.'[20]

These predominantly Hugolian ideas, connected with the theatre, history and the Middle Ages, were more or less intelligible to our friends in La Ferté. But that was not the end of the matter. Having assumed, on the basis of *De L'Allemagne*, that Romanticism was imitation of German literature, what was their consternation when they were told around 1830 that English poetry was its true source. Worse still, when a year later they learn that the historical genre had been discarded in favour of '*le genre intime*'.[21] Finally, between 1832 and 1833, Romanticism has become a 'system of philosophy and political economy'.

All these conflicting definitions leave the two men in a state of total confusion, and we may well wonder with them whether the term Romanticism has any meaning at all. In parodying the excesses of the movement, Musset himself seems to invite this conclusion. It is only with the benefit of hindsight that we can see that all these vicissitudes were different facets of a single, complex phenomenon, whose underlying causes were only to become fully apparent during the course of the nineteenth century. The belief in individualism, freedom and the primacy of subjective feeling was the unique creation of Romanticism, both in its theory and practice, and has become an essential part of our European outlook in art, life, politics and nearly everything else.

CHAPTER IV

THE SALON OF 1824 AND THE CRITICS[1]

THE SALON OF 1824 has acquired a legendary reputation as the climax in the development of French Romantic painting. In retrospect it became the *annus mirabilis* in which the two great rivals, Ingres and Delacroix, confronted each other in public for the first time, the first with his *Vow of Louis XIII*, the second with *The Massacre at Chios* [Fig. 33]– an antithesis which summarises the two main currents, Classical and Romantic, which then divided French art into two sharply opposed camps. In 1824, for the first time, the 'Romantics' as they soon came to be known, among them Horace Vernet, Ary Scheffer and Xavier Sigalon, seemed to be in the ascendant; they made a final break with the lingering classical tradition inherited from David, and successfully imposed themselves on public opinion. The impact of Delacroix on French art was seconded and reinforced by the revelation exerted by Constable's landscapes, notably *The Hay Wain*, exhibited for the first time in France. The story is familiar of how Delacroix, after seeing *The Hay Wain*, is said to have hastily repainted the background of his *Massacre at Chios* in a far looser 'English' technique than previously.

For these reasons, the Salon of 1824 has become a landmark in the discovery of freedom in artistic expression, and a belated vindication of the literary theories formulated primarily by Madame de Staël and Stendhal which made such a liberation possible. But the issue – Classicism versus Romanticism, tradition versus innovation – was by no means decisive. The essential problem remained, as Delécluze expressed it, whether the classical doctrine of imitation was still valid or not: 'Basically, the situation in the arts and letters has remained where Madame de Staël had brought it as early as 1815 . . . the question was still to know whether one would reject or continue to follow the artistic rules of antiquity.'[2]

In the short term, there seemed to be a smooth, unbroken linear progression towards a final victory for Romanticism, especially when the Salon of 1827 was marked by still more decisive works by Delacroix (*The Death of Sardanapalus*), Louis Boulanger, Ary Scheffer and others, culminating in the *Battle of Hernani* in 1830 and the apparent rout of Classicism. The truth, however, was far less simple, for in fact Romanticism, either in art or in literature, never triumphed in such a resounding manner. The forces of tradition in France, in the sense of respect for form, careful modelling and reverence for the past, were simply too deeply entrenched simply to disappear overnight; temporarily eclipsed in the 1830s, they began to re-emerge in the academic art of the mid-nineteenth century with renewed vigour.

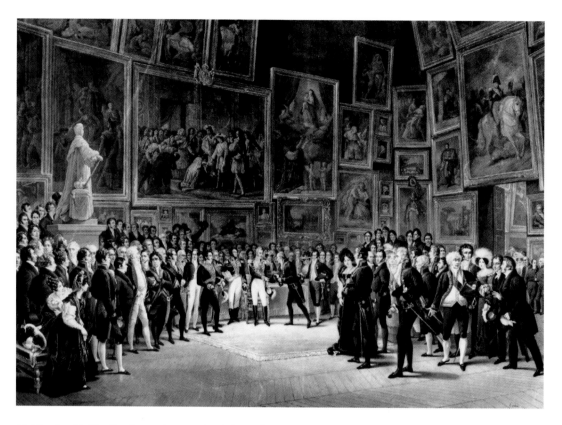

31 **Charles X distributing prizes at the Salon of 1824**
Engraving by Jean Pierre Marie Jazet after François Joseph Heim

The old conflict, therefore, remained unresolved. As a leading historian expressed it more than a century ago, Romanticism never succeeded in imposing its own individual style, nor in conquering the majority of public opinion.[3] Nevertheless, the fact that the Romantic painters never succeeded in creating a new 'school' with the stylistic uniformity which that term implies does not detract from the value of their efforts. Indeed, had they succeeded in doing this, they would scarcely have been 'Romantic' at all, for they believed passionately in freedom of individual expression and an open, fluid approach to such questions as form, content and style. Any kind of finite victory would have been against the basic aspirations of the movement, which was towards progress and evolution. The real significance of this Salon is not, therefore, in a supposed triumph for Delacroix and those who supported him, but in the exchange of views and attitudes of the critics who reviewed the exhibition and in the implications of their ideas. These are, in many respects, simply an extension to the visual arts of those same principles which, in the form of tracts and manifestos, had begun to determine the changes in literature and the theatre. French Romanticism therefore was literary and theoretical in origin, and spread only later to the visual arts. It is not surprising, consequently, that much of the painting at the Salon of 1824,

as well as the criticism of it, has a strong literary bias and much of the theoretical discussion around the Salon applies equally to literature and to painting.

The Salon opened officially on 25 August 1824 in the presence of Charles X who acceded to the throne in the same year. The event was accurately recorded in François Joseph Heim's picture, *Charles X distributing prizes at the Salon of 1824* [Fig. 31], showing all the assembled artists who exhibited in that year; many of their paintings are recognisable on the walls. In size the Salon was considerably larger than previous years with a total number of 2,180 exhibits, of which 1,761 were paintings and 164 sculptures: the rest, engravings, lithographs and miniatures. In terms of genres, there were about 400 landscapes, 300 portraits, 100 religious works (one-fifth commissioned by the Ministry of the Interior for various Paris churches), 100 paintings with literary subjects, 50 from modern history, 36 from classical mythology and 25 from ancient history. Despite the decline of classical mythology and ancient history which had begun in the early years of the Restoration and had been lamented by the conservative critics comte de Kératry and Chauvin, these subjects (especially if classical authors such as Homer are included) were still prominent in 1824 and only faded out after 1830. There was also a parallel slight decline in subjects from modern history compared with previous years: at the Salon of 1819, which marks the climax of the Troubadour style, there were 91 subjects, in 1824 only 50. Of this 50 no less than 21 were of Henri IV (the most popular was Ingres' *Henri IV with his children*), eight of François I (Révoil: *François I knighting his Grandson*), five of St Louis and four of Joan of Arc.

Of the literary subjects, typical examples were either domestic scenes from the lives of French authors, for example Mademoiselle Ribault's *Racine at home*, Pingret's *Molière and Louis XIV*, or illustrations of dramatic episodes from fiction, Madame de Staël's *Corinne* by Gérard, or Rousseau's *Julie and St Preux on Lake Geneva* (from *La Nouvelle Héloise*) by Crespy Le Prince. But the growing interest in literary subject-matter which some critics saw as an invasion of art by literature had not yet reached its peak. There were only a few subjects from Byron, Scott and Shakespeare in 1824, far more in 1827, and the vogue for subjects from Goethe (especially those by Delacroix and Ary Scheffer), only seriously began in 1830 after the publication of Gérard de Nerval's translation of *Faust* in 1828. Although Byron's works had been translated in 1819 by Amédée Pichot, the author's popularity with artists was greatly enhanced, first by his death in 1824, and by numerous stage versions of his works which produced such paintings as Boulanger's *Mazeppa* in 1827.

The Salon of 1824 was arguably less significant for the stylistic innovations it produced than for the critical discussions these generated and their implications. Never since the appearance of David's *Oath of the Horatii* in 1785, immediately before the Revolution, had the critics taken such a passionate interest in the current exhibition. To some writers, notably Stendhal and Thiers, French art seemed to be on the verge of

another revolution, and they confidently predicted the overthrow of the artistic hegemony which David had established and maintained for over 20 years. The opposite camp of critics, led by Delécluze, Landon and Chauvin, staunchly defended the principles of the classical tradition against this onslaught and waged a relentless war on the painters who threatened to undermine it. By 1824 critical opinion was fairly sharply divided into two factions: pro-Classic and pro-Romantic. Stendhal begins his review with an attack on a rival newspaper: 'The battle was begun. The *Débats* will be for the Classics, that is swearing only by David and declaiming every figure painted must be a copy of a statue, and the spectator will admire it, even if it bores him stiff.'[4]

The underlying issue of this debate was that of tradition – respect for the Classics – versus change and innovation. This was not a new issue in France, in fact it was as old as the Quarrel of the Ancients and Moderns in the seventeenth century. Only in the early nineteenth century, when French Romanticism as defined by Madame de Staël and Stendhal set itself the task of regenerating national art and literature, was the question reopened. In Madame de Staël's view this cultural revival was to be achieved by importing foreign literature into France and by fostering a cosmopolitan outlook. As we have seen, *Corinne* (1807), and especially *De'Allemagne* (1813) were seminal books to nineteenth-century critical theory, showing taste to be a relative function of society and political institutions, not, as was maintained by classical theorists like Winckelmann, an absolute quality valid for all time. Beauty is a reflection of the state of society and must change as society changes: outmoded artistic forms must be rejected and give way to new ones more appropriate to the times.

This same premise is taken up and adapted to classical and Renaissance art by Stendhal in his *Historie de la Peinture en Italie*, a crucial work for the evolution of French painting and described by Delécluze as the Bible of the young Romantics. The book revolves round the contrast between the classical and modern ideals of beauty, and Stendhal predicts that the mood of post-Revolutionary France and its 'ever increasing thirst for strong emotions' will lead to a revival of favour for Michelangelo. This prediction was amply fulfilled by two

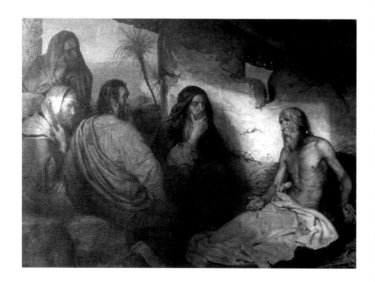

32 **Job on the Dunghill**
Gillot Saint-Evre (Soissons, Musée)

major works which, unfortunately, Stendhal did not see, or if he did, never discussed, Géricault's *Raft of the 'Medusa'* (Salon of 1819) and Delacroix's *Dante and Virgil crossing the Styx* (Salon of 1822).

Following rapidly on the success of the previous two works, a group of young painters including Delacroix, Horace Vernet, Xavier Sigalon, Ary Scheffer, Paul Delaroche and Gillot Saint-Èvre (*Job on the Dunghill* [Fig. 32]) broke with the lingering classical tradition and imposed themselves on public opinion; they were christened the 'Romantics' by the favourable critics, and 'schismatics' or 'sectarians' by their opponents. They formed a heterogeneous group of painters with little in common except the fact that they were under attack, both from the traditionalist faction who condemned their works as a violation of the laws of beauty, and from the uncommitted middle-of-the-road critics who damned them with faint praise. Even the nominally pro-Romantic critics – Stendhal, Augustin Jal, Adolphe Thiers, Flocon and Aycard – rarely approved of them whole-heartedly.

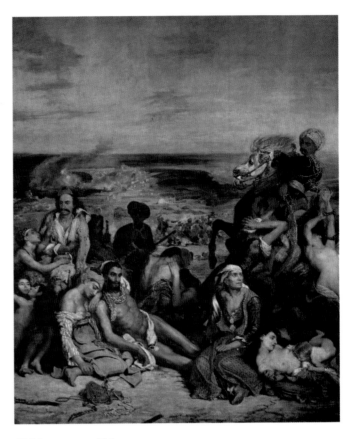

33 **Massacre at Chios**
Eugène Delacroix (Paris, Louvre)

Who were these painters? Delacroix's *Massacre at Chios* [Fig. 33] is invariably singled out by modern writers as the outstanding exhibit at the Salon of 1824, but in fact the painter was only one of the most prominent of the group of young artists in revolt against the previous generation. Nearly all the critics came out strongly for or against the *Massacre*, and the majority were hostile often to the point of frenzy. They objected both to the subject and to its treatment. The fact that the painter chose to represent a life-size massacre at all was bad enough; but they also regarded Delacroix's freedom of technique, the gaudily-coloured background, as evidence of his supposed revolutionary intentions. The diehard traditionalist Chauvin describes the work as a piece of 'butchery', using the term to condemn both the subject and the artist's style. Such expressions of misplaced moral outrage were commonplace among Delacroix's critics. Stendhal was one of the few critics to take a independent critical attitude towards the painting; while he disliked its '*mal du siècle*'

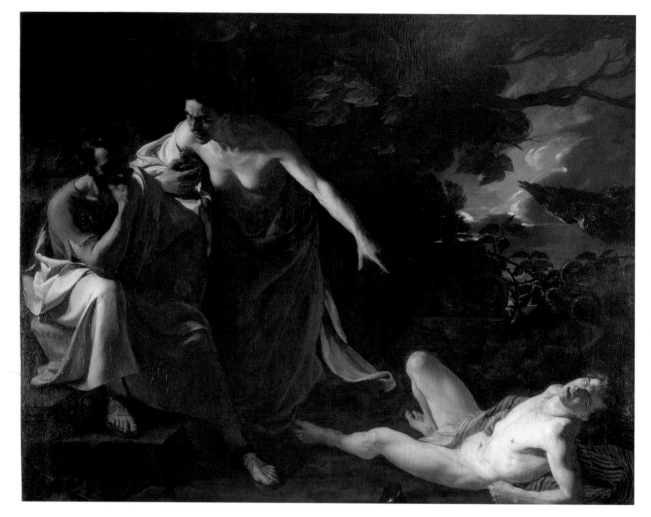

34 Locusta trying out poison on a slave before Narcissus
Xavier Sigalon (Nîmes, Musée des Beaux-Arts)

sentiment, what he calls its 'exaggeratedly gloomy, morbid quality' as in the poetry of Vigny and Alexandre Guiraud, he believed that the real fault of the picture lay not in too much violence but in too little. He wrote: 'A massacre demands an executioner and a victim',[5] sensing that Delacroix's curiously slumped forms were no match for the fanatical horror of Girodet's *Revolt at Cairo* (1810).

Delacroix's main champion, however, was a lawyer and liberal politician, Adolphe Thiers, who began his career as a critic in *Le Globe* and *Le Constitutionnel* by his warm defence of the *Dante and Virgil crossing the Styx* in 1822. In 1824, again, he immediately recognised the painter's 'bold and passionate' temperament and, while not blind to certain faults in the *Massacre*, predicted a great future for Delacroix. Usually bracketed with Delacroix was

Xavier Sigalon (1787-1837) from Nîmes, who exhibited his *Locusta trying out poison on a slave before Narcissus* [Fig. 34], inspired by some lines from Racine's *Britannicus*. In view of its sadistic subject, this painting was surprisingly well received. Even the pro-classical critics, such as one anonymous writer in the *Mercure de France* who called himself '*L'Amateur sans Prétention*', who could not tolerate Delacroix, were more indulgent towards Sigalon and regarded him as a more 'sensible' version of Delacroix. Sigalon was an artist whom they may have hoped could be tamed and won back to the classical fold. If so they were mistaken,

35 **Death of Gaston de Foix at the Battle of Ravenna**
Ary Scheffer (Château de Versailles)

for in 1827, encouraged by his initial success, he went even further towards extreme violence with his *Dream of Athalie* (Nantes, Musée). This work was greeted with such storms of protest that the artist lost heart and returned to Nîmes to eke out a living as a portrait painter. Sigalon's career provides an all too clear demonstration of the power wielded by nineteenth-century critics, first in encouraging him to pursue a particular line, then in abandoning him when it went too far for their taste.

The Dutch-born artist Ary Scheffer (1795-1858) was also grouped with the Romantics. He studied under Marcisse Guérin and continued to work and exhibit in France. His reputation suffered greatly from Baudelaire's attacks in the *Salon of 1846* and he is still known as the purveyor of sentimental, mystical and literary themes which he took up in the 1830s and '40s. But in 1824 Scheffer was generally regarded as one of the most promising artists of his generation. He exhibited two major works, *The Death of Gaston de Foix at the Battle of Ravenna* (Château de Versailles) [Fig. 35] and *St Thomas Aquinas preaching during the Tempest* (Paris, Hôpital de Laënnec). Adolphe Thiers was one of his greatest admirers, seeing him as the leading representative of modern-history painting. Thiers, who later became a historian himself, considered that a sense of the past was the outstanding achievement of the age: 'We have already noted in literature remarkable progress in the manner of writing history, of reproducing the morals, customs and character of past ages, and of giving each epoch its true local colour.'[6] Making the same observation of painting, he believed that Scheffer was well equipped to portray historical truth on canvas: he also praised Scheffer's style for its breadth, nobility and simplicity: '*cette grande composition est empreinte de vigueur et de noblesse, elle émeut, elle attache*'.[7]

36 **Louis XIV declaring his Grandson King of Spain before the Spanish Ambassador**
Baron François Gérard (Château de Versailles)

The problem raised by Thiers which faced all painters of modern history was how to raise their art to the level of prestige enjoyed by ancient history and mythology. The conservative critics, however, dismissed the attempt out of hand. Chauvin wrote of *Death of Gaston de Foix at the Battle of Ravenna*: 'There is nothing great, heroic or moving in this picture. . . . The artist seems to throw his colours on the canvas with contempt, or at random; he seeks truth without nobility, attitudes without selection'. [8] Delécluze, for his part, considered that the painting was no more than a large sketch, not a finished work; the artist had needlessly encumbered the scene with a lot of useless ironmongery and to show the hero's bare chest covered in blood, even though Gaston had been pierced by 17 blows of the lance, was an affront to good taste. [9]

The same problem of how to bring history painting up to date also faced Gérard in his painting of *Louis XIV declaring his Grandson King of Spain before the Spanish Ambassador* [Fig. 36]. He set about the task in a very different manner and managed to satisfy nearly all the critics, left, right and centre. In fact, if one can speak of the most popular work in the eyes of the time, it was this painting. Praise was virtually unanimous; all the critics said more or less the same thing, namely that the painting was a masterpiece of characterisation and historical evocation. The only minor reservation was made by Delécluze who considered that modern, that is, contemporary, dress was out of place in any painting, no matter how well painted. Apart from this, Gérard's work was universally hailed as a triumph of modern, historical realism. But its success can also be attributed to the implicit political allusion to a recent French military intervention in Spain in 1823, when the duc d'Angoulême led an expeditionary force to restore the Bourbon régime. This conscious assertion of the legitimacy of the Bourbon dynasty was not lost on the critics and accounts for the note of chauvinism in their response to the work.

The other outstandingly popular painter of modern history was Horace Vernet (1789–1863), the youngest member of a family of artists, whose extraordinary facility and

37 **The Battle of Montmirail**
Horace Vernet (London, National Gallery)

military dash endeared him to all shades of public opinion. P.-A. Viellard described him as 'le phénomène de notre école';[10] another critic called him the 'Voltaire of painting'; *The Battle of Montmirail* [Fig. 37] was widely acclaimed as the image of modern warfare. Jal wrote: 'It is truly the image of a battle.'[11] Stendhal, in much the same vein, proclaimed on the strength of his own military experience that the painting was a masterpiece: 'Only Horace Vernet gives real pleasure to the public of 1824', and pleasure being Stendhal's main criterion of success, he declared that Vernet is the typical Romantic painter because he presents the men of today, and not the men of those remote, heroic times who probably never existed anyway.[12]

Delacroix, Sigalon, Saint-Evre, Scheffer, Vernet and Delaroche (*Joan of Arc and Cardinal Winchester* [Fig. 38]) – these painters were almost unanimously heralded as Romantic. When, however, it came to a definition of what was meant by Romanticism there was less agreement. At first sight the pro-Romantic critics seem a fragmented group with little common ground, unlike the pro-Classics who stood for a well-defined traditional set of values. According to Thiers, Romanticism was unlimited freedom in the choice and expression of subjects: '*L'art doit être libre et libre de la manière la plus illimitée.*'[13] For Stendhal, it was the realistic portrayal of modern life. For men like Flocon and Aycard, it was simply 'truth to nature', in contrast to the classical doctrine of imitation. For others, Romanticism was an extension to art of the literary movement linked with the names of Shakespeare, Byron and Scott. For Augustin Jal, a liberal and ex-naval officer, Romanticism was the inevitable result of social upheaval finding an outlet in the arts as well as in everyday life. Within all these conflicting definitions, there is agreement on one fundamental point: the need for a regeneration of French art, and that all efforts which tend towards this aim must be applauded. The issue centred on that of tradition versus change – as Stendhal put it, 'whether French art is to be allowed to develop or whether it is to remain as static as government shares'.[14] In 1823, in *Racine et Shakespeare*, he had already equated Classicism with the outdated art of a previous generation; what was now needed was a similar artistic revolution to the one carried out by David in 1780. Even his opponent, Delécluze, had to admit that the term Classicism had lost its original meaning as the synonym for perfection. It had become the byword for uninspired hack work, debased by a generation of artists who swore by David's principles but totally lacked his ability.[15] To illustrate his point, Stendhal contrasts Vernet's *Battle of Montmirail* with David's *Sabine Women* (1799); the one, in his view, is the epitome of Romanticism, the other of Classicism. The central figure of Romulus, instead of fighting for his life and throne, thinks only of striking a fine posture and displaying his muscles;[16] the picture is stiff, stylised and painted with blatant disregard for the realities of war. This, in Stendhal's view, is Classicism, the attempt to

38 Joan of Arc and Cardinal Winchester
Paul Delaroche (London, Wallace Collection)

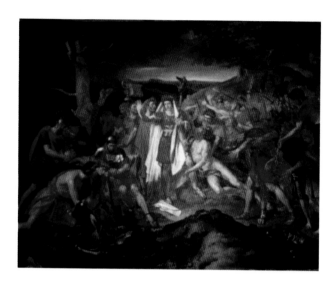

39 **Germanicus paying a last homage to the remains of the Romans who perished with Varus on the Battlefield**
Abel de Pujol (La Rochelle, Hôtel de Ville)

perpetuate outworn conventions in circumstances which render them meaningless. It was, unfortunately, this pedantic neo-Grecian aspect of David's art which attracted the widest following among his pupils like Abel de Pujol, Merry-Joseph Blondel, Léon Cogniet, Isidore Péan Du Pavillon, Louis-Charles Auguste Couder who, if they had not actually studied in David's studio, copied his art closely to the point of pastiche.

The kind of art produced by this Davidian progeny is Stendhal's constant butt in his *Salon of 1824*, and he ridicules these vast anachronistic canvases the size of a wall with naked or semi-naked heroes gesticulating like the actor Talma on the stage. He begins his *Salon* with an offensive against a work by Abel de Pujol, *Germanicus paying a last homage to the remains of the Romans who perished with Varus on the Battlefield* (La Rochelle, Hôtel de Ville) [Fig. 39] showing a Roman soldier presenting Germanicus with the legion's eagle; supposedly in a North German forest, the soldier is entirely naked. Even Delécluze, who was sympathetic to the cause of David and his pupils, had to admit that it was poorly represented by such works and could not feign much enthusiasm for the end product. The classical school had lost the vigour and imagination which it had possessed a decade ago. Exactly the same criticisms are made by another pro-classical critic, Chauvin, who writes of Cogniet's *Marius on the Ruins of Carthage* (Toulouse, Musée des Augustin) [Fig. 18]: 'All I can find in it is lack of expression, sterility, defective understanding of the subject, uniform, reddish colour, poor draughtsmanship, expression nil.'[17] For once the pro-Classic and pro-Romantic critics were in agreement, and we find precisely the same criticisms from Stendhal, Jal, Thiers and others.

One prominent example of this debased classical art is provided by Couder's *Farewell of Léonidas*.[18] Though lost and no illustrations survive of this work, we can, however, gain a fairly clear notion of its appearance from contemporary accounts and from the old Marseilles catalogue: 'After assembling the three hundred Spartans who are about to accompany him to Thermopylae, the hero, standing in the centre of the composition, is saying farewell to his wife, son and his father . . .'[19] In any case, the painting found little support from any of the critics. Jal wrote: 'How gloomy it is and how it chills me.'[20] Chauvin saw the work as a pale reflection of David's *Farewell of Léonidas* and Stendhal despatches it in half a line.

The other major classical pastiche at the Salon was a work by Isidore Péan Du Pavillon, *The Anger of Achilles*[21] (formerly Douai). Rejected by the Salon jury as a plagiarism of David's style, the painting caused something of a controversy. In retaliation the artist set up a private exhibition where he hoped to draw the public's attention to the injustice he had suffered. Most of the critics, while not especially sympathetic to Du Pavillon, took the rather cynical view that this work was no more blatant a copy than scores of others. More sympathetic than might be expected, Stendhal was willing to allow good qualities in a painting based on the classical models he rejected: 'Such as it is, this painting would have attracted all eyes at the exhibition. It would have

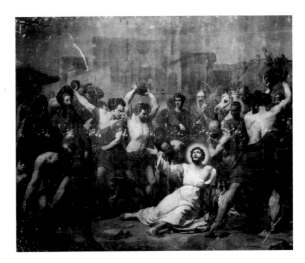

40 **The Martyrdom St Stephen**
Jean-Baptiste Mauzaisse (Paris, Louvre)

been the representative of David's school in its heyday. This painting would have won great success because it portrays an idea. It is an extremely moving scene and appeals to all mothers' hearts; Racine's tragedy [i.e. *Iphigénie* on which it is based] makes it intelligible for everyone. Finally, despite the numerous faults of David's school, despite heroes forgetting to wear clothes in the often cold climate of Greece . . . this picture would have completely effaced the *Assumption* by M. Blondel, the *Martyrdom of St Stephen* by M. Mauzaisse [Fig. 40], the *Marriage of the Virgin* by Alexandre François Caminade, the *Transfiguration* and twenty other works which, in my view, may have more merit, but whose authors have not taken a subject so deeply embedded in the most intimate feelings of the human heart.'[22]

So much for the most obviously derivative of David's pupils. Although the object of general ridicule, they were a force to be reckoned with and were still exhibiting in considerable numbers in 1824. For all their faults, they still represented the traditional standards by which many critics continued to judge works of art – namely grand design, dramatic subject, unity of composition and careful finish. For the majority of critics, the fault of such pictures was not their underlying principle but the fact that they were the unworthy inheritors of a great tradition. Nor, despite the onslaught of the Romantic critics, did such works vanish from the repertoire: they merely disappear temporarily in the 1830s and re-emerge late in the 1840s and 1850s. For decades conservative critics had lamented the demise of history painting, but this never occurred.

There were, of course, many other shades of what could loosely be termed classical art at the Salon of 1824. First, that of the older, more talented and more independent generation of David's followers, Prudhon and Girodet, both of whom died in the same year. Both sent a handful of works which were rarely given due attention, most critics

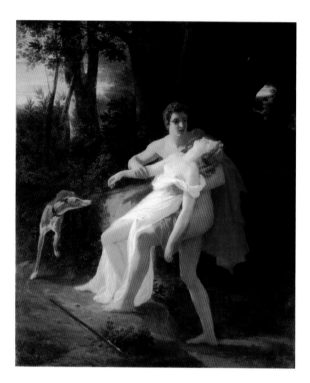

41 Cephalus and Procris
François-Edouard Picot (Tourcoing, Musée)

bewailing the decline of genius and evoking nostalgically the heyday of *Justice and Vengeance pursuing Crime* and the *Burial of Atala*. Prudhon's final and moving work *Christ on the Cross* (Paris, Louvre) was barely noticed. Nor can Girodet's two portraits of the Vendéan generals, *Cathelineau* and *Bonchamps* (both in the museum of Cholet, Maine-et-Loire), be easily written off as the products of decline.[23] Another of David's talented pupils was François Edouard Picot (1786-1863) who exhibited a *Cephalus and Procris* [Fig.41], (Tourcoing, Musée), a charming and anodyne picture which managed to please most people and was considered by the journal *La Pandore* to be one of the best works at the Salon. Frequently grouped with this latter artist was Michel-Matrin Drolling:[24] his *Separation of Hecuba and Polyxena* (Le Puy, Musée Crozarier) [Fig. 42] was likewise admired by critics of all shades, from Chauvin to Stendhal, perhaps because it seemed to combine the classical '*beau idéal*' with modern sentiment. To quote *La Pandore* again: 'This figure [Polyxena] is no less remarkable for the beauty of her expression than for the truth of the colour. The character of devotion depicted on this young victim's face is full of nobility . . .'[25] Much the same opinion was voiced by other critics in slightly different words. Polyxena's head was praised as a model of expressive beauty, and frequently put on a par with the Italian Old Masters.

Another prominent and loosely classical painting was *The Swiss on the Rütli*[26] [Fig. 43], by Baron Charles Auguste Guillaume Henri François Louis de Steuben (1788-1856).[27] The subject of the painting was the oath-taking by three Swiss patriots on the Rütli field to free their country from Austrian oppression. The composition and the theme, the call for liberty, also has a Neo-Classical precedent in Fuseli's work, of c.1780, the *Oath on the Rütli*. The demand for national independence and hatred of tyranny in Steuben's work evidently held a contemporary significance for it struck a chord of sympathy in most spectators. Jal's comment is fairly typical of the liberal critic: 'The execution of this work responds to the noble feelings which inspired the author to create it.'[28] One of the most popular paintings at the exhibition, it was frequently engraved, used as the frontispiece for books, and inspired a poem by the prolific poetess Madame Tastu entitled *La Liberté ou Le Serment des Suisses*.

In a category all on its own was Ingres' great work *The Vow of Louis XIII* [Fig. 44]. While

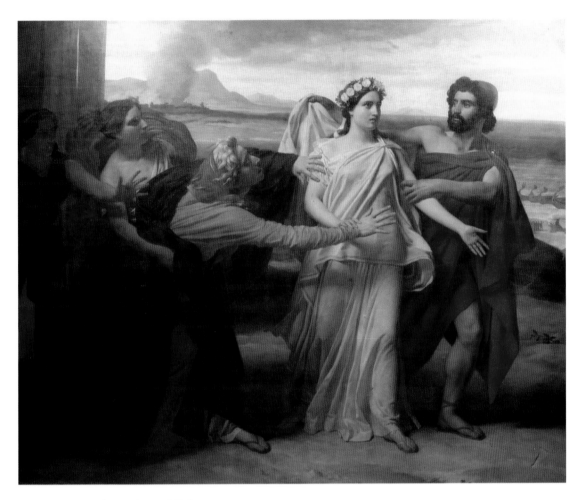

42 **Separation of Hecuba and Polyxena**
Michel-Martrin Drolling (Le Puy, Musée Crozatier)

most critics instantly recognised it as a masterpiece, except for the outraged critic of
L'Oriflamme who wrote '*Croûte, croûte détestable*' ('Daub, detestable daub'), nearly all were
baffled by this painting which so obstinately seemed to defy all their traditional
categories. It was neither an orthodox classical work, nor recognisably Romantic; as a result
Ingres was claimed by both sides as one of theirs. Landon and Delécluze saw the work as
the embodiment of traditional values, careful draughtsmanship, and so on. Others praised
Ingres for his specifically un-academic qualities, the picturesque, Troubadour or 'gothic'
element in his work which most critics found incompatible with the painter's love of
plastic beauty. The major point of disagreement concerned Ingres' ambivalent relationship,
not only to the classical tradition, but also to Raphael and the Old Masters. Was the *Vow of
Louis XIII* a pastiche of Raphael's *Sistine Madonna* or not? If so, what was the meaning of
Louis XIII, such an obvious product of nineteenth-century mediaevalism? The work

43 The Swiss on the Rütli
Engraving by Hermann Raunheim after
Baron Steuben

seemed an unhappy alliance between two conflicting tendencies, particularly to Stendhal who considered that it lacked the 'divine unction' of its great Renaissance predecessor; to him the Virgin seemed tight-lipped and sullen in comparison with Raphael's *Madonnas*. In spite of this criticism, however, Stendhal conceded that Ingres' painting possessed a painstaking quality of grandeur which lifted it far above the average run of religious works at the Salon. Landon and Delécluze, on the other hand, had no reservations in praising Ingres' work as a worthy successor to the classical tradition. They considered that the charge of plagiarism was unjustified and that the painting was the work of an original genius. Landon summarised their view: 'The disposition of the central group is grand, clear and of a happy simplicity; and whatever the source of Monsieur Ingres' original idea, there is such a difference between that kind of borrowing and true plagiarism that we would be sooner inclined to congratulate him on it.'[29]

Another central topic and bone of contention between the pro-Classics and the pro-Romantics concerned the actual size of paintings. Grand-style figure painting, though still prominent, was on the decline. It was in this gradual disappearance of large-scale works in favour of easel paintings of genre subjects and landscape that the real revolution in French painting took place. This tendency was strenuously resisted by Ingres and by Delacroix, both of whom strove to maintain the dignity of grand-style history painting even though the tide was turning against them. As early as 1819 Auguste-Hilarion Kératry had lamented the decline of history painting and accused painters of neglecting the most worthwhile aspect of their art.[30] The decline continued steadily in 1822 and in 1824, and Chauvin expressed the standard criticism of genre when he wrote that small proportions made it impossible for the artist to convey noble forms and moving expression. Another anonymous article by a group, which called itself '*une Societé de gens de lettres*', complains that small-scale art has become the 'music-hall of painting'.[31]

The main reason for the controversy was that the distinctly lower middle-class and democratic overtones of genre painting marked a visible break with the grand, pseudo-heroic canvases by David's pupils which by the 1820s had frozen into academic orthodoxy. As Stendhal noted, few people in 1820 lived in houses with rooms large enough to accommodate this kind of art; what the nineteenth-century collector wanted was small cabinet paintings. Genre painting – typified by a sentimental tear-jerker like Pierre Roch

Vigneron's *Military execution* – appealed not only to the purse but also the heart of the middle classes. It seemed a revival of the 'genre larmoyant' popularised by Greuze towards the end of the eighteenth century with subjects like Ary Scheffer's *Woman in Childbirth* (Dordrechts Museum) the same artist's *Kind old woman* (*La Bonne Vieille*) [Fig. 45] or Prudhon's *Unhappy Family* (Salon of 1822). The latter prompted Stendhal to exclaim: 'I came to study Prudhon's technique, his use of colour, *chiaroscuro* and drawing and so on, but I could only think of the despair of that unfortunate family. This is the electrifying effect of truth, and this primarily is what is lacking at the present moment: truth in the portrayal of human feeling.'[32]

Stendhal approached this affecting little scene from the psychological point of view of the novelist, but other left-wing critics explicitly allied the democratic content of such works with the Romantic cause. Flocon and Aycard, in particular, wrote that history painters might consider themselves superior to genre, but the painter who portrayed the sufferings of common humanity with grace and truthfulness has attained one of the main aims of art.[33] Popularity of appeal becomes a criterion of success, and the critic claims to speak for the mass of public opinion. Flocon and Aycard devote a long section in their *Salon* to the overtly sentimental genre paintings of Ary and Henri

44 **The Vow of Louis XIII**
Jean-Auguste Dominique Ingres (Montauban Cathedral)

Scheffer; a typical example is Ary's *Burial of the Young Fisherman*, a scene from Walter Scott's *The Antiquary* (Chapter XXXI) in which the novelist, significantly, describes the fisherman's cottage in terms of the painter Wilkie, paying tribute to 'that exquisite feeling of nature that characterises his enchanting productions'. Scott conceived his scene as a painter and the critics, in their turn, viewed the painting as a novel. They write that no painter could rival Scott's description, whose emotional effect depends on accumulation of detail and the reactions of the different characters to the sight of the dead young fisherman in his coffin.

Landscape painting and portraits had always been considered inferior genres in the traditional hierarchy, and the considerable number of these at the Salon was seen as a major innovation. The vast majority of French landscapes in 1824 were still in the classical, Claudian style – semi-historical views of Italy by artists like Jean Victor Bertin, Jean Joseph

45 La Bonne Vieille (The Kind old woman)
Engraving by Bonnemaison after Ary Scheffer
(formerly in the collection of the duchesse de Berry)

Xavier Bidauld, Jean-Charles Joesph Rémond, Pierre Athanase Chauvin (*View of the Ruffinella* [Fig. 46]), Lancelot Theodore Turpin de Crissé (*Apollo and the Shepherds*) and Louise Etienne Watelet (who hung next to Constable). With such crisp, well executed paintings French artists continued to enjoy the prestige of history painting. As might be expected, they were firmly supported by the conservative critics who saw them as the embodiment of '*la belle nature*'; it was not the business of the landscape painter to show ordinary nature, only its carefully selected and most beautiful aspects. This doctrine, however, and the Mediterranean ideal in general, found itself increasingly undermined by Northern influences, especially by English ones. Ever since the Peace of Amiens in 1802 English artists such as John Opie, Thomas Girtin and Benjamin West had begun to visit France. Then again in 1815, after relations had been suspended during the Napoleonic wars, a new wave of English artists including Benjamin Robert Haydon, David Wilkie, the Fielding brothers and Anthony Vandyke Copley crossed the Channel. In 1817 Bonington came to settle in France, first taking drawing lessons in Calais, then in 1820 going to Paris to study under Gros. A typical example of Bonington's work in France is his *Abbey of St Bertin, St Omer* (dated 1823) [Fig. 47] and in 1824 the artist contributed lithographs to the Normandy volume of Taylor's *Voyages pittoresques dans l'ancienne France*. French artists were deeply impressed by this new style of landscape painting, evocative of a foreign civilisation which in their eyes conjured up images of Ossian and Scott.

This romantic vision of the British Isles was consciously nurtured by Charles Nodier who published an account of his journey in 1821 to 'Caledonia' in the *Promenade de Dieppe aux montagnes d'Ecosse* (with illustrations by Thompson and Isabey). While in London he had seen an exhibition at the London Academy in 1822 and wrote that 'in landscapes and seascapes the English are unrivalled in Europe . . . The highest honours of the exhibition must go to a large landscape [*The Hay Wain*] by Constable which can be matched by few

46 **View of the Ruffinella**
Pierre-Athanase Chauvin (Paris, Musée des Arts Décoratifs)

works of either past or contemporary artists.'[34] Nodier concluded that French painters were
still too bound to the historical landscape, seeing everything through the eyes of Rome,
whereas English painters had proved more responsive to the French countryside than the
French themselves. Whether Nodier exerted any direct influence on French art in the
1820s is difficult to prove. It may be no more than coincidence that Louis-Jacques Mandé
Daguerre's *Ruins of Holyrood Chapel* (Salon of 1824) [Fig. 48] shows a remarkable affinity
of mood and atmosphere with the author's novel *Trilby* of 1822, set in a monastery and a
haunted cottage. What is certain, however, is that Nodier voiced the increasing fascination

47 Abbey of St Bertin, St Omer
Richard Parkes Bonington (Nottingham, Castle Museum)

of French artists and writers with English landscape.

Most French critics, however, remained obdurately chauvinistic in their attitude to the English exhibits at the Salon (which included three Constables, five Boningtons and nine Copley Fieldings); indeed, as Constable wrote to his sister of his own works: 'They have caused a great stir; the French critics by profession are very angry at the French artists for admiring them.'[35] It is hardly surprising that the classically trained French critics failed to appreciate the novelty of the *Hay Wain* and condemned it as mannered; they especially disliked its broken, flecked brushwork and lack of structure, as well as its mundane subject. The *Journal du Commerce*, one of the few French newspapers to come out wholly in Constable's favour, perceptively noted: 'great truth of tone and detail, both in the sky and in the background, the amazing transparency of the water, a vigour and honesty of colouring which eclipses all its contemporaries . . .'[36] But the majority, even among the pro-Romantic critics, remained traditionalist in their approach to landscape; Jal's *Artist* for instance, complains that Constable lacks poetry or a sense of style and prefers a *View of Neuilly* by Watelet.[37] Stendhal provides an interesting case of the dilemma in which many forward-looking critics found themselves, unable to accept the classical landscapes of Louis Etienne Watelet and Lancelot Theodore Turpin de Crissé, but unenthused by Constable's flatly unheroic scenes. For while he praised the *Hay Wain* for its truth to nature – '*vrai comme un mirroir*' – he criticised it for its lack of ideal or grandeur, and wrote that Constable would have done better to paint some spectacular scene like the Grande Chartreuse, rather than a stagnant corner of England.[38]

Finally, there is a group of painters including Granet, Forbin, Schnetz, Léopold Robert, Bouton and Daguerre who have been dubbed the '*juste milieu*' by earlier historians. In the

48 **Ruins of Holyrood Chapel**
Louis-Jacques-Mandé Daguerre (Liverpool, Walker Art Gallery)

sense that these painters were the great favourites of their day, popular with all the critics
without exception, the term is not inappropriate. But the term '*juste milieu*' also implies
political allegiances of which these artists were totally innocent. They led independent lives,
working mostly in Italy. Schnetz and Robert, who resemble each other closely in style and
subject-matter, passed briefly through David's studio around 1812 and they became
inseparable friends. The Swiss artist Léopold Robert (1794–1835) was unable to compete
for the Prix de Rome on account of his nationality and went to earn his living in Rome

49 Death of the Brigand mourned by his Mistress
Léopold-Louis Robert, 1824 (London, Wallace Collection)

in 1818. He was joined there by Victor Schnetz (1787-1870) who had studied under Regnault and David, and after about 1820 turned to modern history and Italian rural life. They later met François-Marius Granet (1775-1849) and were deeply impressed by his sombre paintings of convents and Capuchin friars.

Success came to them in hitherto undiscovered subjects – scenes of Neapolitan peasants, festivals and dances; they were quick to exploit the Romantic fascination with outlaws and brigands, many of whom had recently been captured and imprisoned in the Castel Sant' Angelo. At the Salon of 1824 Robert exhibited six paintings, the most prominent of which were the *Neapolitan Fisherman improvising on Ischia* (Neuchâtel, Musée d'Art et d'Histoire), and the *Death of the Brigand mourned by his Mistress* (London, Wallace Collection [Fig.49]). Acclaim for these paintings was almost universal from critics of all tendencies. Jal wrote: 'The essence of this painting is its energy.'[39] Thiers, in the *Revue Européene*, praised the figures in the *Neapolitan Fisherman* as – '*admirables de beauté, d'expression et de pantomime*'.[40] The only slight note of dissension was sounded by Stendhal, who criticised the poses of the Italian fishermen as mannered and affected; he went on, however, to hand out unreserved praise to the *Death of the Brigand mourned by his Mistress*: 'Here is nature, passionate nature, not thinking about good manners.'[41]

Schnetz, who sent ten pictures to the Salon, met the same success as Robert. Stendhal was foremost among his admirers and, perhaps unwisely, risked his critical reputation with the prediction that Schnetz was one of the few French painters who would be remembered in a hundred years' time. Schnetz's *St Genevieve distributing Alms to the Poor* (in a dark

50 **The Fortune Teller predicting the Future to the young Sixtus Quintus**
Jean-Victor Schnetz (Arras, Musée)

corner of the church of Notre-Dame de Bonne Nouvelle in Paris) was widely seen as worthy of the Old Masters the artist so laboriously copied. But his greatest success was undoubtedly the *Fortune-Teller predicting the Future to the young Sixtus Quintus* (Arras, Musée) [Fig. 50], hailed by all as a model of expressive realism. How can we account for the reputation enjoyed in their own day by artists now almost forgotten? The usual explanation is that they appealed to the middle-of-the-road spectator by their combination of high finish and exotic subject-matter. This undoubtedly constituted some of their appeal but they also contained an anecdotal and picturesque element which made them irresistible to writers. Robert's scenes of Italian peasant girls dancing rondellas against the bright blue Bay of Naples provide the exact counterpart to Lamartine's descriptions of similar scenes in *Graziella*. Significantly it was Lamartine – who otherwise wrote little on painting – who paid one of the warmest tributes to Robert and, in 1852, declared: 'Léopold Robert will survive because, like the tender and pious Scheffer who as just died, he is an innovator, an initiator, an inventor of a new type of painting.'[42]

51 Domenichino and the Cardinal Aldobrandini
Engraving after François-Marius Granet
From Landon's *Annales du Musée*, Salon de 1824

Closely related to Schnetz and Robert in theme but not in style, is the painter François-Marius Granet (1775-1849) from Aix en Provence.[43] Like them, he passed through David's studio and with his friend, the comte de Forbin, went to live and work in Italy. From the start of his career as a student in the Cloître des Feuillants, Granet had been drawn to the Dutch rather than the Italian masters and his numerous cloister scenes are characterised by dark Rembrandtesque interiors lit by sudden shafts of light [Fig 52]. Granet was also a recognisable product of Romantic historicism in his love of idealising episodes from the past lives of artists.[44] One typical specimen of this genre is the work he exhibited at the Salon of 1824, *Domenichino and Cardinal Aldobrandini* [Fig. 51] showing the painter come to seek the cardinal's protection from the persecution of his rivals in Naples. In his *Memoirs*, Granet relates that he had always admired Domenichino who had been neglected because of the simplicity of his character and his art. But this type of small-scale history painting

52 **A young novice from Albano in the choir of the convent of
St. Clare in Rome**
François-Marius Granet (Paris, Louvre)

found less favour than Granet's standard monks and cloisters. The French public expected every artist to have one speciality and stick to it, wary of any work which escaped the confines of a particular genre. They also failed to appreciate the novelty of Granet's technique. Jal's *Artist* and Stendhal complained that the artist's heads and bodies were too sketchy. Delécluze, on the other hand, often more tolerant in practice than in theory, called it simply '*un charmant ouvrage*'.[45] As in their attitude to English artists, most of the French critics demanded a ready-made, finished product and rarely called on the spectator to participate in the creative process.

This brief survey of the main exhibits at the Salon of 1824, and the critics' reactions to them, is enough to show that artists of the 'Romantic' tendency, though very much in evidence, had by no means won an outright victory over their rivals. This was due partly to the persistence of the old classical academic tradition, deriving its authority from the recent and all-powerful example of David, which obstinately refused to yield to the younger generation; partly to the lack of a clear definition of the term 'Romanticism' and how this could be applied to the visual arts. Even in the minds of sympathetic critics like Augustin Jal there remained a lingering suspicion that the notion of Romanticism could not easily be translated into pictorial terms ('*La révolution romantique ne peut aller aussi loin en peinture qu'en littérature . . .*'),[46] since it invariably came up against the fundamental obstacle, the human figure which in turn demanded 'correct' draughtsmanship, the prerogative of academic teaching. Thus the Romantic movement, disunited and self-contradictory, never succeeded in creating its own distinctive style, as the Classic painters had done in the seventeenth century. Delacroix, though closely associated with the movement at its outset, was too much of an individual to be classified as the leader of any group, indeed he always dissociated himself from any collectivist tendencies and had no sympathy with the theoretical aims of the Romantics.

The sequel to 1824, the equally significant Salon of 1827, confirmed this state of affairs. The battle raged as furiously as ever between the critics. The Romantics were represented by many spectacular paintings, including Delacroix's *Sardanapalus*, Boulanger's *Mazeppa*, E. Devéria's *Birth of Henri IV*, Delaroche's *Death of President Duranti* and *Death of Queen Elizabeth*, Scheffer's *Femmes Souliotes* and Sigalon's *Athalie*. They seemed, on the face of it, to have won the day; 'On all sides, classicism is fighting against extinction, it is the Ancien Régime of the fine arts,'[47] wrote Jal, confident that the old guard had been routed. But the Classics, embodied in such a work of static monumentality as Ingres' *Apotheosis of Homer*, proved a formidable enemy; though temporarily eclipsed, they remained a permanent force in French art and even returned with renewed vigour after around 1840.

By 1831 it was clear that much of the steam had gone out of the Romantic movement. In the Salon of that year the main exhibit, Léopold Robert's *Harvesters in the Pontine Marshes* [Fig. 85], drew enormous crowds and was hailed by the critics as a worthy successor to Giorgione, Poussin and Raphael.[48] The huge success of a neutral work like this, combining Davidian-style figure drawing with exotic picturesque subject-matter, shows clearly that by then the battle of Romanticism was over. The storm had subsided and critics lost interest in the old polemics. Delaroche and Ary Scheffer, finally cured of their earlier Romantic tendencies, were offering the public more reassuring works, with historical and religious themes more acceptable to polite society. Meanwhile the foundation of the Galerie Louis-Philippe at Versailles put the energies of many artists to good use, including Horace Vernet, Schnetz and Steuben, keeping them busy for nearly a decade celebrating the glories of the French national past in large and, mostly, uninspired canvases. The 1830s, the aftermath of the Romantic battle, was a period of mediocrity and reconciliation, in which old enemies like Delécluze and Delacroix concluded a truce.

The Salon of 1824 was, therefore, inconclusive in that it failed to produce a definitive change in the course of French art, least of all a specifically Romantic style. But the critical debate to which it gave rise had some lasting consequences, as significant as some of the literary theory already discussed; indeed much of the literary and art-criticism is almost interchangeable in the application of its ideas. For, as some of the more lucid critics clearly recognised, Romanticism was not merely a terminology or a label, nor even a debate on the relative merits of colour or draughtsmanship, but a statement of the right of the arts to evolve freely, without the constraint of accepted taste or authority. This idea became a permanent acquisition in French aesthetic theory and it was never again seriously contested. Starting from the notion of historical relativity, the more intelligent critics like Stendhal, Thiers and Arnold Scheffer believed that art and society were in a constant state of flux and change. Concluding his review of the Salon of 1827, Scheffer predicted that today's Romanticism, so ardently defended by young *avant-garde* critics, would be tomorrow's Classicism and become in its turn the butt of a new generation.[49] Seen from this viewpoint, Classicism and Romanticism emerge not as polar opposites, but as different aspects of a cyclical historical process.

CHAPTER V

THE INFLUENCE OF LITERATURE ON FRENCH PAINTING 1800-40[1]

TAKING A RETROSPECTIVE LOOK at the more colourful aspects of the French Romantic movement, Théophile Gautier wrote of the cheerful sense of brotherhood, linking artists and writers in a single united movement: '*En ce temps-là la peinture et la poésie fraternisaient. Les artistes lisaient les poètes et les poètes visitaient les artistes. On trouvait Shakespeare, Dante, Goethe, Byron et Scott dans l'atelier comme dans le cabinet d'étude.*'[2] ('At that time, poetry and painting formed a brotherhood. Artists read poetry and poets frequented artists. Shakespeare, Dante, Goethe, Byron and Scott were to be found as much in the studio as in the study.') Though naïve and simplistic in some respects, Gautier clearly perceived the remarkable intimacy which existed between French artists and writers during the first decades of the nineteenth century. Never before had writers been so closely aware of developments in the visual arts, and rarely had painters helped themselves so freely to themes from literature. In their search for novel subject-matter artists devoured authors from the classics, the Italian Renaissance, the French seventeenth century to Shakespeare, Milton, Ossian and, most of all, their own contemporaries Goethe, Byron, Scott, Chateaubriand, Lamartine and Victor Hugo. All these writers provided painters with an inexhaustible range of new and exciting subjects – passion, murder, heroism and historical pageantry, culled from every imaginable period and country. French painting was invaded by scenes from *Macbeth*, *Götz von Berlichingen* [Fig. 55], *Faust* [Fig. 54], *The Giaour*, *The Prisoner of Chillon*, *Ivanhoe* [Fig. 72, Fig. 74 and Fig. 77], *Quentin Durward* [Fig. 73 & Fig. 78], *The Two Foscari*, *Marino Faliero, Doge of Venice*, to name only a few of the favourite literary subjects at the climax of the Romantic movement. Whether this literary influence was a salutary one or not depended on the critic's personal viewpoint. Some welcomed it, but many deplored it, like Eugène Fromentin, writing later in his celebrated book on Dutch art, *Les Maîtres d'Autrefois* (1876), who believed that the subject – 'dramatic, pathetic, romantic, historical or sentimental' – contributed as much to the success of a nineteenth-century painting as the artist's own talent.

It is, of course, true that long before the nineteenth-century painters were well versed in the main literary and philosophical trends of their times and were actively encouraged to express these in their work. In the Middle Ages and the Renaissance especially, artists usually shared in the dominant philosophical outlook of the age. Later in the seventeenth century an artist like Poussin, the 'painter-philosopher', deliberately set out to illustrate abstract literary ideas and nearly all his paintings embody some moral truth which might

53 **Marguerite à L'Eglise (From** Faust I)
Engraving by Alphonse François, after Ary Scheffer

equally be expressed in words. But this is far from the close, almost incestuous, relationship which linked painting and literature in the nineteenth century. This new union began almost certainly in the late eighteenth century when writers like Diderot (whose famous *Salons* appeared between 1759 and 1781) began to take an unusually close critical look at the art of their own times and to publish their verdict in the form of journalism. Diderot was on close terms with many contemporary artists, including Chardin and Claude-Joseph Vernet, and with the help of his hostess Madame Geoffrin, used his verbal powers to make – or break – their reputations. This development clearly led to a new social intimacy between artists and writers, but it also made for friction and resentment on both sides. Writers, who had long enjoyed a privileged social position over painters, tended to look down on artists as ignorant artisans and craftsmen, with narrow minds devoid of culture. Artists, on the other hand, resented the interference of writers and accused them of lack of technical competence to pronounce judgement on the visual arts.

This state of affairs continued in intensified form into the nineteenth century, exemplified in the circle of artists and writers, the Cénacle, centred on Victor Hugo, and

in the work and writings of Eugène Delacroix. The feeling of unity and fellowship between artists and writers around 1830 was expressed by the leading nineteenth-century critic Sainte-Beuve: '*Les peintres novateurs étaient nos frères*'. ('The avant-garde painters were our brothers'.)[3] Yet the old feeling of antagonism and rivalry persisted. At the height of the Romantic movement, literature had gained a clear ascendancy over painting, both in terms of chronological priority and in its dominant influence. French painting in the early nineteenth century follows closely in the footsteps of literature, but rarely takes the initiative. This is precisely what painters most feared, particularly articulate ones such as Delacroix who clearly foresaw the danger in the domination of painting by literature. Well aware of the pitfall of 'literary' painting and constantly on his guard against using his art as mere illustration, Delacroix fought strenuously to emancipate painting from these dangers. And yet – and this is the paradox of Delacroix and his generation – no artist ever made a more generous use of literary subjects, ranging from Shakespeare to Byron and Scott. Delacroix's problem was how to be a literate but not 'literary' artist, with the taint which that word implied; how to rival the writer, but on his own pictorial terms.

The question was further complicated by the traditional confusion of painting and literature originating in classical times, according to which the two arts were more or less interchangeable, differing only in their means but not in their essential content. Thus, painting was seen as a kind of silent poetry, and poetry a form of painting in words. This confusion gave rise in the eighteenth century to a spate of descriptive poetry like Thomson's *Seasons* and Klopstock's *Odes*, intended to convey a sequence of pictures in words but which tire the reader's patience by their profusion of adjectives and verbose descriptive passages. The result was clearly an abuse of the literary medium, for all narrative interest was sacrificed to word painting. Lessing's *Laöcoon* (1766) was an attempt to redraw the natural barriers between the two arts, and to confine literature to the depiction of objects in time (i.e. action and narrative) and painting to objects in space. Closely following the German critic's ideas, Madame de Staël repeated Lessing's plea for the two arts to respect the natural limits imposed by the medium, urging painters to confine themselves to colour and form instead, as Poussin did, of trying to ape philosophy: 'The arts are superior to thought; their language is colour, form or sound.'[4] But this advice was blindly ignored by the majority of early nineteenth-century artists and writers. The interaction between painting and literature went unchecked; in fact it became a crucial factor in the evolution of Romantic art, resulting in blurred horizons, disorder and a proliferation of minor artists all too happy to exploit the themes invented by others, but also giving the movement creative vitality and infinite variety. In the hands of Chateaubriand and Victor Hugo, pictorial effects in literature were carried still further in a

conscious attempt to rival the full range of the painter's palette, including the most strident colours and bizarre shapes. From around 1800 onwards, literature and painting in France share a common repertory of themes and imagery – moonlit ruined castles, stormy seas, knights in armour and pale, ashen maidens in distress or on the verge of suicide – straying from the page onto canvas, and from the canvas back to the page. These subjects were nearly always the invention of writers, for the Romantic movement in France was primarily a literary phenomenon. Painters only followed suit after some delay, restrained perhaps by the strength of the French classical tradition and their own native conservatism.

The new range of authors who provided subject-matter for French painters was immense. Novels and lyric poetry were more widely read in the nineteenth century than ever before. With the impetus given to foreign literature by Madame de Staël's comparative studies in *De La Littérature* and *De L'Allemagne*, backed up by a spate of translations, new horizons were suddenly opened up, taking in the whole of European civilisation. The classics, Homer, Virgil and Plutarch especially, had long been honoured by French artists. Despite the hostile attitude of many artists and pro-Romantic critics of the 1820 generation who abandoned them for the more fashionable Middle Ages, and authors such as Byron and Walter Scott, they never disappeared from the repertory entirely, but were temporarily relegated to second place.

54 Faust and Mephistopheles
Eugène Delacroix
(London, Wallace Collection)

55 Götz von Berlichingen
Eugène Delacroix
(Paris, Louvre, Cabinet des Dessins)

For a long time the classical authors found a staunch champion in the arch-conservative Ingres, whose *Apotheosis of Homer* (Salon of 1827) [Fig. 56], showing Homer crowned with laurels in the centre, flanked by Raphael, Phidias, Poussin and the great figures of French seventeenth-century literature, Racine, Fénelon, Boileau and La Fontaine, was deliberately conceived as an affirmation of faith in the classical tradition of order and hierarchy, and a rejection of what Ingres regarded as Romantic chaos. But this triumphant presentation of Homer was not the most common view of the poet in early nineteenth-century art. Many artists, including David, Guillaume Lethière and Baron Gérard, fixed on Homer, the blind poet reciting his epics in old age, as the prototype of suffering genius, exiled and spurned by his own contemporaries.[5] Though not based on the strict facts of the poet's life, this interpretation of Homer gained strong adherence among

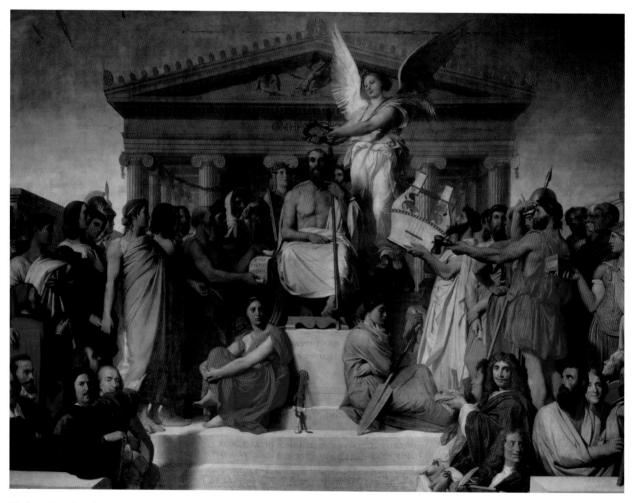

56 Apotheosis of Homer
Jean-Auguste Dominique Ingres (Paris, Louvre)

many artists and writers of the period from 1800-20, who readily seized on any theme suggestive of suffering and misfortune. Two of the greatest poets of the age, Lamartine and Vigny, lent their voices in support of this view. In 1817, in the poem *La Gloire* Lamartine paid tribute to Homer: '*Aveugle, il mendiait au prix de son génie un pain mouillé de pleurs.*' ('Blind, he begged a piece of bread soaked in tears as the price of his genius.')[6]

Again in a long passage in the *Chant du Pèlerinage d'Harold*, Lamartine made Homer into a symbol of the poet's destiny, condemned to pay for his genius with insults and oblivion.[7] There is a touching reminder of the poet's deep love of Homer in his château of Saint-Point where, above a chimney-piece, his wife painted roundels inspired by Ingres' *Apotheosis of Homer*, with Homer in the centre, Shakespeare on the left and Dante on the right.[8] Finally, Alfred de Vigny, in whose writings the sufferings of artists, writers and soldiers recur like a plaintive theme, allotted a central place to Ingres' *Apotheosis of Homer* in *Stello*. In this curious novel devoted to the outcasts of modern society, the doctor takes the philosopher on a visit to the Musée Charles X (the Louvre) in order to honour '*ce vieux pauvre assis sur un trône d'or avec son bâton de mendiant et aveugle comme un sceptre entre ses jambes, ses pieds fatigués*'.[9] ('This poor old foot-weary man seated on a golden throne with his blind beggar's staff for all the world like a sceptre between his knees.')

Dante was far the most important poet of late mediaeval, or early modern, times depending on our terminology, to capture the imagination of the Romantic generation.[10] For nearly all eighteenth-century writers, and especially Voltaire, Dante was classified with Shakespeare as a barbarian, a creator of grotesque and aborted creatures which had no place in the Temple of Taste. The first writer to show a change of attitude was Madame de Staël, first in *De La Littérature* where Dante is praised for his 'energy which has nothing in common with the literature of his time',[11] but damned in the second half of the sentence for his 'countless defects'; then, with far more conviction, in Corinne's first improvisation on the Capitol, when the heroine hails her fellow-poet in the following accolade: '*Le Dante, l'Homère des temps modernes, poète sacré de nos mystères religieux, héros de la pensée, plongea son génie dans le Styx, pour aborder à l'enfer; et son âme fut profonde comme les abîmes qu'il a décrits.*'[12] ('Dante, the Homer of modern times, the sacred poet of our religious mysteries, the hero of thought, plunged his genius into the Styx to approach hell; his soul was as deep as the chasms he has described.')

Thus Dante came to be admired in the nineteenth century for the same qualities which earned him the contempt of the eighteenth: a sombre fertile imagination, a profound concern with the anguish and suffering of humanity and the great mystery of life and death and, above all, an innate pictorial sense which enabled him to stamp indelible images on

57 **Paolo and Francesca**
Ary Scheffer (London, Wallace Collection)

the reader's mind. The vast but easily assimilated world of *The Divine Comedy* exerted a powerful hold over the imagination of French artists, beginning with David's *Death of Ugolino* of 1786 through Ingres' *Paolo and Francesca* (1819), reaching its climax with Delacroix's *Dante and Virgil crossing the Styx* at the Salon of 1822 and ending in the 1830s and 1840s with Ary Scheffer's versions of the story of *Paolo and Francesca* [Fig. 57] and *Dante and Beatrice* of 1846.[13]

Delacroix had a lifelong obsession with Dante, and with Michelangelo, both of whom were closely associated in his mind. The profound affinity between Dante and Michelangelo was clearly perceived in 1817 by Stendhal, who asserted: 'The proud genius of these two men is absolutely identical. If Michelangelo had written a poem, he would be created Count Ugolino, and if Dante had been a sculptor he would have created Moses.

Like Dante, Michelangelo does not merely give pleasure; he threatens us, crushes the imagination beneath the weight of suffering, and leaves us without enough strength to feel courage, so totally are we filled with a sense of catastrophe.'[14] Stendhal went on to predict that 'the thirst for energy will bring us back to Michelangelo's masterpieces', thereby making an accurate prediction of the great Michelangesque revival in early nineteenth-century French art, beginning with Géricault's *Raft of the 'Medusa'* of 1819 and Delacroix's *Dante and Virgil* of 1822. In these works the turbulent passions of the early Romantic movement found their first true expression in painting. With its contorted, writhing figures in the foreground and a dark backcloth relieved only by the flaming city walls and the red and green of Dante's clothes, Delacroix's *Dante and Virgil crossing the Styx* creates the most powerful image of despair [Fig. 58]; the shades of the damned cling desperately to the boat, while the poets make their perilous journey across the river into the nether regions of the Inferno.

58 **Dante and Virgil crossing the Styx**
Eugène Delacroix (Paris, Louvre)

The invasion of French territory by the literature of foreign countries, especially of England, was one of the most striking characteristics of Romanticism. English literature, above all Ossian, Shakespeare, Byron and Scott, opened up an entire new repertory of themes, emotion and imagery to French artists, long weary of the gods and goddesses of their imported classical culture. In place of the Mediterranean world of antiquity they discovered a new realm of strange exotic Northern landscapes, mountains and lakes cloaked in mist, ruined Gothic castles, pale sensitive heroines and brooding melancholy heroes. They also encountered deep passions and violent action which had long been banished from the French stage. This new cult of England and everything English, from manners and dress to art and letters, began in the first decade of the nineteenth century and reached its peak in the 1820s. Delacroix's conscious adoption of the style of the English dandy set a pattern which artists and writers including Musset and Baudelaire were to imitate until the middle of the century and beyond.

The initial impetus for this cultural exchange came with the end of hostilities between the two countries when the Peace of Amiens was signed in 1802. As the memory of the Napoleonic wars faded, English artists such as John Sell Cotman and Bonington came over to France in search of new scenic and pictorial effects. Richard Parkes Bonington (1802-28), the friend of Delacroix and Gros, was trained in France and it was during this stay that he painted the superb view of the *Abbey of St Bertin, St Omer* (Castle Museum, Nottingham) [Fig. 47]. Artists were drawn to France partly out of archaeological curiosity, reinforced by the new nineteenth-century taste for Gothic architecture (preferably in a ruinous and picturesque condition), but mainly by the country's unique light, limpid skies and chalky cliffs which provided ready-made subjects for a painter like Bonington. The French, for their part, were initially still too humiliated by the defeat of Waterloo to wish to visit England, the 'perfidious Albion'. Soon, however, curiosity overcame chauvinism and a handful of French travellers began to trickle over to England, to seek out the largely mythical land which their imagination had constructed with the help of Ossian's poetry and early novels of Walter Scott.

One of these early travellers was Charles Nodier (1780-1844), novelist, bibliophile, scholar, antiquarian and leader of the '*groupe de l'Arsenal*', of which he was librarian.[15] Nodier was one of the first writers to take a serious interest in the historic buildings of France, and in 1824 in collaboration with Baron Taylor, helped to produce the *Voyages pittoresques et romantiques dans l'ancienne France*, illustrated by E. Isabey, in which he made an eloquent plea for the preservation of mediaeval monuments. The following year, in 1821, Nodier set out from Dieppe on a pilgrimage for the land of Ossian and Scott and wrote a delightful account of his travels in his *Promenade de Dieppe aux montagnes d'Ecosse*,

illustrated by Thomson and Isabey. In London, he visited St Paul's Cathedral and Westminster Abbey, where he allowed his imagination to roam freely in the dark mystery of the latter's mediaeval vaults. In the city's museums and art galleries he was favourably impressed by the portrait busts by Chantrey, the most fashionable sculptor of the day. What struck him most, however, was the English landscape painting of Constable and Turner, which had no rivals in France or the rest of Europe; recognising the superiority of the English school, Nodier observed that most French artists were still too inhibited by their classical background and natural preference for Rome to be capable of that kind of spontaneity. The goal of his pilgrimage, however, was not England but Scotland, the romantic 'Caledonia' of Ossian and Scott which was to exert such a strong fascination over the imaginations of many nineteenth-century artists and travellers.

The rise and fall of the pseudo-Gaelic bard Ossian is the story of the greatest literary hoax of all time – a hoax which nonetheless deceived some of the greatest minds of the day, including Goethe, Lamartine and Madame de Staël, and inspired artists like Gérard, Girodet and Ingres to produce some of their most significant works.[16] The Ossianic poems were originally thought to be a specimen of primitive Celtic literature dating from the third century A.D. which had been transmitted orally to the present day. Taking the form of a saga told by the sole survivor of an ancient Celtic tribe, Ossian, they relate the warlike exploits of his father, Fingal, king of Morven and the various disasters which befell the tribe through war and bereavement. Ossian himself is a blind and aged bard – a latter-day Homer – accompanied only by Malvina, the wife or mistress of his son Oscar who died in battle. The mood of the poems is one of unrelieved melancholy and endless misfortunes; fathers who accidentally kill their sons in battle, young girls who die of grief when their brothers and lovers kill each other. This universal sense of loss and destruction is reinforced by the poem's setting in the Scottish Highlands of stunted trees, desolate heaths and crags shrouded in mist.

The poems first appeared in June 1760 as an anonymous volume entitled *Fragments of Ancient Poetry*, collected in the Highlands of Scotland, and translated from the Gaelic or Erse language, published in Edinburgh. Two more editions rapidly followed the success of the first and a complete edition, *The Works of Ossian,* appeared in 1765. The 'author' or translator of the poems, as he was described in the second edition, was James Macpherson (1736-96), an obscure Scottish schoolmaster who claimed to have gathered the poems from oral tradition. It soon became clear, however, that the Ossianic poems were largely his own fabrication. Dr Johnson was among the first to doubt the authenticity of the poetry and finally, after years of research, the Highlands Society published a report in 1805 which could find no positive evidence in support of Macpherson's claims. But the facts did not

59 **The final scene from** René
Franz Catel (Copenhagen, Thorwaldsen Museum)

deter Ossian's readers: in fact the poetry continued to enjoy an enormous vogue through-out Europe long after the forgery had been exposed. The Northern countries, Germany and Scandinavia especially, felt a particular affinity with the typical Ossianic landscape and its all-pervasive melancholy. *Ossian* first appeared in France in 1777 in a translation by Letourneur (who had also produced translations of Shakespeare and Young's *Nights*, among others), re-edited many times. It was this edition of *Ossian* which Napoleon carried in his pocket on his military campaigns, and it was largely Napoleon's own passion for Ossian, the 'Homer of the North', which established the bard's reputation in France. The subject-matter of Ossian's poems coincided neatly with the propagandist aims of the Napoleonic

régime, for they contain many allusions to the events of the *Odyssey* and the *Iliad* and consistently glorify the martial virtues. For this reason the most important Ossianic paintings were commissioned by Napoleon.

Ossian was, in fact, exactly what the reading public of Europe had unconsciously been waiting for. Already well prepared by the *Weltschmerz* of Goethe's *Werther* (1774) and the sentimental effusions of Rousseau's *La Nouvelle Héloïse* (1761), Ossian's poetry offered an accurate reflection of the mood and feelings of the times. It was, in a sense, only a variant on the *mal du siècle* epitomised in the writings of Chateaubriand and in the tormented soul of his hero René: 'Arise, o longed-for tempests' [Fig. 59]. Much of Chateaubriand's descriptive writing is profoundly

60 **Apotheosis of the French heroes who died for their country**
Anne-Louis Girodet de Roussy-Trioson (Château de Malmaison)

influenced by Ossian. Both share the same preference for wild remote scenery and a more than accidental resemblance of Ossian's Scottish highlands to the Breton coastline evoked in the *Mémoires d'-Outre-tombe*. Echoes from Ossian can be found throughout the literature of early nineteenth-century France. Lamartine spoke for many adolescents of his own age when he described how a volume of Ossian's poetry became the silent companion of his love for a girl in his native Burgundy: '*C'était le moment où Ossian, le poëte de ce génie des ruines et des batailles, régnait sur l'imagination de la France. Baour-Lormian le traduisait en vers sonores pour les camps de l'empereur. Les femmes le chantaient en romances plaintives ou en farfares triomphales au départ, sur la tombe ou au retour de leurs amants. De petites éditions en volumes portatifs se glissaient dans toutes les bibliothèques. Il m'en tomba une sous la main. Je m'abîmai dans cet océan d'ombres, de sang, de larmes, de fantômes, d'écume, de neige, de brumes, de frimas, et d'images dont l'immensité, le demi-jour et la tristesse correspondaient si bien à*

61 **The Dream of Ossian**
Jean–Auguste Dominique Ingres (Montauban, Musée Ingres)

la mélancolie grandiose d'une âme de seize ans qui ouvre ses premiers rayons sur l'infini. Ossian, ses sites et ses images correspondaient merveilleusement aussi à la nature du pays des montagnes presque écossaises, à la saison de l'année et à la mélancolie des sites où je le lisais.[17] ('It was the moment when Ossian, the poet of ruins and battles, reigned supreme in France's imagination. Baour-Lormian translated it into sonorous verse for the emperor's armies. Women sang it in doleful ballads or as triumphal fanfares when their lovers departed, or returned, or on their tombs. Small portable editions slipped into libraries. One fell into my hands. I sank into this sea of shadows, blood, tears, ghosts, foam, snow, mist, hoar-frosts, and images whose hugeness, twilight and sorrow struck such a chord with the overwhelming melancholy of the soul of a sixteen-year-old which was beginning to perceive infinity. The scenery and imagery of Ossian were also marvellously similar to the almost Scottish mountainous landscape, to the time of the year, and the melancholy of the places where I read it.') The young poet imagined himself one of Ossian's heroes, in love and reciting a plaintive song on the harp to his beloved against the background of Fingal's ancestral mansion.

These were the key elements of the imagery which was to exert such a potent influence over a whole generation of writers and artists. Ossian needed no historical substance to suggest a particular mood and atmosphere, an ill-defined compound of transient emotions and pale, vapid colours. These, precisely, were the colours of Lamartine's early poetry.[18] The most decisive literary formulation of the reasons for Ossian's success in France came, however, from Madame de Staël, who put the matter into a wider philosophical perspective: 'The turmoil into which the Ossianic songs plunge the imagination dispose the mind to the deepest meditations. Melancholy poetry is most in harmony with philosophy, as sorrow more than any other feeling penetrates deeper into man's character and destiny.'[19] Madame de Staël saw Ossian as the epitome of the Northern imagination, the Homer of the North who responded to the spiritual needs of a world-weary generation. Her inclusion in *Corinne* of the Ossianic picture by George Augustus Wallis, *Comalla asleep on his Father's Tomb*, is a measure of the importance of Madame de Staël attached to the poet.

Apart from literary and philosophical factors, the cult of Ossian also coincided with the artistic movement in France known as Primitivism. This new trend originated among a group of pupils in David's studio, led by Maurice Quai (c. 1779-1804) and supported by his friend Nodier, who wore long beards and called themselves the 'Barbus'. They were essentially conservative Catholic rebels who, dissatisfied with David's own search for Greek purity in *The Sabine Women*, looked back to Etruscan art in their desire to purge painting of all later stylistic accretions and to revitalise it in contact with the earliest sources. This

62 **Malvina mourning the death of Oscar**
Elisabeth Harvey (Paris, Musée des Arts Décoratifs)

quest for the primitive, or what has been called the 'tabula rasa',[20] was only another aspect of the phenomenon which manifested itself in England in the art of William Blake and John Flaxman. All these artists demanded a radical reform of current artistic traditions and practice, and regarded Ossian as the authentic voice of a primitive civilisation. The following words are attributed to Maurice Quai in Delécluze's biography of David, almost the only documentary source for this obscure episode in early nineteenth-century art: 'As for the thoughts with which we reformers must continually occupy our spirits and hearts, no source can be too primitive for us to draw on. It is in Homer, then Ossian, but above all in the Bible;

it is in scenes and descriptions of primitive peoples, in whose midst those books were written, that we shall discover how to regenerate our souls and our spirits.'[21]

Paintings with Ossianic subjects fall largely into the period from 1800 to 1820, but after 1824 they decline sharply in favour of the more fashionable Romantic authors. The Napoleonic vogue for Ossian was firmly launched in 1800, when the Emperor commissioned the architect Fontaine to decorate his château, Malmaison, on the outskirts of Paris. Part of this scheme included medallions of celebrated writers and philosophers including Ossian in the library by Roench. The same year saw the appearance at the Salon of Paul Duqueylar's *Ossian singing his poetry* (Aix-en-Provence, Musée Granet), a frigid composition showing Oscar as Apollo. Duqueylar (1771-1845) was an obscure Provençal in David's studio, and the Neo-Classical lineage of his painting is all too apparent. He manifestly failed to solve the problem facing the artists of this generation, namely how to square their classical training with a Northern mythological subject. A work by François Gérard entitled *Ossian summoning up Ghosts on the Banks of the Lara* (Berlin), finished in 1801, went much further in the direction of early Romanticism. The painting, commissioned by Napoleon for Malmaison, was to have been the last in a series of four illustrating the lives of Moses, Homer, Ariosto and Ossian, corresponding to Madame de Staël's division of literature into the Classical Mediterranean and the Romantic North. Showing Ossian summoning up all his warriors and lovers in his imagination, with a swiftly flowing stream in the centre and the ruined castle of Selma in the background, Gérard has attempted to summarise the entire Ossianic mythology rather than depict a single episode.

This synthetic approach was also adopted by Girodet, but on a far more ambitious scale. The vast size of his canvas is nearly matched by the length of its title, which fully explains its subject: '*The ghosts of French heroes who died for their fatherland, led thither by Victory, come in their spectral garb to visit the shadows of Ossian and his warriors, who feast them in friendship*' [Fig. 60]. In this painting, another commission for Malmaison, Girodet was determined to outdo his rivals in the complexity of his iconography, designed both to glorify the Emperor's generals and to flatter Napoleon's private cult of Ossian. When it first appeared at the Salon of 1802 the work so baffled the general public that Girodet was forced to explain its meaning in an open letter to Napoleon dated 6 Messidor, An X. The French generals on the right, he stated, were those who had served on the Egyptian campaign, surmounted by an allegorical figure bearing a hen, being welcomed by the warriors of Morven on the left into the sojourn of peace; the eagle, emblem of the Austrian armies, was an allusion to the Peace of Lunéville signed in 1801.[22]

The interest of the painting today, however, lies less in its elaborate allegory and its propagandist intention than in its daring attempt to fuse the Nordic literary myth with modern history. The result is a strange blend of realism and fantasy. It was the unreal quality of the picture which many of the artist's contemporaries, including Delécluze and David, found so disconcerting. Girodet, however, firmly defended his right to exercise his imagination freely in his art, and in a significant letter to Bernardin de Saint-Pierre, made an explicit parallel between painting and literature which in retrospect can be seen as a key statement in the evolution of Romantic theory: 'Novels are never banished from literature; nor are fictions excluded from poetry; why therefore should they be from painting?'[23] Ingres' *The Dream of Ossian* of 1812 [Fig. 61] was the third important painting inspired by Ossian, and radically different from the other two. Commissioned to decorate Napoleon's bedroom in the imperial palace of Monte Cavallo in Rome, it was originally a square painting but was considerably altered in 1835 and left unfinished. The work is a record of Ingres' own passion for Ossian, which began in his early years in David's studio and lasted for his entire life. The artist's notebooks show that, as with other writers who preoccupied his thoughts, he had meditated deeply on the subject of Ossian. In brief verbal jottings, Ingres selected some leitmotivs from the poems: 'Snow, heaths, deaths from great heights, the lone pine, dark forest, the mastiff's bark, the eagle's screech, the torrent's roar, the noise and glimmer of the tempest.'[24]

The painting is clearly derived from Gérard's composition, but marks a definite step backwards towards the linear primitivism of Blake and Flaxman. Ossian himself is shown slumped in pyramidal form over his harp, dreaming of his son Oscar, Fingal, Malvina and the rest of the tribe. The deliberate superimposition of two realms, the terrestrial and the

63 **Don Juan and Haidée**
Engraving by Étienne Achille Reveil after Alexandre-Marie Colin

supernatural, the irrational perspective and the harsh sculptural quality of the figures, make *The Dream of Ossian* one of Ingres' most bizarre paintings, a cold static monument to the myth which inspired it.

From 1800 to 1820 several other French artists, as well as ones from England, Germany and Scandinavia, tackled themes from Ossian, among them Jean-Augustin Franquelin's *Death of Malvina* (1819) (Fontainebleau, Chateau) and the comte de Forbin's *Vision of Ossian* (Salon of 1808). Of the lesser-known works inspired by Ossian, Elisabeth Harvey's *Malvina mourning the death of Oscar* (Paris, Musée des Arts Décoratifs) [Fig. 62], shown at the Salon of 1806,[25] is pitched

64 **Lord Byron and Countess Guccioli**
Engraving after Achille Devéria

in a minor lyrical key but, unlike the paintings of Girodet and Ingres, makes no attempt to raise Ossian to the status of a full-scale modern myth. The problem which confronted all these artists, which none of them entirely solved, was how to dissolve solid forms into figments of the imagination. Confronted with this Northern mythology, French artists never managed to free themselves from their classical training and, despite the winged helmets, shields, harps and other Ossianic trappings, forms modelled on the primacy of classical sculpture constantly reappear through the Nordic disguise. Paintings from *Ossian* correspond to a transitional phase in early nineteenth-century French art, between late Neo-Classicism and early Romanticism. It was only around 1820, when the artistic hegemony imposed by David on his pupils began to weaken, that French artists felt sufficiently liberated to adapt their style to new literary influences and to make a pictorial contribution to the Romantic movement.

The next phase in the evolution of Romanticism was marked by the penetration of French consciousness by the life and writings of Lord Byron.[26] Byron was one of the few writers to become a legend in his own lifetime. It was undoubtedly the satanic aura attached to the poet's name, his reputation as the aristocratic rebel who dared defy the conventions of polite society, which caught the imagination of the French before they had read a single word of his poetry. They were fatally attracted to his legendary personality, a mixture of the callous Don Juan, blasphemer and iconoclast on the one hand, and idealistic champion of freedom on the other. This is how Byron appeared to Lamartine in his poem *L'Homme:*

Toi, dont le monde encore ignore le vrai nom,
Esprit mystérieux, mortel, ange ou démon,
Qui que tu sois, Byron, bon ou fatal génie,
J'aime de tes concerts la sauvage harmonie
 (*Méditations*)

('Thou, whose true name is still unknown to the world, mysterious spirit, mortal, angel or demon, whoever thou may be, Byron, good or fatal genius, I love thy concerts' savage harmony.')

The Byronic hero, brooding, sensitive and concealing his tormented soul behind a mask of cold disdain, created a new prototype for the Romantic generation. Henceforth a passionate individualism became the order of the day. The pessimism and gloom of Ossian gave way to an open invitation to rebel against the tyranny of opinion and to reject outworn social and artistic conventions. Byron's appearance in France came at the precise moment when a new, more militant brand of Romanticism began to assert itself against the old-fashioned Catholic royalist school typified by *La Muse Française*. While the old guard feared, justifiably, that Byron's influence threatened to unleash uncontrollable demonic forces, younger writers like Stendhal recognised Byron as a fellow rebel and potential source of liberation from the dead weight of tradition.

In a more specific sense, Byron was one of the chief instigators of the Romantic philhellenism which swept France during the 1820s. From his first pilgrimage to Greece in 1809-11 until his legendary death at Missolonghi in 1824, Byron was universally known as the champion of Greek freedom against Turkish repression. His direct participation in the War of Independence, showing that he was not merely a poet but a man of action, further enhanced the romantic aura surrounding his name. In *Childe Harold's Pilgrimage* (published in 1812) [Fig. 65], a largely autobiographical account of the poet's world-weary meanderings through Europe, Byron painted a new and poignant image of modern Greece, its people, ancient monuments and landscape:

65 **Childe Harold and Inès de Castro**
Engraving by Aubry Lecomte after François-Louis Dejuinne

And yet how lovely in thine age of woe,

Land of lost gods and godlike men, art thou!

Thy vales of evergreen, thy hills of snow,

Proclaim thee Nature's varied favourite now:

Thy fanes, thy temples to thy surface bow,

Commingling slowly with heroic earth,

Broke by the share of every rustic plough.

(Canto II, LXXXV)

This was not the Greece of the classical antiquarian, but the country of the nineteenth-century traveller in search of new images to stir his jaded senses. Greece was also for Byron the setting for actions of fanatical courage and heroism. The kind of ferocious energy depicted in his epic poems of oriental background, like *The Corsair, The Giaour, The Bride of Abydos* and parts of *Don Juan* [Fig. 66] and *Childe Harold*, provided French painters – notably Delacroix – with a wide range of new subject-matter, of languorous sultanas indolently reposing in the harem while outside fierce janissaries wielding their *yataghans* are interlocked in mortal combat. Thanks largely to Byron, the drama and exotic colours of the Orient became an integral part of French Romantic art.

Byron's works began to trickle into France around 1818, when the first English edition appeared, but they were only widely read and known through the French translations which rapidly followed in the wake of the original. The first French translation of Byron was Léon Thiessé's version of *The Bride of Abydos*, published in 1816; but the monumental work which contributed to the diffusion of Byron's poetry throughout France was Amédée Pichot's *Oeuvres de Lord Byron*, begun in 1819 in collaboration with Eusèbe de Salle, completed in 1821, and republished several times afterwards. It was through Pichot's translation that Byron's name entered the repertory of French Romanticism and became a standard source of inspiration for artists and writers. His reception, however, was by no means unanimously favourable. Older writers,

66 **The Shipwreck of Don Juan**
Antoine Johannot (Besançon, Musée des Beaux-Arts)

67a (top left) **Mazeppa**, 67b (top right) the **Giaour**, 67c (bottom right) **Lara** 67d (bottom left) **the Bride of Abydos** Théodore Géricault, Lithographs (London, British Museum)

brought up on the Catholic and monarchist doctrines of Chateaubriand's *Génie du Christianisme*, were profoundly hostile to Byron's systematic mockery of all religious values. Even young Romantics like Lamartine, inclined to piety but uncertain of their faith, felt the need to temper their admiration for his poetry with misgivings about the depths of his blasphemy.

Another conservatively-minded young poet, Alfred de Vigny, marked a decisive step towards the full appreciation of Byron in a laudatory article in the *Conservateur Littéraire* (December 1820). Byron's first whole-hearted enthusiasts in France were, however, the group of young liberals, among them, Jean-Jacques Antoine Ampère, Stapfer and Stendhal, who met at the house of Etienne Delécluze on the rue Chabanais. Their common view-point was expressed by Stendhal as early as 1818, when he wrote to his friend, Adolphe de Mareste: 'I am an ardent Romantic, which means that I stand for Shakespeare against Racine and for Lord Byron against Boileau.'[27] From the moment of their meeting in a box

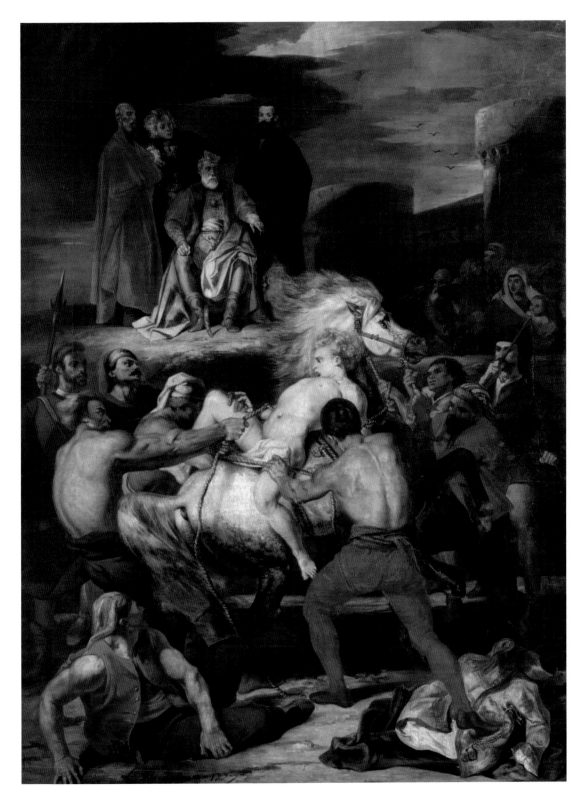

68 **Torture of Mazeppa**
Louis Boulanger (Rouen, Musée des Beaux-Arts)

69 Execution of the Doge Marino Faliero
Eugène Delacroix (London, Wallace Collection)

at La Scala in Milan in 1816, Stendhal was one of Byron's most passionate admirers and associated him in a triple cult with Napoleon and Canova.

The impact of Byron on the visual arts was great, not so much in terms of the number of works inspired by him, as in their significance. Byron's example helped French artists and writers to overcome their lingering attachment to old artistic traditions and thereby contributed to a fully-fledged Romantic movement. Just at the moment when painters were seeking new forms and release from Davidian teaching, Byron's poetry revealed to them a world of exotic imagery, of violent, dramatic action, of voluptuous forms mingled with sadism and cruelty; a world of crime, rape and torture, in which love is invariably followed by guilt or a tragic end. Such graphic scenes left an indelible stamp on the Romantics' imagination. It was this essentially tragic vision which drew French artists to Byron's poetry. The satirical poem *Don Juan* was by far the most popular of all his works (it was treated nineteen times between 1827 and 1859), followed by *Lara*, *The Corsair*, *The Prisoner of Chillon*, *Mazeppa* and *The Giaour*. For the first generation of Romantic painters, like Géricault, Vernet and Delacroix, Byron was automatically associated with the Greek War of Independence, and his vision of the Orient in *The Bride of Abydos*, *The Corsair*, and *The Giaour* strongly coloured their interpretation of his work.

The trend began with two lithographs by Géricault, one of *Lara wounded* published in 1819, followed in 1823 by four others, a *Mazeppa* [Fig. 67a], a *Giaour* [Fig. 67b], a *Lara* [Fig. 67c], and a *Bride of Abydos* [Fig. 67d].[28] In 1824, the year of the first 'Romantic' Salon, Delacroix designed a number of lithographs for the paper *Le Miroir*, with subjects from Scott, Goethe, Shakespeare and Byron, including a *Marino Faliero* and a *Shipwreck of Don Juan* (both themes he was later to treat on a large scale). The Salon of 1827 marked the final triumph of Byron in French Romanticism, exemplified by two of Delacroix's most spectacular early paintings, his *Execution of the Doge Marino Faliero* (London, Wallace Collection) [Fig. 69], and the *Death of Sardanapalus* (Paris, Musée du Louvre) [Fig. 70]. There were also two ambitious compositions by Louis Boulanger and Horace Vernet on

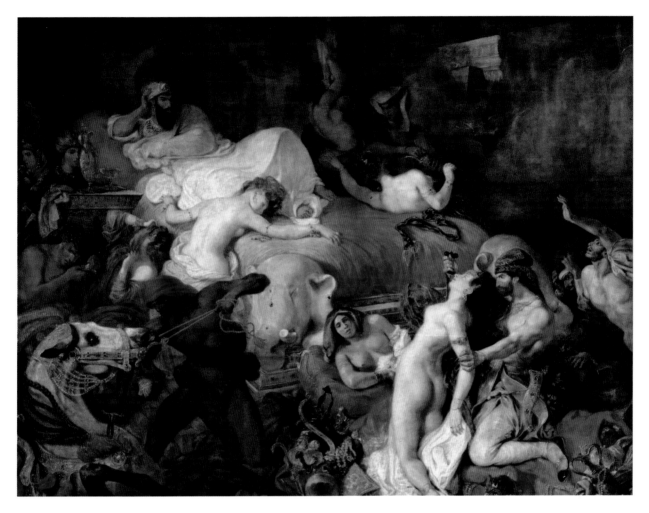

70 **Death of Sardanapalus**
Eugène Delacroix (Paris, Louvre)

the theme of *Mazeppa* (1818), the story of a page who is caught in the act of adultery by
his master, strapped to a wild courser and just as he is on the point of expiring having
careered headlong through forests and deserts, is finally rescued by a beautiful young girl;
the page, revived, lives to exact a terrible vengeance on his master. The poem, a typically
Byronic mixture of sadism and revenge, is treated by both painters in highly melodramatic
fashion. Horace Vernet's version in Avignon, with its glistening courser and ferocious wolf
on the left, is full of the macabre trappings of early Romanticism. Louis Boulanger's *Torture
of Mazeppa* (Rouen, Musée des Beaux-Arts) [Fig.68], on the other hand, is treated on a
monumental scale and although derived from Delacroix's, scored a major success at the

Salon of 1827. Suddenly thrust into prominence as one of the rising stars of the Romantic movement, Boulanger (1800-67) was hailed by Victor Hugo in the dedication of his poem *Mazeppa* (*Orientales XXXIV*) and again by Vigny, who also dedicated a copy of his novel *Cinq-Mars* to Boulanger, '*le peintre-poète de Mazeppa*'. As late as the mid-nineteenth century the subject of Mazeppa continued to interest artists as shown by a painting by Théodore Chassériau of 1853.

By far the most important works inspired by Byron were those of Eugène Delacroix. So close were these considered to be to the spirit of the original that poet and painter were frequently linked by contemporary writers as twins of genius. From early in his career Delacroix felt instinctively drawn to Byron's poetry. His interest in Byron seems to date from 1819 when, in a letter of 22 September to his friend Pierret, he expressed his regret at not yet having read *The Lament of Tasso*.[29] The first reference to Byron in Delacroix's *Journal* (begun in 1822 and kept up, with interruptions, till the end of his life) occurs on 11 April 1824, when he was hard at work on the *Massacre at Chios*; according to this entry, he was meditating on 'hundreds' of subjects, including *Mazeppa*, *Don Juan* and *Tasso*. Further on, in the same passage, we learn that Delacroix was looking for inspiration in Dante, Lamartine, Byron and Michelangelo. The longest and most significant passage occurs, however, in the following month (10-11 May 1824), a crucial text for the understanding of Delacroix's entire approach to the question of painting and literature: 'Painting, I have told myself a thousand times, has its own privileges that are peculiar to itself. The poet is very rich: you must remember certain passages in Byron to inflame you eternally; they suit me very well. The end of *The Bride of Abydos*, *The Death of Selim*, his body tossed about by the waves and above all, that hand lifted by the wave which has just spent itself on the shore. That is sublime and could only come from him. I can see those things translated into painting. The death of Hassan in *The Giaour*, the Giaour looking at his victim and the Muslim's curses on Hassan's murderer. The description of Hassan's deserted palace.'[30] This mental pre-selection of the most graphic passages from *The Bride of Abydos* and *The Giaour* shows that, even in his ardent youth, Delacroix needed the external stimulus of literature to rouse his imagination. He seized on these Byronic subjects precisely because they offered him ready-made themes of passion and violence which he could not have created unaided. Given his subject-matter, Delacroix was left free to tackle what he saw as the artist's real task: the search for a pictorial equivalent of the literary text, or the conversion of an idea into tangible form. What he admired and envied in Byron was a creative facility which enabled him to command inspiration at will, where his own creative powers tended to flag during the long painstaking process of composition. Byron above all had that supreme talent for spontaneous improvisation which Delacroix

strove to cultivate throughout his life. On 15 May 1824, in a mood of profound discouragement, he turned again to the poet's example: 'Reading the review about Lord Byron at the beginning of this volume, this morning, I felt again that insatiable desire to create . . . Lucky the poet and even luckier to have a language which he can bend to his imaginings.'[31]

Delacroix returned to Byronic subjects many times throughout his career, and only the most outstanding examples can be considered in this study. The glaring contradictions in Byron's personality, and the contrast between his virile, often heroic dandyism and an almost feminine sensibility, are clearly what inspired Delacroix to paint two of his best-known early works, the *Execution of the Doge Marino Faliero* (1826) [Fig. 69] and the *Death of Sardanapalus* (1827) [Fig. 70].[32] They epitomise the preoccupations of French Romanticism at its height, offering violent themes treated in a spectacularly bold and original manner. The *Execution of the Doge Marino Faliero* was included in the exhibition held in aid of the Greek relief, opened on 15 May 1826, at the Galerie Lebrun, where it attracted huge crowds. According to Victor Hugo: '*La foule se passionnait pour ce tableau.*'[33] It was apparently Delacroix's favourite of his own works, and he wrote a detailed commentary on the picture explaining its action: a member of the Council of Ten, which has sentenced the Doge Marino Faliero to death for conspiring against the Republic, holds the sword proclaiming that the traitor has been punished. To this point Delacroix closely follows the text of Byron's play, *Marino Faliero, Doge of Venice* (published in 1820), with one important difference in the *mise en scène*. Byron's execution takes place at the top of the stairs of the Doge's palace and, as the curtain falls, a member of the populace down below rushes forward and exclaims: 'The gory head rolls down the giant's steps' (Act V, Scene III). In Delacroix's painting [Fig. 69], on the other hand, the execution takes place at the foot of the steps, partly to avoid the impossibility of showing the severed head bumping awkwardly downstairs, partly to bring the body closer to the spectator and the people for whom the Doge conspired. The gruesome nature of the scene is thereby intensified, a cold static presentation of the butchery accomplished. There can be no doubt as to the democratic implications in Byron's play. The Doge is presented as a kind of rebel against his own class, who conspires against the Republic from motives of sympathy with the masses and who dies condemned by his aristocratic peers for having threatened their privileges. Whether Delacroix sympathised with those views is doubtful, and he made no attempt to lend the scene any kind of political message. What he offers instead is a splendid array of clear, brilliant colours painted under the strong influence of his friend Bonington and magnificent draperies in keeping with the Venetian setting.

The *Death of Sardanapalus* (Salon of 1827) [Fig. 70] is, on the face of it, still more Byronic

in its mixture of sadism, cruelty and sex, the most spectacular holocaust of the entire Romantic period. Its convulsive movement, violence and sensuality place the picture in total opposition to the cold monumentality of Ingres' *Apotheosis of Homer*, exhibited in the same year. Byron's play *Sardanapalus* (published in 1821) seems, however, to have provided no more than the initial impetus for Delacroix's reconstruction of this event, which probably owes more to ancient historians such as Quintus Curtius than to Byron; additionally, Etruscan sculpture, Indian architecture and, above all, Rubens, contributed to the cumulative visual effects of this vast and complex painting. An Assyrian King, Sardanapalus, was the last ruler of Nineveh and a noted despot and debauchee; he ended his life, in true Wagnerian style, on a funeral pyre, surrounded by his concubines, as his rebellious subjects outside burst into the palace. Unlike Delacroix's painting, Byron's play contains no scene of general slaughter, but ends with Sardanapalus alone on the pyre which Myrrha, his favourite concubine, ignites. Byron even manages to lend the king a measure of dignity, seeing in him a reflection of his own spleen and world-weariness. Delacroix, on the other hand, turns the episode into a riot of self-destructive violence, an orgy of masochism, expressed in colour as intense as anything painted by Rubens. The nude concubine in the foreground is, in fact, derived from a nereid in Rubens' *Marie de Medici* cycle, while the ferocious man about to stab her in the chest is clearly an echo from Gros' *Plague-stricken at Jaffa* (1804). And yet, despite superb passages, there is an awkwardness, a disjunction of scale between the figures and their relationship to the background, which shows Delacroix had still not achieved the total fusion of all the elements he was seeking.

The *Death of Sardanapalus* is whole-heartedly Romantic in its uninhibited reaction against the principles of classical, academic teaching, but not entirely Romantic in its execution. Nevertheless, the painting was an outstanding event in the evolution of the Romantic movement, as significant in its excess as Victor Hugo's *Préface de Cromwell*, published in 1827. Inspired by the example of Byron and the invasion of foreign literature, spurred on by militant critics, French painting had finally gained enough self-confidence to break openly with 'the rules' and to embark on a new era of free creativity. In the event, only Delacroix had the courage to stay the course. In the 1830s and '40s his art (still more inspired by Shakespeare and Byron) took on an entirely new character, in which the heroes of Romantic drama and fiction merge with their exotic backgrounds, creating strange and beautiful harmonies.

Sir Walter Scott

Byron's brand of Romanticism, and its French offshoot, was a kind of feverish intoxication with the present moment. The novels of Walter Scott, on the other hand, have less to do

with individualism than with the traditions and mores of old feudal societies, re-created with an antiquarian's respect for the past. Scott was admired in France, still earlier than in England, as the pioneer, the creator virtually, of the historical novel.[34] He excelled at the presentation of broad historical panoramas – especially the Middle Ages, the twelfth century in *Ivanhoe*, and the fifteenth century in *Quentin Durward* – aided by a brilliant sense of pageantry, a shrewd understanding of human motives and behaviour, and a concrete literary style which enabled him to re-create all the minutiae of a historical period, dress, furnishings, armour, with the graphic detail of a painter. His visual sense was widely praised by the French; Balzac greatly admired his 'talent for painting' in the opening pages of *Ivanhoe*,[35] while Sainte-Beuve described him as 'an immortal painter'.[36]

Added to these qualities was the writer's deep penetration of the true underlying historical issues of a period, which raise his novels above the level of mere romance and lend them a more general significance. The true nature of Scott's achievement was, inevitably, only fully understood by writers like Balzac and Alfred de Vigny, whose debt to him was immense. The historical novel enjoyed a vast popularity in nineteenth-century France and ranks as one of the outstanding contributions of the Romantic movement. It is no accident that Lucien de Rubempré, the hero of Balzac's *Illusions Perdues*, hopes to make his fortune with a novel called 'The Archer of Charles IX' and to become another Scott. Similarly Vigny's *Cinq-Mars* (1826), an impressive novel set in the period of Richelieu, would have been inconceivable without the example of Walter Scott who showed French writers not only how to assimilate history in detail and mass, but also to extract from it the broad political forces which determine its course more fundamentally than individuals. For this reason, if for no other, Scott continues to find favour among Marxist historians.

French artists, on the other hand, responded to Scott's novels on a more superficial level.[37] The vogue for subjects from Scott reached its height between 1827 and 1833, and can be seen as a continuation of the so-called Troubadour style which flourished a little earlier in France and was typically represented by the works of two artists from Lyons, Pierre-Henri Révoil (1776-1842) and Fleury-

71 **The Bride of Lammermoor**
Engraving by Blanchard after Antoine Johannot

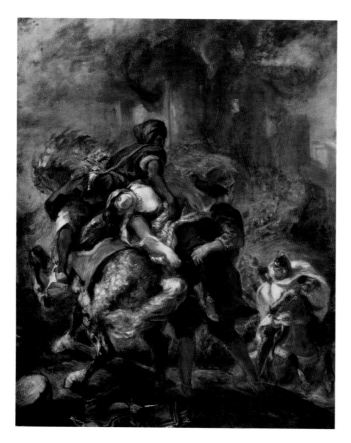

72 **Abduction of Rebecca from** Ivanhoe
Eugène Delacroix (New York, Metropolitan Museum of Art)

François Richard (1777-1852).[38] Their brilliantly painted scenes, mainly culled from French national history and the Crusades, of knights and ladies in vaulted Gothic chambers, enjoyed an extraordinary popularity in the early nineteenth century, favoured by the Catholic monarchist revival initiated largely by Chateaubriand's *Génie du Christianisme*. This kind of subject provided French artists with a convenient compromise between the prestige of history and the small size of genre painting. It was precisely this formula which made the novels of Walter Scott so attractive to French artists of the Romantic period. In nearly every chapter they found ready-made '*tableaux historiques*' in the form of Gothic interiors – the château of Plessis-lès-Tours or the bishop's palace at Liège, from *Quentin Durward* – complete with their accessories of polished armour, tapestries, chairs. In addition to these pictorial allurements which gave French artists a unique opportunity to display their skill in high finish and minute detail, nearly all such scenes contained subjects of high romantic interest, love-torn cavaliers and indolent young ladies strumming lutes in expectation of amorous attention. This sentimental attitude to the mediaeval past, seen through the eyes of Walter Scott, is distantly echoed in the day-dreams of Flaubert's Emma Bovary as she longs for some romantically dressed cavalier in a plumed helmet to come galloping up to her out of the distance.[39] Significantly it is at a performance of Donizetti's *Lucia di Lammermoor* that Emma feels 'the echo of her own conscience', shortly before meeting Léon, her old lover, as she is about to leave the theatre.

The impact of Walter Scott on French art was summarised by a critic in *L'Artiste* (1837), who wrote that Scott was foremost amongst those writers who provided natural subjects for painting; artists merely had to follow the prescribed text line by line: 'Artists only have to follow Scott's text line by line to give their works an accurate expression, a living truth; there they will find so to speak a ready-made picture which they only need to copy exactly. Costume, pose, gesture, everything is laid down, foreseen, and perfectly defined.'[40]

Needless to say, this type of literal copying made for excellent vignettists and illustrators, such as the Johannot brothers who illustrated the Furne edition of Scott's collected works published in 1830-2 (for example: *The Bride of Lammermoor* [Fig. 71] by Antoine Johannot, Paris, 1830, showing Lucy Ashton confronted by her brideroom, Edgar Ravenswood). But it did not make for a free and imaginative approach to literature. Except for Delacroix, few artists who treated subjects from Scott showed a willingness to depart radically from the set text and to re-cast it according to their pictorial needs.

Scott's popularity in France began around 1820, reached its climax in the 1830s and declined only after the middle of the century. An early review of *Ivanhoe* by Victor Hugo in 1820 paid tribute to Scott's unique powers of description and his ability to give hackneyed mediaeval subjects new life.[41] This was followed by the first French edition of the *Oeuvres complètes de Walter Scott*, translated by A.J.B. Defauconpret and published in 60 volumes by Gosselin between 1822 and 1829; a second edition was issued between 1826 and 1833

73 **Isabelle de Croye and her aunt Hameline**
From *Quentin Durward*
Louis Boulanger (Montpellier, Musée Fabre)

in 84 volumes, with illustrations and title-pages by Alexandre-Joseph Desenne, helped by Eugène Lami, the Johannot brothers and a large team of English and French engravers. In addition, several of Scott's novels were adapted for the stage, including *Quentin Durward* in 1827 and again in 1832 in a version by Casimir Delavigne; *The Bride of Lammermoor* was staged as an opera in 1827-9, and Donizetti's version was performed in 1839. Of all the novels, the most popular by far were *Quentin Durward* and *Ivanhoe*, on account of their mediaeval romantic subjects, followed by *The Abbot* and *The Bride of Lammermoor*; between 1824 and 1863, *Quentin Durward* was painted 20 times, *Ivanhoe* 17 times. Altogether, in terms of sheer numbers, Scott was far and away the most popular literary source with French artists. In the period from 1820 until 1863, his novels were painted no less than 180 times (including water-colours and drawings), compared with 103 for the works of Byron and 95 for Shakespeare. All this reveals an overwhelming interest in the novels of Scott on the part of French artists, even though not all their efforts are of great artistic value and only a small number has survived. After about 1840 this fashionable enthusiasm began to wane. Only Delacroix continued to find inspiration in his novels and went on to produce some of his finest paintings, like the *Abduction of Rebecca* [Fig. 72] exhibited at the Salon of 1846.

The approach of French artists to Scott's novels was, broadly speaking, episodic or 'picturesque' and psychological: sometimes, but not often, the two elements were successfully combined in a single painting. First of all, the background to many of his novels, the Scottish Highlands, played a large part in his romantic appeal for the French although *Quentin Durward*, an important exception, is set mostly in the Loire valley. The rise of Scott's fortune coincided significantly with the decline of Ossian's, and after about 1820 the former's name was inseparable from his native country. His novels were regarded in France as the authentic and definitive portrayal of 'Caledonia', and helped to promote a new interest in Scottish scenery, typified by illustrated volumes like the *Vues pittoresques en Ecosse* by François Alexandre Pernot and Eugène Lami, published in 1826-8. This new romantic interest in Scotland and her romantic heroine, Mary, Queen of Scots, explains the popularity of *The Abbot* (painted 14 times between 1822 and 1839); the episode of Mary escaping from captivity was a particular favourite, treated by Hyppolite Lecomte in his *Mary Stuart escaping from the castle of Loch Leven* (Salon of 1822, formerly in the château of Saint-Cloud) and again by Alfred Johannot in *Mary Stuart leaving Scotland* (1836) showing the queen bidding farewell to her supporters. The painting was warmly received when it appeared, described in one journal, *Le Voleur*, [42] as 'one of the most charming compositions to come from the fine and graceful talent of M. Alfred Johannot'.[43] A painting by Eugène Devéria, highly praised by Victor Hugo at the Salon of 1827, showed *Mary, Queen of Scots receiving the death sentence* [Fig. 117].

The two novels of high romantic chivalry, *Quentin Durward* and *Ivanhoe*, were usually approached by French artists in the sentimental genre of the Troubadour style, as in Boulanger's water-colour illustrating Chapter IV of *Quentin Durward* when the hero catches sight of Isabelle de Croye and her aunt Hameline [Fig. 73]. This kind of discreet gallantry, repeated in several episodes of the novel, was portrayed on many occasions; as, for example, in a lithograph by Hyppolite Lecomte showing *Quentin at breakfast with Louis XI waited on by Isabelle de Croye*, and in another of 1835 by the same artist illustrating Chapter XV where Quentin is nursed by Isabelle after being attacked while conveying her to Liège. Paintings from *Ivanhoe* were also mainly small-scale psychological studies, like the scene by Eugène Devéria of *Lady Rowena receiving a casket of jewels from Rebecca* [Fig. 74], from the last two pages of the novel (Chapter XLIV).

74 **Lady Rowena receiving a casket of jewels from Rebecca, from** Ivanhoe
Eugène Devéria (Dijon, Musée Magnin)

Inspired by a nostalgic vision of mediaeval chivalry, Scott's novels abound in action and violence. Scenes of extreme brutality are not uncommon, like the death of the Spy Morris in *Rob Roy* (Chapter XXXI) – treated in a painting [Fig. 75] by Camille Roqueplan (1803-55) exhibited at the Salon of 1827 – where the spy from a rival clan is tied up in a sack by his captors and thrown over the top of a cliff. Another such scene occurs in Chapter V of the *Legend of Montrose*, where Allan M'Aulay triumphantly holds the severed head of one of his hereditary enemies in front of the assembled guests at a dinner party. In his painting [Fig. 76] exhibited at the Salon of 1824, Horace Vernet omitted this gruesome scene but nonetheless captured all the untamed wildness of this Scottish chieftain in his native Highland setting. He extracted the spirit of the novel and its character without indulging in narrative or anecdotal description.[44]

The most popular of all the violent episodes in Scott was the abduction of Rebecca by the Templar Brian de Bois-Guilbert, from Chapter XXXI of *Ivanhoe*: 'One turret was now in bright flames, which flashed out furiously from window and shot-hole . . . Rebecca, placed on horseback before one of the Templar's Saracen slaves, was in the midst of the little party; and Bois-Guilbert, notwithstanding the confusion of the bloody fray, showed every attention to her safety. Repeatedly he was by her side, and, neglecting his own defence, held before her the fence of his triangular steel-plated shield; and anon starting from his position by her, he cried his war-cry, dashed forward, struck to earth the most forward of the assailants, and was on the same instant once more at her bridle rein.' It was this text which Léon Cogniet (1794-1880) illustrated in his painting of 1829, *Rebecca abducted by the Templar* (Salon of 1831) in the Wallace Collection in London [Fig. 77]. Though not an unattractive work, Cogniet's painting manifestly fails to capture the explicit violence and drama of Scott's narrative. The seething mass of assailants in the background – Richard the Lionheart's troops forcing an entry into the castle – and the passionate ferocity of the Templar's abduction of Rebecca in the foreground, are both treated in a thin two-dimensional style which creates a purely static effect reinforced by Rebecca's awkward lateral movement across the picture surface. There is no suggestion of terror in her expression, and the spectator might almost be forgiven for assuming that she was setting out on a day's hunting expedition.

How different was Delacroix's treatment of the subject in his *Abduction of Rebecca* (Salon of 1846) in the Metropolitan Museum of Art, New York [Fig. 72] and in the later version in the Louvre, painted in 1856.[45] In both these paintings swirling arabesques, strong diagonals and figures in violent *contrapposto* – all features which Delacroix had assimilated from his study of Rubens and the Baroque painters – serve to heighten the dramatic

75 **Death of Spy Morris from** Rob Roy
Camille Roqueplan (Lille, Musée des Beaux-Arts)

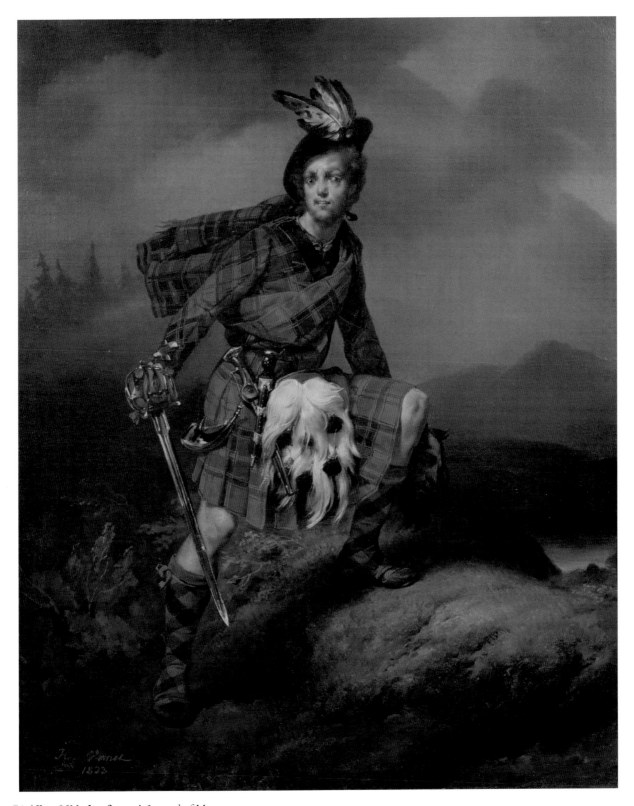

76 **Allan M'Aulay from** A Legend of Montrose
Emile-Jean-Horace-Vernet (London, Wallace Collection)

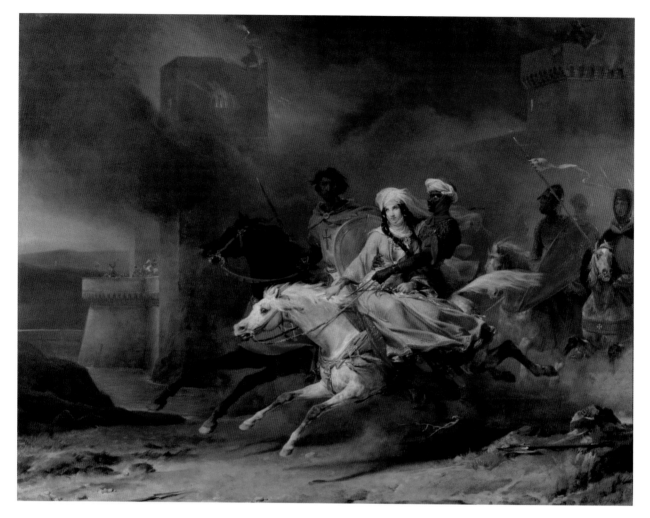

77 **Rebecca abducted by the Templar from** Ivanhoe
Léon Cogniet (London, Wallace Collection)

tension and underline the destructive violence and horror of the scene. The secret of
Delacroix's success was, paradoxically, the critical attitude towards Scott expressed in his
Journal: 'The descriptive passages which overburden modern novels are a sign of sterility;
for it is easier to describe the dress or outward appearance of an object than to trace
subtly the developments of characters or the portrayal of the heart.'[46] This fundamental
reservation about Scott's style, implying more respect for the spirit than the letter of the
novel, enabled Delacroix to strip the scene down to its essentials, to dispense with
redundant detail, and to create a painting rather than an illustration. The proof is that his
paintings can be enjoyed purely in terms of their harmony and colour, the pinks and greens
of the first version and the glowing oranges and reds of the second. The literary text behind
them was little more than a pretext, a stimulus to the painter's imagination.

78 **The Murder of the Bishop of Liège from** Quentin Durward
Eugène Delacroix (Paris, Louvre)

The other scene of extreme violence painted by Delacroix is *The Murder of the Bishop of Liège* (1829, Paris, Louvre) [Fig. 78].[47] Begun in 1827 and exhibited at the Salon of 1831, the subject is taken from Chapter XVII of *Quentin Durward* where the outlaw William De La Marck has the bishop murdered in his own palace. Though the setting is treated in correct archaeological manner, based on the late Gothic style of Westminster Hall which Delacroix had studied with Bonington in 1825, the central drama shows an almost total disregard for detail. All that can be seen is a seething mass of figures, their faces and costumes drawn in a kind of rapid shorthand. The real subject of the picture is, in fact, the Rembrandtesque *chiaroscuro*, used to highlight the long diagonal white tablecloth and the central figure of the bishop, waiting to be slaughtered like a lamb by De La Marck's henchmen. The result is one of Delacroix's most powerful works. Its sinister effect is enhanced by the fact that the painter shows not the actual murder itself, but the still more chilling moment before the atrocity is committed.

Delacroix's relationship to Scott was personal and selective, usually critical, but also

marked by a strong element of self-identification with the author's heroes, exemplified in the strangely elusive *Self-portrait as Ravenswood* (Paris, Louvre), painted around 1824 [Fig. 80].[48] Delacroix, however, was an exceptional figure and never typical of the general current of the period, for his greatest works derived from Scott were painted some time after the fashion for the novels had begun to wane. Only a handful of artists continued to paint subjects from Scott after 1840. Critics like Louis Peisse[49] took an increasingly unfavourable view of Scott's influence on artists, accusing him of reducing them to the role of vignettists and illustrators, resulting in a wholesale trivialisation of the historical genre. In the hands of these minor artists history, in the form of Scott's novels, was reduced to a picturesque chronicle, and painting to the inferior role of copyist. The subordination of painting to literature was a constant threat to the integrity of nineteenth-century artists, who often paid a heavy price for the close relationship between the two arts. Only Delacroix, because of his greater awareness of the problem, managed to create original works which still owe much of their initial inspiration to literature.

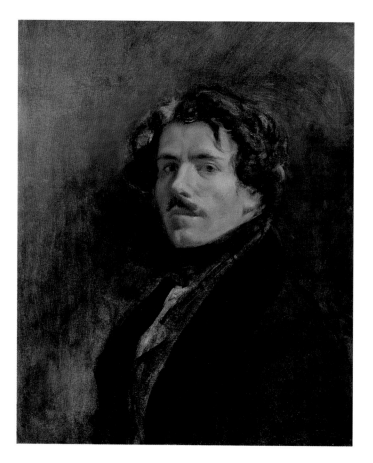

79 **Self-portrait**
Eugène Delacroix (Paris, Louvre)

80 **Self-portrait as Ravenswood**
Eugène Delacroix (Paris, Louvre)

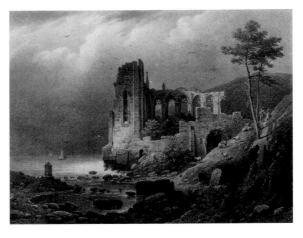

81 **Pernot**
Engraving by Deroy, dirigé by François Alexandre
Pierre Bonnemaison: *View in the Scottish Mountains*
(London, Courtauld Institute)

CHAPTER VI

PICTORIAL IMAGERY IN ROMANTIC POETRY

THE MOST STRIKING characteristic of French Romantic poetry is the richness and profuseness of its imagery. In contrast to the verse of the two previous centuries, in which imagery was carefully regulated by classical convention and the structural demands of form, the Romantic poets, Lamartine, Vigny, Musset and, above all, Victor Hugo, launched into the external world of sight and spectacle with unprecedented relish. This sudden discovery of the visible universe, corresponding to a dramatic widening of the writer's imaginative horizon, can only be compared with the sudden flowering of the Pléiade poets in the sixteenth century. In both periods, images crowd on each other with little regard for the demands of form or relevance; often they are simply the expression of the writer's exuberant imagination. The important difference, however, is that poets of the Romantic period were far more aware of the visual arts and much of their imagery is directly inspired by pictorial sources. French Romantic poetry is consequently unrivalled in its visual power. With its graphic presentation of incident and spectacle, its love of colour ranging from the exotic tones of the Orient to the pale wash of an autumn morning, its intensity of expression including extremes of violence and tenderness: to this extent it can be seen, with important qualifications, as the literary equivalent of the paintings of Delacroix, Ary Scheffer and Horace Vernet. One would have been inconceivable without the other, and both derive much of their vitality from direct contact with a related art. The aim of this final section is to trace some of the complex links between the two arts in the Romantic period culminating in the great epics of Victor Hugo, and to show how these poets all made use of the visual arts in their own subjective manner, often equating specific paintings with the obsessions of their imagination.

The reasons for this intimate relationship between literature and painting have already been suggested. But poetry is always a privileged case and deserves a special answer, even in the nineteenth century when all artists considered themselves equals in genius. Why did poets of this period, unlike others, constantly turn to the pictorial arts in search of inspiration? A purist might argue that this dissatisfaction with the poet's own medium of words was a creative flaw. In the Romantic poet, however, mere words were not enough to contain the richness of his imagination and the variety of his experience. He needed to look constantly outside himself, to press any means into his service. The visual arts were only one of these means, but a particularly valuable one in that they presented a clear and immediate résumé of the external world – of people, foreign countries, landscapes, scenes

from history and mythology – all of which the Romantic writer wanted to include in his verse, if poetry were too become a true microcosm of the world. The nineteenth century was an expansionist, outward-looking age. Following the doctrine and personal examples of Goethe and Madame de Staël, writers felt compelled to explore not only the inner recesses of their own psyches, but also the physical manifestations of world-wide culture and all aspects of social life. Foreign countries, their arts and mores, were opened up and horizons were vastly extended. These new areas of human experience clamoured for representation in nineteenth-century art and literature.

Another related factor which tended to bring the two arts into close contact was the relatively new discovery of the past. Historicism played a constant role in determining the nature and evolution of nineteenth-century art. From around 1800 onwards entire past civilisations, including classical, Egyptian, oriental and mediaeval, were made accessible by travel and scholarship. For the Romantic generation, history became a living reality – '*une résurrection du passé*', in the historian Michelet's

82 **Illustration for the** Confidences
Engraving by Antoine Johannot

words – not the dispassionate study it had been for earlier scholars. Art and archaeology, as the physical embodiment of the past, played a vital part in the process of visualisation. It was on visiting Alexandre Lenoir's recently formed Musée des Monuments Français (a collection of mediaeval sculpture rescued from the ravages of the Revolution) that Michelet first became aware of his vocation as a historian: 'I filled those tombs with my imagination, I could feel the dead through the marble.'[1] Art thus became a primary source of historical material. Michelet constantly views the past in terms of a single painting, the Counter-Reformation as Dürer's *Melancolia*, the French Regency as Watteau's *Departure for Cythera*, and so on. The same habit of mind is also evident in the poets of the Romantic period. Alfred de Musset, for example, who wrote several poems, novels and plays set in the Italian Renaissance (*Le Fils du Titien*, *Lorenzaccio* and *André del Sarto*), saw the period as a broad fresco painted by the most famous artists of the time. The poetry of Victor Hugo, which roams the entire field of history from pre-biblical times up to his own day, would be inconceivable without the vast store of accumulated art dispersed in museums, collections and churches throughout the world.

There was also, at the height of the Romantic period, a strong belief in the interdependence and unity of the arts. The notion of a single confraternity of artists was fundamental to the Romantic movement; its most consistent champion was Théophile Gautier, who wrote: 'This blending of art with poetry has been and remains a characteristic sign of the new school and makes clear why its earliest initiates came from artists rather than men of letters. A host of objects and comparative images which had been thought of as irreducible to words, entered into the language and have remained.'[2] Thus art and poetry became irrevocably intertwined in the nineteenth century. The barriers previously erected between the genres by Lessing and earlier theorists were finally abolished in the search for a complete fusion of all the means of artistic expression. Henceforward differences of medium – language, colour, sound – were minimised as 'communication', the expression of a message or a personal vision, became of paramount importance. The poet and the painter, liberated from the constraints of their respective medium, were free to borrow from each other as and when they chose; thus we sometimes find in this period poems, such as Byron's *Mazeppa*, which inspire paintings which in their turn give rise to new poems. Both writers and painters were, in fact, representatives of a single species, the 'Artist', whose conception of his own importance and role in society steadily increased in the first half of the nineteenth century. From being a mere man of letters in the eighteenth century, the Artist promoted himself in the Romantic period to the part of moralist, legislator, prophet and visionary. Whether he chose to express himself in words or paint, or both, mattered less than the urgency of his message and the sincerity of his emotion.

Alphonse de Lamartine (1790–1869): *Méditations*[3]

The appearance of Lamartine's *Méditations* in 1820 was a major event in the evolution of French lyric poetry. As Chateaubriand had done two decades earlier in *Atala* and the *Génie du Christianisme*, Lamartine struck a blow against the sterile materialism of the Empire period in favour of personal feeling and religious piety. He helped to unleash a flood of pent-up emotion which was to have wide repercussions throughout Europe. To later generations, and especially in the eyes of twentieth-century readers, Lamartine's poetry sometimes came to appear vapid and sentimental, but this was by no means the opinion of his own contemporaries. Talleyrand, for one, is reputed to have sat up for the whole night reading the *Méditations* when they came out and roundly proclaimed: '*Voilà un homme*'. The French public instantly recognised the passion and sustained fervour of the poet's writing. The poignant lines of poems *Le Lac*, *L'Isolement* and *Souvenir* struck an immediate chord of sympathy in the readers of 1820, responding to their deepest spiritual needs in a clear, intelligible, if not particularly original, language.

The success of the *Méditations* can be explained largely by their content, in which love is vaguely associated with alternating moods of religious faith and philosophic doubt. Unlike Chateaubriand, Lamartine was uncertain of his own beliefs; filial piety and a traditionalist conservative temperament held him back from the outright revolt of Byron. For him the monarchist principle and an aristocratic family background were not an adequate basis for religious belief, which in his eyes could only spring from immediate personal experience. The sole guarantee of authenticity recognised by Lamartine is the human heart, the sole certainty is that of spontaneous feeling. This leaves the poet very much at the mercy of transient, fragile emotions like love, and when these fade, as they often do, hope and faith give way to doubt and despair. Hence the gentle but all-pervasive melancholy of the *Méditations*:

83 **Illustration for the** *Méditations*
Engraving by Blanchard after Antoine Johannot

> *J'ai vécu; j'ai passé ce desert de la vie,*
>
> *Où toujours sous mes pas chaque fleur s'est flétrie;*
>
> *Où toujours l'espérance, abusant ma raison,*
>
> *Me montrait le bonheur dans un vague horizon.*
>
> (*La Foi*)

('I have lived; I have crossed life's desert where each flower is tarnished by my every step; where hope, deluding my reason, showed me happiness in a vague horizon.')

Though Lamartine was a mere 29 when he published these lines, many of the poems express a bitterness and disillusionment more appropriate to old age than to youth. This elegiac mood runs through the entire volume and explains why it found a sympathetic response in the generation of 1820 suffering from the '*mal du siècle*'. At the time he came to write the *Méditations*, Lamartine felt a mounting sense of disgust with himself and the dissipation of his past life.[4] After a happy country childhood spent at Milly,

his parent's house set among the vineyards of the Mâconnais, he was sent in 1803 to the Jesuit college of Belley, near Lyon. A few years later he became involved in his first romance with a local doctor's daughter but his parents, who disapproved of the match, sent him away on a prolonged tour of Italy. Avid for pleasure and physical beauty, the poet set off from Mâcon on 1 July 1811, arriving in Rome four months later. For Lamartine, and for the rest of his generation, Italy seemed like the promised land and he responded to its charms with youthful zest.

Italy later provided him with his most fertile source of imagery in poems which evoke the gentle voluptuous lapping of the Mediterranean sea, the bright light and azure blue of the sky. In Naples he had an affair with the mysterious Antoniella. Though only a poor peasant girl who worked in a local factory, Antoniella – or *Graziella* as she reappears in the *Confidences* – later became transformed by the poet's imagination into the archetypal Neapolitan fisherman's daughter, passionate and tender. As far as we can unravel the truth from a few laconic remarks in Lamartine's correspondence, it seems that this was not the sublime romance of *Graziella* and the *Confidences*, but a commonplace adventure which flattered the young man's vanity. He quickly tired of her and returned to France in May 1812, leaving her disconsolate. Whether from grief or simply illness, the girl died three years later. It was an episode of which Lamartine was inwardly ashamed, and may explain why he went to such pains in his fiction and poems to disguise the truth and to show himself in a more favourable light. He was haunted by the memory of a true, devoted love of which he had proved unworthy.

The other affair of the heart which was to provide the greatest source of inspiration for his poetry began in October 1816 at Aix-les-Bains, where Lamartine was staying to recuperate from a liver disease. There he met Julie Charles, a fashionable Parisienne and the wife of a distinguished scientist. Madame Charles was already fatally ill with tuberculosis; she was not however the melancholy spectral figure of Elvire, as Lamartine portrayed her in his poetry, but a charming, slightly coquettish woman who enjoyed the young man's attentions and quickly succumbed to his advances. A brief and passionate love affair ensued, lasting only about three weeks. Two months later, after his return to Paris, Lamartine wrote to his friend Aymon de Virieu: 'I am now in the throes of the most violent passion that ever a man's heart has contained! We are two who will die literally of despair and love.'[5] He continued to see Madame Charles in Paris and to frequent her salon but by the spring of 1817 her health was giving serious cause for concern. The two lovers made plans to meet again in Aix the following autumn, knowing well that this would probably never take place. She died in Paris in December 1817.

These two personal experiences recur like a plaintive leitmotiv throughout Lamartine's poetry, creating an elegiac mood of regret for the past and uncertain faith in the future. There is no permanence in love, nature or human life; everything is in a state of constant mutation and decay. And yet, with this Romantic spleen which to some has seemed a mere literary pose, Lamartine combined an idealistic optimistic faith in the future of humanity and, in his political career, strove for a better life for the underprivileged members of society

Lamartine's poetry is not strikingly pictorial in quality. According to his own definition of poetry, painting (in the sense of description) was one of three ingredients: 'La poésie se compose de trois choses: sentiment, peinture, musique.' ('Poetry consists of three things: feeling, painting, music.')[6] Though feeling and music undoubtedly contributed more to his poetry than painting, visual imagery nonetheless plays an important role in his verse and is frequently used to symbolise the poet's inner life and imagination.[7] The past – his own past – divides itself naturally into a sequence of images which gain an added clarity with the aid of memory. Lamartine nearly always views life at a distance, never directly. Hence the deliberate vagueness of his poetic language, the bland, consciously unoriginal epithets and the soft blurred contours. His images, of a vague generalised kind or abstract entities like 'Les molles clartés', 'Le voile des nuits', are often drawn from nature and natural phenomena, but without the eye for concrete detail typical of the painter's vision. The poet does not attempt to present a realistic picture to the reader, but a symbolic universe, the imaginative equivalent of his deepest feelings. In the Méditations the landscape of the Mâconnais which inspired his finest poems is stripped of all its individual characteristics; the hills of Burgundy are simply 'la montagne', the river Saône becomes 'le fleuve' and the valley leading to Saint-Point becomes 'le vallon'. Everything is reduced by the poet to its essence, endowing people and places with an ethereal, timeless quality. This process of simplification can best be seen in his most celebrated lyric Le Lac, written in 1817 and closely inspired by his affair with Julie Charles at Aix-les-Bains a year earlier. The identity of the two lovers in the poem is well known, and the lake in question is the Lac du Bourget; but there is nothing in the poem itself to betray its origins:

> Ainsi, toujours poussés vers de nouveaux rivages,
> Dans la nuit éternelle emportés sans retour,
> Ne pourrons-nous jamais sur l'océan des âges
> Jeter l'ancre un seul jour?

> . . . Un soir, t'en souvient-il? nous voguions en silence;
> On n'entendait au loin, sur l'onde et sous les cieux,
> Que le bruit des rameurs qui frappaient en cadence
> Tes flots harmonieux. . . []

The poem concludes with an invocation to the scenes which witnessed their love:

> *O lac! rochers muets! grottes! forêt obscure*
>
> *Vous, que le temps épargne ou qu'il peut rajeunir,*
>
> *Gardez de cette nuit, gardez, belle nature,*
>
> *Au moins le souvenir!*
>
>
> *. . . Que le vent qui gémit, le roseau qui soupire,*
>
> *Que les parfums légers de ton air embaumé*
>
> *Que tout ce qu'on entend, l'on voit ou l'on respire,*
>
> *Tout dise: Ils ont aimé!*

('So, always pushed towards new shores, carried away without return in the eternal night, can we ever drop anchor on the ocean of time for even a day? . . .

One night, do you remember, we were rowing silently; from afar, on the water and under the skies, we could only hear the sound of rowers rhythmically striking your harmonious waves . . .

O lake! dumb rocks! caves! shadowy forest! You, whom time spares or can rejuvenate, keep at least the memory of this night, keep it, beautiful nature!

Let the wind which groans, the sighing reed, the light perfumes of your scented air, let all that is heard, seen or breathed, all say: they loved!')

Another aspect of Lamartine's description of nature is his preference for broad, all-enveloping panoramas. He likes objects which melt into blurred horizons stretching away into the far distance; domes and spires of exotic cities silhouetted against a plain, or broad rivers winding their way as far as the eye can see. He rarely fixes on particular objects with precision, but allows them to float indistinctly in the middle distance so that none is given undue prominence. This is the technique of the roving eye, clearly illustrated in the opening lines of *L'Isolement*, in which the poet, seated on a hill top, surveys the scene at his feet:

> *Souvent sur la montagne, à l'ombre du vieux chêne,*
>
> *Au coucher du soleil, tristement je m'assieds;*
>
> *Je promène au hazard mes regards sur la plaine,*
>
> *Dont le tableau changeant se déroule à mes pieds.*
>
>
> *Ici, gronde le fleuve aux vagues écumantes,*
>
> *Il serpente, et s'enfonce en un lointain obscur;*
>
> *Là, le lac immobile étend ses eaux dormantes*
>
> *Où l'étoile du soir se lève dans l'azur.*

('Often at sunset I sit sadly below the mountain, in the shade of the old oak tree; I let my eyes wander at random over the plain whose changing vista spreads out at my feet.

Here roar the river's foaming waves, snake-like, and plunge into a mysterious distance; there, the still lake spreads out its sleeping waters where the evening star rises into the azure.')

This is the typical Lamartine image (or '*tableau*' in his own terminology), open, unconfined, and as fluid as his own emotions, faithfully reflecting the movement of his own inner life. He chooses images not for their pictorial interest but for their psychological association and their concordance with the poetic mood. Hence the paramount importance of harmony and rhythm in his poetry, creating the illusion of a spontaneous flow of emotion, only channelled into a regular pattern of rhyme and cadence. It is for this reason that, in the *Harmonies* especially, many poems are cast in the form of prayers and consciously imitate the incantatory rhythm of the psalms.

In view of the predominance of music in Lamartine's poetry, it is not surprising that the visual element is allotted only a minor role. There is none of the detailed concrete colour notation we find in the verse of Victor Hugo with his preference for brilliant reds, golds and oranges, only a discreet use of contrasts, mainly of black and white, and the occasional touch of subdued autumnal colours. Lamartine is particularly fond of dark trees gently illuminated by clear moonlight, as in the first verses of *Le Soir*:

> *Le soir ramène le silence.*
> *Assis sur ces rochers deserts,*
> *Je suis dans le vague des airs*
> *Le char de la nuit qui s'avance.*
> *Vénus se lève à l'horizon;*
> *A mes pieds l'étoile amoureuse*
> *De sa lueur mystérieuse*
> *Blanchit les tapis de gazon.*

('Silence returns with the evening. Seated on these solitary rocks, I watch the night chariot which moves forward in the vague air. Venus arises on the horizon; at my feet the amorous star bleaches the grassy carpet with its mysterious glimmer.')

Evening-time, with its fading colours dying away on the horizon, is the natural setting for the mood of the *Méditations*, when the bustle of the outside world is briefly excluded for the sake of silence and solitude. As so often in Romantic poetry, especially in Goethe and in the lyrics of Leopardi, the moon is seen by the poet as a soothing influence, gently rising above the trees and bringing peace and consolation to a troubled soul:

> *Doux reflet d'un globe de flamme,*
> *Charmant rayon, que me veux-tu?*
> *Viens-tu dans mon sein abattu*
> *Porter la lumière à mon âme?*

('Sweet reflection of a fiery orb, charming beam, what do you want of me? Do you come to bring light to the soul in my battered breast?')

Lamartine's verse is intimately associated with nature and the seasons of the year. Spring and autumn, especially, inspired some of the poet's most memorable passages, corresponding to his alternating moods of hope and despair. Spring, of course, means rejuvenation and the promise of future happiness; as in the magnificent opening lines of *Jocelyn*, evoking a rustic idyll in the priest's native village as all the shutters open to a radiant morning and girls beckon to each other across the street:

'*O mon Dieu! que la terre est pleine de bonheur!*'

('O God, how full of happiness the earth is!')

Autumn, on the other hand, is the season of transience, decay and, ultimately, death. These are the feelings which inspired one of Lamartine's greatest poems, *La Vigne et la Maison*, written in 1856.[8] Cast in the form of a dialogue between himself and his soul, the poem evokes the author's childhood at Milly and, in a series of poignant images, contrasts the happy home which it once was with the cold, deserted house of the present, with its creaking rusty door hinges and damp walls. The natural melancholy of these reflections is accentuated by the autumnal setting which Lamartine, a countryman by upbringing, notes in such details as the fluff from thistles flying away in the wind and the chilly stirring of reeds on the edge of a pond. The air is clear, yet vaporous and moist:

De l'air plus transparent le crystal est limpide,

Des mots vaporises l'azur vague et liquide

S'y fond avec l'azur des cieux.

('From the more transparent air the crystal is limpid,

From vaporized words the azure nebulous and liquid

Dissolves with the azure of the skies.')

The central character of the poem is the house, a modest winegrower's property in a Burgundian village, and its surrounding vineyard; the vine symbolises growth, maturity at harvest time, followed by decay, but also continuity when it flowers in the spring and renews its crop. The home, for Lamartine, is the cradle of his family and the source of all goodness, wisdom and strength. What happens when its members are dispersed and eventually die?

Que me fait le coteau, le toit, la vigne aride?

Que me ferait le ciel, si le ciel était vide?

Je ne vois en ces lieux que ceux qui n'y sont pas!

('What affect has the hillock, the roof or the arid vine on me, or even the sky if it were empty? In these places, I only see those who are not there!') Nothing can restore the scenes

of our childhood, or those who were dear to us; if we revisit them we find only emptiness, a hollow shell in place of a home, shadows instead of living people. But Lamartine seems to suggest, in almost Proustian language, that by careful observance of the values learnt in family life and with due filial piety and love of our native territory, we may hope to recapture some of that lost happiness and to assure some link of continuity between past and present. The key to the operation is memory, the one faculty which enables us to recall the past at will; images and memory are therefore inextricably linked in the poet's mind. This is the theme of the following lines, which contain the crux of the poem's meaning and also suggest the true motive behind all Lamartine's creative effort:

> Toi qui fis la mémoire, est-ce pour qu'on oublie?
>
> Non, c'est pour rendre au temps à la fin tous ses jours,
>
> Pour faire confluer, là-bas, en un seul cours,
>
> Le passé, l'avenir, ces deux moitiés de vie
>
> Dont l'une dit jamais et l'autre dit toujours.
>
> Ce passé, doux Eden dont notre âme est sortie,
>
> De notre éternité ne fait-il pas partie?

('You who created memory, is it so that one forgets? No, it is to restore to time all its days at the end, there to unite the past and future in a sole course, these two halves of life, one of which says never and the other always. Sweet Eden, this past from which our soul sprang, is it not also part of our eternity?')

Jocelyn

Apart from the lyric poetry, Lamartine's most significant and, perhaps, greatest work is his long epic poem *Jocelyn*, published in 1836.[9] This was originally intended as only a fragment in a vast humanitarian edifice, of which *La Chute d'un Ange* (1838) is the only other complete episode. *Jocelyn* is the story of a humble village curate during the period of the French Revolution. In the opening episode the protagonist is an ordinary happy boy who voluntarily sacrifices his share of the family's meagre inheritance to enable his sister to marry with a small dowry. With no strong sense of vocation, and with a heavy heart, he enters the priesthood. After the outbreak of revolution, he is forced to escape into the mountains where he takes refuge in a cave. There, after several months in hiding, he is later joined by another fugitive, an adolescent whom he first takes for a boy [Fig. 89]. Gradually, however, the nature of his feelings reveal that this is not a boy but a girl, Laurence. They spend several more months together, in pure and chaste love for one another. This brief idyll is brusquely interrupted when Jocelyn is summoned by his local bishop [Fig. 88] and ordered to resume his pastoral duties, now that the Terror is passed and the clergy reinstated. Broken-hearted and abandoned, Laurence goes to Paris where eventually

Jocelyn is shattered to find that she has become a prostitute. Jocelyn returns to his native village, Valneige, and, in an effort to forget the past, resumes the life of a humble and conscientious curate. But his heart is still in turmoil. One day he is called out to a traveller dying from exhaustion. This, we guess straightway, is Laurence. They soon recognise each other and after obtaining her forgiveness, Jocelyn confers divine absolution on Laurence. He finally buries her near the cave where they experienced a few months of transient happiness.

Jocelyn is, as Lamartine intended, an intimate personal confession inside a philosophical and moral framework. The first aspect of the work is clearly indicated by the author's choice of original titles, *Mémoires du Curé de ★ ★ ★, Journal du Curé, Journal d'un Vicaire*, announced in a letter of November 1831 to Madame de Girardin. The intimate nature of *Jocelyn*, which might escape a reader unfamiliar with Lamartine's autobiography, was also clearly perceived by the most acute critic of the time, Charles Augustin Sainte-Beuve, who led the revival of this kind of verse in the 1830s and praised Lamartine for his successful foray into the realm of 'private, domestic, familiar poetry'.[10] The element of personal inspiration in *Jocelyn* was stressed by Lamartine himself in a letter to Virieu: '*Jocelyn*, an episode of intimate poetry . . . It is the poetry of a sixteen-year-old, but in accord with my heart and dreams.'[11]

It was precisely this personal strain in *Jocelyn*, half-revealed, half-disguised in Lamartine's customary manner, which lent the book its unique charm and fascination. In the first place, concealed by the aspect of religious edification, lies the story of a love affair – the nostalgia for a pure and uncorrupted love which had haunted Lamartine ever since his early years of debauchery. Like all the Romantics, the poet believed that unfulfilled love was the only kind which lasted; chastity was vital to its potency, and self-sacrifice – from one or both parties – was essential to its preservation. Secondly, the account of the village curate who lives through the vicissitudes of the Revolution and is tempted away from his vocation by human love, was based on the author's personal experience. The abbé Dumont, a close acquaintance of Lamartine's, was a young extrovert priest who had enjoyed worldly pleasures and, it was rumoured, had had a love affair with Mademoiselle de Milly, the daughter of a local nobleman. In 1791, moreover, he had signed the oath of allegiance demanded of the clergy and had remained comfortably in his rectory at Bussières until his death in 1832. The tombstone inscribed to Dumont's memory by Lamartine, his close friend, remains in the churchyard to this day. It is clear, then, that the memory of this village curate provided the immediate source for the Jocelyn of Lamartine's poem. There, however, the similarity between the two ends, for Dumont was not particularly saintly, nor were chastity and self-sacrifice his strong points. Lamartine has simply drawn on his personal recollection of the man, strengthening and idealising his portrait in the process. The fictional Jocelyn thereby attains the kind of symbolic stature of the ideal village curate,

simple, kindly, generous, humanitarian and, above all, totally free of religious dogma.

And yet the whole of *Jocelyn* is marked by a deeply ambivalent attitude towards religion and the priesthood. The book is far from a simple-hearted apology in favour of Catholicism on the lines of Chateaubriand's *Génie du Christianisme*, however much the two works have in common. Writing 30 years later than Chateaubriand, Lamartine was the child of his age and, like most of his contemporaries, he felt deeply divided on the subject of religion. On the one hand, brought up in the tradition of a pious, aristocratic family and in the memory of a devout mother, Lamartine felt a deep-rooted and lasting respect for the Catholic religion, which he refused to disavow, even under the persistent promptings of his liberal friends. He never entirely broke the umbilical cord, preferring instead to retain a measure of freedom to criticise and argue, but always within the confines of a religious or semi-religious context. On the other hand, he could not escape the philosophi-

84 **Jocelyn saving Laurence from death**
Lithograph after Nicolas Eustache Maurin

cal and humanitarian temper of his own age. The social preoccupations of writers like Lamennais, Ballanche, Pierre Leroux and Saint-Simon inevitably left their mark, especially during the period from 1830-6 when official Catholicism came increasingly under attack and religion was generally in decline.[12] With an optimistic faith in humanitarian ideals and the evolution of mankind, they looked forward to a new age of peace, tolerance, equality and universal love. To some extent – partly from opportunist political reasons – Lamartine shared their ideals, but to the intense annoyance of his free-thinking friends like J-M. Dargaud, he refused to break openly with Catholicism, even when he recognised the impossibility of many of its tenets. This is why Lamartine, and *Jocelyn* in particular, failed to satisfy either party. Denounced by the Catholics for its vagueness and tentative approach to the truths of religion, *Jocelyn* also disappointed the liberals and anti-clericals with its vestigial religious sentiment and its celebration of the priesthood.

Lamartine's aim was indeed to show the virtues of religion and the priesthood, but in a human rather than divine sense, in terms of their efficacy and power for the good of mankind. In his eyes, the greatest need was to modernise Catholicism and to bring religion into line with mid nineteenth-century philosophy. In an important preface to his complete

85 **The Harvesters in the Pontine Marshes**
Léopold Robert (Paris, Louvre)

works, entitled *Des Destinées de la Poésie*, he defined the future role of poetry as
'philosophical, religious, political, social, like the eras which mankind will travel through'.
For this reason, he constantly stresses the basic human content of Jocelyn's religion, and this
is why he makes Jocelyn a simple man, modest, poor and, above all, susceptible to human
love. He is no outstanding paragon of virtue, and often feels doubt and dejection. No
greater contrast could be imagined between Jocelyn and his superior, the Bishop of
Mâcon, a remote, authoritarian cleric and the embodiment of official religion.
Furthermore – and this is what offended Catholic sensibility most deeply – Jocelyn is a
priest without a true sense of vocation, who enters the Church not from a sense of
personal mission but in voluntary self-sacrifice, to enable his sister to marry. Even after his
ordination Jocelyn is clearly not a man who has renounced the world and the lure of
sensuous pleasure. He is susceptible not only to the charms of women, but to the beauties
of nature, the glory of Alpine scenery, the splendour of burgeoning springtime to a degree

86 **Les Femmes Souliotes**
Ary Scheffer (Paris, Louvre)

which might seem dangerous, even suspect, in a priest. Jocelyn is, in fact, like the author, a
lyric poet of superabundant imagination. All this puts him at odds with his role of humble
village curate. In fact, with his great capacity for love which he never entirely manages to
suppress, Jocelyn is a living argument against the celibacy of the priesthood. Here again
Lamartine found the ranks of the Catholic Church ranged against him, and in September
1836, on papal authority, *Jocelyn* was placed on the index of proscribed books.

The poetry of *Jocelyn* lies in its magnificent imagery and an unrivalled sequence of
passages describing the Alpine landscape. In an article devoted to the poem, the critic
Gustave Planche wrote that in his portrayal of the Alps Lamartine had found 'true colours,
brilliant but not crude, varied but not false'.[13] Mountains, cataracts, rocks, waterfalls, snow-
clad peaks and soaring pine trees all form part of the décor of *Jocelyn* which, though

certainly indebted to the eighteenth-century tradition of Alpine literature, sprang directly from Lamartine's own experience and love of the Dauphiné region. Unlike the eighteenth-century writers, however, Lamartine's method is not purely descriptive. Instead he brings all his senses to bear on the subject – sight, sound and smell – in the attempt to create a total picture of the scene; detail, though finely observed, is subordinated to the writing and harmony of a general impression. Those who look for the poetry of *Jocelyn* in 'fine lines' and striking metaphor may be disappointed, for its effect depends on its sweep and overall structure. A supreme example of Lamartine's poetic gift of evocation is the passage describing the arrival of spring in the mountains, in the Quatrième Epoque of the poem:

> *Il est des jours de luxe et de saison choisie*
> *Qui sont comme les fleurs précoces de la vie,*
> *Tout bleus, tout nuancés d'éclatantes couleurs*
> *Tout trempés de rosée et tout fragrants d'odeurs*
> *Que d'une nuit d'orage on voit parfois éclore,*
> *Qu'on savoure un instant, qu'on respire une aurore,*
> *Et dont, comme des fleurs, encor tout enivrés,*
> *On se demande après: Les ai-je respirés?*
>
> (IV, 15-22)

('Splendid days and perfect seasons are like life's early flowers, all gay, all blended with brilliant colours, drenched in dew and fragrant with the scents that a stormy night sometimes yields, which we savour for a second, of which we breathe in a dawn, and after which, like flowers that have quite intoxicated us, one wonders, Have I breathed them?') Two pages later the author goes on to elaborate this picture, creating the most extraordinarily rich and varied tapestry of effects in which the grass, ivy, flowers and trees weave their intricate patterns:

> *Tout ce que l'air touchait s'éveillait pour verdir,*
> *La feuille du matin sous l'oeil semblait grandir;*
> *Comme s'il n'avait eu pour été qu'une aurore,*
> *Il hâtait tout du souffle, il pressait tout d'éclore,*
> *Et les herbes, les fleurs, les lianes des bois*
> *S'étendaient en tapis, s'arrondissaient en toits,*
> *S'entrelaçaient aux troncs, se suspendaient aux roches,*
> *Sortaient de terre en grappe, en dentelles, en cloches,*
> *Entravaient nos sentiers par des réseaux de fleurs,*
> *Et nos yeux éblouis dans des flots de couleurs!*
>
> (IV, 73-84)

('Everything touched by the air sprang into life. The morning leaf seemed to grow under the eye; as if summer had lasted only for a dawn, it hastened everything into blossom with its breath, and the grass, flowers, creeper spread out like a carpet, rounded out dome-like, twisted round the trunks, fell from the rocks, burst forth from the earth in clusters, in lacy fronds, clogging up our path with a web of flowers, dazzling our eyes with waves of colour.')

A persistent feature of Lamartine's poetry is the use of reflection, of one image reflected in another, creating an almost vertiginous impression of the richness and variety of nature:

> Tous ces dômes des bois, qui frémissaient aux vents,
> Ondoyaient comme un lac aux flots verts et mouvants . . .
>
> (IV, 93-4)

or again:

> Lac lipide et dormant comme un morceau tombé
> De cet azur nocturne à ce ciel dérobé . . .
>
> (II, 633-4)

('The forest canopies which quiver in the wind ripple like a lake with green and moving billows . . . Limpid lake, sleeping like a fragment fallen from this nocturnal azure to the hidden sky . . .') These mirror-like images are closely linked in the poet's mind with ideas of brilliance, clarity and limpidity. Snow-capped peaks tinged with pink by the sun, the clear dark waters of lakes, the crystalline effect of snow and ice, the diaphanous texture of vine-leaves in the evening sun and the azure dome of a cloudless sky: these recurrent images in *Jocelyn*, like separate fragments, contribute to the unity of the overall picture. Many images are, so to speak, a distillation of other sensations, smell and taste, like the unforgettable opening lines describing the delicious sensation of days gliding past like fruit melting in the mouth:

> Le jour s'est écoulé comme fond dans la bouche
> Un fruit délicieux sous la dent qui le touche,
> Ne laissant après lui que parfum et saveur.
>
> (I, 1-3)

('The day passed like a delicious fruit which sinks into the mouth under the teeth which touch it, leaving behind only scent and savour.')

Much of the beauty of *Jocelyn* is due to the poem's variety of mood and inspiration. The use of alternating rhythms and different rhyme patterns – alexandrines, octosyllables, decasyllables – helps to avoid the monotony which can easily result from a long sustained narrative in verse. The reader can breathe, put the book down or pick it up again, depending on his mood. No poetry offers a more faithful reflection of the

movements of the human spirit, oscillating between joy and sorrow, faith and doubt, optimism and dejection. But the most poignant passages are those recalling past happiness and the transience of human life. Here memory comes as a powerful aid to the poet's imagination, when Jocelyn returns to the scenes of his earlier happiness:

> *Quand j'eus seul devant Dieu pleuré toutes mes larmes,*
>
> *Je voulus sur ces lieux, si pleins de tristes charmes,*
>
> *Attacher un regard avant de mourir,*
>
> *Et je passais le soir à les tous parcourir.*
>
> *Oh! qu'en peu de saisons les étés et les glaces*
>
> *Avaient fait du vallon évanouir nos traces!*
>
> *Et que sur ces sentiers si connus de mes piés,*
>
> *La terre en peu de jours nous avait oubliés!*
>
> *La végétation, comme une mer de plantes,*
>
> *Avait tout recouvert de ses vagues grimpantes,*
>
> *La liane et la ronce entravaient chaque pas;*
>
> *L'herbe que je foulais ne me connaissait pas . . .*
>
> (IX, 1413-24)

('When I had wept all my tears alone before God, I wanted to look once again before dying upon these places so full of sad charm, and I spent the evening scouring them. O, how in such a short time the summers and frosts had obliterated our traces in the valley! And the earth of these tracks which my feet knew so well had forgotten us in so few days! The vegetation, like a sea of plants, had covered everything again with its twining surges, and the creeper and bramble hindered each step; the grass I trod knew me no longer . . .')

The question remains: what, if anything, did painting contribute to the composition of *Jocelyn* and, second, what effect did *Jocelyn* have on French art of the period? It should already be apparent from these extracts that although visual imagery is abundant in Lamartine's poetry, it by no means predominates as in the poetry of Hugo, or even Musset or Vigny. It lacks the precision and sharp focus which often indicate the presence of a painting behind a poetic image; as in the *Méditations*, Lamartine is content with vague, generalised terms and rarely allows his eye to dwell on detail for long. He was, it must be admitted, the least pictorially-minded of the writers discussed in this study. Nevertheless, there is one significant exception to this rule. The passage entitled *Les Laboureurs* (*Jocelyn, Neuvième Epoque*), one of the most richly poetic in the entire book, celebrating agriculture and the joys of rural life, was directly inspired by Léopold Robert's picture *The Harvesters in the Pontine Marshes*, exhibited at the Salon of 1831 [Fig. 85].[14] In a note to the first edition of *Jocelyn* Lamartine explicitly acknowledged his debt to the painting: 'Reading these poems, the reader can have no doubt that the poet was inspired here by the painter.

The inimitable picture of the Harvesters by the unfortunate Robert is obviously the model for this piece!'[15]

This statement is clear proof of the high esteem in which Lamartine held the work of Léopold Robert, and a positive refutation of certain critics who can see no parallel between Robert's rather stereotyped and operatic vision of Italian life and the simple Virgilian grandeur of Lamartine's verse. The important point here is not how later generations saw a painter such as Robert, but how Lamartine and his contemporaries saw him. To them Robert was not – as he seemed to Courbet – a chocolate-box painter, but an inspired genius who created an imagery which appealed to the sentimental needs of an entire generation. 'Never', Lamartine wrote, 'has a writer or a poet been more in sympathy with more souls at once.'[16]

In his enthusiasm for Léopold Robert, Lamartine was simply in tune with current fashion. In his *Histoire de la littérature dramatique*, Jules Janin recalls the vast popularity enjoyed by *The Harvesters in the Pontine Marshes* diffused throughout France by countless engravings by Mercuri among others: 'We remember the Harvesters with rapture, with tears, like a revelation, when the crowd pressed up to it, intoxicated with delight . . .'[17] For Lamartine and many others Robert's painting represented a great pictorial epic of mankind, the equivalent of his own poetic creation. Later, in the *Cours familier de Littérature* (published between 1856 and 1869), Lamartine reaffirmed his deep admiration for *The Harvesters in the Pontine Marshes*, describing it as 'the complete image of earthly happiness' and a hymn of praise in favour of laborious humanity and the basic instincts of family life. Again he drew the parallel between Robert's painting and his own verse: 'I too have sung the episode of the ploughmen in *Jocelyn*, my domestic poem; but how pale my ink is beside the colours of his palette.'[18]

To enable the reader to compare the painting with the passage inspired by it – and to measure the differences between them – an extract from *Les Laboureurs* is quoted below. In his portrayal of this bucolic idyll, Lamartine makes no attempt at a literal transposition of the painting. He uses it rather as the springboard for his own imagination, creating an unforgettable picture of Arcadian simplicity:

> *Laissant souffler ses boeufs, le jeune homme s'appuie*
> *Debout, au tronc d'un chêne, et de sa main essuie*
> *La sueur du sentier sur son front mâle et doux,*
> *La femme et les enfants tout petits, à genoux*
> *Devant les boeufs privés baissant leur corne à terre,*
> *Leur cassent des rejets de frêne et de fougère*
> *Et jettent devant eux en verdoyants monceaux*

Les feuilles que leurs mains émondent des rameaux;

Ils ruminent en paix, pendant que l'ombre obscure,

Sous le soleil montant, se replie à mesure,

Et, laissant de la glèbe attiédir la froideur,

Vient mourir et border les pieds du laboureur.

(IX, 327-58)

('While the oxen breathe, the young man stands leaning against the trunk of an oak and with his hand wipes the damp from the sweaty climb on his strong gentle face. The woman and tiny children, kneeling before the tame oxen with their horns lowered to the ground, break off shoots from the ash and fern and throw before them verdant heaps of leaves whose branches their hands have lopped; the oxen chew the cud in peace, while the sombre shadows shift under the rising sun and, leaving the earth to be warmed, recede and touch the ploughman's feet.')

This tribute to the dignity of human labour is completed by a hymn to the earth, the image of fertility and the source of all life:

O travail, sainte loi du monde,

Ton mystère va s'accomplir;

Pour rendre la glèbe féconde,

De sueur il faut l'amollir!

(IX, 351-5)

('O toil, holy law of the world, your mystery will be fulfilled; to make this earth fruitful, it has to be softened with sweat.')

Paintings with literary subjects from Lamartine

The second aspect of the problem, that is the reverse effect of Lamartine's poetry and, in particular, of *Jocelyn* on French art of the nineteenth century, has received practically no attention from scholars. A considerable number of paintings were however exhibited at the Salon with subjects from Lamartine's writings. Though most of these were by unfamiliar or completely unknown artists, their sheer number indicates the strong illustrative appeal of Lamartine's work and suggests that he may even have actively influenced the course of mid-nineteenth-century art, notably in a devotional and non-realistic direction. Such a suggestion must remain provisional until more of the paintings (or engravings after them) have been located and reproduced. A statistical count of the Livrets of the Salon reveals that between 1820 and 1881 no less than 71 works with subjects from Lamartine were exhibited; of these 24 were taken from the *Méditations* and the *Harmonies poétiques*, 16 from Jocelyn, 12 from *Graziella*, and four from *La Chute d'un Ange* and the remainder from other

works including the *Voyage en Orient*, the *Confidences* and the *Histoire des Girondins*.

A highly significant painting, *Les Femmes Souliotes* (1827, Paris, Louvre) [Fig. 86] by the Dutch-born Ary Scheffer (1795-1858) was probably directly inspired by Lamartine's *Dernier chant du Pèlerinage d'Harold*, which appeared in 1823.[19] The book is a kind of elaboration and completion of Byron's poem of the same title. Its liberal, philhellene inspiration clearly held a powerful appeal for an artist with strong political sympathies like Scheffer. The episode he chose to portray is taken from Canto XXVI of the poem relating the heroic death of 60 Greek women who, rather than fall captive to the Turks, throw themselves one by one off a rock into the abyss below:

> *Chaque mère, à ces mots, dans l'abîme sans fond,*
> *Jette un poids à son tour, et l'abîme répond;*
> *Puis, formant tout à coup une funèbre danse,*
> *Entrelaçant nos mains et tournant en cadence . . .*
> *Comme un anneau brisé d'une chaîne de mort,*
> *S'en détache, et d'un saut s'élance dans l'abîme.*

('At these words, one by one, each mother throws herself into the bottomless chasm, and the chasm echoes; then, suddenly forming a funeral dance, intertwining hands and turning rhythmically . . . like a broken link in the chain of death, breaks away from it and with a leap throws herself into the abyss.')

We shall never, unfortunately, know what the majority of these paintings looked like and whether or not they conformed to the text and spirit of Lamartine's writings. What is significant is that they were painted at all; for while the epics, novels and travel books like the *Voyage en Orient* provided a ready-made store of picturesque and sentimental episodes, often in an exotic Italian or oriental setting, poetry – especially the rather ethereal poems of the *Méditations* – would seem the least obvious choice for an artist to represent. What could be harder than to translate poems such as *Souvenir* or *Isolement* into pictorial terms, when they offer nothing more tangible than a nebulous mood or atmosphere? And yet the poems were precisely the most popular subjects with painters, beginning with a work entitled *Souvenir* by *Arsenne* at the Salon of 1827 and running through well into the 1880s; these include two versions of the most famous poem in the *Méditations*, *Le Lac*, one by Emile Perrin at the Salon of 1846, and another by Madame Becq de Fouquières at the Salon of 1880. Alfred de Curzon (1820-95), an artist of more than average talent, evidently felt a strong attraction to Lamartine, since he painted four pictures inspired by the writer, two from *Graziella* and two from the Preface to the *Méditations*. All this indicates the lasting popularity of Lamartine's poetry, from its publication until the last years

87 Graziella
Engraving after Charles Victor Eugène Lefèbvre

of the nineteenth century. It is perhaps significant that from 1850 onwards an increasing number of artists turned to the short novel *Graziella* (written on Ischia in 1844 and later published as part of the *Confidences*), whose appeal evidently lay in its vivid depiction of Neapolitan fisher folk and their picturesque setting. One lost version of *Graziella* which must have been strikingly beautiful, to judge by the engraving after it, was Charles Lefèbvre's painting exhibited at the Salon of 1849 [Fig. 87]. It shows the poor Italian fishergirl offering locks of her hair as a pledge of her love for the handsome young Frenchman (Lamartine) who finally abandons her.

The impact of *Jocelyn* on the French public is clearly attested by the number of paintings inspired by it which began to appear almost immediately after its publication in 1836. The following year Clément Boulanger (1805-42), a pupil of Ingres, exhibited *Jocelyn at the Eagle's Cave*, and Achille Demahis (1801-43), a painting of the scene in which Jocelyn discovers that Laurence is a woman. At the same Salon of 1837 Claude Jacquand (1805-78), a painter in the Troubadour style from Lyon, illustrated two of the book's most dramatic episodes, *Jocelyn at the Bishop's Feet* [Fig. 88] and *Laurence in the Eagle's Cave* [Fig. 89]. The first scene, (Ve Epoque, lines 444-5) illustrates the lines:

> *Sortez, mais non pas tel que vous êtes entré;*
> *Sortez, en emportant la divine colère . . .*

('Leave, but not as you entered; leave swept away by divine rage . . .') as the Bishop of Mâcon vents his fury on Jocelyn, who shows reluctance to abandon Laurence and resume his vocation as a priest. Jacquand's other painting was evidently intended as a pendant to the first as it conforms closely to the sequences of events. Two pages further on Laurence is seen waiting in vain for Jocelyn to return to their mountain retreat:

> *Elle était à genoux sur ses talons pliés*
> *Ses membres fléchissants à la roche appuyés,*
> *Son front pâle et pensif, sous le poids qui l'incline,*
> *Comme écrasé du poids, penché sur sa poitrine,*
> *Ses bras tout défaillants passés autour du cou*
> *De sa biche, qui dort les flancs sur son genou . . .*
>
> (V,571-6)

88 **Jocelyn at the Bishop's Feet**
Lithograph by Louis René Lucien Rollet after
Claude Jacquand

89 **Laurence in the Eagle's Cave**
Lithograph by Louis René Lucien Rollet after
Claude Jacquand

('She was on her knees, her bent limbs supported by the rock, her face pale and pensive,
under the weight which bowed it, as if crushed by its burden, and bent to her breast, her
exhausted arms draped round the neck of the kid which slept, its flank against her knee.')

These two paintings were warmly praised by the critic Auguste Bourjot, who clearly
perceived that the appeal of *Jocelyn* for artists lay precisely in its concordance of mood
between the characters and their surroundings; the poetic ideal matched by a
sublime setting: 'Monsieur de Lamartine's poem has been quite an abundant source of
inspiration for several talented painters. Elevated poetry and intimate fiction are presented
side by side in *Jocelyn*; the author has always managed to combine his landscape
harmoniously with his characters, and to complete and frame all the scenes. *Jocelyn at the
feet of the bishop* and *Laurence awaiting Jocelyn* by M. Jacquand, are both pictures
executed with truth and vigour. The colouring is vivid and rich in tone.'[20]

Jocelyn continued to attract several artists in the 1840s and '50s, notably Gaspard Lacroix
(1810–78), a pupil of Corot who turned twice to the episode of the *Laboureurs*, the first
time in a picture exhibited in 1844, the second in 1849 [Fig. 90]. More definite
conclusions as the nature of Lamartine's effect on the arts must wait until more of the
above-mentioned paintings come to light, but the evidence suggests that, while the impact

of Jocelyn on painters was by no means as deep as that of *Atala* or *Corinne*, it was one of the key nineteenth-century books which, through paintings and engravings, became part of the visual and imaginative repertory of its own time.

Poems inspired by painting

'*Le sublime lasse, le beau trompe, le pathétique seul est infaillible dans l'art. Celui qui sait attendrir sait tout. Il y a plus de génie dans une larme que dans tous les musées et dans toutes les bibliothèques de l'univers.*' (*Les Confidences*)

('The sublime wearies, beauty deceives, only the pathetic is infallible in art. He who knows how to stir our feelings knows everything. There is more genius in a tear than in all the museums and libraries in the universe.')

This explicit statement of Lamartine's idealist philosophy may help to explain why he valued lyric poetry as the supreme expression of human emotion, and why the visual arts played only a small part in his literary activity. Paintings, sculpture and objects generally were too material to express the kind of feelings and atmosphere which belong more to the sphere of music than that of art. The idealism professed by Lamartine – pure emotion springing directly from the heart – implies a certain disregard for the physical properties inseparable from the visual arts. He also wished to avoid the precise detail, the clear-cut contours and the definite colour which painting by its nature imposes on the writer. This is why, perhaps, they play a far less significant role in his verse than in that of the other Romantic poets.

90 **Les Laboureurs (The Ploughmen)**
Gaspard Lacroix (Grenoble, Musée)

Nevertheless, Lamartine was by no means out of touch with contemporary art and certain painters, notably Léopold Robert, Henri Decaisne and Alexandre Calame, inspired him in individual poems. His main contact with painters came from his English wife Marianne, a talented amateur artist who painted portraits of their daughter Julia and of their favourite dog Fido, preserved in the château of Saint-Point.[21] Other works by Madame de Lamartine are a copy of Guido Reni's *Urania* (Mâcon, Musée des Ursulines), *Saints Elizabeth* and *Genevieve* in the church at Saint-Point and an accomplished *Portrait of the Marquise de la*

Grange (dated 1839). She also practised sculpture and designed allegorical statues of the rivers Saône and Rhône (Mâcon, Musée des Ursulines) and a design for the font in Saint-Germain L'Auxerrois, executed by Jouffroy. All this adds up to rather more than the work of a drawing-room artist. Her studio at Saint-Point became the focal point for a number of prominent mid-nineteenth-century artists. 'There are a lot of people here: painters, artists, of all kinds and nothing could be pleasanter than our evenings spent in reading and conversation,' wrote Dargaud to his fiancée in 1834.[22] One distinguished visitor to Saint-Point in 1840, and again in 1858, was Paul Huet, the Romantic landscape painter and an ardent republican, who much admired Lamartine's poetry. In a letter, he

91 **Elm trees at Saint-Cloud**
Paul Huet (Mâcon, Musée des Ursulines)

wrote a warm account of the poet's hospitality: 'I have been to see Monsieur de Lamartine at Saint-Point, and I spent one of the most enjoyable days of my life with him, a simple and friendly welcome, with eager and generous hospitality; the day was spent in good artists' conversation in the shade of delightful woods.'[23] It was probably during this first visit that Huet made his chalk sketch of the château whose towers and ivy-covered Gothic façade offered him a most congenial subject. Whether or not Huet directly influenced Lamartine or vice versa is doubtful, but there is certainly an affinity of mood between them and they shared the same lyrical perception of landscape, as seen in Huet's *Elm trees at Saint-Cloud* [Fig. 91]. This similarity did not escape the critic Gustave Planche, who wrote that, by an inevitable association of ideas, Huet's early paintings recalled the first *Méditations* of Lamartine.[24]

The single painter most intimately associated with Lamartine was the Belgian Henri Decaisne (1799-1852)[25] who studied under Girodet and Gros, the author of the celebrated *Portrait of Lamartine* (1839) now in Mâcon, Musée des Ursulines [Fig. 92]. This portrait, which hung in the poet's Paris apartment on the rue de l'Université, shows Lamartine in his favourite pose as country gentleman, surrounded by his faithful dogs. Though unkindly described by one contemporary Charles Alexandre, as 'painted with a feeble talent', the painting is an excellent piece of characterisation and faithful to the spirit of Lamartine's life and writings. It was clearly a tribute and act of homage to the

92 **Portrait of Lamartine**
Henri Decaisne (Mâcon, Musée des Ursulines)

writer, and is exactly as the author of *La Vigne et la Maison* would have wished to be remembered, relaxed in his native Burgundian countryside. Decaisne was on friendly terms both with the poet and his wife, and during several visits to their home gave Madame de Lamartine instruction in painting and drawing. Madame de Lamartine is said to have asked Decaisne for a sketch entitled *The Christ Child crushing the Serpent with His Foot* to include in her personal album. Later, at the height of his political career in 1848, Lamartine showed his gratitude to the painter by nominating him Inspector of the National Museums. Decaisne's death in 1852 was felt as a great loss by the poet, and Madame de Lamartine paid him a tribute, praising his loyalty, sincerity and intelligence.[26]

Lamartine, for his part, profoundly admired the work of Decaisne and was visibly influenced by it in the poem, *La Femme*, in the *Recueillements Poétiques*. At the Salon of 1836, Lamartine shared Musset's enthusiasm for Decaisne's *The Guardian Angel* [Fig. 93], a painting which may, in its turn, owe its conception to Lamartine's article *Des Destinées de la Poésie*, published in March 1834.[27] The idea of the 'guardian angel' evidently held a powerful emotional appeal for Lamartine and recurs several times in his poetry. It was clearly the portrayal of maternal solicitude associated with religious devotion which attracted Lamartine to Decaisne's picture. This precisely is the theme of *La Femme*, dedicated to Decaisne and inspired by the painting *Charity* (formerly Hamburg) which Lamartine had recently seen at the Salon of 1838. The last lines of the poem pay explicit homage to the painter:

> *Amour et charité, même nom dont on nomme*
> *La pitié du Très-Haut et l'extase de l'homme!*
> *Oui, tu les a compris, peintre aux langues de feu!*
> *La beauté, sous ta main, par un double mystère,*
> *Unit ces deux amours du ciel et de la terre.*
> *Ah! gardons l'un pour l'homme, et brûlons l'autre à Dieu.*

('Love and charity, the same name given to the compassion of the Almighty and to man's ecstasy! Yes, you have understood them, painter with tongues of fire! Under your hand, by a double mystery, beauty unites terrestrial and celestial love. Ah! let us keep one for mankind and let the other burn for God.')

Lamartine was also strongly attracted to the paintings of Alexandre Calame (1810-64), a Swiss painter of Alpine scenery who enjoyed wide favour throughout Europe in the mid-nineteenth century [Fig. 94]. Modern taste may find his work too composed and highly finished, but to Lamartine and his contemporaries Calame represented one of the summits of landscape art. Snow-capped peaks, deep lakes with a mirror-like surface, uprooted pine trees lying across raging torrents, all these elements corresponded closely with Lamartine's personal experiences of the Alpine regions and the majestic sequence of images evoked in *Jocelyn*. The close affinity between Lamartine and Calame and the reciprocal

93 **The Guardian Angel**
Henri Decaisne (Paris, Louvre)

94 **Landscape with Mont–Blanc**
Alexandre Calame (Genève, Musée d'Art et d'histoire)

admiration which united them was noted by the artist's biographer.[28] As evidence of this
he quotes the following letter of 27 February 1849 from Lamartine to the painter: 'I always
have in front of me and in my memory the beautiful page of painted poetry with which
you have adorned Madame de Lamartine's study. I was used to admiring you at the Salon
for your own sake and I had no idea that my admiration would turn to gratitude. I ought
to fill the white margin that you have left expressly under this beautiful drawing with verse
worthy of you, but I have left all poetry on these lakes and in the mountains where you
breathe it so pure and sparkling . . .')[29] This letter reveals, incidentally, that Lamartine had

already admired the work of Calame at the Paris Salons before he received the landscape or sketch as a present from the painter.

Is the painting mentioned in this letter to be identified with the landscape which inspired the poem *Mont Blanc, sur un paysage de Monsieur Calame*?[30] The editor of the Pléiade edition[31] notes that this poem was first announced under the title *Paysage* in the *Revue des Deux Mondes* (1 May 1843) as follows: 'The celebrated landscapist from Geneva, Calame, has sent this time [to Madame de Lamartine's lottery] a beautiful scene representing the summit of the Alps covered in snow, with a valley and lake in the distance.' Though he fails to connect this painting with the one in the letter quoted above, it would seem that they are the self-same landscape, given to Madame de Lamartine as a present. However, the letter suggests that Lamartine had still not written the poem he intended to write, and that the poem can only have been composed in 1849 (when the letter is dated) or afterwards. Whatever its exact date, the poem *Mont Blanc* makes no attempt at a literal rendering of Calame's painting. For Lamartine the landscape was merely a point of departure as he turns its grandiose Alpine scenery into a symbol of the heights of solitary genius:

> *Montagne à la cime voilée,*
> *Pourquoi vas-tu chercher si haut,*
> *Au fond de la voûte étoilée,*
> *Des autans l'éternel assaut?*

> *. . . Ah! c'est là l'image sublime*
> *De tout ce que Dieu fit grandir:*
> *Le génie à l'auguste cime*
> *S'isole aussi pour resplendir.*

('Mountain with your veiled summit, why do you seek so high the eternal battering from the elements in the depths of the starry vault? . . . Ah, there is to be found the sublime image of all that God makes great: genius also isolates itself to shine brightly on the majestic summit.')

CHAPTER VII

ALFRED DE VIGNY (1797-1863)

'*Les beautés de tout art ne sont possible que dérivant de la vérité la plus intime*'. (*Stello*) ('Beauty in all art is only possible when it comes from the most intimate truth.')

In any survey of French literature, Alfred de Vigny is the hardest poet to classify. He was, in every way, an exceptional figure, proud, sensitive, aloof, pursuing his solitary thoughts in defiance of what he saw as a hostile world. Born in 1797, the son of an impoverished noble family, Vigny retained from his background an exaggerated aristocratic pride which took the form of a highly personal moral code based on a stoical conception of honour and duty. During a short military career in the Royal Household, which he entered in 1814, he was briefly able to live up to his own ideal and to translate his heroic dreams into reality. This is how the young officer appears in the anonymous portrait in the Musée Carnavalet in Paris[Fig. 95], his neck firmly encased in a rigid collar, wearing a scarlet uniform resplendent with epaulettes and polished buttons. Here Vigny is, every inch, the typical officer and gentleman with a visible stiff upper lip, indifferent to hardship and suffering.

The reality of military life for Vigny, however, was very different, for during the Spanish campaign of 1823 he spent most of the time confined to barracks in the Pyrenees and saw very little active service. The tedium and frustration of garrison life is one of the recurrent themes of one of his most important books, *Servitude et Grandeur militaires* (1835), a moving apology in favour of the soldier whom Vigny regarded as one of the 'pariahs' and most abused members of modern society. Even though his own dreams of valour and heroism proved illusory, Vigny never ceased to prize the military virtues above all others. In a significant passage in his Journal he later expressed his ideal of stoical simplicity and heroism in a telling comparison with David's *Oath of the Horatii*: '*Si la misère était ce que David a peint dans les Horaces, une froide maison de pierres, toute vide, ayant pour meubles deux chaises de pierre, un lit de bois dur . . . je bénirais cette misère parce que je suis stoicien . . .*'[1] ('If poverty was what David painted in the *Horatii*, a cold stone house, empty, with two stone chairs for furniture, a bed of hard wood . . . I would bless this poverty because I am a stoic . . .')

The same moral code underlies all Vigny's greatest poems such as *Moise* (1826), *La Colère de Samson* (1839), *Le Mont des Oliviers* (1839) and *La Mort du Loup* (1838). They are conceived on a grand, epic scale and expressed in language of restrained eloquence which

marks them out as some of the greatest but least typical creations of the Romantic period. Their common ethos is admirably summarised in the famous lines from *La Mort du Loup*: '*Seul le silence est grand; tout le reste est faiblesse.*' ('Only silence is great; all the rest is weakness.') Unlike Hugo, Lamartine and Musset, Vigny is never prolix. His poetry is contained in the most highly concentrated form which subordinates emotion, though often strong and passionate, to a strict discipline of order and harmony. The result has more in common with the classical concision of a poet such as André Chénier, who he greatly admired, than with his own contemporaries. Silence, solitude and deep concentration were, in Vigny's eyes, the most valued qualities and the absolute prerequisite for artistic creation. Only in such conditions could the artist – or priest, soldier, legislator or creative individual of any kind – extract the true substance of his work and discover the form appropriate to his inner thoughts.

95 **Portrait of Alfred de Vigny**
Anonymous (Paris, Musée Carnavalet)

Vigny's poetic and artistic creed tends, therefore, towards an almost Platonic concentration on pure ideas and the elimination of all extraneous matter. Though rich and abundant in imagery of many different kinds, culled from many sources including the Bible, Homer, Milton, Ossian, sculpture and painting, Vigny never allows his imagination[2] to run riot, as Hugo frequently does. Everything in his verse is firmly subjected to a central theme or idea. In his theoretical writings like *Le Journal d'un Poète* and in his *Correspondance*, Vigny constantly reverts to his basic conception of art as a concentric sphere, a focal point around which the artist gathers the many different types of beauty diffused throughout nature: he defines the rounded and finite form of the globe, with its varied and brilliant colours, as an image of art's axis, pivoting round the central idea.[3] The same notion underlies the poem *La Beauté Idéale*, a homage to the painter Girodet, in which art is described as a prism:

> *A son gré si la Muse imitait la nature,*
> *Les formes, la pensée et tous les bruits épars*
> *Viendraient se rencontrer dans le prisme des arts,*
> *Centre où de l'univers les Beautés réunies*

Apporteraient au coeur toutes les harmonies,

Les bruits et les couleurs de la terre et des cieux,

Le charme de l'oreille et le charme des yeux.

('If the Muse imitated nature to her liking, shapes, thought, and all the scattered sounds would come together in the prism of arts, the centre where the combined beauties of the universe would bring to the heart all the harmonies, sounds and colours of the earth and skies, to delight the ear and eyes.') In this almost synaesthetic conception of art, sights, sounds and colour meet around a central point. This is why Vigny's greatest poems like *La Bouteille à la Mer* (1854) and *La Maison du Berger* (1844), though long and diffuse in passages, all converge on one simple and noble theme. His guiding principle was a passionate belief in the value of human effort, even when everything else − God, nature and the laws of the universe − conspires to frustrate mankind and condemn it to suffering. This bleak pessimism combined with a stubborn faith in human values makes Vigny the supreme philosophical poet of the French language.

Given the nature of Vigny's moral and philosophical beliefs, it is natural that his poetic ideal was one of simplicity and purity. His verse shows a persistent love of simple, clear-cut forms, mirror-like surfaces, limpid water and fountains, colours of the rainbow and all kinds of diaphanous and transparent effects. These are the recurrent images of Vigny's poetry: '*source à l'onde pure*', '*cristal liquide*' *(Le Bain de Suzanne),*' *vague de cristal*' *(Le Déluge),* '*Il est dans le Ciel même une pure fontaine; Une eau brilliante y court sur un sable vermeil*' *(Eloa).* ('In heaven itself there is a pure fountain where glittering water runs on ruby-red sand.') Diamonds and precious stones serve to express ideas of hardness, resilience and the clear-sightedness of genius. In *La Maison du Berger*, Vigny's most sustained piece of lyrical writing, the art of poetry is hailed as: '*Poésie! ô trésor! perle de la pensée!*' and, in the same poem, compared with a brilliant, shining mirror ('*Ce fin miroir solide, étincelant et dur*'). Again, in the *Journal d'un poète* (October 1837), poetry is described as 'crystallised Enthusiasm'. Vigny also displays a preference for clear, even light, as in the description of paradise

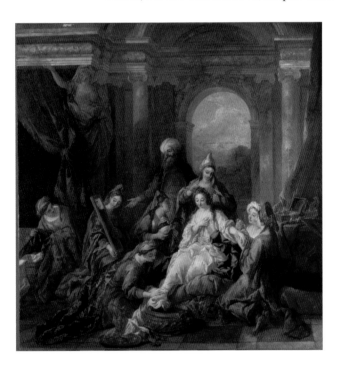

96 **The Toilet of Esther**
Jean-François De Troy (Paris, Louvre)

in *Eloa* – almost as in early Flemish or fifteenth-century Italian painting – without *chiaroscuro* or the murky intrusion of darkness and shadow. Similarly Eloa's profile has a Raphaelesque purity, 'serene and pure as a beautiful lily'. On the other hand, counter-balancing this tendency towards chastity and immobility, there was a strongly voluptuous streak in Vigny's nature. This found an outlet in imagery of a richly sensual kind, in soft oriental perfumes, elaborate gilded boudoirs and, above all, the erotic charms of the *femme fatale* who, nonchalantly reclining on her couch, has her lover poisoned as in the poem *Dolorida*); or like Dalila in *La Colère de Samson*, the lascivious jewel-bespangled mistress who betrays the great man to his enemies. Vigny also felt a persistent nostalgia for the decadent erotic charms of *dix-huitième* art, especially Nattier and Greuze. Similar sensations of soft voluptuous pleasure and indolence are evoked in *Le Bain d'une Dame Romaine*, a poem possibly suggested by De Troy's painting of *The Toilet of Esther* (1738) in the Louvre [Fig. 96] in which a Roman lady, surrounded by an entourage of female slaves, performs the elaborate ritual of her toilette amidst urns and glittering mirrors. Nearly always, however, physical pleasure in Vigny's poetry is associated with guilt. As a result of his stormy affair with the actress Marie Dorval, who proved a notoriously fickle mistress, Vigny became a profound misogynist, believing that women used their female charms to ensnare and emasculate great men. The creative individual, therefore, in his view must preserve all his strength for his real task in life. In a mood of pessimistic resignation, Vigny therefore adopted the life of a recluse in an ivory tower, especially after 1848 and the collapse of his political ambitions. Amidst the remote countryside of Le Maine-Giraud in the Charente, he finally discovered '*la sainte solitude*', the peace and equilibrium which enabled him to come to terms with his own nature and observe the turbulent events of the outside world from a calm philosophical viewpoint.

Though Vigny's prime concern as a poet was with moral, religious and philosophical problems, he was by no means indifferent to the visual arts.[4] Paintings, drawings and sculpture played a considerable part in his creative process and, in particular, helped to provide the external form, the colour and shapes, needed to clothe his philosophical ideas. Vigny's response to the arts and the workings of his imagination were very different from those of Hugo. Hugo was a visionary who saw things whole, in whose mind pictorial images arose spontaneously. Vigny, on the other hand, had a less fertile imagination but a more disciplined mind; deliberately and purposefully, the poems are constructed like an edifice, starting from the bare thread of an idea or narrative, and then progressively adding the external details and elaborating the *mise en scène*. The visual arts were therefore less integral to his imagination, but no less important to his working method. On several

97 Statue of Moses
Michelangelo (Rome, San Pietro in Vincoli)

occasions in his *Correspondance* Vigny expressed his own approach to the task of writing poetry in terms of the artist in front of his easel: 'A great painter produces sketches and outlines ceaselessly, day and night, despite himself; but he must choose only the finest for translation into painting.'[5] Selection and concentration were, therefore, fundamental to Vigny's conception of artistic creation, whether painting a picture or writing a poem. It is clear, moreover, that like the artists he most admired, Raphael, Michelangelo and Girodet, Vigny went about writing in the same manner, beginning with a sketch, or initial idea, rejecting mistakes, until he finally and painstakingly achieved the desired result.

Awareness of his own laborious working method sometimes led Vigny to compare himself with a sculptor, hewing out poems from a mass of amorphous material: 'I always loved to lead the life of a sculptor.'[6] Inevitably the reader thinks of the larger-than-life figures of Vigny's poems, like Samson and Moses, in terms of sculpture. The great sculptors of Greek and Egyptian antiquity and Michelangelo opened up to him a world of power, heroism and nobility which he strove to emulate in his own verse. The whole of Vigny's work is deeply marked by philhellenism. As a child he had stood spellbound in the Louvre in front of the *Apollo Belvedere*, *Venus and her Sisters*, *Niobe*, and the *Laöcoon*.[7] He possessed plaster casts and drawings of the most famous classical statues, and on a visit to London in 1836 he admired the Elgin marbles. In 1827, when the Egyptian gallery of the Louvre was opened, Vigny was profoundly impressed by the enormous figures of gods and kings, shown seated with their knees closely pressed together. The hieratic rigidity of this sculpture left a distinct mark on *La Colère de Samson*, especially in the lines which compare Samson's male strength with an Egyptian colossus:

> *Les genoux de Samson fortement sont unis*
> *Comme les deux genoux du colosse Anubis.*

('Samson's knees are strongly joined like the two knees of the colossus Anubis.')

The same habit of visualising figures from biblical history in sculptural terms is evident in *Moise*, published in 1822. The theme of the poem is a recurrent one in Vigny –

the lassitude and isolation of the genius-prophet abandoned by God once his task is accomplished:

> *O Seigneur! j'ai vécu puissant et solitaire,*
>
> *Laissez-moi m'endormir du sommeil de la terre!*

('O Lord! I have lived strong and solitary. Let me sleep in the earth's slumber!')

Though Vigny's treatment of the subject was clearly indebted to the Bible and earlier literature,[8] his presentation of Moses, an unforgettably powerful and lonely figure, would hardly have been possible without some reference to Michelangelo's statue in San Pietro in Vincoli in Rome [Fig. 97]. Stendhal was one of the first writers to predict the enormous importance of this statue for nineteenth-century art.[9] Despite significant differences – Vigny's prophet is upright while Michelangelo's is seated – Vigny's Moses shares with Michelangelo's statue the same epic proportions and the same tragic grandeur ('*L'orage est dans ma voix, l'éclair est sur ma bouche*') ('The storm is in my voice, lightning is on my mouth.') Moreover, Vigny is known to have felt a powerful sympathy for Michelangelo as a man and artist, whom he saw as one of the supreme examples of persecuted genius.

In general, therefore, Vigny displays a consistent tendency towards sculptural forms and large figures conceived on an epic scale, strongly detached from their setting and other secondary figures. They tower above the rest of humanity by their sheer volume and stature which, according to Vigny's pessimistic ethos, predestines them for the tragic fate of all great men.

Vigny's second great cry of anguish and despair is *Le Mont des Oliviers*, published in 1844. The poem shows Christ on the Mount of Olives, abandoned by his disciples who are fast asleep at his feet, addressing a series of desperate questions to God, his creator, demanding the reason for the existence of so much evil and injustice in this world, and some explanation for the suffering he has to undergo. These problems, which had troubled Vigny's conscience for many years, once to the point of denying the divinity of Christ altogether, all find a passionate outlet in this great poem. Needless to say, God no more comes to the rescue of Jesus than he did to Moses. His only answer to his son's profound despair is a stony silence:

> *Si le Ciel nous laissa comme un monde avorté,*
>
> *Le juste opposera le dédain à l'absence*
>
> *Et ne répondra plus que par un froid silence*
>
> *Au silence éternel de la Divinité.*

('If God leaves us as imperfect world, in his absence the righteous man will oppose disdain and will only reply with a cold silence to God's eternal silence.')

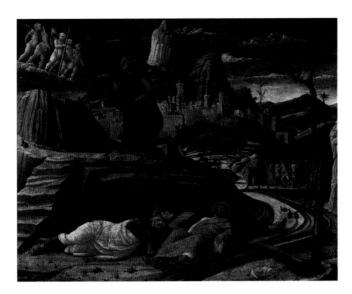

98 The Agony in the Garden
Andrea Mantegna (London, National Gallery)

The origins of this poem have been much dicussed.[10] Much of its emotion springs directly from Vigny's personal religious doubts, pent-up over a long period of time and finally released in this great *cri du coeur*. These had been recently reinforced by his reading of the works of modern thinkers, like David Strauss' *Das Leben Jesu* (translated into French in 1835) which tended to reduce or deny altogether the role of God in creation and to view Christ as a purely human figure. Vigny's deep pessimism, however, and his sense of religious uncertainty never allowed him to settle for such a facile solution, for he knew that the kind of problems raised in *Le Mont des Oliviers* permitted of no simple answer. The only dignified stance, for him, was one of silent resignation and contempt for a Creator who allowed such suffering in His name. One final experience may also have contributed to the composition of this poem. When in London in 1838, Vigny had seen the painting *The Agony in the Garden* by the great Italian Renaissance artist, Andrea Mantegna; then in the collection of Lady Blessington, the painting is now in the National Gallery, London[11] [Fig. 98]. Though different in many respects from Vigny's poem, Mantegna's painting may have helped Vigny to visualise the setting of the Mount of Olives, with its simple sculptural forms, its barren rocks and skeleton-like trees. As so often in the process of transformation of a work of art, Vigny drastically simplifies the setting, reducing it to the bare essentials. He omits the city of Jerusalem on the right in Mantegna's painting, and his Christ is clad in a white shroud, not like Mantegna's, in a dark robe. In essentials, however, the composition of *Le Mont des Oliviers* is identical to Mantegna's *Agony in the Garden*: the apostles, like dead men, are slumped in a deep sleep ('*Mais un sommeil de mort accable les apôtres*'), and in both, Christ, a solitary figure on a rock, implores the protection of his divine Father. The same gaunt simplicity marks the painting and the poem. But the difference of meaning in the one and the other is crucial, for whereas Mantegna's work was conceived in a profoundly religious spirit, Vigny's poem starts from an entirely different premise: the philosophical despair of a nineteenth-century mind, anguished by the silence of a God who abandons even His own Son to doubt and solitude.

Vigny's approach to painting and painters, some of whom he knew personally, was consistent. His prime interest in all the visual arts was the perception of form and the expression of an ideal. It was natural therefore that he was instinctively drawn to artists of the classical academic tradition like Raphael, Ingres, Girodet and Flaxman who placed the greatest emphasis on purity of outline and the least on colour and movement. Vigny's involvement with painting was not purely intellectual, however. In fact, on more than one occasion, he expressed a deep love of the art: 'How much pleasure you give me in talking of painting, one of the things I love most,' he wrote to a friend,[12] and in his correspondence he often shows considerable insight into the painter's problems of composition, though not of technique which hardly interested him at all.

As a child, the young Vigny had watched with delight as his mother, a talented amateur, made copies after Raphael and Mignard. He later recalled how Girodet, a

99 **Eloa tempted by Satan**
Jules Claude Ziegler

friend of the family, used to visit their home and, 'with flaming eyes', showed him and his parents his collection of Flaxman engravings which he passed round under the light.[13] Then, like all serious young men of around 1800, Vigny saw and probably collected engravings after the Old Masters, especially Raphael's *The Holy Family*, Guido Reni, Salvator Rosa and Poussin's *The Deluge* [Fig. 104]. Later in life he became close friends with several artists, in particular Girodet, David d'Angers the sculptor, who executed a medallion of Vigny, and Jean Gigoux (1806-94); he also knew Henri Lehmann (1814-82) and Jules Claude Ziegler (1804-56), a pupil of Ingres who drew illustrations for an edition of *Eloa* [Fig.99]. That these relations with artists were not confined to a purely social level is shown by the fact that David d'Angers had a high opinion of Vigny's taste in art. In 1862, when Vigny was seriously ill, Jean Gigoux sent the poet a collection of eighteenth-century prints by Eisen and Gravelot to cheer his spirits.

The range of Vigny's knowledge of art was, therefore, fairly restricted. As in sculpture, he sought noble, idealised forms, ideas, symbols and themes rather than physical detail. His love of purity and transparent effects made him generally indifferent to colour and attentive primarily to line and form. In fact, if we can visualise the slightly ridiculous figure of

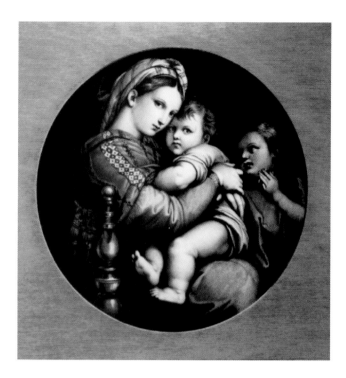

100 Madonna della Sedia
Engraving by Auguste Gaspard Louis Desnoyers after Raphael

Vigny's sex-starved angel Eloa who allows Lucifer to seduce her, it is in terms of pure whiteness. Absence of marked contrast of colour is the common characteristic of all the artists Vigny admired. Mostly, it seems, his imagination worked exclusively in black and white, as in the pure outline drawings of Flaxman which he so admired. In moods of deep pessimism and despair, Vigny's vision was one of unrelieved blackness; in one of his most cryptic and significant utterances, he wrote in his *Journal*: 'If I were a painter, I would like to be a Raphael in black: angelic form and dark colour.'[14]

The art of Raphael was, for Vigny and all the writers of his generation, the supreme embodiment of formal beauty. 'Pure', 'angelic' are the words which most repeatedly crop up in an almost monotonous paean of praise to the artist in Vigny's correspondence. In a letter to fellow poet Auguste Brizeux, he congratulated the latter on a poem entitled *Marie*: 'Your Marie is as beautiful as Raphael's Virgins.'[15] Vigny, of course, thought of Raphael almost exclusively as the painter of beautiful women as in the *Fornarina*, tender Madonnas (*The Madonna della Sedia*) [Fig. 100] and religious ecstasy (*The Transfiguration*). It was in the spirit of a Raphael Madonna that Vigny taught the actress Marie Dorval to enact the role of Kitty Bell, surrounded by her children, in his play *Chatterton* (1835).[16] Moreover, the same Raphaelesque atmosphere pervades the entire opening section of *Eloa*. Though the painter's name is never mentioned, we are infallibly reminded of Raphael's art in the slightly contrived religious purity which Vigny's angel is supposed to embody:

> *Toute parée, aux yeux du Ciel qui la contemple,*
> *Elle marche vers Dieu comme une épouse au Temple . . .*
> *Ses ailes sont d'argent; sous une pâle robe*
> *Son pied blanc tour à tour se montre et se dérobe,*
> *Et son sein agité, mais à peine aperçu,*
> *Soulève les contours du céleste tissu.*

('All adorned, with eyes cast up to the heavens which look down upon her, she moves towards God like a bride at the temple . . . Her wings are of silver; her white foot appears and disappears under her light-coloured robe, and scarcely perceptibly, her agitated bosom lifts the outlines of the heavenly gauze.')

This same ethereal quality suggesting the ceaseless aspiration towards some higher ideal can be found in nearly all Raphael's work. In the *Sistine Madonna* in Dresden [Fig. 101], for example, the beautiful Virgin in the centre is borne gently heavenwards on a cloud; is it merely a coincidence that Vigny's Eloa also reveals her small feet below the hem of her garment? Whether there was a direct borrowing here or not, the art of Raphael represented a model of suave beauty, purity, idealism and tenderness to which he always aspired in his poetry.

Moreover, Vigny's consistent preference for the same qualities in contemporary artists, Girodet, Ingres and Flaxman especially, follows naturally in the line of Raphael and Poussin. Vigny held Girodet (1767-1824) in the highest esteem bordering on adulation, and in a letter referred to the artist as '*le Raphael de notre âge*'.[17] For Vigny – as well as Chateaubriand and their entire generation – Girodet was the poetic artist par excellence ('*le poétique auteur d'Atala et d'Endymion*')[18] who pioneered the fusion of literature, history and painting to a remarkable degree. This fervent belief in the mutual interdependence of the arts is the theme of Vigny's posthumous homage to Girodet, *La Beauté Idéale, aux Mânes de Girodet*, published in the *Mercure de France* in 1825:

> *Où donc est la beauté que rêve le poète?*
> *Aucun d'entre les arts n'est son digne interprète,*
> *Et souvent il voudrait, par son rêve égaré,*
> *Confondre ce que Dieu pour l'homme a séparé*
> *Il voudrait ajouter les sons à la peinture.*

(Where now is the beauty of which the poet dreams? No art is its worthy interpreter; in his misguided dream, he often tries to mingle together what God has separated for man, to add sound to painting.) Again in a letter to Madame J-E. Périe[19] congratulating her on an article on Girodet,[20] Vigny refers to the artist as 'that great poet of painting'; he looks back on the time when he used to visit 'that almost impenetrable sanctuary' of the painter's studio, where he read his poetry aloud in front of Girodet's 'immortal pictures'. Clearly Vigny felt Girodet's death in 1824 as a great loss, both on a personal and an artistic level. For, in his extreme and highly imaginative compositions, Girodet had epitomised the

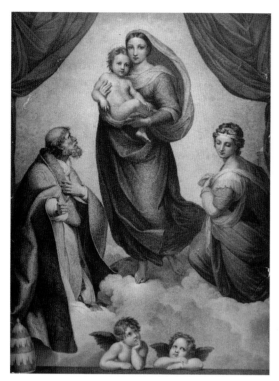

101 Sistine Madonna
Engraving by Johann Georg Nordheim after Raphael

aspirations of a generation of artists and writers determined to break away from the rigid old-fashioned division of art into genres and categories in their search for a new kind of beauty – in Vigny's words '*L'amour de la Beauté souveraine des arts*'[21] (The love of Beauty, queen of the arts.).

Moreover, just as Girodet nourished his imagination on literature, so Vigny found inspiration in the painter's masterpieces like the *Deluge* and *Endymion*. The intimate association in his mind between poetry and painting is again stressed by Vigny in the letter to Victor Hugo where he misses his long conversations with Girodet, when he 'revived the dying flame of his genius by reciting your finest verses and all the poetry inspired in me by the divine forms he had drawn.' In practice, however, Vigny was indebted to Girodet's painting only in a general sense and he never attempted to transpose it literally into verse. One of the few concrete details Vigny derived from the painter occurs in *Eloa* (Ch. II) in the passage describing Satan asleep:

Et des enchantements non moins délicieux
De la Vierge céleste occupèrent les yeux.
Comme un cygne endormi, qui seul, loin de la rive
Livre son aile blanche à l'onde fugitive,
Le jeune homme inconnu mollement s'appuyait
Sur ce lit de vapeur qui sous ses bras fuyait.

('And their eyes were filled with the no less delicious enchantments of the Virgin. Like a sleeping swan, which alone, far from the shore, surrenders his white wing to the fugitive wave, the unknown young man softly rests on this airy bed which escapes beneath his arms.') Though Vigny's character is not naked but dressed in a purple robe, his nonchalant, reclining posture is instantly recognisable as an adaptation of Girodet's *Endymion* (1793) [Fig. 102].

The painting which most profoundly affected Vigny, however, was Girodet's *Deluge* (1806)[22] [Fig. 103]. His own poem of that title, written in 1823 in the Pyrenees, was in some measure intended as a tribute to Girodet's painting, though it goes far beyond this visual prototype in its scope, variety and imaginative power. To identify Girodet's work as the sole source of Vigny's *Deluge* would therefore be a gross oversimplification, for in

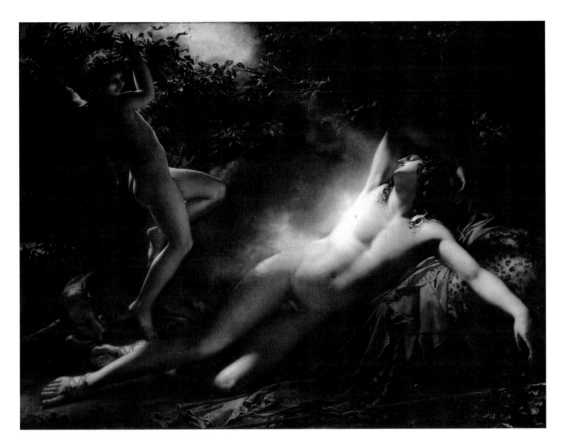

102 **The Sleep of Endymion**
Anne-Louis Girodet de Roussy-Trioson (Paris, Louvre)

addition to this image the poet also had extensive recourse to the biblical narrative, Milton, Michelangelo and Poussin's version of the same subject in the Louvre [Fig. 104]. To begin with, the differences between Girodet's and Vigny's conceptions of the scene are striking. Girodet's *Deluge* is conceived on a far more restricted scale: 'This painting is not the universal Deluge [that is, the flood of Noah] but as I have already stated, a *scene of a deluge*; or, if you reject this qualification as too vague, perhaps you would prefer: a family, surprised during the night by an inundation, is about to be engulfed by the waters.'[23] Girodet's painting is, in fact, laid out within the tight confines of classical tragedy; strict unity of action is observed by the closely interlocking group of husband, wife and two children shown desperately clinging to a broken tree, while they are visibly and inevitably doomed to perish. The theme of the Deluge was popular with many late eighteenth and early nine-teenth-century artists in France; among them are versions by Bounieu (1783), Regnault (1789), Lagrenée the Elder, Delafontaine and others. Girodet's painting, therefore, with its

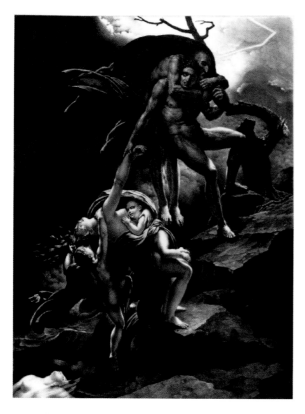

103 **The Deluge**
Engraving by Aubry Lecomte after Anne-Louis Girodet de
Roussy-Trioson

mixture of horror and pathos, is still within the mood
of '*sensibilité*' and its fascination with shipwrecks, floods
and all kinds of natural disasters.

Vigny's poem, on the other hand, is a truly universal
Deluge. By virtue of its narrative sequence, the poem
is able to encompass a far greater range of time, begin-
ning with an idyllic picture of the world before the
Flood and ending in its cataclysmic destruction. It is
conceived on a broad, panoramic scale, taking in the
whole of natural creation. Cast in the form of a
symbolic narrative, it tells the story of two young
people, Sara and Emmanuel, who refuse to leave each
other and perish in the flood. Victims of their love,
their death is a passionate protest against the wrath of
God, and in a typical gesture of heroic defiance they
refuse to accept salvation in Noah's ark; '*De ton lâche
salut je refuse l'exil*'. Though the initial impulse to write
the poem may have come from Girodet's painting,
Vigny's overall composition clearly owed more to lit-
erary prototypes, in particular the Book of Genesis and
Byron's *Heaven and Earth*, Bernardin de Saint-Pierre and
Chateaubriand.[24]

Two significant details, however, suggest that Vigny had pictorial images at the back of
his mind in composing his poem. The first occurs in the description of the
shipwreck when the survivors, stranded on a raft, resort to cannibalism in the face of
starvation. This is almost certainly an allusion to the tragic events of the Raft of the
'*Medusa*', a subject painted by Géricault in 1819. Evidently the topic exerted a horrifying
fascination on Vigny's mind, for he refers to the 'Medusa' at least twice in his letters; on 24
August 1863, in a letter to his young Irish friend Augusta Holmès, he wrote that 'none of
the shipwrecked of the '*Medusa*' have suffered more than myself, except those who have
eaten human flesh.'[25] The other passage, almost at the end of the poem, describes the plight
of the young couple, stranded on the mountain while the flood waters threaten to engulf
them from below:

> *Tout s'était englouti sous les flots triomphants,*
> *Déplorable spectacle! excepté deux enfants.*

Sur le sommet d'Arar tous deux étaient encore,

Mais par l'onde et les vents battus depuis l'aurore.

Sous les lambeaux mouillés des tuniques de lin,

La vierge était tombée aux bras de l'orphelin . . .

('All was engulfed beneath the triumphant waves, a piteous sight, with the exception of two children. The two were still on the summit of Arar, since dawn overcome by the waves and winds. Under the soaking tatters of their linen tunics, the maiden had fallen into the arms of the orphan . . .')

Though there are four figures in the painting and only two in Vigny's poem, the attitude of Sara the girl bears more than a slight resemblance to the female figure in Girodet's *Déluge*, clinging desperately to the man's outstretched arm. Otherwise there are hardly any literal '*correspondances*' between the picture and the poem. What attracted Vigny to Girodet's painting, rather, was the tragic pessimism of its general message, and its classic portrayal of the victims of a hostile universe.

It was, appropriately, through Girodet that Vigny's interest was aroused at an early age in the art of John Flaxman (1755-1826). A pioneer in the search for Neo-Classical purity via Etruscan vases and early Greek sculpture, Flaxman's work was quickly adopted in France, especially by the most advanced members of David's studio such as Girodet who found in the English artist a kindred spirit with aims which corresponded closely with their own. Flaxman's most popular and influential works were his series of drawings for Homer's *Iliad* and *Odyssey*, executed in Rome between 1787 and 1794 and rapidly diffused throughout

Europe in the form of engravings made by Tommaso Piroli in 1793 [Fig. 105]. These light, aerial, almost weightless figures rise from the earth to Olympus and descend again with an exquisite poise and delicacy, and they enchanted Vigny from the moment he saw them as a child. In 1824 he wrote to a friend Augustin Soulié: 'My Bible and some English engravings follow me like household gods.' [26] Flaxman's art is indeed – as Vigny wished his own to be – 'pure spirit' in an almost mystical Swedenborgian sense, without any of the physical, sensual attributes of the pagan gods as they are normally portrayed.

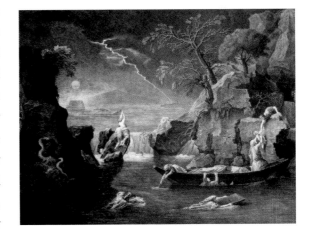

104 **The Deluge**
Engraving by Carl Gottfried Eichler after Poussin

105 Hebe offering Nectar to the Gods
Engraving by Tommaso Piroli after John Flaxman
(Illustration to Homer's *Illiad*)

'*Flaxman,*' Vigny wrote, '*le premier, je crois, a senti et exprimé la marche bondissante des dieux de L'Olympe qui, sans ailes, s'élançaient et redescendaient comme l'aigle et parcouraient la terre en trois pas*'. ('Flaxman, I believe, was the first to feel and express the bounding steps of the Olympian gods who, wingless, sprang forward and plunged down like the eagle, and crossed the world in three steps').[27] The constant movement in Flaxman's drawings of the *Iliad* and the *Odyssey*, Venus descending to Helen, Apollo descending to Hector's body, to quote only two examples, fascinated Vigny.

He loved the pure, simple outlines of forms without volume or substance which move gracefully but purposefully to their chosen destination. Moreover, several details in Vigny's poems were probably inspired by Flaxman engravings such as, for example, the relentless forward movement of Moses as he strides through the heavens:

Je renverse les monts sous les ailes des vents;
Mon pied infatigable est plus fort que l'espace.

(*Moise*)[28]

('I overturn mountains under wings of wind; my unwearied foot is stronger than space.') Or again, in the aerial flight of Eloa, a winged angel, from one world to the next as she pursues Satan down into Hell. Such examples which could no doubt be multiplied after detailed research, suggest that Vigny had Flaxman's engravings constantly at the back of his mind and that he sought to model his own characters on their simple, classical forms. His final advice to Augusta Holmès in a letter written in 1862, right at the end of his life was: 'You do well to draw . . . copy Flaxman. The good thing about this silent art is that it occupies the mind without entirely absorbing it, so that one can reflect on one's life while continuing to model beautiful forms, and one does not need conversation and the applause of indifferent people.'[29]

The same perception of clear outlines and pure form also led Vigny to admire the work of Ingres, the supreme draughtsman and leading exponent of the classical academic tradition in nineteenth-century France. In a letter to the poet Auguste Brizeux, written in the autumn of 1831, Vigny requested an introduction to Ingres' studio: 'I think and think again of the pure forms of this great draughtsman.'[30] In Ingres Vigny found another artist whose pictorial aims corresponded closely with his own literary ideal. Vigny once described his own quest for 'an individual style which remains the pure expression of one's thought' ('*un style à soi qui reste comme l'expression pure de sa pensée*').[31] He found in Ingres the

same single-minded, almost fanatical pursuit of formal beauty, the same painstaking method of composition, working through many different preliminary studies before anything like perfection was achieved. Success, Vigny wrote in his *Journal*, did not come easily to the greatest artists: 'The public needs something rather crude . . . Ingres' drawing is too pure, Decamps too original, and Delacroix is too much of a colourist.'[32]

Again, there is ample evidence that Vigny closely associated poetry with the art of pictorial composition, especially as practised by Ingres in such archetypal classical works as the *Venus Anadyomene* [Fig. 106]. Some of Vigny's lesser contemporaries, poets like Auguste Brizeux and Jules de Rességuier, both of whom he knew well, attempted literal transpositions of Ingres' paintings. Jules de Rességuier wrote poems inspired by Ingres' *Grande Odalisque* (1814) and *La Source*;[33] the first of these begins with the lines:

106 **Venus Anadyomene**
Jean-Auguste Dominique Ingres, Preliminary study (Montauban, Musée Ingres)

> *Oh! que puis-je fuir le maître que je sers!*
> *Loin du sérail inaccessible,*
> *Joindre le bien aimé sous le lotos flexible*
> *De la fontaine des déserts!*

('O! if I could flee the master whom I serve! Far from the inaccessible harem, join the beloved under the pliant lotus of the deserts' fountain!')

Vigny was well acquainted with this kind of poetry and he duly applauded the authors. He praised Rességuier's *Odalisque* as the poetic equivalent of Ingres' purity of line.[34] These minor poets, however, indulge in little more than playful verbal embroidery on well-known paintings. In their cult of form without philosophical or moral substance they come closer in spirit to the Parnassians than Vigny, for whom ideas and thought always remained of paramount importance. Unlike these writers who turned to art mainly for decorative reasons, Vigny regarded form as the visible expression of the idea, or symbol, which alone gives the poem its function.

This highly personal, subjective approach to works of art is clearly illustrated in a typical passage in *Stello* (1832), Vigny's strange symbolic novel devoted to the 'pariahs' of modern society. Chapter XXXVIII of *Stello* is entitled '*Le Ciel d'Homère*', an obvious allusion to Ingres' ceiling painted in 1827 for the *Salle des Antiquités Egyptiennes* in the Louvre [Fig. 56]. The painting, a hierarchical and elaborate composition, was designed to

celebrate the principal writers and painters of classical and modern times, with Homer occupying pride of place in the centre. The entire structure of Ingres' work consciously reaffirms the artist's belief in the superiority of the classical tradition, its vitality and continuity in European civilisation: the proof of this fact is the respect and awe with which writers of later generations, Tasso, Ariosto, Molière, Racine, Fénelon, all look to Homer as a fount of wisdom and inspiration. Vigny, however, whose theme in *Stello* is the misfortune of genius, subtly alters the painting's meaning in accordance with the thesis propounded by the mysterious Docteur Noir that 'all arts are useless to the State'. Even Plato, he reminds Stello, had no use for artists and writers and banished them from government. The doctor explains to Stello: 'However . . . suppose that we held here between us the divine Plato, could we not, if you please, take him to the Charles X museum . . . under the sublime ceiling where the reign is depicted, what shall I say, Homer's heaven? We could show him this poor old man, seated on a golden throne with a beggar's or a blind man's staff like a sceptre between his knees, his tired feet dusty and bruised, and seated at his feet his two daughters (two goddesses), the *Iliad* and the *Odyssey*. A crowd of crowned men gaze at him and worship, but stand, while he is seated among the geniuses. These men are the greatest whose names have been preserved, the Poets, and if I had said the most unhappy, it would be the same. From his time until our own, they form an almost uninterrupted chain of glorious exiles, of persecuted and courageous heroes, thinkers driven mad by poverty, warriors inspired by the battlefield, of sailors saving their lyres from the sea and not from dungeons; men filled with love and ranged around the greatest and the most unhappy, as if to ask him the reason for so much hatred which petrifies them with amazement.' Vigny concludes: 'Let us enlarge this lofty ceiling in our thoughts, lift and broaden this cupola until it can contain all the unfortunates whom Poetry or Imagination struck with their universal stigma.'[35] The whole passage shows that Vigny responded to and admired the classical symmetry of Ingres' painting. There are, however, a number of significant differences between the original and his interpretation of it. In the first place, Ingres' Homer is not a 'poor old man' but relatively young and virile-looking; secondly, the ranks of his admirers are obviously not the victims of hatred and persecution, but figures enjoying honour and distinction. By such means, Vigny, while respecting most of the details, gradually rewrites the painting and turns it into a symbol of his own preoccupations. Ingres merely provided him with the backcloth and the principal characters, which he then re-cast in an entirely different form. The *Apotheosis of Homer* has undergone a radical change of meaning, transformed by Vigny into an illustration of his deeply pessimistic belief that writers, artists and all creative individuals are condemned by the nature of their vocation to neglect and persecution.

CHAPTER VIII

Victor Hugo (1802–85)

IN THE POETRY OF Victor Hugo we are immediately aware of a writer of extraordinarily powerful vision.[1] Hugo was, above all, a seer who used his sight to embrace both detail and overall shape and forms, and to recreate them in an entirely original *oeuvre* which marks the climax of the Romantic movement in art and literature. No other French writer exhibits such a profusion of concrete imagery, much of it – but by no means all – derived from the visual arts. For, as well as being France's greatest poet (acknowledged even by his severest critics like André Gide), Victor Hugo was an exceptionally gifted artist who left a corpus of remarkable pen and ink drawings [Fig. 107][2]; in their strange, almost surreal character, these sometimes express the workings of the poet's imagination more intimately than the poetry itself, often marred by grandiloquence and a surfeit of rhetoric. Victor Hugo is the archetypal Romantic artist, both poet and painter in one, a man who knew no boundaries of medium. The two activities were inextricably linked in Hugo's mind, for although a particular drawing rarely corresponds to a particular poem and vice versa, both sprang from the same deep recesses of his imagination. And imagination was, as Baudelaire recognised, Hugo's '*faculté maîtresse*', the single dominant motive force at work in all his vast, profuse and varied output.[3]

Imagination in Hugo's poetry operates on two levels. The first is that of the born observer with an acute eye for detail – a rapid, synthetic vision which enabled him to transcribe visual impressions, in his travel books (for example, *Choses Vues* and *Le Rhin*) with an artist's precision. The same capacity for accurate observation can also be found in some of the less ambitious descriptive poems of *Les Contemplations*, in *Lettre* for example, a continuous succession of images evoking the Normandy countryside in spring:

> . . . *une ancienne chapelle*
>
> *Y mêle son aiguille, et range à ses côtés*
>
> *Quelques ormes tortus, aux profils irrités,*
>
> *Qui semblent, fatigués du zéphyr qui s'en joue,*
>
> *Faire une remontrance au vent qui les secoue.*
>
> (*L'Ame en Fleur, VI*)

('. . . there is an ancient chapel with its spire, some twisted elms at its sides, whose agitated outlines, tired of the playful breeze, seem to remonstrate with the wind which shakes them.')

107 **La Ville en pente**
Victor Hugo, Pen and ink wash (Paris, Musée Victor Hugo)

It is immediately clear, however, that the purely descriptive element is only the springboard for Hugo's imagination. As for Baudelaire, the visible world for Hugo becomes the pretext for an elaborate pattern of symbols. His 'inner eye', so to speak, instantly starts to work on its raw material and to transform it into something entirely personal. The scene of an old chapel mingling its pointed spire among the curving boughs of the elms is more than a two-dimensional pattern of lines and shapes; it is also a symbol of resilience and unceasing struggle in the face of adversity. Image gives way to metaphor as Hugo's imagination endows the trees with human qualities – angry profiles, tired, pleading gestures – and thus brings nature into a state of perpetual animation. The whole of creation for Hugo was full of living souls; the poet is a seer but he in turn is constantly observed by the ubiquitous eyes of nature, the sun, the stars, even the flowers. Unlike Gautier and the Parnassian poets, Hugo was not content with a pictorial evocation of external shapes and forms. His imagination was penetrative, working deeply into its material, assimilating, transforming, magnifying and frequently distorting it, to produce some of the strangest and yet most impressive poetry ever written in French. The full range of Hugo's creativity can only be appreciated when we consider the distance he travelled from the early, and relatively conventional royalist *Odes et Ballades* (1826) to the cosmic vision of *La Bouche d'Ombre* in the *Contemplations* and the extraordinary epics of *La Légende des Siècles*.

Imagery abounds in the poetry of Victor Hugo, and it is for its intrinsic beauty that his verse is read, even by readers with little sympathy for the writer's philosophical and mystical pretensions. Striking, concrete and often unexpected, images flow spontaneously from Hugo's pen and instantly transform a commonplace scene or event into something strange and almost magical. In *La Rose de l'Infante*, from *La Légende des Siècles*, for instance, a Gothic arch in the window of a Spanish palace is compared with a bishop's mitre. One of the most famous examples are the final lines from *Ruth et Booz*:

> *Le croissant fin et clair parmi ces fleurs de l'ombre*
> *Brillait à l'occident, et Ruth se demandait,*

> *Immobile, ouvrant l'oeil à moitié sous ses voiles,*
> *Quel dieu, quel moissonneur de l'éternel été,*
> *Avait, en s'en allant, négligemment jeté*
> *Cette faucille d'or dans le champ des étoiles.*
>
> (*Légende des Siècles, VI*)

('The fine, clear crescent shone in the west among these flowers of the shade, and Ruth wondered, motionless, half-opening her eyes beneath her veils, what god, which harvester of the eternal summer, had, departing, carelessly thrown down this golden sickle in the field of stars.')

The strongly pictorial quality of this description of moonlight over a peaceful summer landscape – a golden sickle among a field of stars – suggests a painting combined with the biblical account of Ruth and Booz to create this memorable scene. The atmosphere of primitive biblical simplicity has something in common with Poussin's *Summer* from the *Four Seasons* in the Louvre, but another possible source has been suggested in Louis Hersent's version of *Ruth and Booz*[4] [Fig. 108], which Hugo could well have seen at the Salon of 1822. There is certainly no trace of the crescent-shaped moon in Hersent's painting, nor of the ladder of his descendants which Booz sees in a dream, but the languorous attitudes of the old man and his young wife are in close accord with Hugo's poem: '*L'ombre était nuptiale, auguste et solonnelle . . .*' ('The shadow was nuptial, sacred and solemn . . .')

The acute visual perception at the root of Hugo's imagination is most explicit in the opening lines of *Lettre* in the *Contemplations*, a precise but evocative description of the windswept Normandy countryside:

> *Tu vois cela d'ici – des ocres et des craies,*
> *Plaines où les sillons croisent leurs mille raies,*
> *Chaumes à fleur de terre et que masque un buisson,*
> *Quelques meules de foin debout sur le gazon,*
> *De vieux toits enfumant le paysage bistre . . .*
> *Voilà les premiers plans . . .*

('You can see it from here – ochre and chalk, plains where furrows cross their thousand streaks, squat thatched cottages concealed by a bush, haystacks upright in meadows, old roofs filling the tawny countryside with smoke . . . that is the foreground . . .')

The poem is composed like a picture inside a frame, with foreground, background and fine notation of texture, colour and shape. As a result a clear mental image is formed by the reader – the squat cottages, the chalky plain and the stunted trees – as clear as Hugo's

108 Ruth and Booz
Engraving by Étienne Achille Reveil after Louis
Hersent from Charles-Paul Landon's *Annales du
Musée, Salon de 1822*

original perception of it. Hugo's imagination, in fact, worked pictorially. The use of an almost monochrome palette in this poem (ochre, bistre) suggests the technique of the etcher and is reminiscent of certain of Rembrandt's engravings of the flat Dutch countryside. Moreover, the poet is known to have greatly admired Rembrandt's etchings and some of his own drawings, *Landscape with three trees* [Fig. 109] for instance, were directly inspired by Rembrandt, [Fig. 110].

Another poem containing a wealth of imagery is *Pasteurs et Troupeaux* (written from Jersey in 1855) which starts off as a modest descriptive piece of a pastoral scene but ends in a crescendo of sublime and majestic verse. On a walk near the sea the poet meets a young shepherdess whose sheep, as they scatter, leave bits of their wool on the hedgerows which look like foam from the sea. Then, in a dramatic extension and reversal of this image, a promontory looms up ahead which Hugo sees as another shepherd guarding his flock, the waves, the rocks and the sea: 'The shepherd headland with his hat of clouds, leans on his elbow and dreams of the sound of all infinity . . .'

In the final line the wind scatters the sea's foam like the fleece of the shepherd's flock ('*la laine des moutons sinistres de la mer*'). Here, once again, the visionary power of Hugo's imagination comes to the fore. The entire poem is constructed on the Baudelaireian concept of '*correspondances*', or 'metaphor' as Proust named it – the perception of hidden connections between unrelated objects and different areas of experience. At this point Hugo rises above the purely visual level of imagination and enters the realm of symbolism and myth which was to play a dominant part in his later poetry.

The dualistic nature of Hugo's imagination is also apparent in his obsession with contrasts. Violent antitheses of light and shade underlie all his poetry, especially the monumental epics *La Bouche d'Ombre* and *Le Satyr*, corresponding to the dark and often sinister effects of *chiaroscuro* in his own drawings. Hugo emphasises such contrasts not only for their visual potential, but also for their moral connotations of good and evil. Light is synonymous in his mind with goodness, love and hope; darkness with evil, oppression, cruelty and despair. Within the cosmic framework of Hugo's philosophy lies a primitive Manichean conception of life, based on the struggle of opposing forces which seek to gain the upper hand: on the one hand, an optimistic belief in the future progress of humanity, on the other the sinister power of evil which constantly threatens to undo the achievements of

civilisation and to plunge men back into barbarism. Man, in this process, is midway between the divine and the brute – in Pascalian terms, suspended between two infinities, heaven and hell, the sky and the abyss. In this unequal struggle evil is often the winner, and it is no accident that the figures from history, among them Philip II of Spain, who fill the pages of *La Légende des Siècles* are among the blackest villains of all time. Hence the predominance of darkness and sombre colours in much of Hugo's poetry, the equivalent of the deep pessimistic strain in his nature. In *La Bouche d'Ombre* Hugo gives his most elaborate symbolic interpretation of this power of darkness, summarised in the line: '*Homme, tout ce qui fait de l'ombre a fait le mal.*'

109 **Landscape with three trees**
Hugo, Pen and ink wash (Paris, Musée Victor Hugo)

(*Contemplations XXV. Au Bord de l'Infini*) (Man, everything that casts a shadow has created evil.) Until the final section of the poem when hope and optimism reassert themselves, *La Bouche d'Ombre* is heavy with images of shadow and blackness – '*L'arbre noir, fatal fruit*', '*Un affreux soleil noir d'où rayonne la nuit*' ('the black tree, fatal fruit, a hideous black sun from which the night shines'). This is one of the many echoes from Dürer's *Melancolia* which recur throughout Hugo's poetry; black, for Hugo, signifies foreboding, evil and despair, the loss of the original transparency of creation when the sun is eclipsed. Its opposite – all too rarely glimpsed – is the vast blue infinity of the sky and luminous orb of the sun, piercing the darkness with rays of hope.

Hugo and the Artists of his Time[5]

Throughout his long creative life, painting and the visual arts were never far from Hugo's thoughts, but at no period was he as closely involved with them as during the decade 1820-30, culminating in the publication of the *Orientales* in 1829. These poems of Oriental, Moorish and Philhellene inspiration, written mostly in 1828, bear the strong imprint of Hugo's visual preoccupations. He was also stimulated in this direction of colour and pictorial effect by his recently formed friendships with several Romantic artists, including Achille and Eugène Devéria, the sculptor David d'Angers, Eugène Delacroix, Célestin Nanteuil, Paul Huet and, especially, Louis Boulanger who became a lifelong admirer and friend. All these artists, later joined by writers such as Sainte-Beuve and Victor Pavie, were

110 The Three Trees
Rembrandt, Etching (Paris, Petit Palais)

motivated by the same youthful enthusiasms and ideals; to break with the constraints of the classical tradition and to explore the full range of colour, feeling and vocabulary previously confined within the limits of 'good taste'. Henceforward everything had a right to representation in art – ugliness as well as beauty, the grotesque as well as the sublime: '*D'ailleurs, tout est sujet, tout relève de l'art; tout a droit de cité en poésie.*' ('Besides, everything is subject-matter, everything comes within the sphere of art; everything has the right of citizenship in poetry.')[6] It was this doctrine which united these artists – despite wide divergences of temperament and ability – and which gave the Romantic move-ment its sense of purpose and its coherence, albeit temporary. At no other time than during the period 1820-30, marked by the two great 'Romantic' Salons of 1824 and 1827, was the fusion between art and letters in France more complete.

Hugo was the focal point of this group, known as the *Cénacle de Joseph Delorme* after Sainte-Beuve's volume of poetry, *Poésies de Joseph Delorme*, published in 1829. The *avant-garde* artists crowded into his house on the rue Notre-Dame-des-Champs, drawn by the magnetic force of Hugo's personality. For there can be no doubt that – except for Eugène Delacroix, with whom he was never on particularly cordial terms – none was the poet's equal in stature; he literally towered above them by the sheer power of his genius. When Baudelaire later accused Victor Hugo of having 'ruined' Boulanger,[7] he was perhaps doing the poet an injustice, for Boulanger never had the makings of a great artist in the first place. The truth was that Boulanger, the Devérias and Nanteuil[8] were small fry, talented Romantic minor artists who only occasionally rose above the level of illustration. They were, in fact, ideally equipped for this role, particularly, Célestin Nanteuil (1813-73), whose outlook of the humble mediaeval artist-craftsman and love of filigree Gothic forms made for admirable illustrations of Hugo's work, for example, the *Portrait of Victor Hugo*, a design for a frontispiece showing the poet surrounded by his various fictional characters in a Gothic frame [Fig. 111]. Louis Boulanger (1806-67)[9] was an artist of rather more ambition. Introduced to Victor Hugo in 1824 by the Devéria brothers, he instantly fell under the poet's spell. According to a contemporary witness, Sainte-Beuve and Boulanger, with his

'intelligence open to Shakespeare and Rembrandt', were among Hugo's most assiduous visitors.[10] His admiration for Hugo never waned and the two men became firm friends, travelling together and constantly exchanging ideas on art and literature. In 1829, in the company of Sainte-Beuve and the architect Charles Robelin, they made a journey through France, Alsace and Germany, in the course of which they discovered many ancient mediaeval cities and became deeply interested in Gothic architecture. On their return to Paris in 1830 Boulanger took an active part in the *Battle of Hernani* and designed models for the play's costumes. He also became one of Hugo's most prolific illustrators, producing a constant stream of lithographs after his early poems, including *La Ronde du Sabbat (Ballade XIV)* [Fig. 112], *Le feu du ciel (Orientales I)*, *Sarah la baigneuse (Orientales XIV)* which strive, with some success, to capture the phantasmagoric quality of the original works. Even after he had turned towards more classical subjects, such as the *Triumph of Petrarch* (Salon of 1836), Boulanger continued to find inspiration in the works of Victor Hugo and showed talent in his costume designs for the plays *La Esméralda* (1836), *Ruy Blas* (1838) and *Les Burgraves* (1843). But Boulanger's was an essentially minor talent and his technique too brittle to convey the full power of Hugo's original works. We cannot help feeling aware of the discrepancy between the poet and his illustrator.

111 **Victor Hugo in 1832**
Célestin Nanteuil
(Frontispiece for the author's Complete Works)

Hugo himself, however, showed no such reservations about Boulanger's ability and revelled in the painter's adulation. In 1828 he dedicated two of the *Ballades* to Boulanger, *Deux Archers* and *La Légende de la Nonne*, with the following accompanying note which testifies to his genuine respect for the artist: 'Monsieur Boulanger's reputation rests already on many first-class works, amongst which we shall only recall the fine painting of Mazeppa, so noted at the last Salon, and that huge lithograph into which he injected so much life, reality and poetry on the '*Witches' Sabbath*.'[11] The exchange between Hugo and Boulanger, however, was mostly in a one-way direction and the poet was only rarely inspired by the painter. The outstanding exception was Boulanger's famous painting of *Mazeppa* (Rouen, Musée des Beaux-Arts), exhibited at the Salon of 1827 and referred to by Hugo above,

which prompted one of Hugo's most ambitious poems in the *Orientales (XXXIV)*, written in May 1828 [Fig. 68]. The poem[12] is dedicated to Boulanger and a short preliminary quotation from Byron – Away! – Away! – reveals that Hugo also had Byron's epic of the same title in mind. But, in the process of borrowing, Hugo totally transforms the runaway horse of Byron's anecdotal and macabre narrative into a potent symbol of the frenzied aspirations of Romantic genius:

> *Ainsi, lorsqu'un mortel, sur qui son dieu s'étale,*
>
> *S'est vu lier vivant sur ta croupe fatale,*
>
> *Génie, ardent coursier,*
>
> *En vain il lutte, hélas! tu bondis, tu l'emportes*
>
> *Hors du monde réel, dont tu brises les portes*
>
> *Avec tes pieds d'acier!*

('Thus, when a mortal, watched over by his god, found himself bound alive on your ill-fated back, Genius, passionate steed; alas, in vain he struggles! You leap, you drag him out of the real world, whose doors you shatter with your feet of steel!')

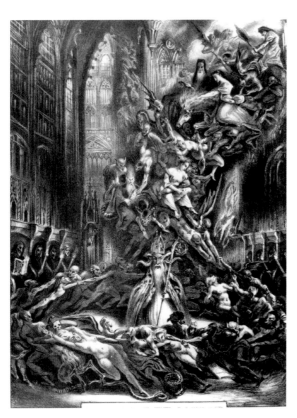

112 **La Ronde du Sabbat**
Lithograph after Louis Boulanger

Another artist in Hugo's circle, one of real originality, was the landscape painter Paul Huet (1803-69),[13] whose relations with the Cénacle date from around 1829. The lyrical, spontaneous quality of Huet's landscapes was described by Baudelaire as '*amoureusement poétique*',[14] and they were highly valued by many writers of the time, Lamartine, Sainte-Beuve, as well as by Victor Hugo. In retrospect they seemed to Baudelaire, writing in his *Salon of 1859* with a strong sentiment of nostalgia for the heady days of early Romanticism, to epitomise all the poetic charm which his own generation had voluntarily sacrificed to the new idol of Realism. Landscape was the quintessentially Romantic art form; as Huet later explained to Baudelaire, it was the natural outlet for 'tender and meditative souls', a 'new, vivid and sincere form of expression'.[15] Hence the strong literary appeal of Huet's paintings, especially to the lyric poets Lamartine and Sainte-Beuve. Although of a very

different temperament, Huet was a profound admirer of Hugo's poetry and some of his landscapes were exhibited with accompanying lines from the poet's verse, for example *The Abbey in the Woods* (Valence, Musée) [Fig. 113] shown at the Salon of 1831:

> *Trouvez-moi, trouvez-moi*
> *Quelque asile sauvage*
> *Quelque abri d'autrefois . . .*
> *Trouvez-le-moi bien sombre,*
> *Bien calme, bien dormant,*
> *Couvert d'arbres sans nombre,*
> *Dans le silence et l'ombre*
> *Caché profondément.*
> *(Rêves, Ode XXV)*

('Find me, find me, some wild sanctuary, some bygone refuge . . . Find a truly dark one for me, truly calm and in deep sleep, covered in endless trees, hidden deep in silence and shadow.')

Eugène Delacroix was the only artist who could face Victor Hugo on equal terms,[16] and it was perhaps because they were matched in creative power that neither ever felt at ease in the other's company. At first sight they appear to be the outstanding kindred spirits of the Romantic movement. As Baudelaire noted, however, the coupling of artists and writers in which many contemporary critics indulged can be misleading and, in the case of Hugo and Delacroix, overlooks important differences between them; for one thing, the regular, mechanical pound of the poet's verse cannot be equated with the painter's constant search for spontaneity and effortless creativity. In 1826 when they first met, relations between them were cordial enough.[17] They were both enthusiastic admirers of Shakespeare and Delacroix painted some beautiful costume

113 **The Abbey in the Woods**
Paul Huet (Valence, Musée)

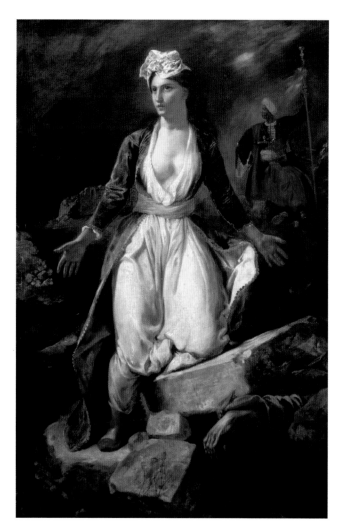

114 Greece expiring on the Ruins of Missolonghi
Eugène Delacroix (Bordeaux, Musée des Beaux-Arts)

designs for Hugo's play *Amy Robsart*. Hugo wrote enthusiastically of Delacroix's early works, notably of the *Death of Sardanapalus* [Fig. 70], which he praised warmly in a letter of 3 April 1828 to Victor Pavie: 'His Sardanapalus is a magnificent thing, so huge that it escapes small-minded people . . .',[18] adding the curious rider that the picture would have been even more impressive if the artist had set fire to the funeral pyre, turning it into a 'basket of flames'. Hugo evidently wanted something still more melodramatic than the original.

In a little-known article reviewing the Exhibition of 1826 in aid of the Greek War of Independence,[19] Hugo again came to the artist's support in his comments on the allegorical painting of *Greece expiring on the Ruins of Missolonghi* [Fig. 114], in which he found all the 'qualities of this young and already great colourist'. And he fully recognised the emotional and dramatic impact of Delacroix's *Execution of the Doge Marino Faliero*, shown at the Salon of 1827: 'Why has he already ceased to exhibit his *Marino Faliero*, in which all was solemn, simple and grand, with so much nature and history?'[20] After about 1830, however, when Delacroix really came into his stride and his style began to take on its own highly individual character, Victor Hugo seems to have lost all sympathy for the painter. In particular he disliked the women in Delacroix's paintings, who were altogether too ethereal and unfinished for his more robust taste. This, at any rate, seems to be the meaning of Hugo's reaction to the *Women of Algiers* (1834) [Fig. 115] in which he praised the 'brilliant oriental light and colour' but expressed a deep aversion to the painter's notion of feminine beauty ('*cette laideur exquise*').[21] The limits of Hugo's tastes in contemporary art are evident from his ambiguous comment, and contrast strongly with the far more perceptive and 'modern' attitude to Delacroix which runs throughout Baudelaire's art-criticism.

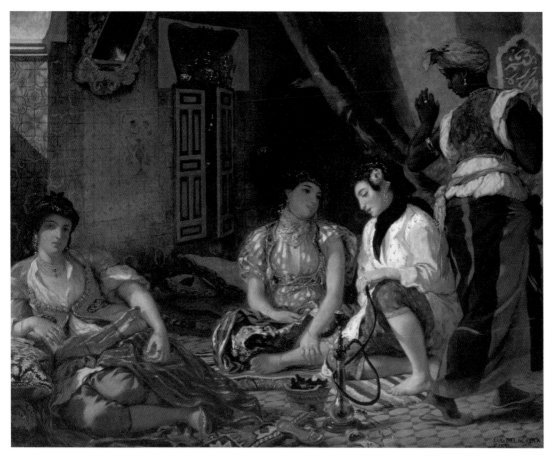

115 **The Women of Algiers**
Eugène Delacroix (Paris, Louvre)

It is, of course, true that as one who grew up and achieved his own poetic maturity in the thick of the battle of Romanticism, Hugo can hardly be expected to have fully understood the evolution of Romantic painting or to have judged it dispassionately. Though usually short on technical insight and showing no great interest in the properties of colour which historians have seen retrospectively as the major contribution of the movement, Hugo's brief and scattered comments reveal a genuine sympathy with the aims of young, contemporary painters. The main evidence is, again, the article on the Greek exhibition of 1826, which firmly concludes in favour of innovation and originality: 'This young school, if one can thus call a combination of such diverse talents, promises a great future for painting.'[22] Apart from his remarks on the two paintings by Delacroix already quoted, Hugo also singles out works by Saint-Evre (*Job* [Fig. 32], *Don Juan*, *Isabeau de Bavière*), seascapes

by Gudin, Ingres' *Sistine Chapel*, Granet's scenes of cloisters, and two small exhibits by Boulanger (*Cimabue meeting Giotto* and *Salvador Rosa captured by Brigands*) which he qualified as '*deux petits chefs-d'oeuvre*'. But the painting which really captured his attention was a work by Eugène Devéria showing *Mary, Queen of Scots receiving the death sentence* [Fig. 116]. It was exactly the kind of historical drama, with an authentic historical *mise en scène*, to which Hugo felt most strongly drawn at this time, and he duly accorded it high praise: 'That black scaffold, that royal victim, that circle of historic figures among whom one notices Leicester, even the windows, the ogives, and the heraldic walls, everything is moving and interesting in Monsieur Devéria's beautiful painting.'[23]

The *Orientales*

These, briefly, were some of Hugo's contacts with the art of his own time when he came to write the *Orientales* in 1827-8. Pictorial concerns were therefore uppermost in his mind, although the exact degree of their direct influence on his own poetry has been contested. It has been pointed out that Hugo made no attempt to translate literally the colour of Romantic painting into his own verse, and that he showed more interest in the contrasted effects of light and shade in painting – and particularly in engraving – than in pure colour.[24] Nevertheless, colour is strongly present in the *Orientales* and pervades their entire atmosphere. In the words of his own preface: '*Les couleurs orientales sont venues comme d'elles-mêmes empreindre toutes ses pensées, toutes ses rêveries . . .*'[25] ('Eastern colours imprinted themselves on all his thoughts and dreams.') Moreover, since Hugo had never travelled to the Near East, only to Moorish Spain (where he had accompanied his father as a child), these colours must, at least in part, have filtered down to him through paintings, prints and illustrated travel books such as Baron Taylor's *Voyage pittoresque en Espagne* (1826-32), written in collaboration with the Orientalist painter Adrien Dauzats. The suggestion that Hugo was more or less consciously trying to paint pictures in words, with all the visual resources at his disposal, is borne out by some remarks of Sainte-Beuve, who was especially close to the poet at this time and qualified

116 **Mary, Queen of Scots, receiving the Death Sentence**
Eugène Devéria (Angers, Musée des Beaux-Arts)

to interpret his motives: 'Henceforth it would be difficult to predict new progress in this artistic style (*cette manière d'artiste*), of which the *Feu du Ciel*, *Mazeppa* and *Fantômes* are the last word.'[26]

This '*manière d'artiste*' is evident, first of all, in the range of colour and imagery of the *Orientales*, creating an impression of unprecedented boldness, of ardour and intensity. Reds, yellows, copper, gold, purple, carmine, scarlet have suddenly invaded the traditionally neutral palette of French verse. Linguistic devices – for example, the description of Lazzara's admirer, an old Turkish pasha, as 'dripping in precious stones' ('*tout ruisselants de pierreries*')[27] – would have seemed startlingly unfamiliar in their time, though many have since become common clichés. The juxtaposition of strong colours also occurs frequently: a green and red Turkish pavilion ('*un kiosque rouge et vert*', *XXI*) and a memorable description of a snake glittering on the sand in *Les Tronçons du Serpent*:

> *Un jour, pensif, j'errais au bord d'un golfe, ouvert*
> *Entre deux promontoires,*
> *Et je vis sur le sable un serpent jaune et vert,*
> *Jaspé de taches noires.*
>
> (*Orientales, XXVI*)

('One day, I pensively wandered by the edge of a bay, opening out between two headlands, and I saw on the sand a yellow and green snake, marbled with black speckles.') All this helps to create the myriad effect of vibrant oriental colours, sometimes sharply detached from each other, elsewhere merging with the surrounding atmosphere as the golden domes and minarets of a Moorish town dissolve into a violet horizon . . .

> *Avec les mille tours de ses palais de fées,*
> *Brumeuse, denteler l'horizon violet.*
>
> (*Rêverie. Orientales, XXXVI*)

(' . . . With the thousand towers of its fairy palace, misty, indenting the violet horizon.') Night-time creates even more magical effects, as the moonlight opens its silvery fan over the waves. Shapes and forms play an equally important role in Hugo's imaginative process, for he was receptive to architecture as well as to painting. Apart from his well-known advocacy of Gothic architecture in *Notre Dame de Paris* and elsewhere, he was particularly drawn to the complicated forms, the slender, tapering minarets of oriental cities as they pierced the white mist or stood silhouetted against a bright azure sky. He loved the delicate, filigree patterns created by Moorish architecture, as in this evocation of Istanbul:

> *. . . Les moresques balcons en trèfles découpés,*
> *Les vitraux se cachant sous des grilles discrètes,*

> *Et les palais dorés, et comme des aigrettes*
> *Les palmiers sur leur front groupés.*
> (*Les Têtes du Sérail. Orientales, III*)

(' . . . Moorish balconies carved into the shape of trefoils, stained glass windows hidden beneath discreet wrought-iron grates, golden palaces, and palm trees like plumes grouped on their facades.')

To describe the overall tonality of the *Orientales* is easy enough, but the problem begins as soon as an attempt is made to pinpoint Hugo's visual sources with any accuracy. Hugo's imagination did not work in a piecemeal way but synthetically, from an accumulated store of visual memories which may, or may not, have originally been triggered off by a work of art. It is, therefore, often difficult to say whether he is writing from a painting or a personal experience, or both; for example, in *Les Fantômes*, whether the young Spanish girl who died from an excess of dancing is a childhood memory, or a transcription of a Goya *Capricho*, or one superimposed on the other. The same problem arises with two Philhellene poems denouncing recent Turkish atrocities in Greece, *La Ville Prise* written in 1825, and *La Douleur du Pacha*, finished in 1828. This was a highly topical issue and had been extensively reported in the French press of the 1820s. Hugo may, therefore, have been influenced by no more than the current wave of Philhellene feeling which swept through France, especially in the wake of Byron's death at Missolonghi and a spate of minor poetry celebrating the Greek cause, like Casimir Delavigne's *Messéniennes* (1818-19) and A. Guiraud's *Chants hellènes* (1824). But by far the most dramatic impulse came from Delacroix's *Massacre at Chios* [Fig. 33], exhibited at the Salon of 1824, where it made a profound impression on Hugo and all who saw it. *La Ville Prise* was almost certainly written with the impact of Delacroix's painting fresh in his mind,[28] as the following lines testify:

> *Les mères ont frémi; les vierges palpitantes,*
> *O Calife! ont pleuré leurs jeunes ans flétris,*
> *Et les coursiers fougueux ont traîné hors des tentes*
> *Leurs corps vivants, de coups et de baisers meurtris.*
> (*Orientales, XXIII*)

('The mothers shuddered; the maidens, o Caliph! trembling with fear, have cried away their blighted youth, and the fiery steeds have dragged their living bodies from the tents, bruised with blows and kisses.')

The second poem, *La Douleur du Pacha*, was begun in 1827, three years after the revelation of Delacroix's painting and is consequently less directly marked by it. The only lines which recall the *Massacre at Chios* are those evoking the destruction of Greece, its widows and its children, the victims of war.[29] The rest of the poem is devoted to a

picturesque description of an oriental court, with its slaves and concubines, presided over by the morose presence of an elderly pasha strongly reminiscent of the sultan in Delacroix's *Death of Sardanapalus*:

> *Qu'a-t-il donc ce pacha, que la guerre réclame,*
> *Et qui, triste et rêveur, pleure comme une femme? . . .*

('What afflicts this pasha, summoned by war, and who, sad and brooding, weeps like a woman? . . .') Moreover, Hugo is known to have seen and admired Delacroix's *Sardanapalus*, which he probably saw in the painter's studio before it belatedly entered the Salon of 1827 in February 1828, and he probably modified his poem to include certain elements of the painting.[30] He clearly expressed his admiration for the painting, and other literary works of the same period, in a letter to Delacroix of October 1827: 'Please convey my admiration to Sardanapalus, Faliero, The Bishop of Liège, Faust, in fact to all your retinue.'[31]

The most undisputed example of pictorial inspiration in the *Orientales* is the poem *Le Feu du Ciel*.[32] Here the inspiration came from John Martin, the English painter and engraver of spectacular Biblical epics whose work enjoyed vast popularity at the height of French Romanticism.[33] Appropriately, in 1829, the year of publication of the *Orientales*, Martin was awarded a gold medal by Charles X. The appeal of Martin's works for the Romantics, including Michelet, Flaubert and Gautier, lay evidently in his taste for scenes of oriental and Biblical horror and destruction, like the *Fall of Nineveh* (London, British Museum) and the *Destruction of Sodom*. This same streak of masochism, on a gigantic cosmic scale, pervades the entire Romantic movement from Byron and Delacroix, to the epic visions of Lamartine's *La Chute d'un Ange* and Flaubert's *Salammbô*. Martin's fame, it seems, was well established in France in the late 1820s, and engravings of his main compositions like *Belshazzar's Feast* (painted in 1821 and engraved in 1826) [Fig. 117] were already in wide circulation. With his usual flair for discerning the latest fashions, Sainte-Beuve wrote an article on Racine's *Athalie*[34] in which Martin's name appears more than once. It was also Sainte-Beuve who, in a series of articles drew the connection between John Martin and Hugo's poem *Le Feu du Ciel*. Moreover, David d'Angers and Victor Pavie, with whom Hugo was closely associated, returned in May 1828 to Paris from London where they saw the *Fall of Nineveh* and brought back several engravings which Hugo probably saw. There is little doubt, therefore, that Martin's work provided the essential catalyst to his imagination in this spectacular poem.

Le Feu du Ciel evokes the destruction of Sodom and Gomorrha in a sequence of cataclysmic images. The black cloud, heavy with lightning, first hovers over other cities:

> *La voyez-vous passer, la nuée au flanc noir?*
> *Tantôt pâle, tantôt rouge et splendide à voir,*
> *Morne comme un été stérile?*

('Do you see the black-edged cloud passing overhead? Sometimes pale, sometimes red and marvellous to see, gloomy as a barren summer?') Next Egypt appears on the scene, with its striped fields ('*bariolés comme un riche tapis*'), the pyramids and the Nile, like a yellow tiger-skin spotted with tiny islands. The cloud stops over the ruins of Babel. Then the two cities appear, the object of divine wrath:

> *Voilà que deux cités, étranges, inconnues,*
> *Et d'étage en étage escaladant les nues,*
> *Puis l'oeil entrevoyait, dans le chaos confus,*
> *Aqueducs, escaliers, piliers aux larges fûts,*
> *Chapiteaux évasés; puis un groupe difforme*
> *D'éléphants de granit portant un dôme énorme . . .*
> *Immense entassement de ténèbres voilé!*

('There they are, two cities, strange and unknown, scaling the clouds from flight to flight; then in the confused morass, the eye catches a glimpse of aqueducts, stairs, pillars with wide shafts and splayed capitals; then an amorphous group of granite elephants carrying a huge dome . . . vast pile veiled in shadows!') Finally the cloud breaks, wreaking terrible destruction:

> *Le nuage éclate!*
> *La flamme écarlate*
> *Déchire ses flancs,*
> *L'ouvre comme un gouffre,*
> *Tombe en flots de soufre*
> *Aux palais croulants,*
> *Et jette, tremblante,*
> *Sa lueur sanglante*
> *Sur leurs frontons blancs.*

('The cloud bursts! The scarlet flame rips its side, opening it like a chasm, and falls in waves of sulphur on the crumbling palaces, then trembling, casts its blood-stained glare on their white pediments.')

As many critics from Sainte-Beuve onwards have noted, *Le Feu du Ciel* is constructed from a series of pictures following each other in rapid succession, creating the kind of vertiginous effect with twentieth-century film-goers would recognise in certain Hollywood blockbusters. Hugo's contemporaries might have found an affinity with the Diorama, a sort of early cinematographic technique which became all the rage in Paris around 1820. Though some of Hugo's sources in this poem were literary, derived from works like Volney's *Ruines* and Vivant Denon's *Voyage dans la Basse et la Haute Egypte* (1802),

which provided certain details of Egyptian archaeology,[35] the overwhelming impression is pictorial. In conceiving these vast Ninevite constructions with their endless rows of columns, Hugo clearly was thinking of Martin's engravings like *Belshazzar's Feast* [Fig. 117] and the *Fall of Babylon* (in which the enormous black cloud hovers ominously overhead); the fall of lightning is visibly derived from Martin's *Destruction of Sodom* (illustrating the Book of Genesis, XIX), a work which in its turn recalls Milton and Poussin's *Deluge* in its tragic horror. The result is a poem of graphic power equal to artist's originals and, in a sense, marks the climax of the *Orientales* and Hugo's early involvement with the visual arts.

Dürer and Rembrandt in Hugo's Poetry

Hugo was, finally, greatly indebted to certain artists of the past, Dürer, Rembrandt, Callot, Piranesi and Goya, who clearly exerted a profound influence on his imagination.[36] All of these artists were in different ways visionaries and pessimists obsessed with the great mysteries of life and death; all of them, too, expressed their sombre visions in largely or exclusively monochromatic works. The work of Albrecht Dürer held a particular significance for Hugo and inspired one of his best-known poems. At first, it seems, Dürer's name was for Hugo no more than a vague synonym for the German mediaeval tradition of forests, castles and popular folklore which the Romantics consciously revived. This kind of setting serves as a backcloth to his *Ballades*, notably *La chasse du Burgrave* and *La ronde du sabbat*. In 1829 Hugo wrote to his young friend and disciple Victor Pavie to congratulate him on a poem, comparing it with 'one of those admirable old pictures by Albrecht Dürer or by Rembrandt'.[37] This somewhat arbitrary coupling of the two artists, linking them with the popular pseudo-mediaeval ballad, suggests that at this stage Hugo had no very precise idea of either, or was perhaps confusing their different works in a single mental image. Hugo's first poem explicitly prompted by Dürer is the ballad *Un Dessin d'Albert Dürer, Minuit*,[38] a mediaeval fantasy with its cortège of knights, bishops and ladies, all relentlessly pursued by the spectre of Death, as in Dürer's engravings:

> *Ainsi la mort nous chasse et nous foule . . .*
> *Bons évêques à charge d'âmes,*
> *Dames,*
> *Saints docteurs, lansquenets fougueux,*
> *Gueux,*
> *Nous serons un jour, barons, prêtres*
> *Reîtres,*
> *Avec nos voeux et nos remords*
> *Morts.*

('Thus death chases and tramples us . . . good bishops in charge of souls, ladies, holy doctors, hot-headed foot-soldiers, beggars, one day, with our desires and remorse, we shall all be dead, barons, priests and mercenary soldiers.')

In the 1830s, however, Hugo seems to have acquired a deeper and more precise understanding of Dürer's art. This was enhanced by his travels in the Rhineland related in *Le Rhin* (1840), where he had ample opportunity to study the artist's works in libraries and churches. Two of Dürer's best-known engravings, *The Knight Death and the Devil* [Fig. 118] and *Melancolia* [Fig. 119], (1513) began to assume a particular significance in Hugo's mind and echoes of them reverberate throughout his poetry. The first of these shows the Knight pursuing his solitary path through the forest, while weird demons try to distract him with temptation. He is usually interpreted as the embodiment of Christian chivalry, secure in the faith which makes him indifferent to Evil and Death.[39] But Hugo never attempted to translate this image literally. Instead, he retained the elements – the haunted forest, the weird eyes of the demons – which most haunted his imagination and transformed them into something entirely different. The process can be seen at work in the other, far more mature poem of 1837 *A Albert Dürer*:

117 **Belshazzar's Feast**
Engraving after John Martin
(London, British Museum)

> *Dans les vieilles forêts où la sève à grands flots*
> *Court du fût noir de l'aulne au tronc blanc des bouleaux,*
> *Bien des fois, n'est-ce pas, à travers la clairière,*
> *Pâle, effaré, n'osant regarder en arrière,*
> *Tu t'es hâté, tremblant et d'un pas convulsif,*
> *O mon maître Albert Dürer, ô vieux peintre pensif!*
> *On devine, devant tes tableaux qu'on vénère,*
> *Que dans les noirs taillis ton oeil visionnaire*
> *Voyait distinctement, par l'ombre recouverts,*
> *Le faune aux doigts palmés, le sylvain aux yeux verts,*
> *Et l'antique dryade aux mains pleines de feuilles.*
> *Une forêt pour toi, c'est un monstre hideux.*
> *Le songe et le réel s'y mêlent tous les deux . . .*
>
> (*Voix Intérieures, X*)

('In the old forests where great waves of sap rise up from the black trunk of the alder tree to the silver bark of birches, have you not hastened many times, o my master Albert Dürer, o ancient, pensive painter, across the glade, pale, afraid, not daring to look behind, trembling and with a convulsive step. One can sense from your revered pictures that in the

118 **The Knight, Death and the Devil**
Engraving by Albrecht Dürer (Budapest, Magyar
Nemzeti Galeria)

119 **Melancholia**
Engraving by Albrecht Dürer (Vienna, Albertina
Graphische Sammlung)

black copses, masked by the shadows, your visionary eye saw clearly the web-footed fawn, the green-eyed sylvan and the antique dryad with hands full of leaves. For you a forest is a hideous monster in which dream and reality mingle together.')

Hugo has clearly identified himself with Dürer's art so closely that the original engraving (and other related works like *The Witch* and *St Eustace*) is nearly lost from sight. Dürer simply becomes another visionary after Hugo's own image. In doing so, Hugo goes far beyond the simple *données* of Dürer's engravings, endowing the artist with powers of transformation and fantasy which he never possessed. There is certainly no trace in any of Dürer's work of the '*fleurs au cou de cygne*' (1.22) (flowers with swan's necks) or the '*chênes monstrueux*' (1.38) (monstrous oaks); these are pure Hugolian invention, typical creations of his fertile imagination. In this fantastic forest everything is in a state of constant metamorphosis, neither wholly alive nor wholly dead, at an intermediate stage between plant and animal, vegetable and mineral. Dürer's art, in this case, provided no more than a springboard for Hugo's imagination which reached deep into the subconscious to extract these extraordinary images. They can only be paralleled in the kind of visionary re-creation of history practised by Jules Michelet, who also dwelt at length on such ambiguous states of nature, of flux and change, exemplified in Jupiter who takes the form of a swan in the myth of Leda and the

120 **Faust in his Study**
Etching by Rembrandt, (London, British Museum)

goat turned prophet in Michelangelo's *Moses*.[40] The fact that both writers have extensive recourse to the visual arts as the embodiment of their fantasies is no accident, and reveals a basic affinity in their creative processes.[41]

The other Dürer engraving, *Melancolia* [Fig. 119], has inspired more pages of commentary and interpretation than any other major work, with the exception of Goethe's *Faust*. Even modern scholars have not succeeded in unravelling the precise meaning of all the engraving's details – the ladder, the polyhedron, the compass etc. – but, according to the most authoritative study by Panofsky and Saxl, contemporary astrology provides the key to its obscure symbolism.[42] The winged female figure is a personification of Saturn, the planet of melancholics, shown in that state of brooding melancholy which periodically afflicts those engaged in intellectual or creative work. Melancolia does not, therefore, represent the abandonment of the quest for knowledge, as several earlier commentators have supposed. Michelet saw the dejected figure ('*l'ange de la science et de l'art*') as the symbol of the failure of the Renaissance, the Faustian impasse reached by all who place too much faith in intellectual inquiry: '*Image vraiment complète du découragement, qui supprime l'espoir, ne promet rien, pas même sur l'enfance. Le présent est mauvais, mais l'avenir est pire. Et l'horloge que je vois ne sonnera que de mauvaises heures.*'[43] ('Perfect image of the despondency which suppresses hope, promises nothing, not even to childhood. The present is bad, but the future is worse. And the clock that I see will only chime bad times.')

This subjective and often pessimistic interpretation of Dürer's *Melancolia* is echoed by a host of other nineteenth-century writers, including Gautier, Baudelaire and Gérard de Nerval. All were evidently haunted by this engraving, which became for them an archetypal image of despair as in Nerval's lines:

> *Je suis le ténébreux, – le veuf, – l'inconsolé,*
> *Le prince d'Aquitaine à la tour abolie:*
> *Ma seule étoile est morte, – et mon luth constellé*
> *Porte le soleil noir de la Mélancolie.*[44]
>
> (*El Desdichado, Les Chimères*)

('I am the shadowy one – the widower – the unconsoled one, the prince of Aquitaine in the destroyed tower: my only star is dead – and my star-like lute carries Melancholy's black sky.') The strange occult symbolism of this poem has never been, and perhaps cannot be, entirely

explained. It is only the best-known instance of the persistent recurrence of this image ('*le soleil noir de la mélancolie*') in nineteenth-century French literature reaching as far as Mallarmé and the Symbolists.[45] All these writers read their own personal obsessions into the original engraving, turning it into another emblem of the *ennui* and spleen which afflicted the Romantic generation. Hugo, most of all, was fascinated by the black sun which, instead of radiance, sheds blackness and gloom, as in the line from *La Bouche d'Ombre: 'Un affreux soleil noir d'où rayonne la nuit* ('A terrifying black sun from which the night shines.')

Hugo returned to this terrifying image in *William Shakespeare*. There he explicitly compares Hamlet with *Melancolia*; Shakespeare's hero is described as surrounded by the same attributes, the bat, the sphere, the compass, the hour-glass with an enormous sun behind him 'which seems to blacken the sky'.[46] Here again the poet reveals his deep-rooted obsession with the eclipse of the sun, signifying hopelessness and black despair. His long poem entitled *Melancolia (Contemplations)*, however, bears even less relation to Dürer's engraving than those discussed. Instead it presents, on a vast panoramic scale, a picture of social injustice in contemporary France: on the one hand the victims, beggars, prostitutes, men imprisoned for stealing a loaf of bread, the spurned poet, children condemned to sweated labour, the abused animal: on the other hand, the rogues and profiteers, the dishonest merchant, the pitiless judge, the unscrupulous lawyer, all the grasping callous people whose wealth and pleasure is an insult to those they exploit. This kind of social criticism, written from a sense of deep indignation and pity for the sufferings of humanity, Hugo was to offer on an even broader scale in *Les Misérables*, begun in 1848. It relates to Dürer's engraving only in its universal anguish and pessimism. There may, however, be a hitherto unnoticed connection between Dürer's *Melancolia* and the following poem in the *Contemplations* entitled *Saturne*, opening with an image of the genius in deep and gloomy meditation which bears a strong resemblance to the figure in the engraving:

> *Il est des jours de brume et de lumière vague,*
> *Où l'homme que la vie à chaque instant confond,*
> *Etudiant la plante, ou l'étoile, ou la vague,*
> *S'accoude au bord croulant du problème sans fond;*
> *Où le songeur, pareil aux antiques augures,*
> *Cherchant Dieu que jadis plus d'un voyant surprit,*
> *Médite en regardant fixement les figures*
> *Qu'on a dans l'ombre de l'esprit.*

('These are days of fog and indistinct light, when man, puzzled by life at every turn, as he studies plants, stars, or waves, leans on the crumbling edge of the bottomless mystery; when the thinker, like the augurs in classical times, seeking the god whom more than one seer

discovered, meditates with his gaze fixed steadily on the forms in the dark recesses of his mind.')

The same visionary power, coupled with despair expressed in predominantly monochrome colour, is found in the work of Rembrandt.[47] The Dutch artist clearly exerted a powerful hold over Hugo's imagination, especially in his etchings which contain the essence of Rembrandt's vision in highly concentrated form; these, we have seen, were greatly admired by Hugo and visibly inspired some of his own drawings. Rembrandt's appeal for the writer lay, first of all, in his universality. He had the same profound concern with humanity, and the same sympathy with the downtrodden and oppressed, the beggars, old women and all the 'bas-fonds' of society who gradually came to occupy a predominant place in the poet's mind. Secondly, Rembrandt, like Hugo, was obsessed with the figure of the solitary thinker, as in the *Philosopher* (Paris, Louvre), lost in meditation in a dark room with a winding staircase in the background; or in the etching of *Faust in his study* [Fig. 120], which inspired Hugo's description of the Archbishop Claude Frollo in *Notre Dame de Paris* (1831) Last, and perhaps most important, Rembrandt was the supreme master of light and shade, that mysterious twilight area between day and night corresponding to the depths of the artist's soul. Intuitively Hugo understood what Marcel Proust analysed in more explicit terms in an early essay on Rembrandt,[48] namely that the artist's golden amber-coloured light was a kind of spiritual equivalent of his inner world. This Rembrandtesque tendency to merge figures and shapes with the surrounding atmosphere is most marked in *Notre Dame de Paris*, in which nocturnal transformations play a significant part;[49] people emerge briefly into the glimmering light, only to recede into the dark amorphous background of the city.

This deep but unstated affinity between artist and poet suggests that Hugo had assimilated Rembrandt's art so closely as to make frequent specific reference to his name unnecessary. Allusions to the artist's name in Hugo's poetry are, indeed, infrequent; one of the few instances, to '*les sorciers de Rembrandt*' in *Aux Feuillantines*,[50] reveals little of Hugo's feeling for Rembrandt, in fact hardly applies to the artist's work at all.[51] In *Notre Dame de Paris*, on the other hand, there are some explicit and detailed passages which show that Rembrandt's art underlies the visualisation of this novel no less than Correggio does in Stendhal's *La Chartreuse de Parme*. The first chapter of *Notre Dame de Paris*, '*The Feast of Fools*' opens with a description of Flemish burghers – '*figures dignes et sévères, de la famille de celles que Rembrandt fait saillir si fortes et si graves sur le fond noir de sa Ronde de Nuit*'. ('Dignified, severe figures, of the kind which Rembrandt made stand out so strongly and so solemnly on the black background of his *Night-Watch*.') The allusion to Rembrandt's

celebrated masterpiece in the Rijksmuseum, Amsterdam, *The Night Watch* (which Hugo had probably not seen at this time) is a clear indication of his approach to the *mise en scène* of this and similar episodes in the novel, in which individual figures are highlighted against a less distinct crowd in the background. As in Rembrandt's picture, lighting is used to create strangely dramatic and hallucinatory effects.

The other, more significant passage occurs later in the novel, in the portrait of Archdeacon Claude Frollo in his study: '*Le lecteur n'est pas sans avoir feuilleté l'oeuvre admirable de Rembrandt, ce Shakespeare de la peinture. Parmi tant de merveilleuses gravures, il y a en particulier une eau-forte qui représente, à ce qu'on suppose, le docteur Faust, et qu'il est impossible de contempler sans éblouissement. C'est une sombre cellule. Au milieu est une table chargée d'objets hideux, têtes de mort, sphères, alambics, compas, parchemins hiéroglyphiques. Le docteur est devant cette table, vêtu de sa grosse houppelande et coiffé jusqu'aux sourcils de son bonnet fourré. On ne le voit qu'à mi-corps. Il est à demi-levé de son immense fauteuil, ses poings crispés s'appuient sur la table, et il considère avec curiosité et terreur un grand cercle lumineux, formé de lettres magiques, qui brille sur le mur du fond comme le spectre solaire dans la chambre noire. Ce soleil cabalistique semble trembler à l'oeil et remplit la blafarde cellule de son rayonnement mystérieux. C'est horrible et c'est beau.*'[52] ('The reader must have doubtless seen some of Rembrandt's admirable works, that Shakespeare of painting. Among many marvellous engravings there is a particular etching which shows, as far as we know, Doctor Faustus, and it is impossible to look at it without amazement. It shows a dark cell. In the middle is a table laden with hideous objects – skulls, spheres, alembics, compasses, hieroglyphic parchments. The Doctor is seated at the table, dressed in his large cloak and covered to the eyebrows with his fur-lined bonnet. He is only visible half-length. He has half risen from his huge chair, his clenched fists resting on the table, and he is studying with curiosity and terror a great luminous circle formed of magic letters which shines on the wall in the background like the solar spectrum in the darkened room. This cabbalistic sun seems to tremble before the eye, and fills the gloomy cell with its mysterious rays. It is both frightening and beautiful.') This minute and detailed description of Rembrandt's etching of *Faust* [Fig. 120] in his study surrounded by all the symbols of alchemy reveals Hugo's intuitive understanding for the artist's work; the obscure symbolism of Faust's scientific instruments and the powerful *chiaroscuro* effect of the setting all contribute to this typically Hugolian mixture of grotesque and sublime beauty.

CHAPTER IX

Alfred de Musset (1810-57)[1]

To many readers today the name of Alfred de Musset may seem synonymous with the outward manifestation of Romanticism. In his person he was the very embodiment of the movement and the supreme lyric poet of youthful love. Young, handsome, aristocratic [Fig. 121], enterprising in love, with a strong partiality for women, dancing and all kinds of pleasure, he began life as a brilliant, precocious poet, writing accomplished verse at the age of 14, and ended it at the age of 47, disillusioned and exhausted from alcohol and debauchery. Musset was the typical *'enfant terrible'* of Romanticism. Born in 1810, *'conçu entre deux batailles, élevés dans les collèges au roulement des tambours'* ('conceived between two battles, brought up in school to the rolling of drums'), as he memorably put it in the autobiographical *Confession d'un Enfant du Siècle* (1836), he grew up in the aftermath of the Napoleonic defeat, too young to have known the glory of battle and too old to be able to face the future with any confidence. This was the meaning of the *'mal du siècle'* for Musset and his generation. The only reality facing him was a life of endless futile leisure, of dissipation. The dandyism, which he shared with Delacroix, was merely an external form of compensation for this inner restlessness.

The quest for pleasure, which a man of more robust constitution might have enjoyed without the initial frenzy and passion, but without the remorse which inevitably followed their satisfaction, was the main ingredient of his poetry and inspired some of his best-known lines, like *'les plus désespérés sont les chants les plus beaux'*[2]. ('The most desperate are the most beautiful songs.') For Musset, permanently scarred by unhappy love affairs and by his disastrous liaison with George Sand, love was inseparable from suffering; and yet, like a drug, he simply could not live without it:

> *Après avoir souffert, il faut souffrir encore;*
> *Il faut aimer sans cesse, après avoir aimé.*
>
> (*La Nuit d'Août*)

('Having suffered, one must suffer again; once you have loved, you must love ceaselessly.') Only in this state of permanent intoxication was he in full command of his creative powers.

This, the more familiar aspect of the poet, is only one side of his life and writing, however. Never far below the surface of his typically Romantic attitudes and postures lies the lucid, mocking observer ready to prick the bubbles of his own sensibility. He retained

a strong dose of eighteenth-century *libertinage*, and a love of the wit and style that accompanied it. Though lyrical by temperament, Musset, like Heine, had an essentially modern, ironical outlook which made him incapable of sustaining his own illusions. He quickly outgrew his own Romanticism; though he continued to exploit its themes – love, passion, intrigue and historical romance – he often treated them in a casual, offhand manner which would have seemed quite alien to writers like Chateaubriand and Lamartine. He, for his part, regarded their inflated rhetoric as pompous, old-fashioned and basically insincere. In nearly all Musset's work there is a touch of the flippant impertinence of the *gamin* who began as the spoilt darling of the fashionable Romantic movement and who later enjoyed poking fun at it.

121 **Drawing of Alfred de Musset**
Eugène Lami (Paris, Comédie Française)

This basic ambiguity in his character and poetry can partly be attributed to Musset's aristocratic dandyism. Well aware of his susceptibilities and capacity for suffering, he hid behind a mask of elegant dress, frivolity and studied rudeness which, in those days, was considered the mark of good breeding. Musset was a man of fastidious tastes; his poetic ideal was not in sonorous, well-rounded verse, but a kind of '*sprezzatura*', the lightness of touch and nonchalance of a curious and amused observer. Art and writing, in his eyes, were not the trade or *métier* of the professional man of letters, but the part-time occupation of a dilettante and gentleman, something to be fitted in between his morning toilet and lunch at a fashionable restaurant. A poem or work of art, in order to be interesting, had to arise from direct contact with life and personal experience. Musset wrote for the ordinary intelligent man or woman of society in search of a good romance, with plenty of excitement and copious tears, livened by fantasy and wit.

It was precisely this recipe which made the *Contes d'Espagne et d'Italie* such a success when they were published in 1830.[3] It was immediately obvious to their more perceptive readers such as Alexandre Dumas that these poems, though conventionally Romantic in their exploitation of passion, adultery, intrigue and violence against an exotic Mediterranean background, strike a distinctive and sometimes discordant note in the well-orchestrated harmonies of Romantic poetry. There is a persistent irony and playfulness, including parody (in the *Ballade à la lune*, for example), which show that Musset was severing his ties with the movement. Already in the dedication to *La Coupe et les Lèvres* (1832), the poet clearly expressed his dislike of sentimental effusions in the manner of Lamartine:

> *Mais je hais les pleurards, les rêveurs à nacelles,*
>
> *Les amants de la nuit, des lacs des cascatelles . . .*

('But I hate whimperers, dreamers of skiffs, lovers of the night, of lakes and waterfalls . . .')
Musset's native lucidity, which some of his contemporaries took for cynicism, made him
temperamentally incapable of sustaining the attitudes of a true Romantic poet. Though
lyrical by nature, he was wary of too much display of tender emotion. This watchfulness is
reflected in the choice of rhythm in his poetry; unlike the smooth regular flow of
Lamartine's verse, he shows a preference for broken rhythms, unexpected cadences and
sudden variations in tempo, as if to keep himself and his reader wide awake. Most of the
longer poems, like *Don Paez* [Fig. 122] and *Les Marrons du Feu*, are narrated in the relaxed
style of the raconteur, but suddenly the dialogue is broken by an exchange of short staccato
monosyllables which serve to heighten the dramatic tension.

The same element of surprise governs Musset's choice of imagery. Again his
determination to break with the current Romantic fashion for exotic local colour, typified
by Hugo's *Orientales*, is clearly stated in the poem *Namouna*:

> *Si d'un coup de pinceau je vous avais bâti*
>
> *Quelque ville aux toits bleus, quelque blanche mosquée,*
>
> *Quelque tirade en vers, d'or et d'argent plaquée,*
>
> *Quelque description de minarets flanquée,*
>
> *Avec l'horizon rouge et le ciel assorti,*
>
> *M'auriez-vous répondu: 'Vous en avez menti?*
>
> *(Canto 1, Stanza XXIV)*

('If with a stroke of the brush I had built for you some town with blue roofs, a white
mosque, a piece of rhetorical verse, plated with gold and silver, some description flanked with minarets, with
a matching red horizon and sky, would you have
replied: 'You have lied?') There was evidently no love
lost between Hugo and Musset, especially after the
latter began to distance himself from the *Cénacle* in the
search for his own poetic identity. Hugo once dis-
missed Musset's work as 'soap bubbles which burst in
the slightest breeze'. Musset, for his part, found Hugo's
poetry too sonorous and heavy-handed for his taste; he
particularly disliked its abuse of rich rhyme and
descriptive adjectives. He sought instead to create an

122 **Illustration for Musset's poem** Don Paez
Adolphe Lalauze after Eugène Lami

effect of lightness and spontaneity, by means of the unexpected juxtaposition of images and elliptic, half-completed metaphors. His images have been described as sudden hallucinations which presuppose an entire symbolic scene.[4] The most striking example of these poetic innovations is the well-known *Ballade à la Lune*:

> *C'était, dans la nuit brune,*
>
> *Sur le clocher jauni,*
>
> *La lune,*
>
> *Comme un point sur un i.*
>
> *Lune, quel esprit sombre*
>
> *Promène au bout d'un fil,*
>
> *Dans l'ombre,*
>
> *Ta face et ton profil?*

('It was in the gloomy night, the moon was like a dot on an 'i' on the yellowing steeple. Moon, what melancholy spirit manipulates your face and profile on the end of a thread, in the shadow?') To readers accustomed to the Romantic cult of the moon as a soothing influence on troubled souls, such an offhand treatment – seeing it as a dot suspended over a church spire – seemed virtual sacrilege. Musset succeeded in offending Classics and Romantics alike. Today, especially after the experiments of Verlaine, Lafforgue and twentieth-century poets, such images no longer seem daring but in their time they were a profound shock to the French poetic creed. Fresh and unexpected images are legion in Musset's poetry: one example from the poem *Venise* describes a cloud passing in front of the moon, compared with the gesture of the abbess of the convent of Santa Croce as she draws the folds of her cloak over her surplice. Or again, in *Don Paez*, a more conventional but beautiful simile of the moon piercing the Gothic tracery of a Spanish palace:

> *La lune se levait; sa lueur souple et molle,*
>
> *Glissant au trèfles gris de l'ogive espagnole,*
>
> *Mêlait aux flammes d'or ses longs rayons d'argent,*
>
> *Sur les pâles velours et le marbre changeant.*

> (*I, 45-8*)

('The moon rose; its soft and gentle glow, sliding into the grey trefoils of the Spanish arch, mingled its long silver beams with flames of gold, on the pale velvet and mottled marble.') Though abundant, Musset's imagery is rapid, allusive and sparing in its use of colour and pictorial effects. His aim in the *Contes d'Espagne et d'Italie* was to set the scene quickly, to evoke the exotic setting – Madrid or Venice – with a few conventional stage props and leave the rest to the reader's imagination. His descriptions of these cities, which he had not

123 Drawing of George Sand
Alfred de Musset (Paris, Institut de France)

visited at the time of writing the poems, are compounded of the stock-in-trade from the traveller's repertory of dark-eyed Spanish duennas, with fans, mantillas and legs well concealed by long black stockings. *Venise*, on the other hand, came to him as a glittering vision of marble palaces, gondoliers and courtesans promising a wealth of sensuous delights. To a writer with no more than a rudimentary or second-hand knowledge of his setting, therefore, painting clearly offered a valuable stimulus to his imagination and enabled him to visualise Spain and Italy with the ease of an armchair traveller. Though at this stage Musset was perhaps no more familiar with the art of these countries than any ordinary well-educated young man of his day, he had briefly studied drawing and shown considerable talent. Delacroix is reported by George Sand [Fig. 123] to have said of him that 'he would have made a great painter, if he had wanted to be.'[5] He had also acquired some knowledge of the most important Italian and Spanish painters and, apart from a great admiration for the works of Raphael whose name recurs frequently throughout his writings, Musset had evidently studied Goya's etchings in some detail.[6]

References to specific works of art in the *Contes d'Espagne* do not occur frequently, but paintings by Venetian artists, especially Canaletto and Longhi, clearly underlie Musset's evocation of the city in poems like *Venise* and the third canto of *Portia*. The second poem contains a memorable description of Venice at sunset, when all the city's domes and palaces are silhouetted against a purple sky:

> *Une heure est à Venise, – heure des sérénades;*
> *Quand le soleil s'enfuit, laissant aux promenades*
> *Un ciel pur, et couvert d'un voile plus vermeil*
> *Que celui que l'Aurore écarte à son réveil . . .*
> *La ville est assoupie, et les flots prisonniers*
> *S'endorment sur le bord de ses blancs escaliers . . .*
>
> (*Portia III, 303-12*)

('There is a time in Venice – the time of serenades; when the sun sets, leaving a clear pure sky over the promenades, covered with a veil more purple than the one which Dawn discards on her awakening . . . The city is drowsy, and the imprisoned waves sleep at the foot of its white steps . . .') Though there is no explicit pictorial allusion here, the entire

124 **Ruega por ella**
Goya, Etching (London, British
Museum)

125 **Ruega por ella**
Musset, Pen drawing after Goya's etching
(Paris, private collection)

passage is composed with the clarity and sense of form and colour which can only have
come from familiarity with Venetian painting. Elsewhere, in *Mardoche*, the poet indulges his
fantasy of an ideal mistress as a young woman by Giorgione:

> *Un sein vierge et doré comme la jeune vigne,*
>
> *Telle que par instant Giorgione en devina,*
>
> *Ou que dans cette histoire était la Rosina.*
>
> (*Mardoche, XIII, 128-30*)

('A virginal breast, gilded like the young vine, as Giorgione for a moment perceived her,
or such was Rosina in this story.')

The most literal borrowings from the visual arts, however, occur in the poems devoted
to Spain and Spanish women, notably in *Madrid, Madame la Marquise* and *l'Andalouse*. All
these short pieces are directly inspired by examples of Goya's *Caprichos*, both in their
general feeling and in certain concrete details which reappear unchanged in the poems.[7]
Like all his Romantic contemporaries, Musset was fascinated by the dark,
mysteriously voluptuous qualities of Spanish women, their exotic customs and dress. More
than anywhere else, he found these qualities embodied in the *majas* of the *Caprichos*, plates
like *Bellos consejos* (Good Advice) and *Ruega por ella* (She prays for her) [Fig. 124], several
of which Musset copied, with slight adaptations, into his own sketchbooks . In his copy of

Ruega por ella [Fig. 125], for example, Musset includes the young woman on the left lifting her dress to reveal a shapely leg, a hideous old duenna in the middle, and another young woman on the right holding a fan, dressed in a black lace mantilla covering a white lace bodice leaving an ample bosom half exposed. All these Goyaesque women, complete with their exotic accessories, figure in the sequence of Spanish poems, beginning with *Barcelone*, which conjures up Musset's ideal of Andalusian female beauty:

> *Avez-vous vu, dans Barcelone,*
> *Une Andalouse au sein bruni?*
> *Pâle, comme un beau soir d'automne!*
> *C'est ma maîtresse, ma lionne!*
> *La marquesa d'Amegui . . .*
> *Elle est à moi, – moi seul au monde, –*
> *Ses grands sourcils noirs sont à moi*
> *Son corps souple et sa jambe ronde,*
> *Sa chevelure qui l'inonde,*
> *Plus longue qu'un manteau de roi . . .*
> *Et qu'elle est folle dans sa joie!*
> *Lorsqu'elle chante le matin,*
> *Lorsqu'en tirant son bas de soie,*
> *Elle fait sur son flanc qui ploie,*
> *Craquer son corset de satin!*

('Have you seen in Barcelona an Andalucian with a tanned breast? Pale as a beautiful autumn evening! She is my mistress, my lioness! The Marquesa d'Amegui . . . She belongs to me – me alone in the world – her great black brows are mine, her pliant body and well formed leg, her hair which drowns her, longer than a king's train . . . And how mad she is in her joy! While she sings in the morning, drawing on her silk stocking, she makes her satin corset crack on her curving side!') All the details from Goya's plate are incorporated, via Musset's own copy, into a *transposition d'art* as complete as those later perfected by Théophile Gautier in *Emaux et Camées*.

Musset's Art-Criticism

Musset was fascinated by art and artists as he constantly returns to them and their problems in his writing. A practising artist himself, he mixed frequently with painters and evidently enjoyed their company. Shortly after his introduction to Hugo's *Cénacle* where he met Boulanger and possibly Paul Chenavard, the philosophical painter, he was soon a regular visitor at Eugène Devéria's brilliant salon, where he appeared in 1828 at a masked

ball in the costume of a Renaissance page.[8] Musset found a special affinity with Eugène Lami (1800-90), the talented painter and illustrator, described by Baudelaire as 'the poet of dandyism, almost English in his love of things aristocratic'. Lami sketched Musset more than once and eventually illustrated the 1883 edition of the poet's complete works. Later, through his friendship with Charles Nodier, the director of the Bibliothèque de l'Arsenal, Musset came into contact with the illustrator Tony Johannot and his brother Alfred, and, above all, Delacroix. He seems, though, to have found little in common with Delacroix and was, apparently, bored by the painter's long discussions of aesthetics and theoretical matters. In general, Musset kept his distance; he enjoyed the friendship of artists, but he was clearly more at home in fashionable society than in their bohemian *milieu*. Moreover, he disliked their studio jargon and had little time for their endless arguments and sectarian attitudes which he felt missed the point of what should be an artist's true concern. Musset also turned to the problem of the artist in several plays, among them *Lorenzaccio* (1834) and *André del Sarto* (1833) and in the short story, *Le Fils du Titien* (1838). All are set at the tail-end of the Italian Renaissance, the period he saw as one of decadence following the deaths of the great artists, Raphael, Michelangelo and Titian. But they offer very little insight into his true opinions of the art of that time. Instead he trims his heroes down to the size of minor theatrical figures, dominated by their mistresses to an extent that any divine spark which might have lingered in them is finally extinguished. Like the poet himself, Musset's fictional artist-figures depend for their nourishment on love; when love abandons them, nothing is left but a void. This is André del Sarto's final cri du coeur: '*J'ai eu du génie autrefois, ou quelque chose qui ressemblait à du génie . . . mon génie mourut dans mon amour.*'[9] ('Once I had genius, or something which resembled genius . . . my genius died with my love.')

It was, however, in his contemporary art-criticism that Musset expressed his views on painting most directly. These reviews, written at different times, have only recently been published together,[10] and include the *Exposition du Luxembourg au Profit des Blessés* (1830), a short but impressive piece on paintings by Gros (1831) exhibited on the same occasion, and a full-length review of the Salon of 1836 which first appeared in the *Revue des Deux-Mondes*. Despite its light-hearted tone and apparent dilettantism, Musset's art-criticism is consistent in its main themes and clearly linked, though sometimes tenuously, with the rest of his literary output. The one question to which he returns time and again is: what is art? Much though he hated the dogmatic discussion of aesthetics, he could not escape this crucial issue. All poetry, after all, implied an instinctive reflection on the problems of artistic creation. His own answer is contained in the text *Un Mot sur l'Art Moderne* (1833),

126 Napoleon visiting the Plague-stricken of Jaffa
Baron Antoine Jean Gros (Paris, Louvre)

which states unequivocally that art is a matter of feeling, and that feeling is the product of individual temperament: '*Il n'y a pas d'art, il n'y a que des hommes . . .*' ('There is no art, there are only men . . . Art is feeling, and everyone feels in his own way. Do you know where art is to be found? In man's head, in his heart, in his hand, even in his finger tips.')[11] Journalism, studio talk, sectarian discussion were all, in his view, a waste of time and a distraction from the real nature of art. Primacy of feeling, style, and the unique stamp of the individual temperament are, therefore, Musset's main criteria of a work of art, just as much as of poetry. Hence his constant complaint of the proliferation of pastiches in French art, the total negation of any originality. In this sense, if not in others, Musset stands comparison with Baudelaire who was later to pursue these ideas in much greater depth.

A vital factor which determined Musset's artistic tastes was his own particular vantage point in history. The '*enfant du siècle*', who grew up in the wake of Waterloo and the collapse of the Empire, looked back to the heroic Napoleonic era with undisguised nostalgia. As a child who had only heard the distant rumble of battle from the schoolroom, Musset was fascinated by the imperial myth and everything which related to the recent past. Only this can explain his remarkable insight into Gros' *Napoleon visiting the Plague-stricken of Jaffa* (1804, Paris, Louvre) [Fig. 126] and his *Battle of Aboukir* (1806, Versailles, Musée), both works on a heroic scale celebrating the glories of Napoleon's exploits. What Musset recognised in these paintings, and others of the Davidian school, was a sense of moral grandeur totally absent from his own generation. *Napoleon visiting the Plague-stricken at Jaffa*, showing the Emperor healing his plague-stricken soldiers with a Christ-like gesture, was in Musset's words, 'living, terrible, majestic, superb'.[12] He went on to characterise the painting in terms which reveal complete moral sympathy with this lesson in heroism and the stoical endurance of suffering: 'Thus everything favours the harmonious effect of this painting, the wan daylight illuminating it, the brilliant half-tone working its way beneath the arcading, the contrast between the rags of our soldiers on their sick beds and the brilliant oriental costumes, the intrinsic interest of the scene, the finest an artist's

brush could ever depict, which relates the struggle of the moral greatness in mankind against overwhelming physical suffering.'[13]

The *Salon of 1836*, Musset's only full-length review of contemporary art, is marked by the same ambivalent attitude to Romanticism as his other writing. The Romantic movement, in Musset's opinion, was the product of a disunited, unheroic age and had visibly failed to produce any concerted artistic effort to compare with the earlier generation of David, Gros and Géricault. It had, above all, made the fatal mistake of turning its back on the present, misled by the current obsession with history: the theatre, novels, paintings and even musi-

127 **Evening Angelus**
Guillaume Bodinier (Angers, Musée des Beaux-Arts)

cians, he observed, were all fatally attracted to the past: 'Where does one see a painter, a poet concerned with what is happening, not in Venice, or Cadiz, but in Paris, all around him?'[14] This concern with modernity and realism is a recurrent theme of Musset's art-criticism and one which links him directly with Stendhal and Baudelaire. But the paintings which confronted Musset in 1836 show that French art was in a kind of limbo; the great Salons of 1824 and 1827 and the battle of Romanticism were already distant memories, while fully-fledged Realism in the shape of Courbet – which Musset would almost certainly have disliked if he had known it – had not yet come into existence. Musset wrote at a time when the Romantic movement was on the wane. As a result, his criticism hovers between nostalgia for the past, recognition of the popular favourites of the present and an attitude of cautious but not entirely whole-hearted approval of Delacroix, the single outstanding artist in a period of relative mediocrity. Unlike Baudelaire, who claimed that criticism should be '*partiale, passionnée, politique*',[15] Musset's critical stance is usually one of an easy-going eclecticism, ready to admire anything above the average level and to enjoy anything which caught his fancy, whether it was the sight of a pretty woman, an attractive landscape or a moving human drama.

As with so many other nineteenth-century writers who turned their hand to art-criticism, Musset delighted in the anecdotal and picturesque aspects of painting. The first to engage his attention was a work by Auguste Hesse (1806-70), entitled *Leonardo da Vinci freeing some Birds*:[16] 'This painting suggests a kind of freshness which charms at first sight and invites one to linger.'[17] This type of anodyne historical genre scene from the lives of famous artists enjoyed an enormous popularity in the first half of the nineteenth century,[18] and Musset – whose own short story *Le Fils du Titien* inspired several paintings

exhibited at the Salon – was merely echoing the taste of his contemporaries in devoting more than a page to it. He also shared the general admiration for Granet, who exhibited several paintings in 1836, including *The Cardinal Protector of the church of Sainte-Marie-des-Anges* (Aix-en-Provence, Musée des Beaux-Arts): Granet, he wrote, was the same as always, 'simple and admirable'.[19] Few today would disagree with this judgement of a minor but still underrated master. Guillaume Bodinier's (1795-1872) *Evening Angelus* [Fig. 127] (Angers, Musée des Beaux-Arts) was another genre painting which Musset singled out for praise: 'a soft, agreeable composition, full of melancholy'.[20] But the works which most appealed to Musset's imagination were those depicting the life of ease and amorous pleasure, such as Eugène Lami's *Voiture de Masques* [Fig. 128] (Paris, Musée Carnavalet) and Wintherhalter's *Far-niente*. Like Stendhal, Musset looked at women in art with the eyes of a lover and found himself irresistibly attracted to the young girl in Wintherhalter's picture leaning nonchalantly against a fountain.

A religious painting which especially caught his attention was *The Guardian Angel* by the Belgian painter Henri Decaisne[21] (1799-1852) [Fig. 93]. This work, full of the unctuous piety of the period, was deeply admired by both Musset and Lamartine and shows a close affinity between the artistic tastes of the two poets.[22] A passage in Musset's *Salon of 1836*, in which he quotes 'the most eminent' poet of the day as praising Decaisne's picture as 'one of the finest at the Salon'[23] has puzzled even recent editors of Musset's criticism. There is no doubt that this remark praising Decaisne was made by Lamartine, who had his portrait painted by the artist in 1839. The full significance of Decaisne for Lamartine's poetry has been studied earlier, but the fact that the same painting elicited such similar responses in the two poets is evidence of a remarkable coincidence of taste. Musset, for his part, praised

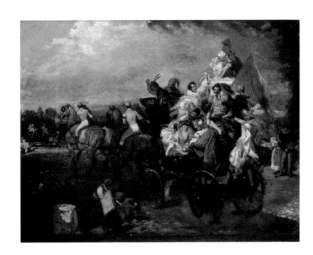

128 **Voiture de Masques**
Eugène Lami (Paris, Musée Carnavalet)

The Guardian Angel without reservation: 'The angel's head is admirable, in the full meaning of the word; the rest is simple and harmonious. Moreover, the subject is so beautiful that it plays a large part in our emotion in front of it; a child lying in its cradle, a mother drowsy with tiredness, and an angel watching in her place.'[24]

Nicolas Charlet's *Retreat from Russia* (Lyon, Musée) [Fig. 129] was the single painting which clearly made most impact on Musset. A pupil of Gros, Charlet (1792-1845) devoted his entire energies to a retrospective glorification of Napoleon and the Empire. This fact, combined with the painting's tremendous power showing masses of soldiers, dead

and alive, strewn along the desolate Russian plains like waves of an inhospitable sea, explains why Musset responded to it so immediately and with the full force of his prose: 'What does this picture represent therefore ...Where is its focal point which one usually finds in battle scenes in our museums? Where are the horses, the plumed helmets, the captains, the marshals? None of that; it is the Imperial army, it is the soldier, or rather it is mankind; naked human misery, under a foggy sky, on ice-bound terrain, without guide, without leader, without heroism. It is despair in the desert. Where is the emperor? He has left; far away, over there, on the horizon, amid these appalling clouds of dust, his carriage is perhaps rolling over heaps of corpses, carrying his misfortune away with him; but not even the dust is visible.'[25]

Charlet's painting was a truly epic vision of modern warfare, a mass of confused figures, leaderless and without direction. This sense of tragedy was precisely what was missing in Horace Vernet's countless battle pieces, with their neatly turned-out toy

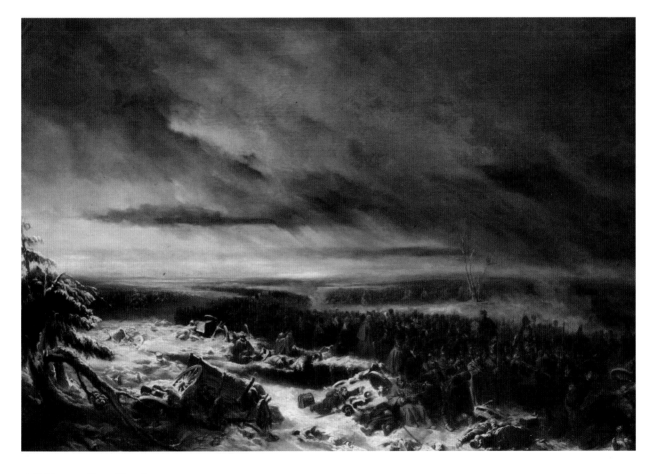

129 **Retreat from Russia**
Nicolas Charlet (Lyon, Musée des Beaux-Arts)

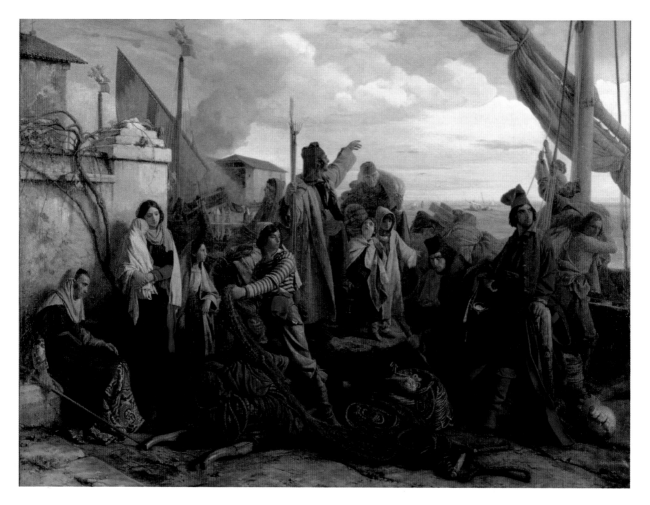

130 **Fishermen leaving for the Adriatic**

Léopold Robert (Neuchâtel, Musée d'Art et d'Histoire)

soldiers in polished boots and buttons glittering on their uniforms. Vernet was a painter of the barracks and parade ground rather than the field of battle. He did, however, undoubtedly have dash and a slickness of execution which made him hugely popular with the French public. Musset readily acknowledged this quality in Vernet's exhibits at the Salon of 1836, the battles of Friedland and Wagram: '*Le vrai talent de M. Vernet, c'est la verve.*'[26] He went on aptly to describe Vernet's art as 'rapid, facile prose, almost action'. Musset, who was by no means disposed to quarrel with popular opinion, recognised that Vernet's enormous popularity could not lightly be dismissed. Like Stendhal reviewing Vernet in 1824, he was compelled to admit that an artist who gives the public what they want must, in a sense, offer a true reflection of modern life.

Though Musset's attitude towards Delacroix (who exhibited a *St Sebastian* in 1836) was a good deal less enthusiastic than Baudelaire's, he clearly recognised a great artist when he saw

one. Unlike many critics of his own time who adopted a consistently carping tone, he also had the intelligence to see that the 'faults' of Delacroix's draughtsmanship were only the reverse side of his outstanding qualities: 'In all he does, there is the same inspiration, and it is found as much in his greatest successes as in his greatest aberrations.'[27] This feeling for the 'constant identity' underlying Delacroix's *oeuvre* reveals a genuine understanding of the artist's creative processes; indeed, Musset writes in almost the same terms as Baudelaire does some 20 years later, and which find distant echoes in the brilliant critical improvisations of Marcel Proust on Vermeer. Moreover, Musset recognised in Delacroix not the leader of the Romantic school – as many *avant-garde* critics over-hastily baptised him – but an outstanding individual, pursuing his own silent, solitary path in total disregard of current theories and fashions. As Musset saw, Delacroix was far too intent on his own pictorial problems to harbour consciously revolutionary aims. His art was, in fact, the complete embodiment of the triumph of individual temperament over ephemeral issues.

The last painting to figure in Musset's *Salon of 1836*, and one which held a particular fascination for him, was Léopold Robert's *Fishermen leaving for the Adriatic* (Neuchâtel, Musée d'Art et d'Histoire) [Fig. 130]. This was originally intended as one of a highly ambitious project to portray the four seasons in different Italian cities: spring in Naples in the *Return from the pilgrimage to the Madonna of the Arch* (Salon of 1827; now in the Louvre), summer in Rome in *Harvesters in the Pontine Marshes* (Salon of 1831, Louvre) [Fig. 85]; autumn was to have been represented by vintage time in Florence, but then changed into *Fishermen leaving for the Adriatic* set in Venice. The last of the series, a Venice *Carnival* in winter, was never completed, for the painter, then living in Venice, conceived a violent and fruitless passion for the Princess Charlotte Bonaparte which finally drove him to suicide. This tragic end to the life of a painter whose poverty and noble, high-minded idealism only enhanced his romantic aura, exerted a strong fascination over many writers including Maurice Barrès late in the nineteenth-century.[28] They were ready to overlook the artist's deficiencies, his laborious composition, for the sake of the pathos and human drama latent in his work. The tragic poverty of the fishermen's lives, and, by implication, the artist's own, is the keynote of Musset's passage on the *Fishermen leaving for the Adriatic*, one of his most lyrical and deeply-felt pieces of writing expended on an artist who, despite his gifts and humanitarian ideals, never quite achieved his own ambitions: 'Oh Lord! The hand which created that and which in six characters expressed a whole nation and people! That powerful, wise, patient, sublime hand, the only one capable of reviving the arts and restoring truth! That hand which in the few works it created, copied from nature only that which is beautiful, noble, eternal! That hand which painted the common people and which, guided solely by the instinct of genius, sought the path of the future where it lies, in humanity! That hand, yours, Léopold! That hand which created this work, how could it shatter the brow which conceived it?'[29]

CONCLUSION

THIS STUDY HAS looked at some of the main points of contact between art and literature in France in the first half of the nineteenth-century. This is not, however, to say that the close relationship between the two arts was finished in 1840, indeed they continued to feed on each other right until the end of the century and beyond. The novels of Balzac (which span the period of roughly 1830 to 1850) are packed with allusions to painting, both Old Masters and contemporary; he greatly admired Girodet, and in two of his novels, *Le Chef d'Oeuvre Inconnu* (1831) and *La Rabouilleuse* (1843) the artist occupies a central place in the fictional context. Balzac was also an avid but undiscriminating collector who portrayed some of his own foibles in *Le Cousin Pons* (1846), a highly dramatic and moving portrayal of the art world in Paris around 1850. Undoubtedly some of Balzac's powerful visual sense, graphic characterisation and grasp of physical details was due to his familiarity with works of art; but he was primarily a craftsman in words, and, despite the countless scattered references to Raphael, Girodet and other artists in *La Comédie Humaine*, it can hardly be said that the visual arts contributed as much to the workings of his imagination as, for example, to the pages of Marcel Proust's *A la Recherche du Temps Perdu*. In that great work painting and imagery derived from it add an extra visual dimension to the already dense texture of the author's prose.

In poetry the process of assimilation of pictorial imagery was continued by Baudelaire, taking up where Gautier left off and investing work of art with deep human significance. The publication of Théophile Gautier's *Emaux et Camées* in 1852 marks the extreme point in the appropriation of the visual arts by literature, the so-called '*transposition d'art*', which he carried to its logical conclusion. In the face of flux and change, and a hostile universe which permitted meaningless suffering, Gautier adopted an attitude of cheerful moral indifference. He found a bastion in art, or, as it was to become in the hands of the Parnassian poets, '*l'art pour l'art*':

> *Tout passe. – l'art robuste*
>
> *Seul a l'éternité;*
>
> *Le buste*
>
> *Survit à la cité.*
>
> (*L'Art*, first published in *L'Artiste, 1857*)

('All passes. – Strong art only possesses eternity; the bust survives the city.') Gautier's literary ideal was primarily sculptural, hard, resilient, static and as pure and beautiful as an Attic statue of early Greece. He had little room for human sentiment, or at least anything

more than a light playful eroticism in the ingenious aesthetic modulations of his verse. Baudelaire, on the other hand, whose great and only passion was '*le culte des images*' (his own words in *Mon Coeur mis à nu*), went straight to the human core of a work of art. In the *Fleurs du Mal* (1857), paintings and drawings by artists such as Callot, Goltzius and, above all, of his idol Delacroix, are woven so intimately into the texture of his poems that they become part of all-embracing symbolism or 'correspondances', linking imagery, words and music in one overall harmony. Painters, in Baudelaire's poem *Les Phares*, were the great beacons or luminaries, whose works hold out rays of hope for mankind in a world in which civilisation was constantly threatened by barbarism:

> *Car c'est vraiment, Seigneur, le meilleur témoignage*
> *Que nous puissions donner de notre dignité*
> *Que cet ardent sanglot qui roule d'âge en âge*
> *Et vient mourir au bord de votre éternité!*

('Because it is truly, Lord, the best witness that we can give of our dignity, this passionate sob which echoes down through the ages and dies on the edge of your eternity.')

This was the ultimate formulation of the Romantic doctrine in painting and literature, and one to which all the artists and writers studied in this book would have subscribed. For by the middle of the nineteenth century – thanks largely to the efforts of the Romantics – the painter was finally recognised as the writer's equal, not only in social status but also in expressive power and potential ability to change men's hearts and modes of perception. Painters, writers and musicians were no longer individuals thinking different thoughts, speaking a different language, but members of a universal brotherhood of free spirits who sought to transmit their unique vision of the world in paint, words or sound, or a combination of all three. This fusion was the permanent achievement of the French Romantic movement, of which the experiments of Mallarmé, Valéry and the Symbolists can be seen as a further extension, often combining auditory, visual and musical sensations in a single work.

It was only in the early twentieth century with the rise of abstract painting and the Modern Movement that artists ceased to feel the need to tell a story or convey a message. The close link between art and literature which had been a dominant characteristic of the Romantic movement was finally severed. Thereafter literary painting and descriptive prose went into terminal decline.

NOTES

226

Abbreviations:

G.B.-A. for *Gazette des Beaux-Arts*
J.W.C.I. for *Journal of the Warburg and Courtauld Institute*

Chapter I

1. The bibliography on Madame de Staël is vast, but two biographies of fairly recent years are those by Jean Christopher Herold, *Mistress to An Age*, London, 1959 and, on a more serious level, Simone Balayé, *Madame de Staël: lumières et liberté*, Paris, 1979. Madame de Staël's first biographer was her cousin, Madame Necker de Saussure whose *Notice sur le caractère et les écrits de Madame de Staël*, published in 1820, remains a standard work on her life and work. Numerous important articles have appeared in the *Cahiers staëliens*, edited by Simone Balayé. On Madame de Staël and the visual arts, see the articles by Jean Ménard: 'Madame de Staël et la Peinture', in *Madame de Staël et l'Europe, Colloque de Coppet* (18-24 July 1966), and Simone Balayé: 'Du sens romanesque de quelques oeuvres d'art dans Corinne, in *Mélanges offerts à André Monchoux, Annales de l'Université de Toulouse*, Tome XIV, 1979. Much visual material was included in the exhibition *Madame de Staël et l'Europe*, held at the Bibliothèque Nationale, Paris, in 1966, but very little was illustrated in the catalogue.

2. Madame de Staël, *De La Littérature*, ed. P. van Tieghem, Paris, 1959, vol. I, p. 21.

3. *Ibid*, vol. II, ch. XVII, p. 248.

4. Especially in ch. XCVIII and XCIX on '*le beau idéal moderne*'.

5. *Ibid.*, vol. I, p. 180.

6. The best and most accessible recent edition of *De L'Allemagne* is that by Simone Balayé, published by Garnier-Flammarion, 2 vols., Paris, 1968. See also comtesse J. de Pange, *Madame de Staël et la découverte de l'Allemagne*, Paris, 1929.

7. *De L'Allemagne*, op. cit., vol. I, ch. XI, 'De l'Esprit de Conversation'.

8. *Ibid.*, preface, p. 39.

9. *Ibid.*, seconde partie, ch. XI: '*De la Poésie Classique et de la Poésie Romantique*'.

10. *Ibid.*, vol. I, ch. XVI: '*La Prusse*'.

11. *Ibid.*, vol. I, ch. XV: '*De l'art dramatique*'.

12. Letter to M. de Gérando, Weimar, 26 February 1804.

13. *De L'Allemagne*, vol. II, *quatrième partie*, ch. XII.

14. *Ibid.*, vol. II, ch. VI: '*Kant*'.

15. *Ibid.*, vol. II, ch. VI, p. 137.

16. *Ibid.*, vol. II, ch. IX: '*Influence de la nouvelle philosophie*'.

17. *Ibid.*, vol. II, ch. IX, p. 162.

18. *Ibid.*, p. 162.

19. *Ibid.*, vol. II, ch. XXXII: '*Des Beaux-Arts en Allemagne*', p. 84.

20. Eugène Delacroix, *Oeuvres Littéraires*, ed. Elie Faure, 2 vols., vol. I, Paris, 1923, pp. 65-7. This passage is in fact a long quotation from *De L'Allemagne*.

21. Delacroix, *Journal*, ed. A. Joubin, 3 vols., vol. I, Paris 1893-5, p. 50. The painter's debt to Madame de Staël's theory is analysed by G. Mras, *Eugène Delacroix's Theory of Art*, Princeton, 1966.

22. *De L'Allemagne*, vol. II, ch. XXXII.

23. The influence of *De L'Allemagne* on French Romantic literature is studied by I.A. Henning in *L'Allemagne de Madame de Staël et la polémique romantique*, Paris, 1929 but its impact on the visual arts has received little or no attention. See also André Monchoux, 'Madame de Staël et le Romantisme français', in *Madame de Staël et l'Europe, Colloque de Coppet* (18-24 July 1966).

24. See Marthe Kolb, *Ary Scheffer et son temps*, Paris, 1937, pp. 109-10.

25. Delacroix's drawings, mainly dated 1826-8, were then made into lithographs for Albert Stapfer's 1828 edition of *Faust* in French translation.

26. See P. Jamot, 'Goethe et Delacroix', in *G.B.-A.*, 1932, and more recently, G. Busch, *Eugène Delacroix: Der Tod des Valentin*, Frankfurt-am Main, 1973.

27. *De L'Allemagne*, vol. I, p. 238.

28. For a modern interpretation of Corinne, see S. Gutwirth, *Madame de Staël Novelist*, Illinois, 1978.

29. M. Schroder, *Icarus. The Image of the Artist in French Romanticism*, Cambridge (Mass.), 1961, pp. 21.

30. C. Dejob, *Madame de Staël et l'Italie*, Paris, 1890.

31. See S. Balayé, *Les Carnets de Voyage de Madame de Staël*, Paris, 1971, p. 94.

32. On this theme, see article by S. Balayé, 'Absence, exil, voyage', *Colloque de Coppet*, June 1966.

33. Chateaubriand, *Mémoires d'Outre-tombe*, vol. IV, 'La mort de Madame de Staël', Brussels, 1849, pp. 352-3.

34. The genesis of *Corinne* has been definitively clarified by S. Balayé in the *Carnets de Voyage*, op. cit. 94-8.

35. Necker de Saussure, *Notice sur Madame de Staël*, Paris, 1820, p. 122.

36. Stendhal, *Mélanges d'art, Salon de 1824*, Paris, 1932, p. 32.

37. C. Pellegrini, *Madame de Staël e il gruppo di Coppet*, Bologna, 1974, pp. 57-63.

38. S. Balayé, 'Madame de Staël et Sismondi, un dialogue critique' in *Cahiers staëliens*, no. 8, 1969.

39. Quoted in G. Gennari, *Le Premier Voyage de Madame de Staël en Italie et la genèse de Corinne*, Paris, 1947, p. 32.

40. Chateaubriand, *Lettre à M. de Fontanes sur la Campagne Romaine* (March 1804), ed. J.M. Gautier, Geneva, 1951.

41. *Corinne*, Book V, ch. I.

42. Sainte-Beuve, *Chateaubriand et son groupe littéraire*, Paris, 1861, vol. I, pp. 326-7.

43. Letter from Monti to Madame de Staël 6 April 1805.

44. Madame C. Lenormant, *Coppet et Weimar, Madame de Staël et la grande-duchesse Louise*, Paris, 1862, p. 70.

45. *Corinne*, Book VIII, ch. IV.

46. See S. Balayé, 'Du sens romanesque de quelques oeuvres d'art dans Corinne de Madame de Staël', in *Mélanges offerts à André Monchoux, Annales de l'Université de Toulouse*, Tome XIV, 1979. Though short, this is by far the best study of the subject published to date.

47. This is almost certainly a reference to the Persian Sibyl, painted between 1613-14, and bought in 1848 by Lord Hertford; now in the Wallace Collection, London. The painting was probably in the Palazzo Ratta in Bologna when Madame de Staël saw it in 1805. On this question, see S. Balayé, *Carnets de Voyages*, p. 184, and S. Balayé and E. Renfrew: 'Madame de Staël et la Sibylle du Dominiquin' in *Cahiers staëliens* (January 1964).

48. *Corinne*, Book VIII, ch. IV.

49. *Corinne*, Book XII, ch. IV.

50. Madame Necker de Saussure, *Notice sur Madame de Staël*, Paris, 1820, pp. 136-7.

51. *Corinne*, Book XIX, ch. VI.

52. *Ibid.*, Book VIII, ch. II.

53. *Ibid.*, Book VIII, ch. IV.

54. Though these two paintings by George Augustus Wallis (1768-1847) were of paramount importance to Madame de Staël, I have been unable to trace them. They may well have been in the collection of the Earl-Bishop of Bristol (1730-1803), many of whose paintings were lost when sequestrated in 1798 by the French army in Italy. Export records published by A. Bertolotti (*Archivio Storico di Roma*, 1880, IV) state that in November 1802 Lord Bristol despatched paintings by Friedrich Rehberg and Vincenzo Camuccini to England, but those by Wallis do not seem to have been among them. The only book on Wallis is by K. von Baudissin: *George-August Wallis. Maler aus Schottland. 1768-1847*, Heidelberg, 1924. In a summary

catalogue the author lists (p. 62) two Ossianic pictures by Wallis: *Comalla asleep on the grave of his father Duthcarron* and *Blind Ossian on the grave of his father Fingal*. Both pictures had belonged to the Earl-Bishop of Bristol and in 1806 were on sale in the cloister of San Isidoro. They were also seen in Rome by the dramatist Kotzebue and by Schlegel. (G.A. Guattani, *Memorie enciclopediche romane*, Rome, 1806, vol. I). It seems almost certain that the first of these Ossianic pictures is the one described by Madame de Staël in *Corinne*.

55. See Balayé, 'Du sens romanesque de quelques oeuvres d'art dans *Corinne*', p. 356. Although anonymous, the painting of Regulus is almost certainly one by Gavin Hamilton which belonged to the Earl-Bishop and which Madame de Staël would have seen in Rome. It was mentioned in an early nineteenth-century inventory of pictures at Downhill, Ireland, and was probably destroyed by fire in 1851. See article by Brinsley Ford, 'The Earl-Bishop. An eccentric and Capricious Patron of the Arts' in *Apollo*, June 1974.

56. The original of Gérard's *Blind Belisarius*, now lost, was in the collection of the duc de Leuchtenburg and is known only through an engraving by Auguste Desnoyers, dated 1806.

57. *Corinne*, Book VIII, ch. IV.

58. See S. Balayé, 'Corinne et ses illustrateurs' in *Revue des sociétés des amis de Versailles*, (2ᵉ trimestre, 1966), in which the question of illustrated editions of *Corinne* is fully covered and several examples reproduced. The main illustrated editions were: Paris, Ledentu; ed. H. Nicolle, 1819, 4 vols. Portuguese translation, Paris, Tournachon-Molin, 1824, 4 vols. Paris, Garnier, 1837. Limoges, M. Ardant frères, 1839, 2 vols. Paris Treuttel et Wurtz, 1841. This is the most fully illustrated edition of Corinne, with drawings by Mauvoisin, engraved by Thomas Williams.

59. *Corinne*, Book XIII, ch. IV.

60. See E. Herriot, *Madame Récamier et ses amis*, 2 vols., Paris, 1905.

61. *Correspondance de François Gérard*, vol. II, Paris, 1886, p. 340.

62. See L. Batiffol, 'Madame Récamier à l'Abbaye aux Bois', in *G.B.-A.*, xxxvi (July 1906).

63. P.A. Coupin, *Revue Encyclopédique, Salon de 1824*. 2nd article; 'M. le Prince de Talleyrand en possède une dans laquelle Corinne est seule. C'est celle-là que je donne, sans hésiter, la préference.'

64. Stendhal, *Mélanges d'art*, op. cit. pp. 31-2.

65. *Correspondance de François Gérard*, op. cit., pp. 350-1.

66. Thiers, in *Le Constitutionnel, Salon de 1822*.

67. Letter of May-June 1821, quoted in C. Clément, *Léopold Robert, d'après sa correspondance inédite*, Paris, 1875, p. 167.

68. *Corinne*, Book XX, ch.V.

69. See S. Balayé, *Carnets de Voyage*, p. 336. On Sergel and Madame de Staël, see exhibition catalogue of the Hamburger Kunsthalle, May-September 1975.

70. A full account of these is given in Y. Bezard, *Madame de Staël d'après ses portraits*, Paris, 1938.

71. Chateaubriand, *Mémoires d'Outre-tombe*, vol. IV, Brussels, 1849, p. 352.

72. Isabey's drawing shows Madame de Staël in 1797, and was the preparatory sketch for a more finished drawing of the sitter seated at a desk with a bust of Necker in the background (Epinal, Musée).

73. On Friedrich Tieck, see the article by comtesse J. de Pange, 'Le Sculpteur Tieck à Coppet', *G.B.-A.*, (January 1952), in which several of the artist's works are reproduced, including some beautiful Nazarene-style drawings of Madame de Staël's daughter Albertine, later duchesse de Broglie. Madame de Staël met Friedrich Tieck (1776-1851) brother of the poet Ludwig Tieck, in Weimar in 1803. He also executed a bas-relief for the mausoleum at Coppet in 1805-8.

74. This painting was more plausibly attributed to Firmin Massot by Edouard Rod in Les Souvenirs du Château de Coppet', three articles in *G.B.-A.*, (1905.)

75. There are two known versions of this picture, a larger one (probably the original) in the museum of Geneva, and a smaller one at Coppet with an inscription to John Rocca. There are also several versions in miniature, two at Coppet, one in the Wallace Collection, London, another in the château de Barente and one in the Bibliothèque Nationale, Paris.

76. Letter from Madame de Staël to Henri Meister, 18 September 1807, in *Lettres inédites à Henri Meister*, eds. P. Usteri, E. Ritter, Paris, 1904.

77. Elisabeth Vigée-Lebrun, *Souvenirs*, vol. II, Paris, 1755-89, p. 193.

78. *Archives de Coppet*, quoted in Y. Bezard, op. cit., p. 17.

79. The original is at Coppet, and a replica in the Château de Broglie.

80. Formerly belonging to the comtesse de Pange, and still presumably in the d'Haussonville family.

81. Painted by J.-P. Mühlhauser.

Chapter II

1. I am most grateful to the editor of the *Burlington Magazine* for allowing me to reprint the substance of an article which first appeared in that journal in January, 1978. Since then several other paintings related to Chateaubriand's *Atala* have appeared, among them a version of *The Burial of Atala* bearing Girodet's monogram on the reverse which has been acquired by the Getty Museum. I am grateful to Alastair Laing for help with

this painting, as well as for drawing to my notice the painting of 1830 by Cesare Mussini (1804-79) in the Galleria d'arte moderna of the Pitti Palace, Florence and the drawing by Girodet (13.2 x 15.7 cm) in the museum of Angers, exhibited at the Heim Gallery in 1977. Mussini's painting was included in the exhibition *Cultura neoclassica e romantica nella Toscana Granducale*, Florence, 1972. The work for this chapter was already complete before the major Girodet retrospective (edited by Sylvain Bellenger) was held at the Louvre in 2005. The main books and articles relevant to this chapter are: *Atala*, ed. Armand Weil, Paris, 1950, which lists most of the known illustrations and works connected with the novel: *Chateaubriand, Le Voyageur et l'Homme politique*. Catalogue de l'exposition, Bibliothèque Nationale, Paris, 1969. H. Lemonnier, 'L'Atala de Chateaubriand et l'Atala de Girodet' in *G.B.-A.*, (1914); A. Poirier, *Les idées artistiques de Chateaubriand*, Paris, 1930. The edition of Chateaubriand's works used is, unless otherwise stated, the *Oeuvres Complètes* in 28 vols., Brussels, 1835.

2. Among these were twelve hexagonal plates in Faïence de Choisy, each one with a different scene from the novel.

3. *Mémoires d'Outre-tombe*, ed. de la Pléiade, vol. I, Paris, p. 445.

4. *Ibid.*, vol. I, p. 445.

5. Author of *Observations critiques sur le roman intitulé 'Atala'*, Paris, 1802.

6. Chateaubriand, *Oeuvres Complètes*, vol. 3, p. 16.

7. Gautier, *Histoire du Romantisme*, p. 3.

8. 'La cime indéterminée des forêts' was the phrase to which he particularly objected.

9. *Atala*, ed. F. Letessier, p. 79.

10. *Le Génie du Christianisme: Des Eglises gothiques*, Oeuvres Complètes, vol. 12, p. 285.

11. *Essai*, vol. I, p. 480, note.

12. *Salon de 1824*: livret no. 333. Engraved in C.P. Landon: *Annales du Musée. Salon de 1824*, vol. I, p. 15.

13. The wording in the livret reads: '*L'envoyé du préteur Sextilius ayant signifié à Marius, proscrit, l'ordre de se retirer de l'Afrique, celui-ci lui répondit: Tu diras à Sextilius que tu as vu Caius Marius banni de son pays, assis sur les ruines de Carthage.*'

14. *Oeuvres Complètes*, vol. 12, 3rd part: Beaux-Arts et Littérature.

15. *Les Martyrs: Remarques sur le livre XXII. Oeuvres romanesques*, Paris, 1969, p. 669.

16. See A. Poirier, *op. cit.*, pp. 19-54.

17. *Essai sur la littérature anglaise*, vol. XI, Paris, 1861, p. 585.

18. *Préface de la première édition d'Atala*, p. 8.

19. *Ibid.*, p. 8.

20. Sainte-Beuve: *Chateaubriand et son groupe littéraire*, ed. Maurice Allem, Paris, s.d., pp. 168-9.

21. *Atala*, op. cit., p. 50.

22. Chateaubriand acknowledged his debt to Girodet in the first book of *Les Martyrs* when he wrote: '*tel, un successeur d'Apelles a représenté le sommeil d'Endymion*'. *Oeuvres romanesques*, p. 113.

23. This work has been made a great deal easier by the invaluable repertory of literary subject matter in French nineteenth-century art at the Department of Art History, Oxford.

24. See M.H. Miller, *Chateaubriand and English literature*, Paris, 1925, pp.123-34.

25. *Salon de 1802*, No. 200.

26. No. 109. Engraved in Landon: *Annales du Musée, Salon de 1802*, vol. III. p1. 51. The painting was bought by Lucien Bonaparte.

27. *Atala, op. cit.*, p. 146.

28. *Décade philosophique*, 12 October 1802, vol. 35, p. 108.

29. See Landon, *Annales du Musée*, 1806, vol. 12, p. 94.

30. *Décade philosophique*, 21 October 1806, vol. 51, pp. 182-3.

31. Engraved in Landon, *Salon de 1808*, p1. 43. P. J. Lordon (1780-1838) was a pupil of Prudhon.

32. *Atala, op. cit.*, p. 139.

33. Salon catalogue no. 346: '*Chactas, après avoir soulevé le linceul qui recouvrait Atala, s'abandonne à des réflexions sinistres en la contemplant pour la dernière fois. Le père Aubry est en prières.*'

34. *Salon* catalogue no. 696.

35. *Salon* catalogue no. 751.

36. *Salon* catalogue no. 869.

37. *Salon* catalogue no. 924.

38. Engraved in Landon, *Annales du Musée, Salon de 1819*, vol. I, p. 59.

39. Cabinet des Dessins, Musée du Louvre. *Inventaire général des dessins du Musée du Louvre*, vol.VI, no. 4332.

40. Cabinet des Dessins, no. 4364. From Book XXII of *Les Martyrs*: '*Ce dernier repas était servi sur une table immense, dans le vestibule de la prison . . .*'

41. From Book XV of *Les Martyrs*, in which the confessors meet in the Roman catacombs and elect Eudore to defend the Christian cause before Diocletian. This is the painting in Aix-en-Provence.

42. See *Girodet 1767-1824*, exhibition catalogue, Montargis, 1967.

43. E.-J. Delécluze, *David, son école et son temps*, 1855, pp. 254-73.

44. *Ibid.*, p. 267.

45. Girodet: *Oeuvres posthumes*, Paris, 1829. *Le Peintre: Chant premier*.

46. *Oeuvres posthumes, op. cit.*, vol. II, p. 110.

47. See article by H. Lemonnier in *G.B.-A.*, (1914).

48. '*Le Peintre*', in *Oeuvres posthumes*, vol. I, pp. 151-2.

49. The work was acquired for the Louvre in 1818 by Louis XVIII. Many versions and replicas of it are known, some by Girodet himself, others by close followers. Most of these are listed in the Girodet catalogue, Montargis, under entry no. 38, including an '*esquisse terminée*' mentioned by Coupin, a version painted by Girodet for the Empress Josephine in 1811, and a replica begun by Pagnest completed and signed by Girodet in 1813 (sent to the museum of Amiens in 1864). A series of engravings after the *Funérailles d'Atala* by Aubry Lecomte were published in 1822; a set of these can be seen in the château of Valençay which belonged to Talleyrand.

50. Girodet catalogue, no. 78; pen on white paper.

51. Bought by M. Ledé, a local drawing master, from Girodet's heir and sold to the museum of Varzy in 1861.

52. *Atala, op. cit.*, pp. 143-4.

53. *Mémoires d'Outre-tombe*, Book V.

54. *Chateaubriand et son groupe littéraire*, vol. I, p. 207.

55. E. Bénézit: *Dictionnaire des Peintres . . .*, vol. 4, p. 287.

56. Baudelaire: *L'Exposition Universelle de 1855*, in *Curiosités Esthétiques*, Paris, 1962, p. 224.

57. N. Schlenoff: *Ingres, ses sources littéraires*, Paris, 1956, p. 69.

58. *Ibid.*, p. 100.

59. P. van Tieghem, *Ossian en France*, Paris, 1917, p. 586.

60. Schlenoff, *op. cit.*, pp. 67-8.

61. A. Robaut, *L'Oeuvre complet d'Eugène Delacroix*, Paris, 1885, p. 35.

62. Delacroix, *Journal*, 14 February 1850, ed. A. Joubin, vol. 1, p. 340.

63. *Ibid.*, vol. III, pp. 240-8.

64. *Ibid.* vol. III, p. 240, note 2.

65. See Teresio Napione, *Chateaubriand nella letteratura e nell'arte italiana*, Turin, 1928, pp. 145-60, where the above-mentioned paintings are reproduced.

66. See Marco Calderini: 'Andrea Gastaldi', in *Bollettino d'Arte*, September 1922.

Chapter III

1. See A.O. Lovejoy: 'On the Discriminations of Romanticisms', first published in *Publications of the Modern Language Association*, 1924, pp.229-53. The opposite point of view, namely that Romanticism possesses a basic underlying unity, was consistently and eloquently expressed by the late Isaiah Berlin.

2. R. Bray, *Chronologie du Romantisme*, Paris, 1932, and P. Martino, *L'Epoque romantique en France, 1815-1830*, Paris, 1944. *The Romantic Movement in French Literature* by H. Stewart and A. Tilley, Cambridge, 1921, is still a mine of useful information.

3. Stendhal., Letter to Mareste, 14 April 1818, in *Correspondance*, vol. I, eds. H. Martineau et V. Del Litto, Paris, 1968, p. 909.

4. Stendhal, *Histoire de la peinture en Italie*, Paris, 1892, ch. CLXXXIV.

5. *Ibid.*, p. 405.

6. Stendhal, letter to Crozet, 28 September 1816, in *Correspondance*, vol. I, p. 819.

7. Stendhal, *Racine et Shakespeare*, ed. R. Fayolle, Paris, 1970, p. 71.

8. *Racine et Shakespeare*, op. cit., p. 72.

9. *Ibid.*, p. 97.

10. *Histoire de la peinture en Italie*, ch. CXXV.

11. See D. Wakefield, 'Stendhal: Art Historians and Art Critics XI', in *Burlington Magazine*, December 1975.

12. On the links between Stendhal and Baudelaire, see Margaret Gilman, *Baudelaire the Critic*, New York, 1943.

13. Charles Baudelaire, Salon de 1846, II, 'Qu'est-ce que le Romantisme?' in *Curiosités esthétiques*, Paris, 1962, p. 103.

14. Victor Hugo, *Préface de Cromwell*, Paris, 1968, p.69.

15. *Ibid.*

16. R. Wellek, *A History of Modern Criticism 1750-1950*, vol. II, London, 1966, p. 255.

17. Hugo, *Préface des Orientales*, February 1829.

18. Letter from Madame Jules Gaulthier to Stendhal, 25 August 1832, in Stendhal, *Correspondance*, vol. II, p. 890.

19. In an article entitled *Du Génie critique et de Bayle* (1835).

20. Alfred de Musset, *Lettres de Dupuis et Cotonet, Oeuvres complètes en prose*, Paris, 1960, p. 820.

21. *Ibid.*, p. 828.

Chapter IV

1. Full bibliography of the reviews covered in this chapter will be found in the article by Pontus Grate, 'La critique d'art et la bataille romantique', in *G.B.-A.*, 1959, and in the much earlier though still indispensable volume by Maurice Tourneux, *Salons et Expositions d'art à Paris 1801-70*, Paris, 1919. For more general studies of art-criticism in the Romantic period, see P. Grate, *Deux critiques de l'époque romantique*, Stockholm, 1959, C.M. Des Granges, *Le Romantisme et la critique 1815-30*, Paris, 1907, and P. Pétroz, *L'Art et la Critique en France depuis 1822*, Paris, 1875.

2. E.-J. Delécluze, *Souvenirs de Soixante Ans*, Paris, 1862, p. 254.

3. L. Rosenthal, *La Peinture romantique*, Paris, 1900, p. 101.

4. Stendhal, *Melanges d'art, op. cit.*, Paris, 1932, *Salon de 1824*, p. 11.

5. *Ibid.*, pp. 67-8.